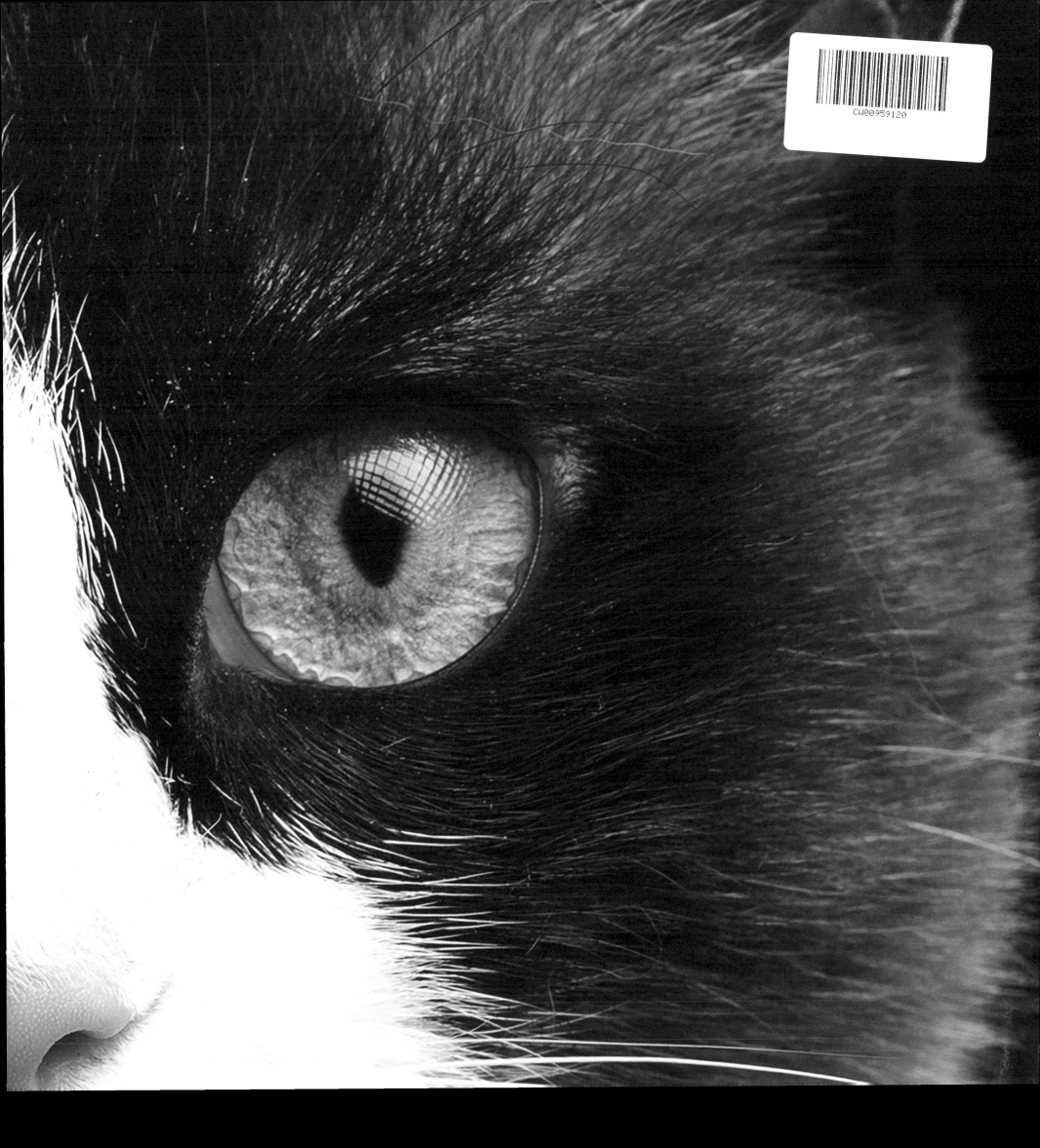

CW00959120

ANIMAL SOUL

ROBERT BAHOU

Published by Robert Bahou and RedDoor
www.reddoorpublishing.com

Photographs, internal layout and cover design by Robert Bahou
© 2016 Robert Bahou
www.robbahou.com

RedDoor Publishing Ltd.
London Road
Burgess Hill
West Sussex RH15 9QU
United Kingdom

Tel. +44 1444 240 152

The right of Robert Bahou to be identified as author of this Work
has been asserted by him in accordance with sections 77 and 78 of
the Copyright Designs and Patents Act 1988

All rights reserved. No part of this publication may be reproduced,
stored in a retrieval system, copied in any form or by any means,
electronic, mechanical, photocopying, recording or otherwise
transmitted without written permission from the author

A CIP catalogue record for this book is available from the British
Library

Behind the scenes photographs used with permission courtesy of
Alesi Enríquez, Tarik Bahou and Monica Matouk

Dustjacket:
Front Cover: *Sam Meditating*, Oss, Netherlands 2015
Back Cover: *Scuba*, Amsterdam, Netherlands 2014

Cover:
Front Cover: *Sam Wakes Up*, Oss, Netherlands, 2015
Back Cover: *Lilly and Skittles*, the Hague, Netherlands, 2015

Editor: Clare Christian
Printer: Graphius | Geers Offset
Printed in Belgium

10 9 8 7 6 5 4 3 2 1

The paper used for *Animal Soul* has been responsibly sourced
and is certified by the Forest Stewardship Council

ISBN: 978-1-910453-21-6

ANIMAL SOUL

ROBERT BAHOU

First Edition
Robert Bahou and RedDoor Publishing

Acknowledgments

In a time where print books and traditional publishers are fading, we see remarkable new platforms emerge in their stead. Animal Soul was brought to life with the help of an incredibly generous group of individuals from all over the world. I would like to sincerely thank each of you for the trust and support you have shown me in searching for a means to fund the project. It is with your help that Animal Soul has seen the light of day. This is momentous in and of itself. I hope you enjoy looking through this book as much as I have enjoyed making it.

Alesi Enríquez, Barcelona, Spain

Alexander Paulusson, Uppsala, Sweden

Alexandra Wood, San Diego, California, United States

Anne Clausen, Shorewood, Wisconsin, United States

Aram Zegerius, Amsterdam, Netherlands

Asher Mendelsohn, Ohio, United States

Bob & Emma Kevitt, San Francisco, California, United States

Carrie D. Miller, Royse City, Texas, United States

Carol McClain, Houston, Texas, United States

Cecilia, Berkshire, United Kingdom

Chelsea, Seattle, Washington, United States

Christina Tellefsen, Kristiansand, Norway

Christina Marshall, West Chester, Pennsylvania, United States

Clare Coulter, Rugby, United Kingdom

Danielle, Holsbeek, Belgium

Danny Clay, Eugene, Oregon, United States

Dayle Lim, Singapore, Singapore

Dave Phelps, Tucker, Georgia, United States

Debbie Lawson, Dubai, United Arab Emirates

Denise Eicher, Alpharetta, Georgia, United States

Dexter Yeats, Idaho, United States

Dimitra Dimitropoulos, Montreal, Canada

Donna A. Jarrett, Ottawa, Canada

Door de Beus, Oost West en Middelbeers, Netherlands

Dorothy Queen, Ulverston, Cumbria, United Kingdom

Elaine Walsh, Tucson, Arizona, United States

Elaine Cassell, Schaumburg, Illinois, United States

Elsa van Latum, Amsterdam, Netherlands

Ellen Holley Dooley, Estes Park, Colorado, United States

Eugene Yi, Saint Paul, Minnesota, United States

Gaëlle Muavaka, Noumea, New Caledonia

Gabriele Joas, Burgau, Germany

Gigi Assassi, London, United Kingdom

Gina Marie-Gallo Mora, Louisiana, United States

Gustavo Romeu Amaral, Belo Horizonte, Brazil

Hana Mufti, London, United Kingdom

Hans Brinker, Seattle, Washington, United States

Heleen Ruhe, Amsterdam, Netherlands

Hof van Felis, Oudesluis, Netherlands

Ivan Wills, Sydney, Australia

James Martinez, Houston, Texas, United States

Janice Haley, Rancho Santa Fe, California, United States

Jennifer Wepierre, Saint-Ségal, Finistère, France

John Austin, Madaba, Jordan

Joonas Toivainen, Lahti, Finland

Jude Dajani, Brighton, United Kingdom

Julie Hadley, Tasmania, Australia

Julie Hancock, Batley, United Kingdom

Karen Barhydt, Missouri, United States

Karin van Elck, Nieuwegein, Netherlands

Kelvin Paull, Saskatoon, Canada

Kim Ott, Pennsylvania, United States

Kristen Dyrr, Apple Valley, California United States

Kosta Stojchev, Valandovo, Macedonia

Kyle Anderson, Alberta, Canada

Lia Sinnige, Lilongwe, Malawi

Linde de Nie, Amsterdam, Netherlands

Lori Duvall, Redwood City, California, United States

Luke Harrington, Chepstow, South Wales

Lynette Jackson-Edwards, London, United Kingdom

Maaike Boes, Bonn, Germany

Maggie Rotter, Canoga Park, California, United States

Maia Austin, Madaba, Jordan

Maren Ramcke, Elmshorn, Germany

Marguerite Anderson, Pennsylvania, United States

Marjan Boonen, Utrecht, Netherlands

Martin Gear, Wickford, United Kingdom

Mary Newman Carnation, Washington, United States

Matt Forrest, Peacehaven, United Kingdom

Megan Struttmann, Virginia, United States

Melissa Fahlstrom, New York, United States

Mina Gürel, Istanbul, Turkey

Mister and Lady, Austin, Texas, United States

Monica Matouk, Madaba, Jordan

Nabila Tekkanat, Helsinki, Finland

Neil Campbell, London, United Kingdom

Nicole V. Cramer, New York, United States

Nina Mileva, Skopje, Macedonia

Nimue Smit, Amsterdam, Netherlands

Pam Linzie, Monroe, Ohio, United States

Pamela Enríquez, San Antonio, Texas, United States

Patricia Lenkov, New York, United States

Paul Todd, Chippenham, Wiltshire, United Kingdom

Pauline Magee, Australia

Pietro Marchesi, Modena, Italy

Pippa Birkin, Matcham, Australia

Raed Khoury, New York, United States

Rafael Roveri Sakata, Sao Paulo, Brazil

Randa Adams, Virginia, United States

Raseljka Maras, Zagreb, Croatia

Rob Rucci, Pennsylvania, United States

Ronald Olufunwa, Brighton, United Kingdom

Ronald Riegman, Haaren, Netherlands

Rowan Rabideau, Bowmanville, Canada

Rudi "Wyando" Ferrari, Cologne, Germany

Sam and Max, Ontario, Canada

Sasha PN, New Malden, United Kingdom

Sasha Rack, Duisburg, Germany

Shawn Peters, New York, United States

Shelley M Hall, Perth, Australia

Sohayla Fawzy, Alexandria, Egypt

Steve Sebban, Tel Aviv, Israel

Ms. Sunshine, Indiana, Pennsylvania, United States

Swara Salih, London, United Kingdom

Tarik Bahou, Amsterdam, Netherlands

Tina Casari, Sherman Oaks, California, United States

Tina Tamer, Mountain View, California, United States

Tintin, Blizzard & Fluffy, Columbus, Ohio, United States

Tycho Tax, Amsterdam, Netherlands

Ulrich Hartmann, Bonn, Germany

Val Woodhouse, West Midlands, United Kingdom

Victor Claerbout, Amsterdam, Netherlands

Victor van Dooren, Amsterdam, Netherlands

Victoria Martin, Somerset, United Kingdom

Viktorija Stojcheva, Valandovo, Macedonia

Wong Shi Quan, Singapore, Singapore

Xin Zong, Brisbane, Australia

Yasemin Erden & Pouncy, Istanbul, Turkey

Yves Grethen, Soleuvre, Luxembourg

Zhiwei Ren, China

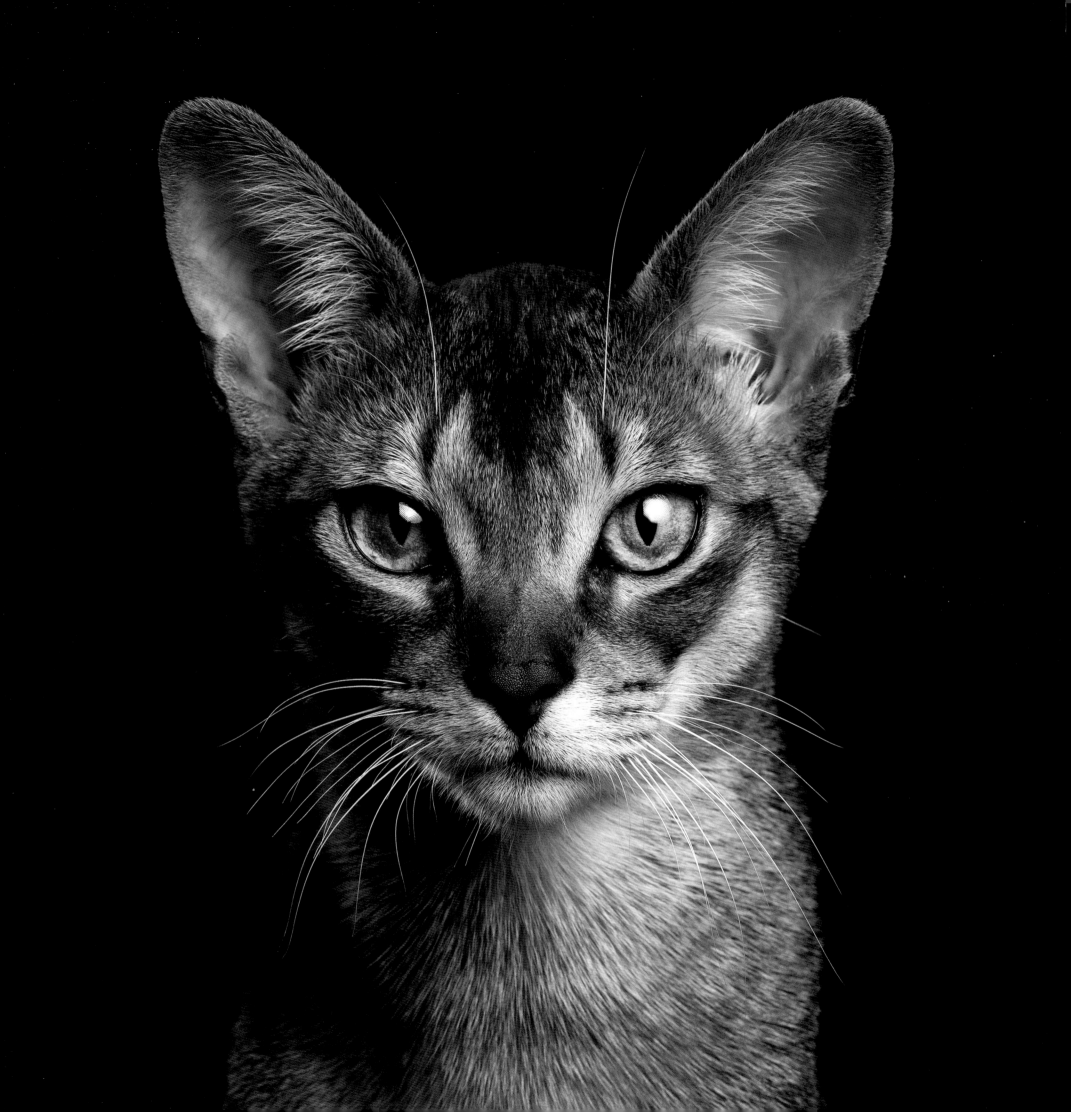

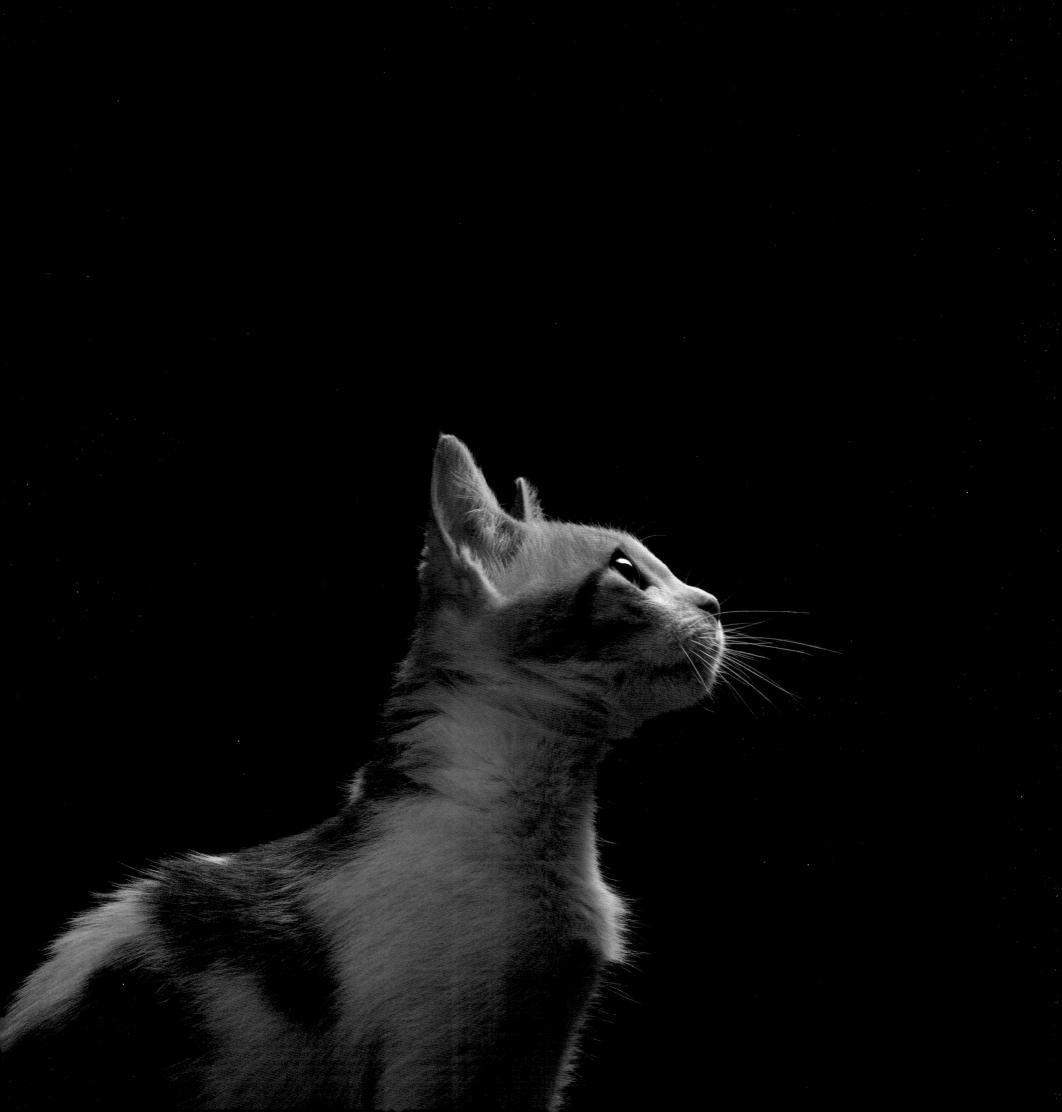

Foreword

Alesi Enríquez

Robert's photographs surprise me, they intrigue me, and most of all, they give me pause. I have found that there are two distinct moments that occur when looking at them. The first is the natural glance. The moment we register what the photo is, and then continue to the following page. The second moment, and the one in which these photos carry their weight, is the instance where we've lost our desire to discover what lies on the next page and instead stare at the photo staring back at us. It is that very moment where we realise that the word 'dog' and the word 'cat' no longer play a role in our experience of the photograph. The very subject of 'animal photos' is one that almost by definition is consumed in short, bite-sized and share-sized portions. This is where these photographs give me pause, here I begin to realise how unfamiliar these photographs are to me. How distant I have grown to being enchanted by something of this nature, without any desire to look past to what comes next. As I look through this series, I often lose myself in the idea that I am standing still and looking at something so familiar, as if I have never seen it before. I can safely say that after having studied this collection, it is difficult to look at dogs and cats in the way I did before. When I see a dog or cat, I catch myself imagining what a portrait of them would yield, what a frozen instant under the right circumstances could tell us. I look at the animals and I wonder, who are they?

Robert manages to find a profound and quiet respect for his subjects, and this echoes through every single photograph in this book. We are put into a position in which we stand eye to eye with the animals that normally walk by our feet, yet it is not uncomfortable. It is in fact wonderfully heartwarming.

I have been with Robert from the very first photo of this series. Although it seems as though this series happened accidentally, it had been in the works for a long time. Robert has incredible respect, patience, and fascination for animals. He carries this calming aura around him that animals seem to be drawn to, and I am convinced this plays a great part in his work. He finds beauty resting in the quiet, simple moments, and he sees these moments in a way only he does. This series is simply about the animals, and nothing else. Sitting still, doing nothing, and that is it. Yet despite how simple an idea this may seem, to my knowledge there has not been another series of photos like this. The photographs hide so little yet at the same time, leave everything open to the imagination.

Give these photographs the time. Come back to them. Again, and then again. You will find something new every time you open these pages. Because, after all, how often do we look back at the same photographs we claim to have already seen?

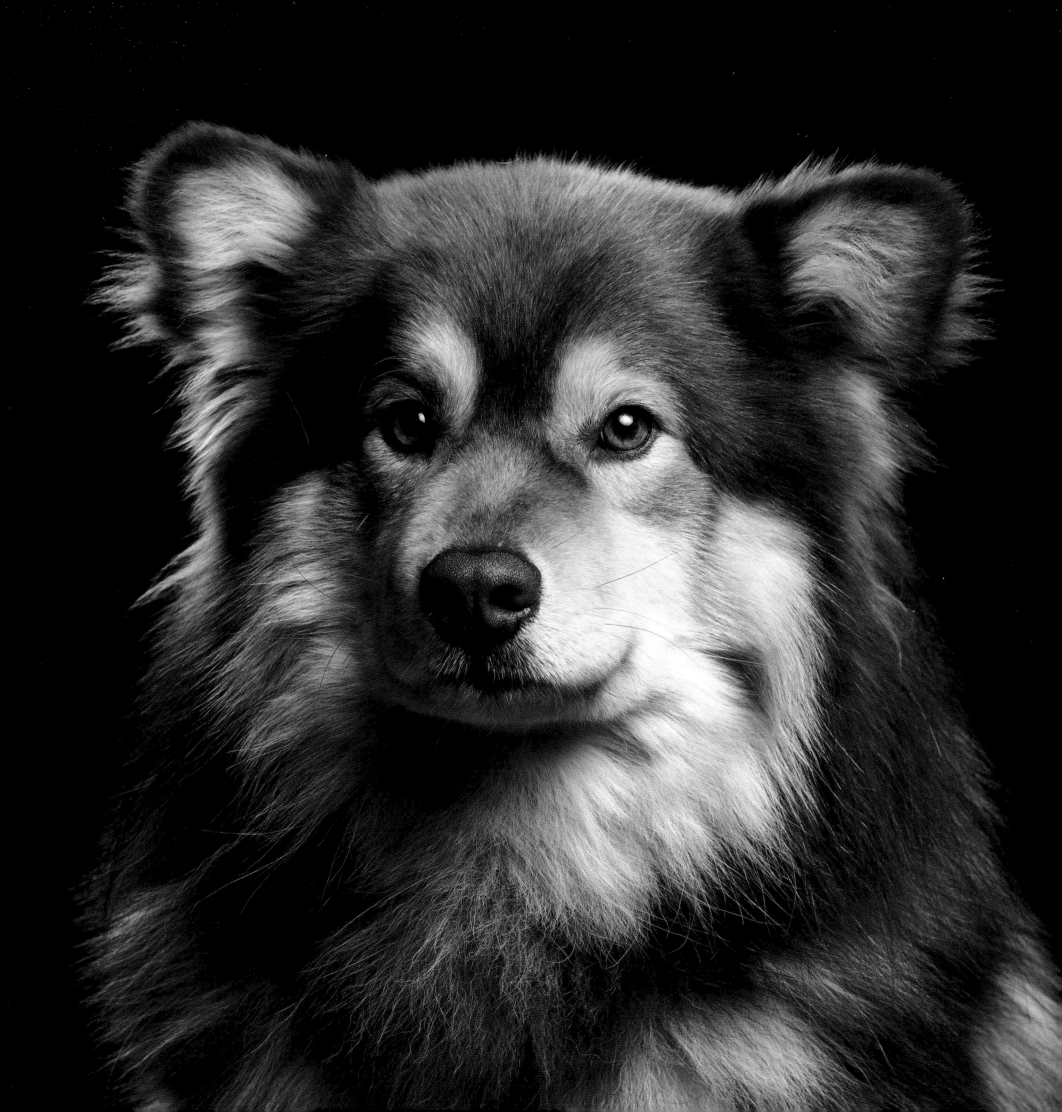

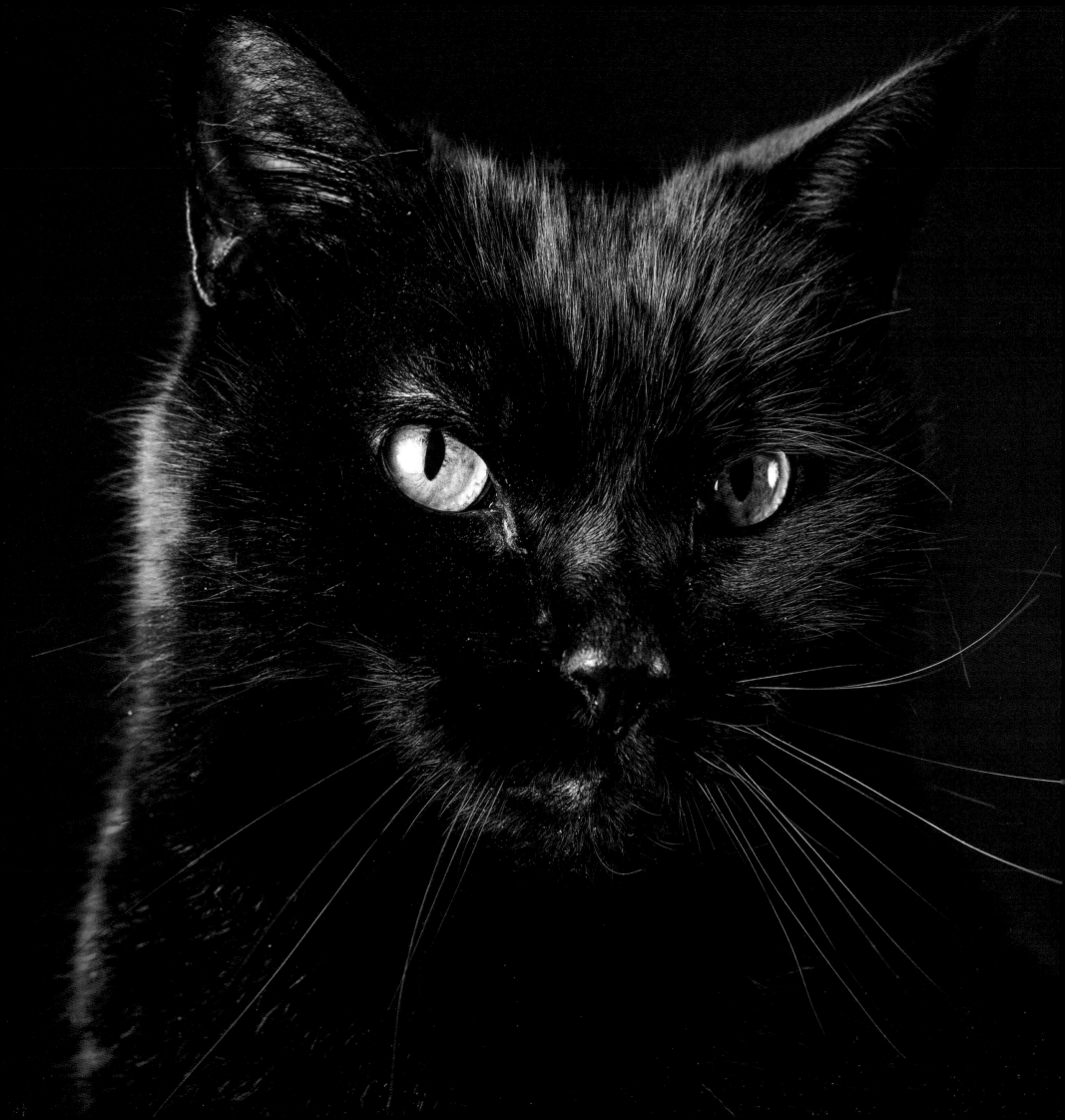

Introduction

Robert Bahou

Capturing a faithful portrait is not easy, but animals make it easier. Human beings are eternally conscious of the presence of a camera, and looking into one renders us unnatural, posed and prepared. Whether consciously or subconsciously, we alter ourselves for the camera, turning to our best side, pulling a particular expression or posing in a pleasing way. This is not the case for animals. I do not believe that animals understand what a camera is, and as a result the photos we make of them bear a hint of truth that we cannot always find with humans. Animals look at the camera as they would anyone or anything else, without the thought or notion of image or appearance. They can gaze into a lens as they would out of a window, losing themselves in curiosity. They can glare at the camera as they would at an insubordinate child who has tested every last bit of their patience. They can glisten with confidence, looking into the lens as though they own it and they can quiver nervously doing anything to avoid it. They often also deliberately ignore the camera altogether and instead focus on whatever else it is that piques their interest. What is certain however, is that animals are able to share a true slice of their character through the photographs that are made of them.

The idea for this specific project came when a friend asked if I could try and photograph her black cat, Tommy, because she was having some trouble capturing anything more than a just a silhouette. I had not tried photographing animals in a studio environment before, so I took it upon myself and gave it a shot. It was definitely not easy, not least because he is a black cat specifically, but more because he is a cat. There was this one shot that struck me in particular (*left*). Tommy was looking past the camera, and it caught me off guard when going through the photos. There was such pensiveness in his eyes as we made him sit on a little velvet pillow and fed him tuna. This was not just a photo of a cat in the more common sense where a cat is nothing but a cat in the photograph. It was a profoundly personal moment between Tommy and the camera, and by extension, us, the viewer. Naturally, I wanted to see if I could somehow replicate this feeling. Then came Gin.

Gin was my next test subject. I was going to try and capture a portrait of her looking at the lens, but from the get-go it looked like a tall order.

She was all but impossible to photograph. She was grumpy, distracted, and had no desire to sit still and look at me. She plunged me into the deep end of photographing animals. She taught me that no matter how stubborn a cat can be, I will be more so. I was feeling a little disheartened when looking through the photos as it looked as though there was not one good capture between the three hundred made. Just as I was nearing the end of the collection I noticed one that I accidentally snapped while she was turning around. I did not need a second glance, that was it. She was looking into the lens as if she was a bitter, cantankerous old man who had no time for my games. It was that moment, that expression, that got her the nickname The Dictator. Later that year this photograph won a national award in the Netherlands. The jury was charmed by Gin's "delightfully angry expression". Charming was perhaps the opposite of her intention. Her desire to be taken seriously was now being overlooked by people all over the country.

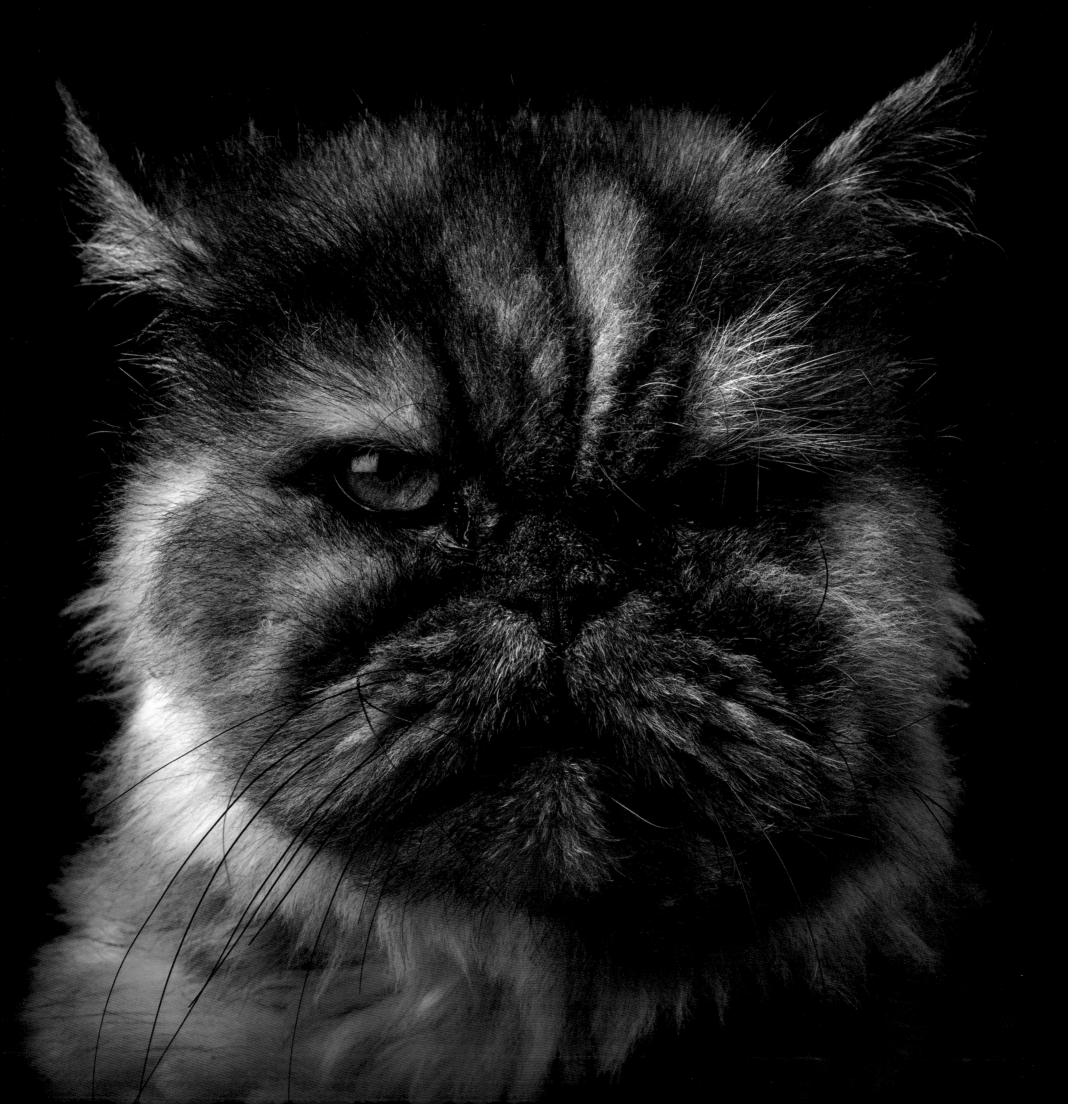

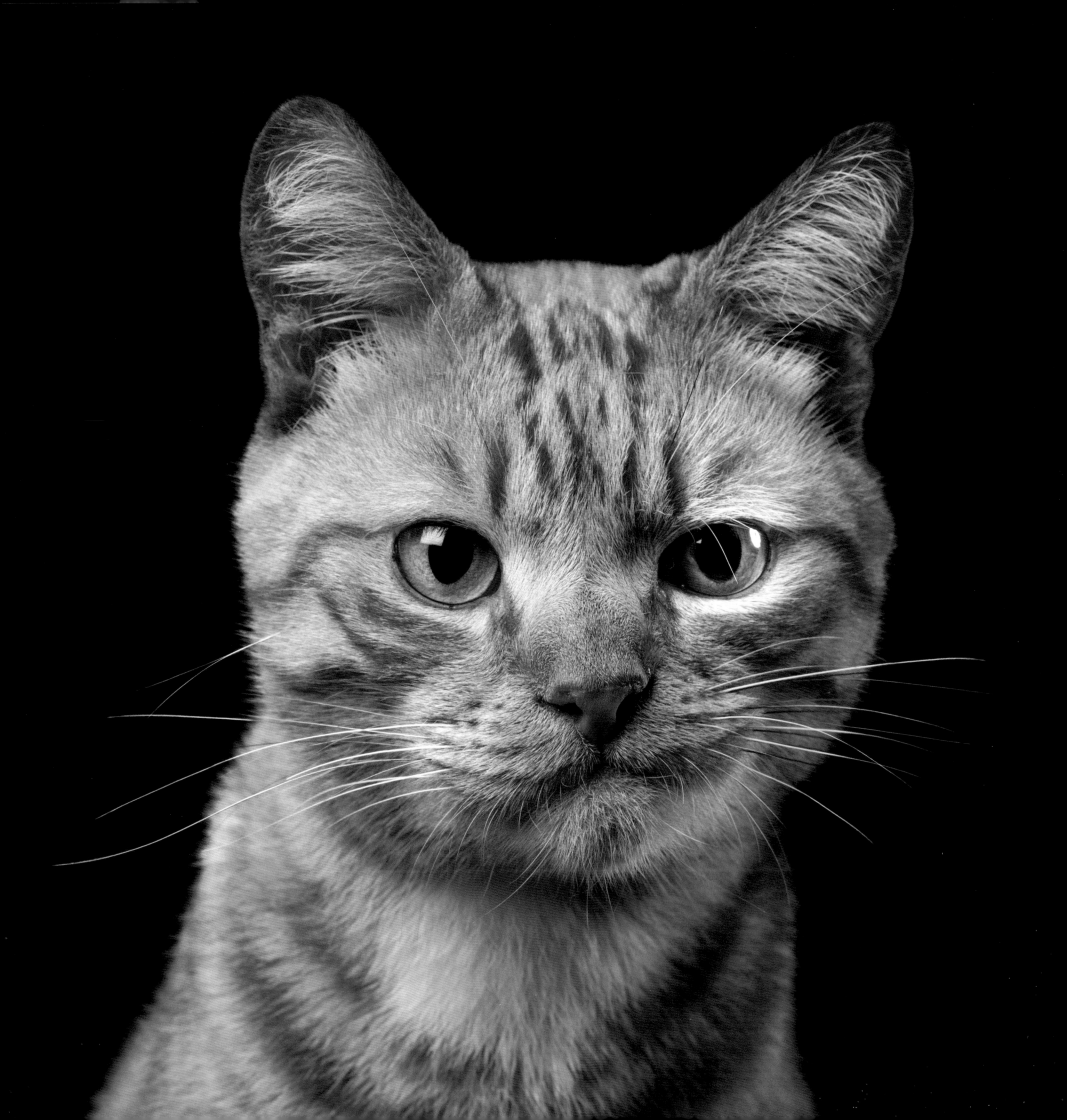

Gin's photo was so extraordinary that it seemed as though I would not be able to make something as special again. Enter Scuba.

Scuba was the next cat I had the privilege to photograph. The whole neighborhood knew about him. As opposed to the majority of cats in this book, he is a real outside, city cat. He has been spotted standing in line at the grocery store a few blocks away from home, and hunting in the marshes on the other side of neighborhood. He is very entitled but still very polite, needless to say, a cat full of personality. I went into the photo session hoping that I could somehow capture a photo as strong as the one of Gin.

At first he refused to sit still on the stool, jumping off as soon as he was put on it. I was not about to let him win at a game of persistence. After about twenty minutes of trying, he gave up resisting, sat still and looked the camera 'in the eye', as if he just wanted to get it out of the way and continue going about his day to day life. It was truly as though he understood what was going on. This (*left*) was the first photograph of the session.

I owe a lot to Scuba. I think I can safely say that you would not be reading this, neither would you have heard of me, were it not for Scuba. Not only is it this particular photograph that seems to speak to virtually every person who lays eyes upon it, it is the photograph that gave me the impetus to get *Animal Soul* moving. It is Scuba who encouraged me to move forward and to pursue this project. I don't know how this book would have developed, or if it would have developed at all without him. What I do know is that I would have never expected to owe so much of my professional career to one of our four legged friends. For this, I am incredibly grateful.

Patience is paramount for these photographs. You can not simply ask an animal to do what you want so that you can make a photo. Most of the time it takes a great deal of waiting and trial and error. This is also because I often have a very specific idea about what I am looking for. Most people doing animal photography do not really concern themselves with such specific demands, as it is not about capturing a telling portrait of the animal, but rather one where the animal looks good.

I am not too fussed about the animal's appearance, if their ears are right or if they are scruffy, or any such imperfections. I care specifically about the story I can capture. I try to make sure that the background is completely black and I avoid grounding the composition (with feet or a solid surface). I feel this combination sends the subject into an empty space where it is nothing but itself, with no distractions and no location. If I ground an image, the viewer quickly becomes conscious of the studio environment, detracting from the visual experience. In keeping with the style of the photographs, this book keeps text at a minimum to avoid distracting from the collection.

I like to think that I am making photos that to a certain extent have the ability to take something commonplace and make it new. Animals have become a staple of Internet consumption and I decided to take the challenge and try and present them in a new light, both literally and figuratively, by distancing myself from the cute and funny photos that populate the web. Instead, my sights were set on the idea that I could make photos that cast a glimpse into an animal's soul and draw attention to the profoundly individual expressions they may have. Photographing animals is not easy, neither is it predictable, but it is the challenge and the reward that make it all worth it.

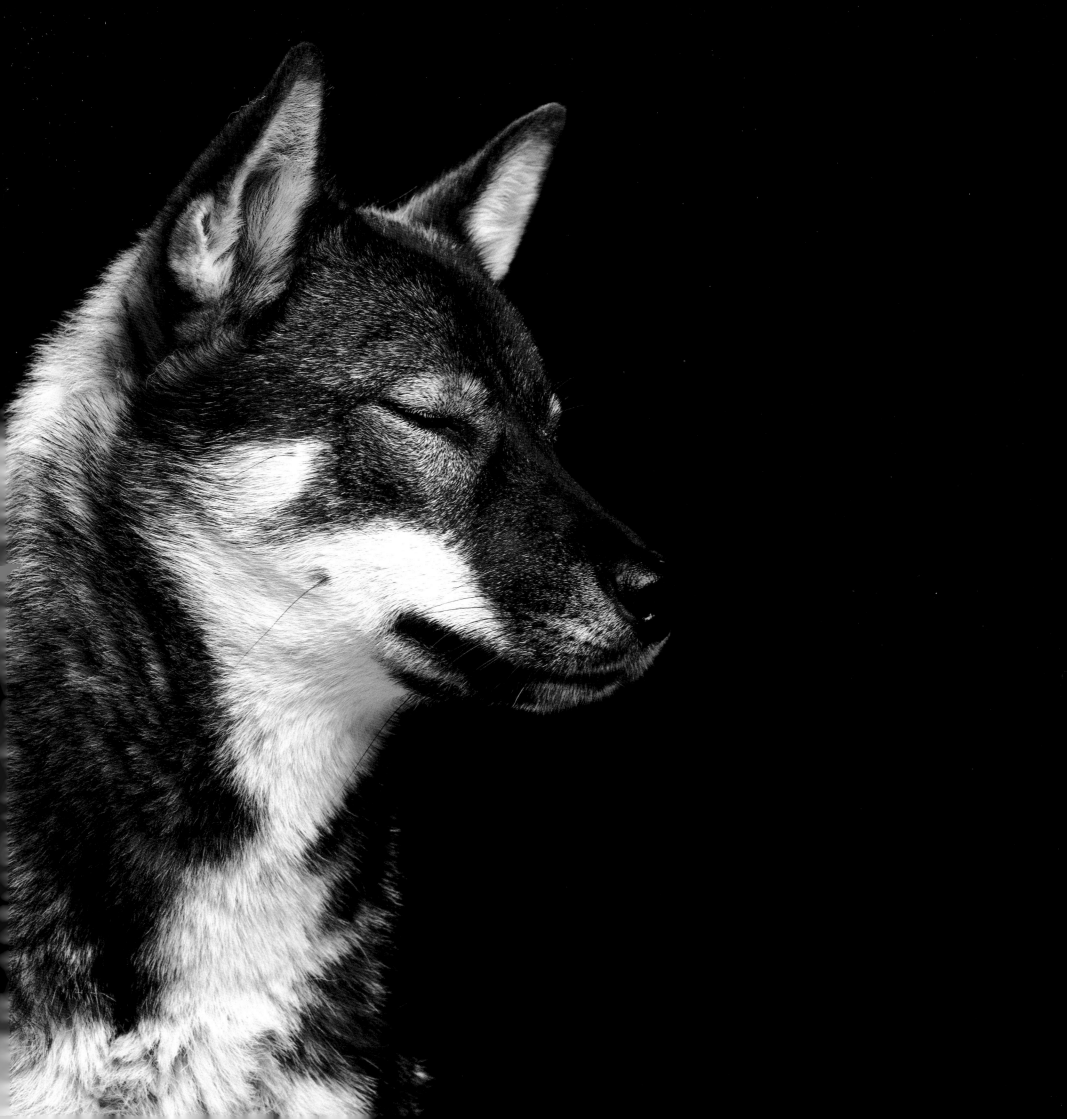

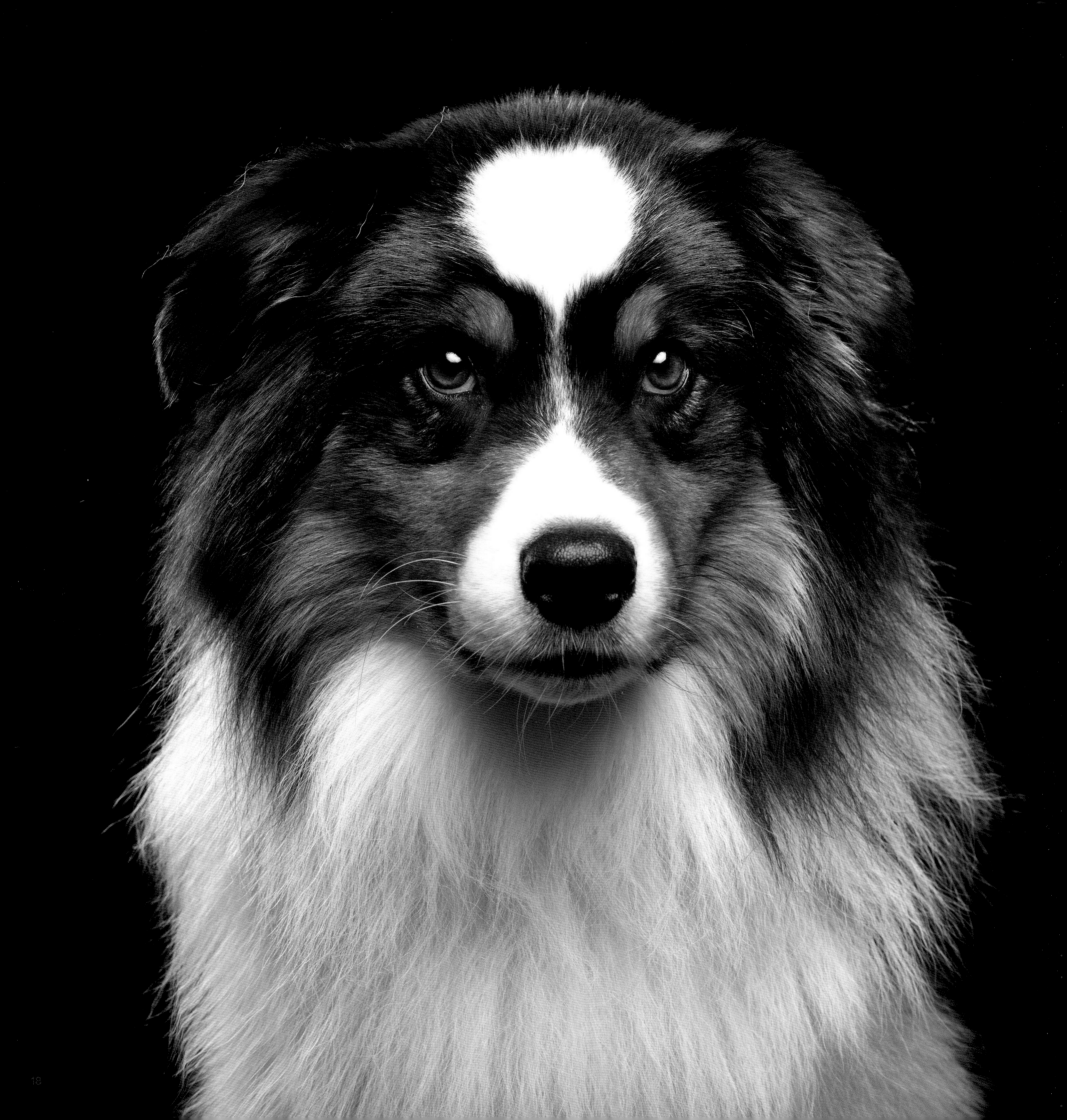

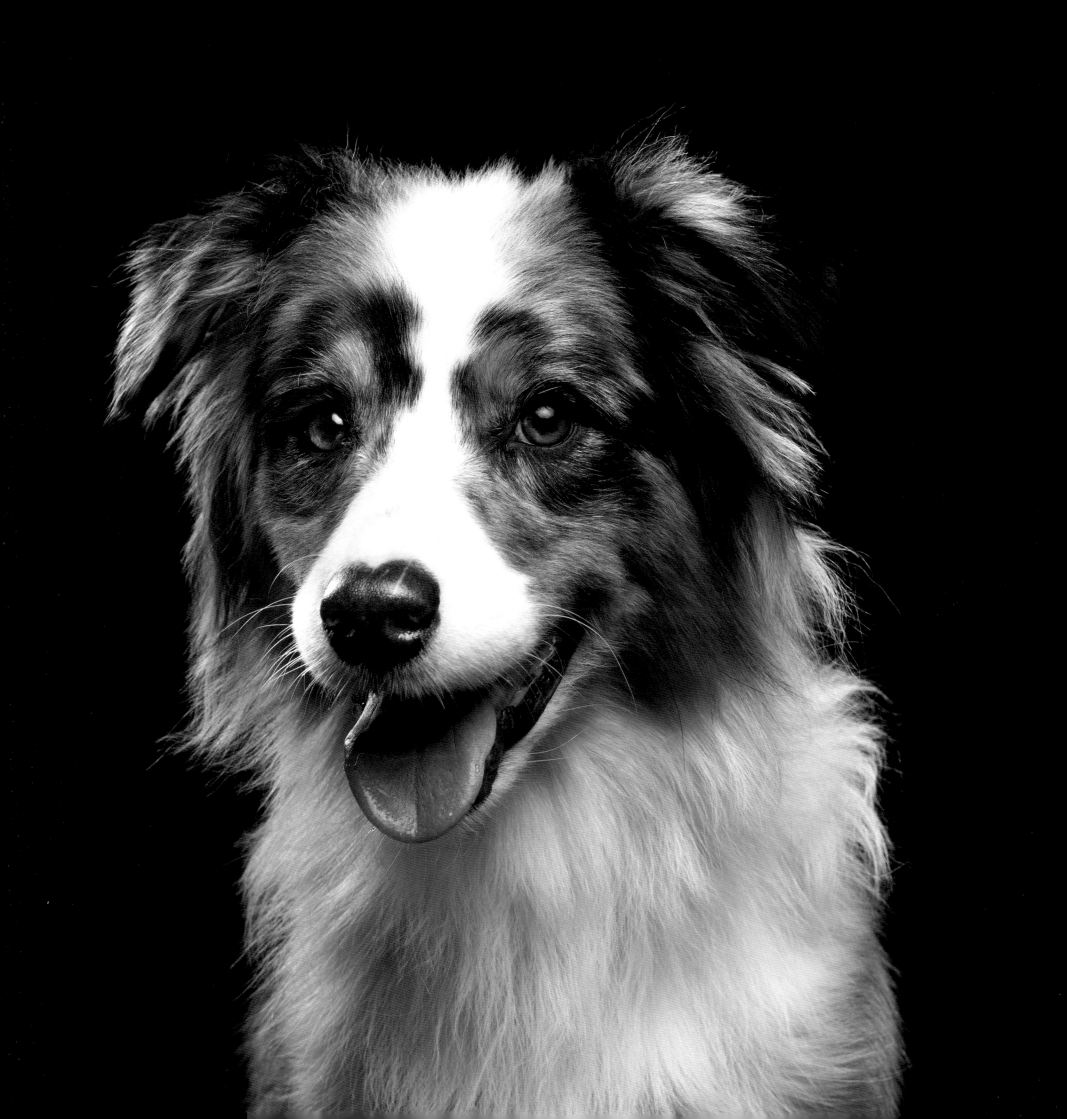

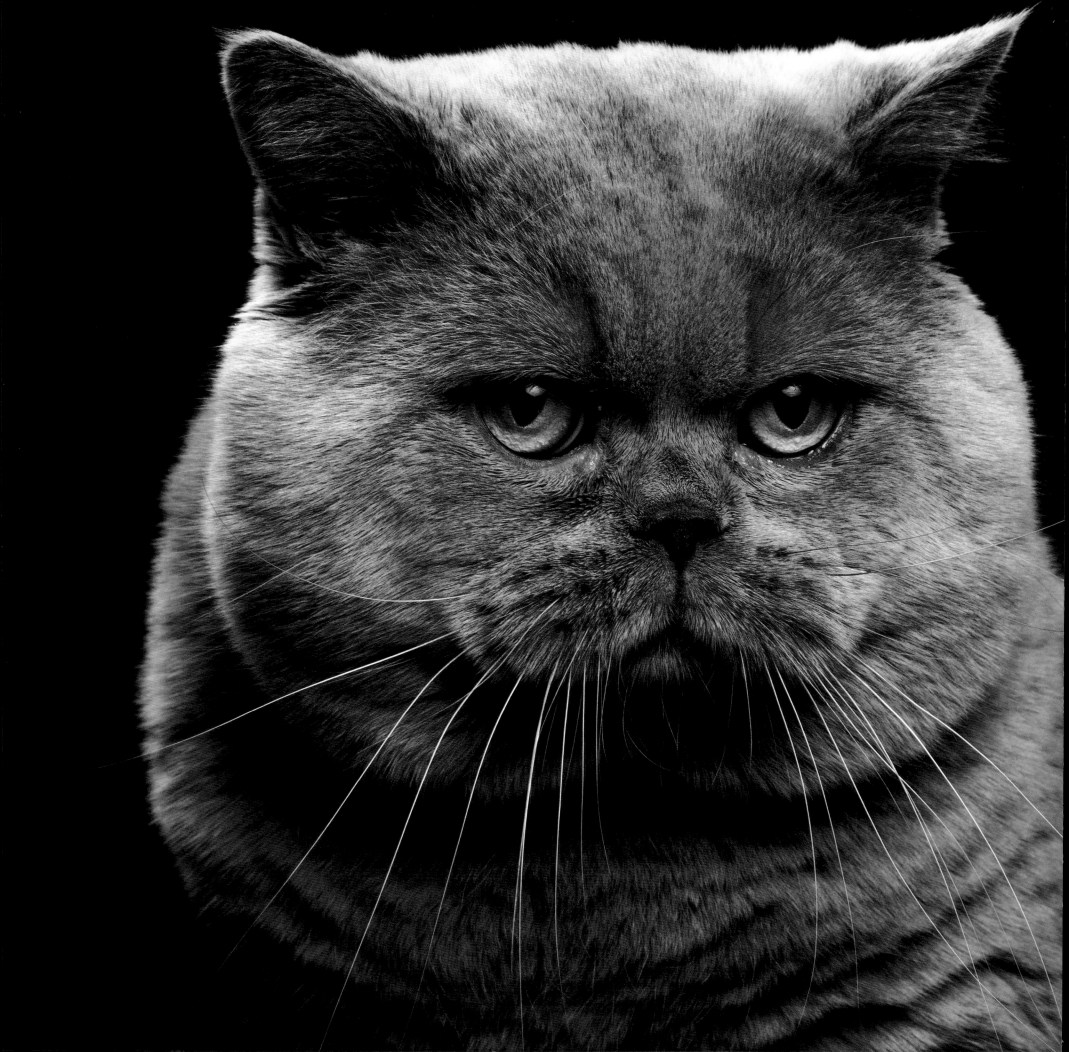

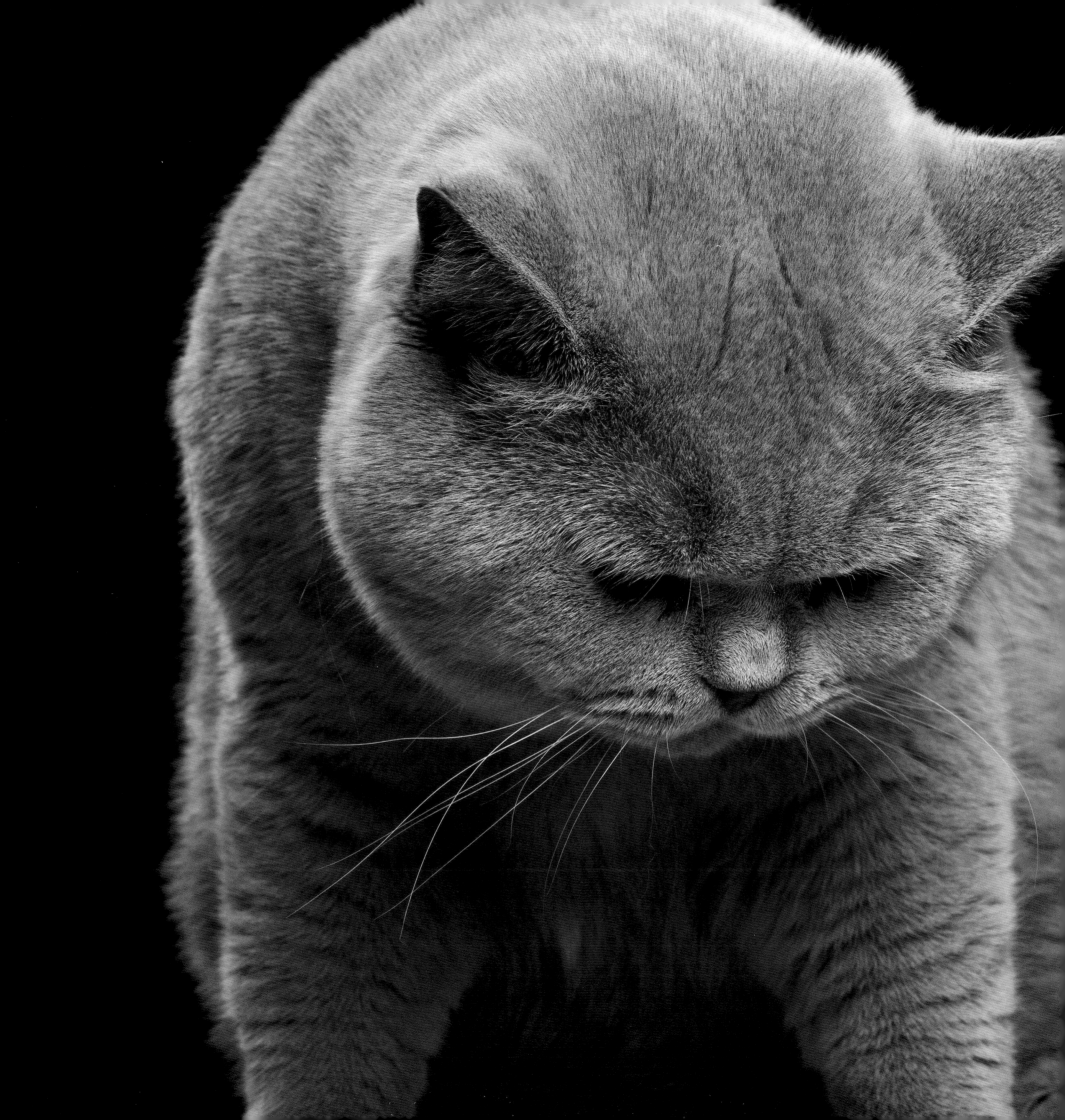

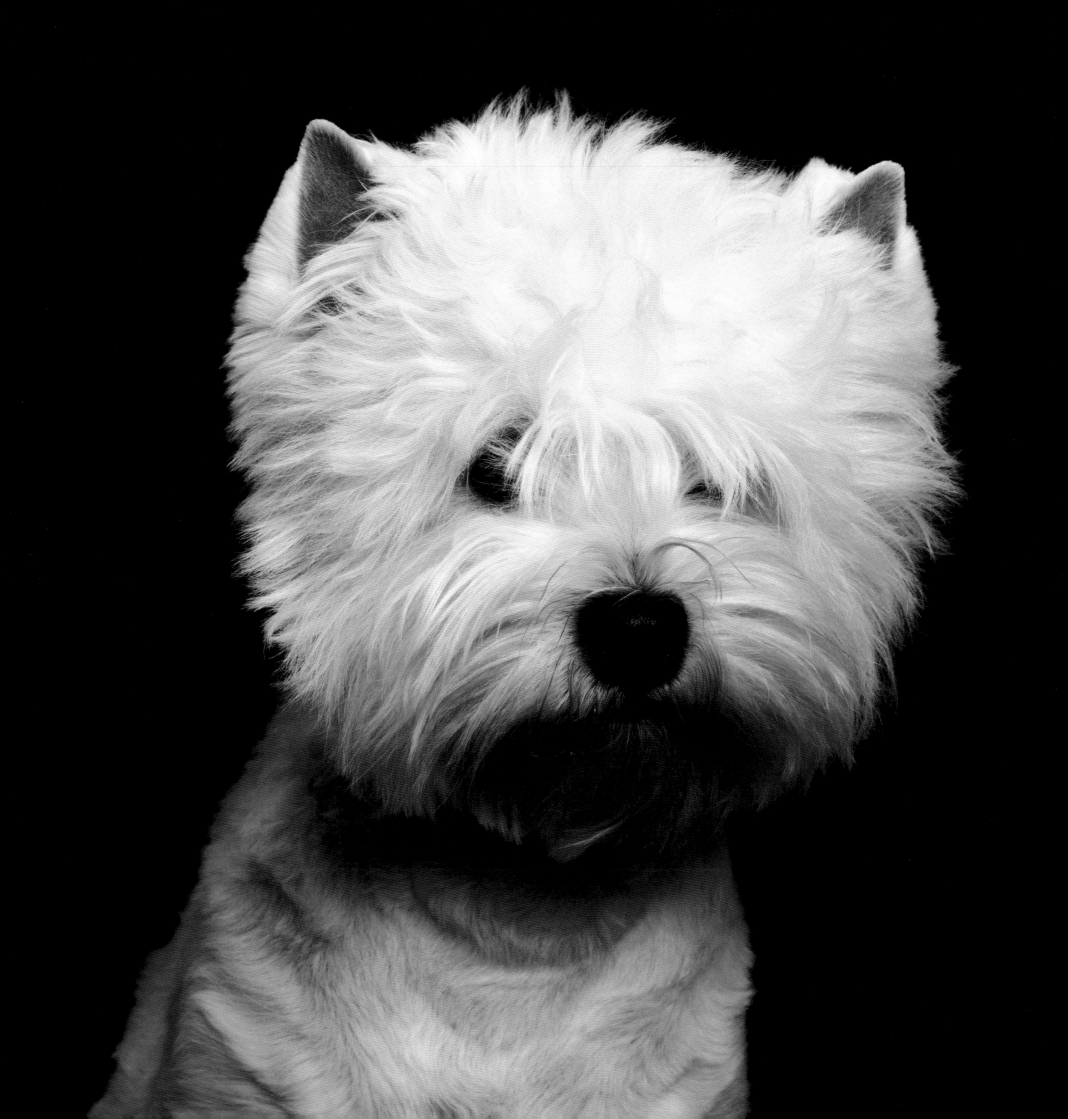

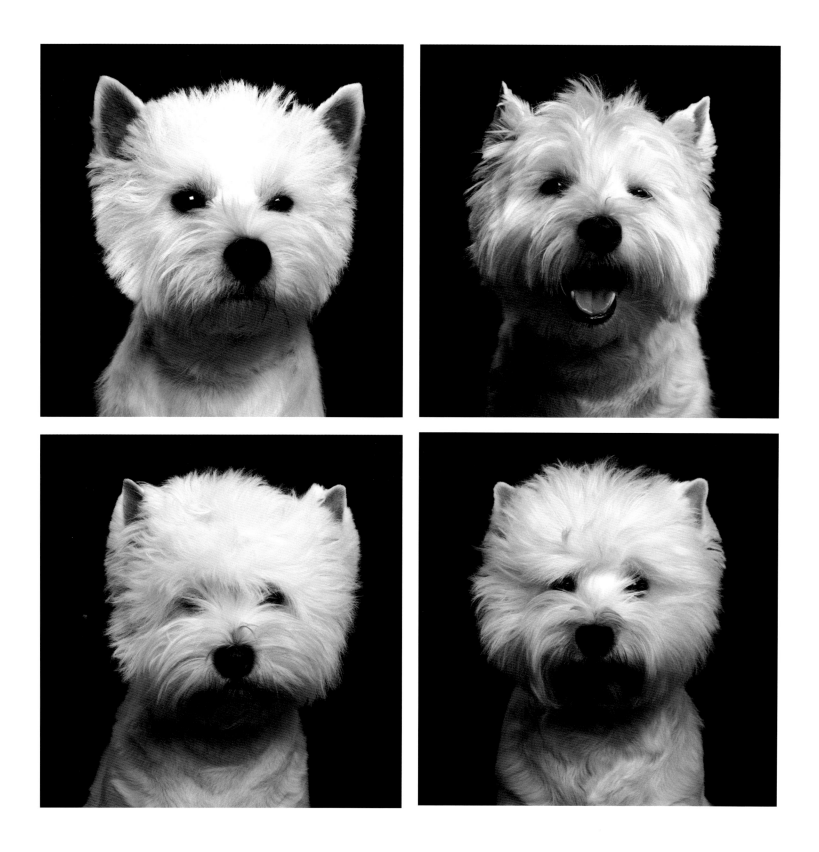

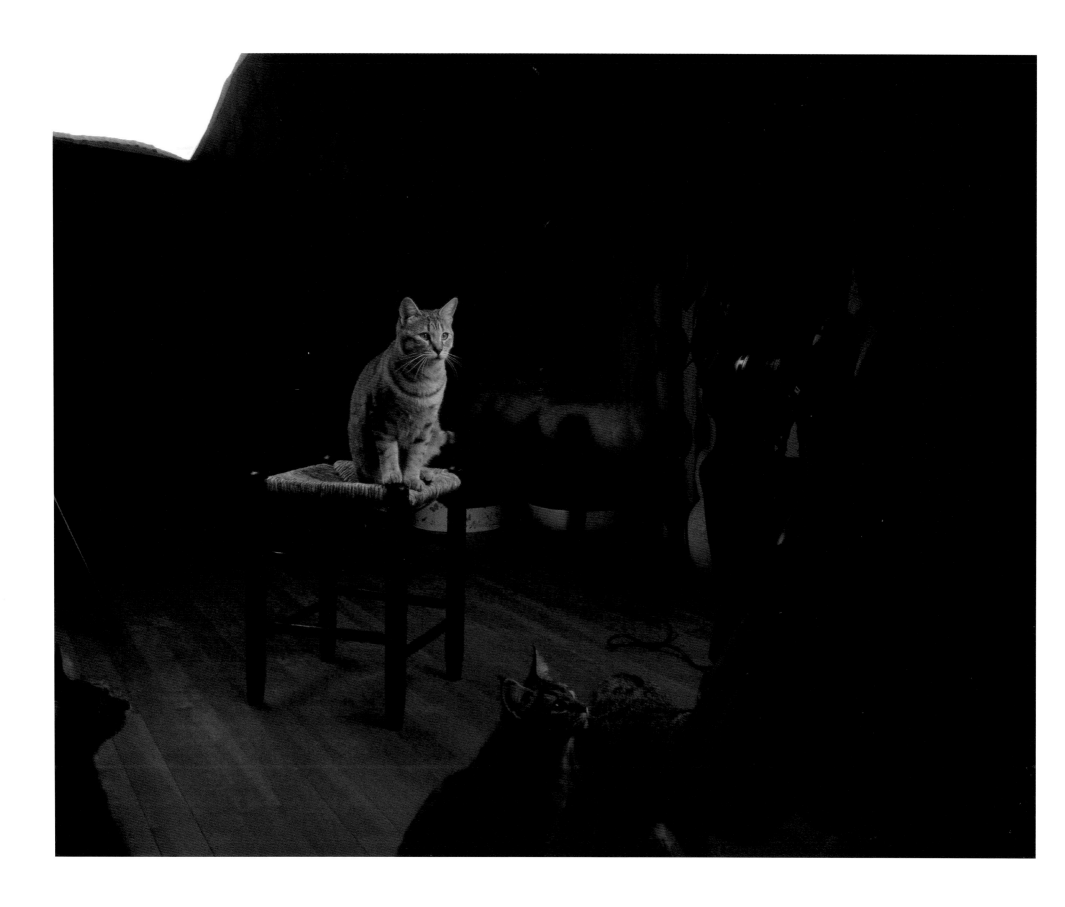

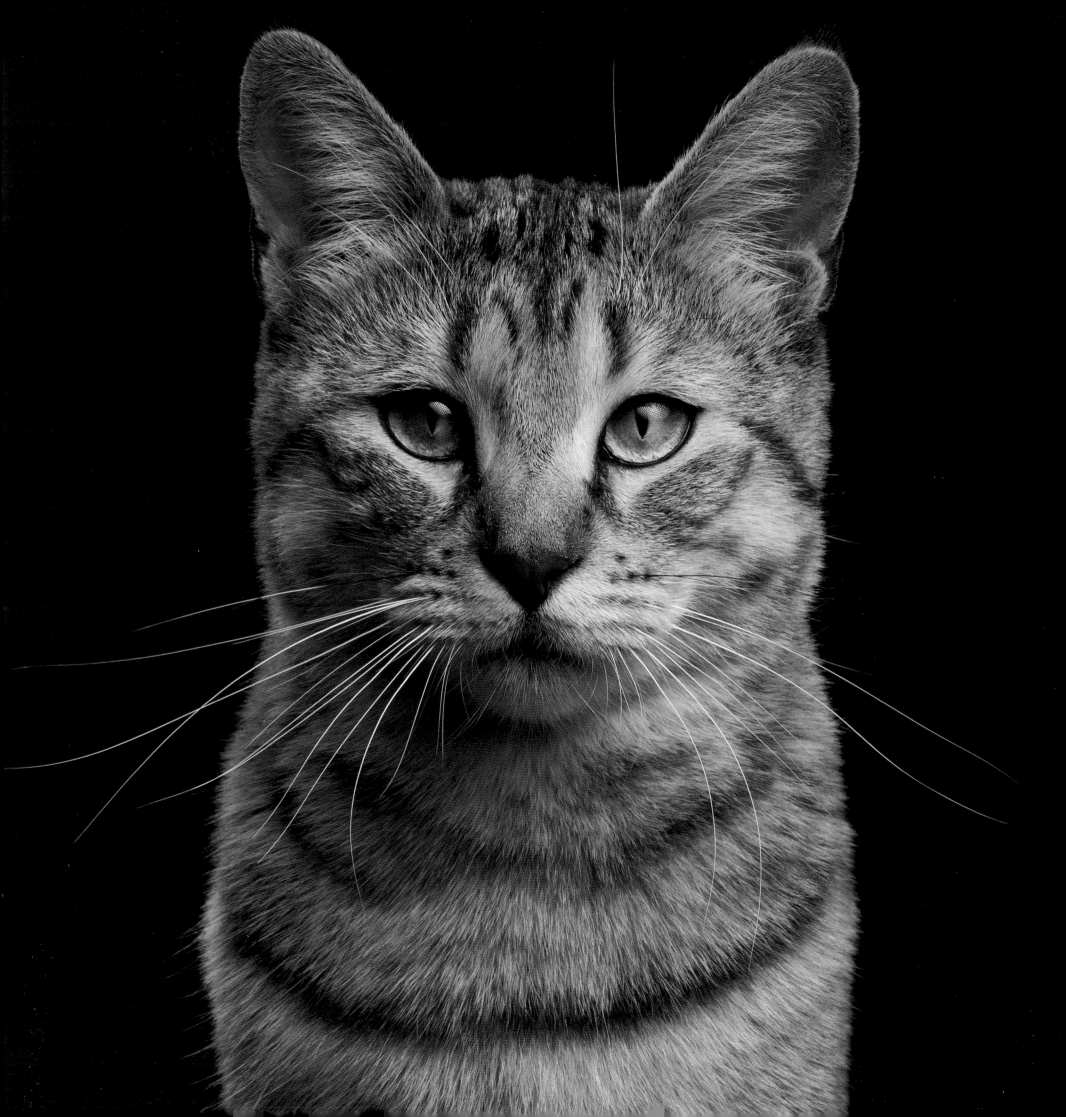

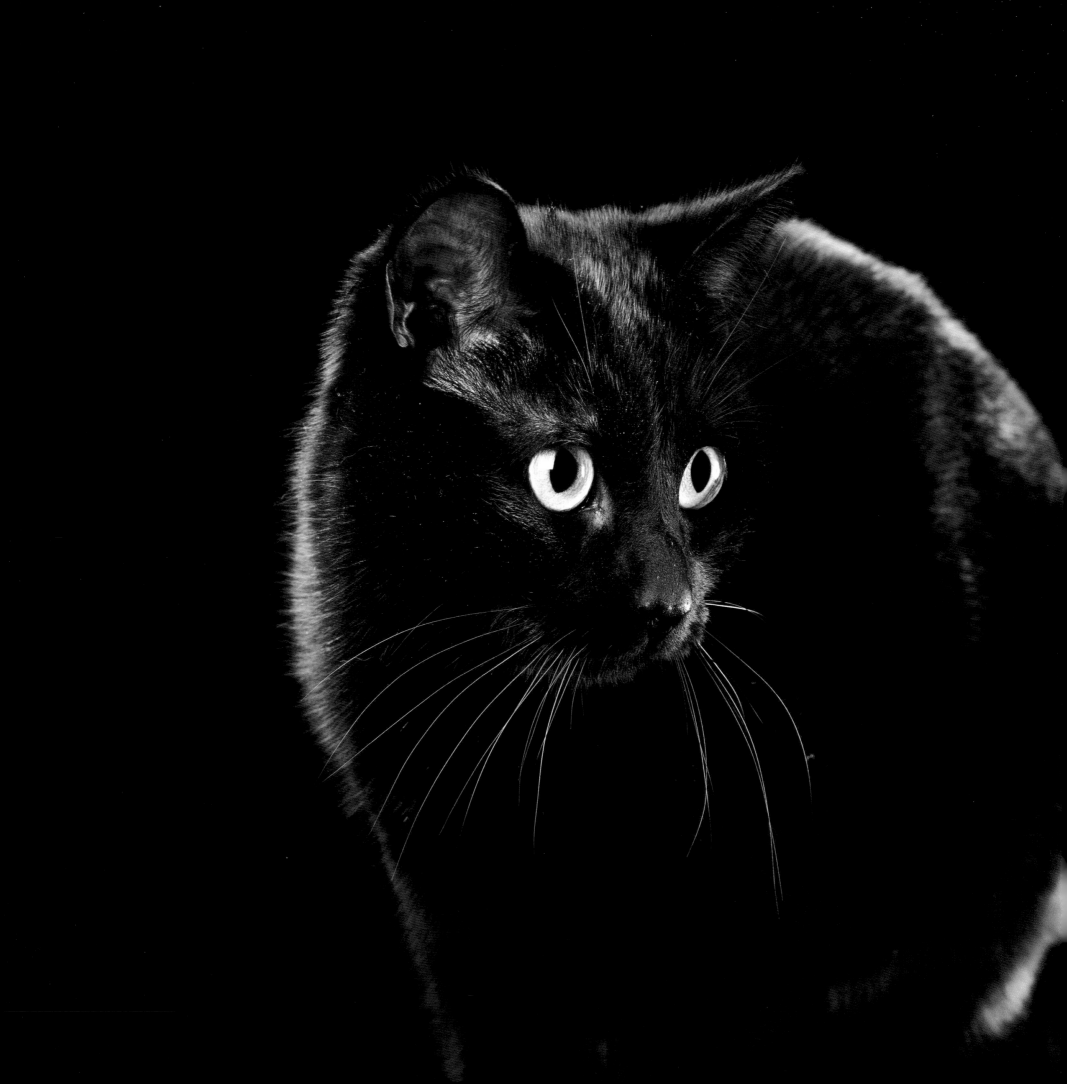

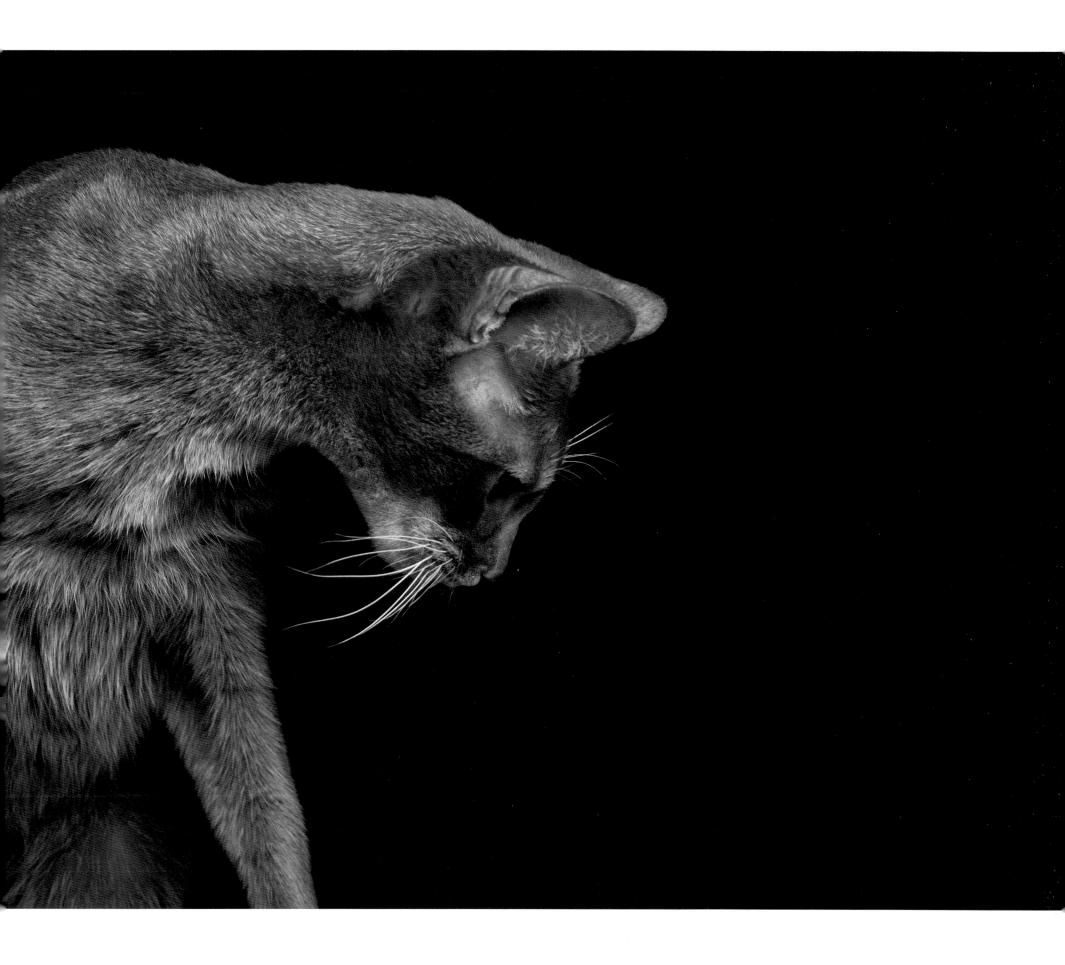

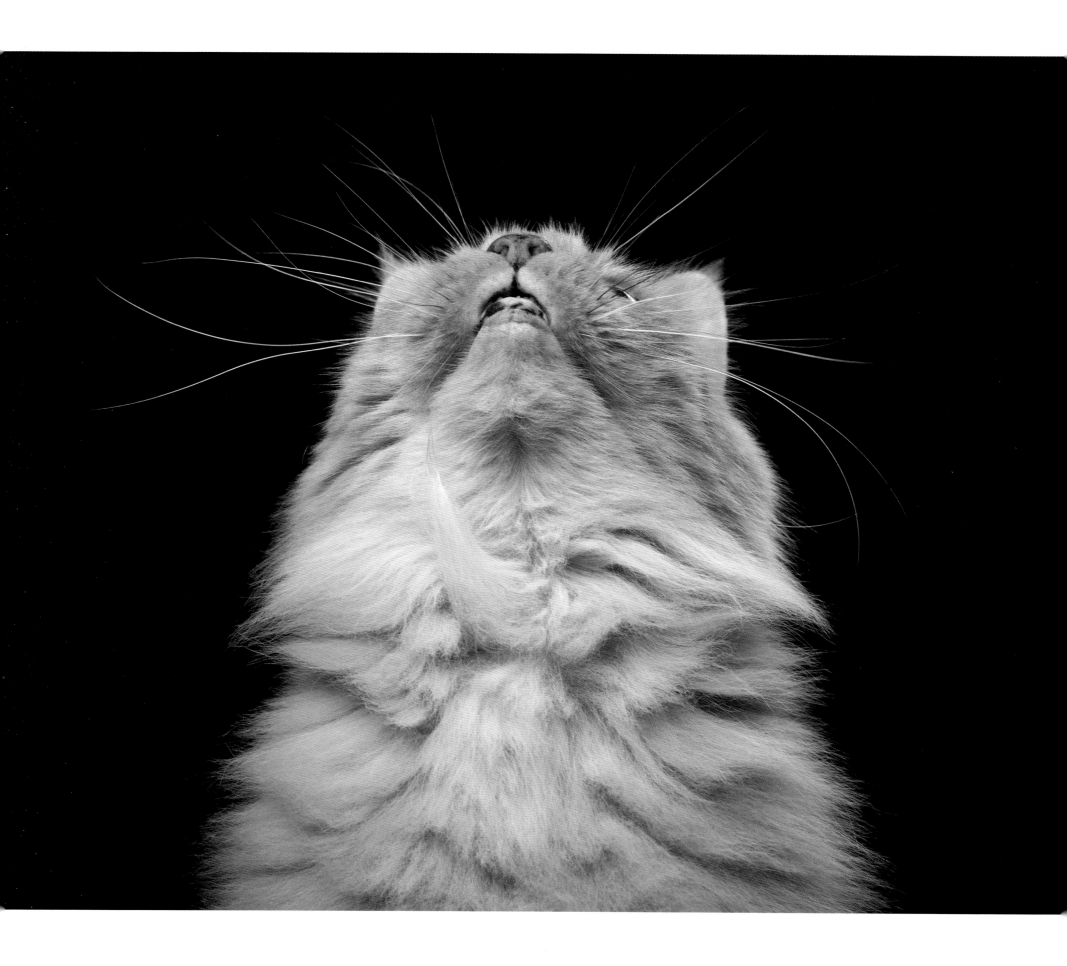

"A cat is an example of sophistication minus civilisation."

Anonymous

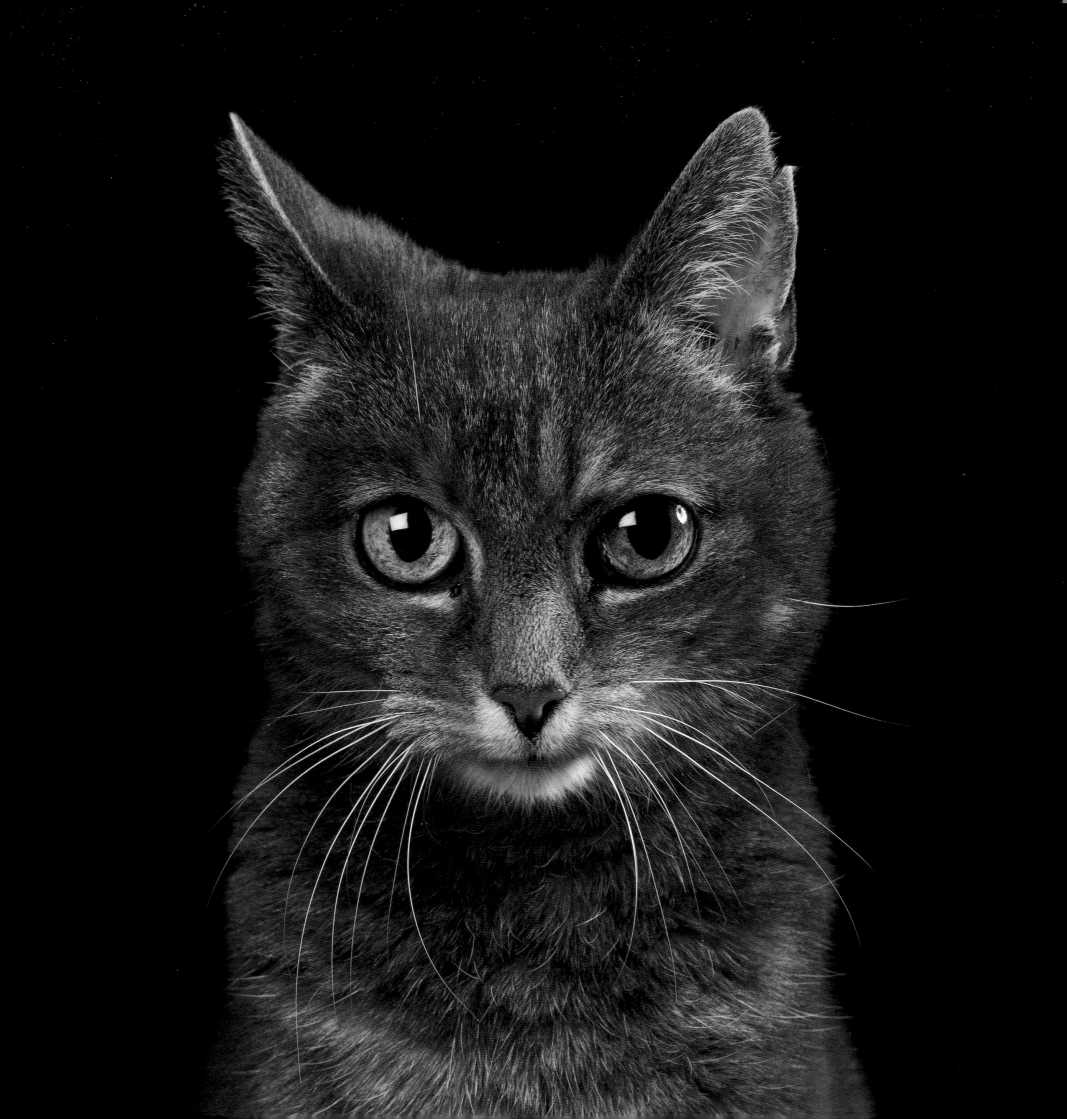

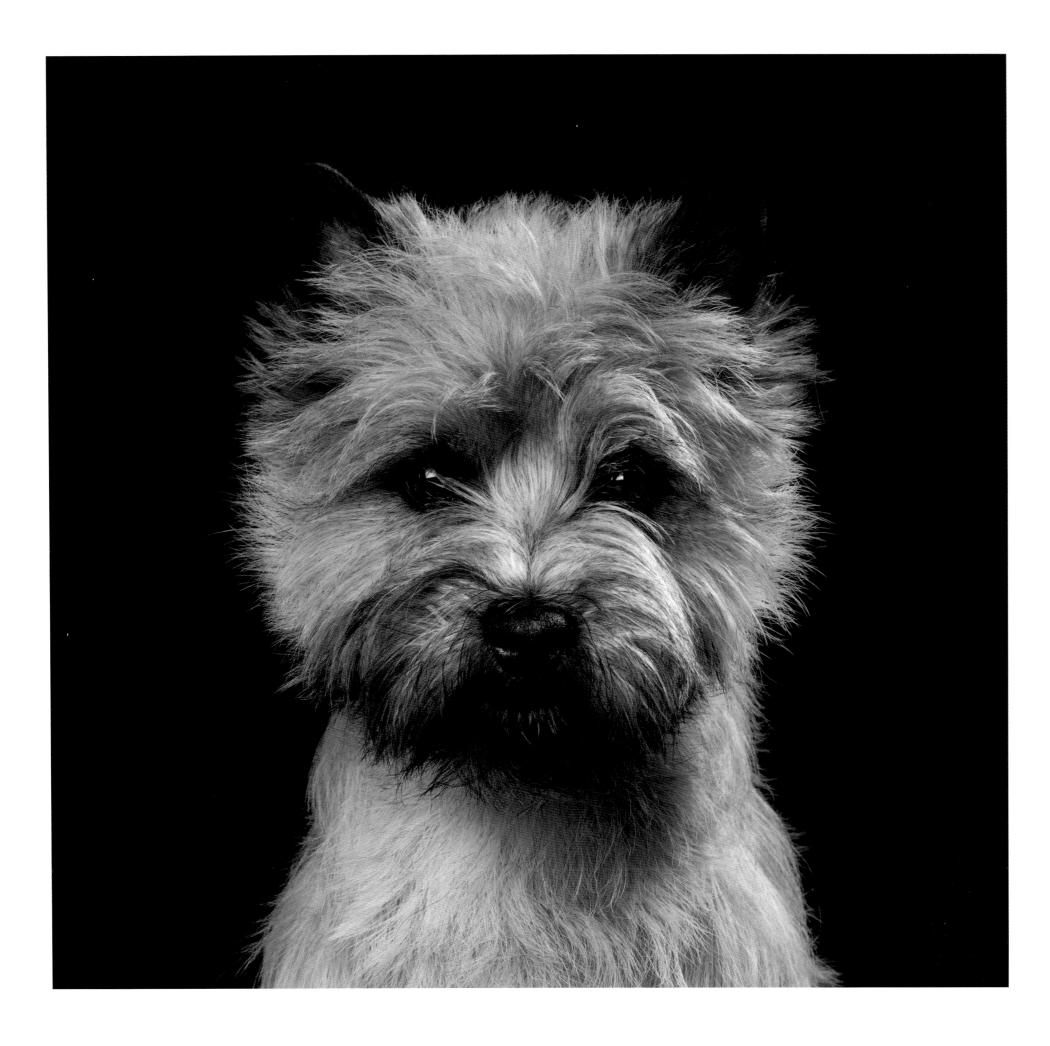

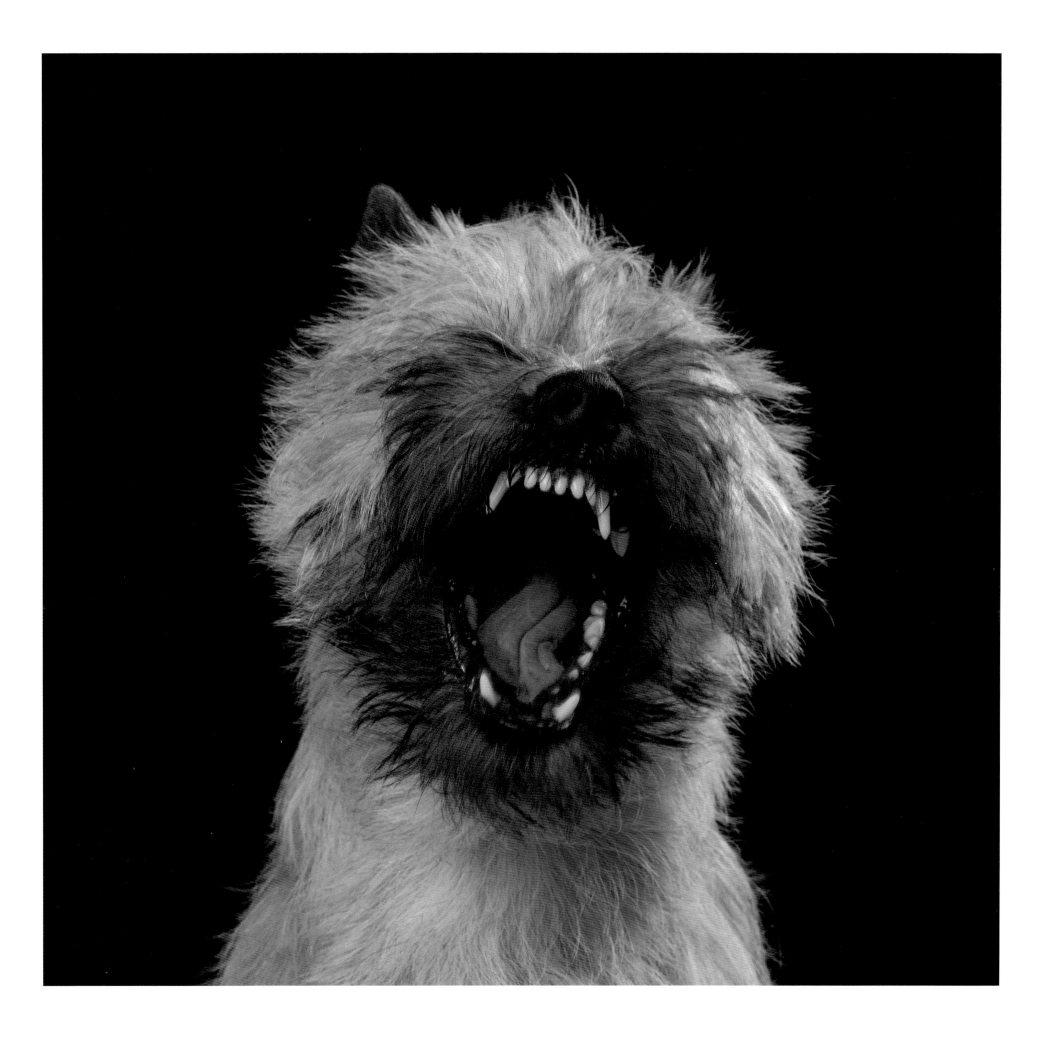

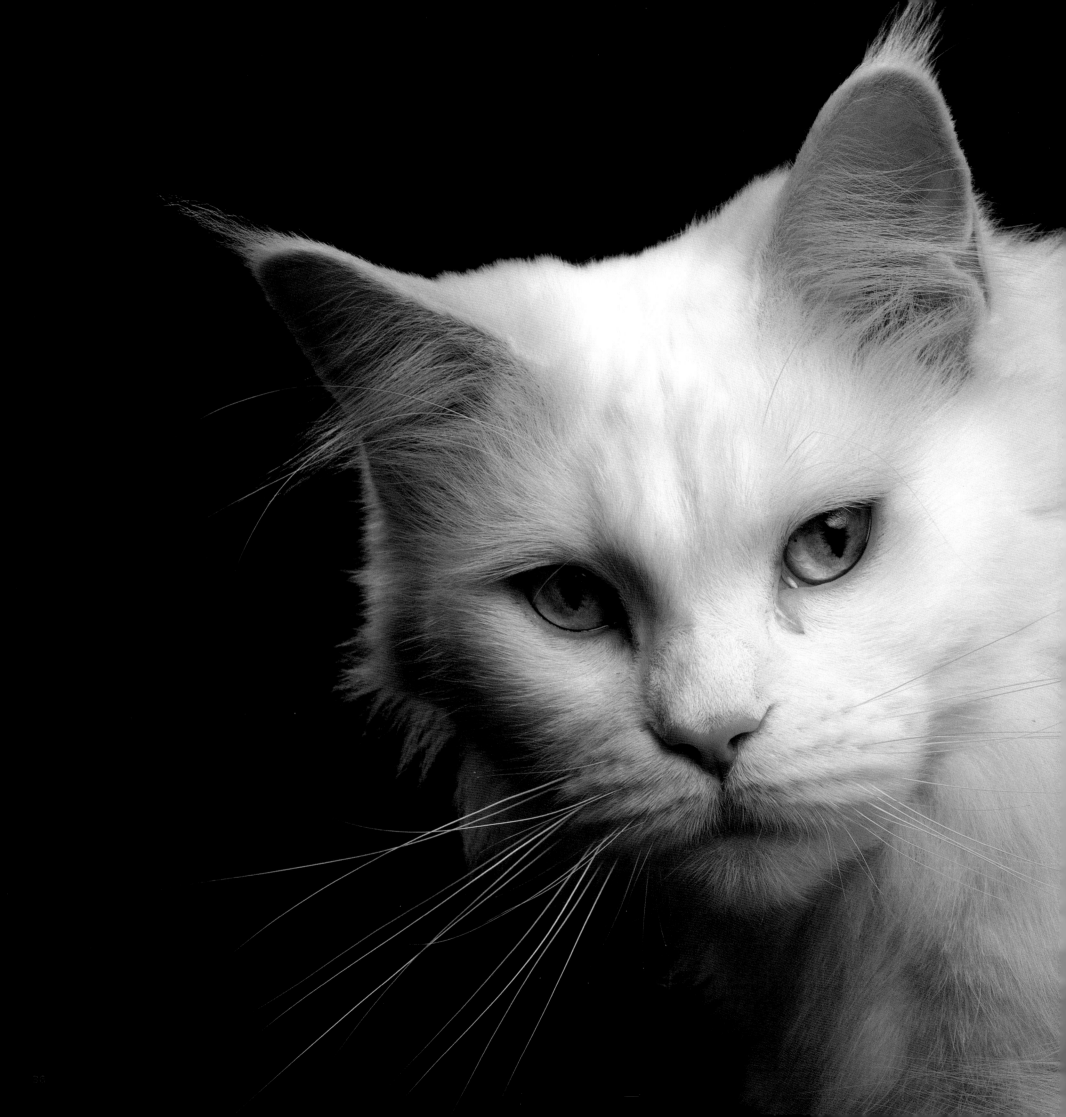

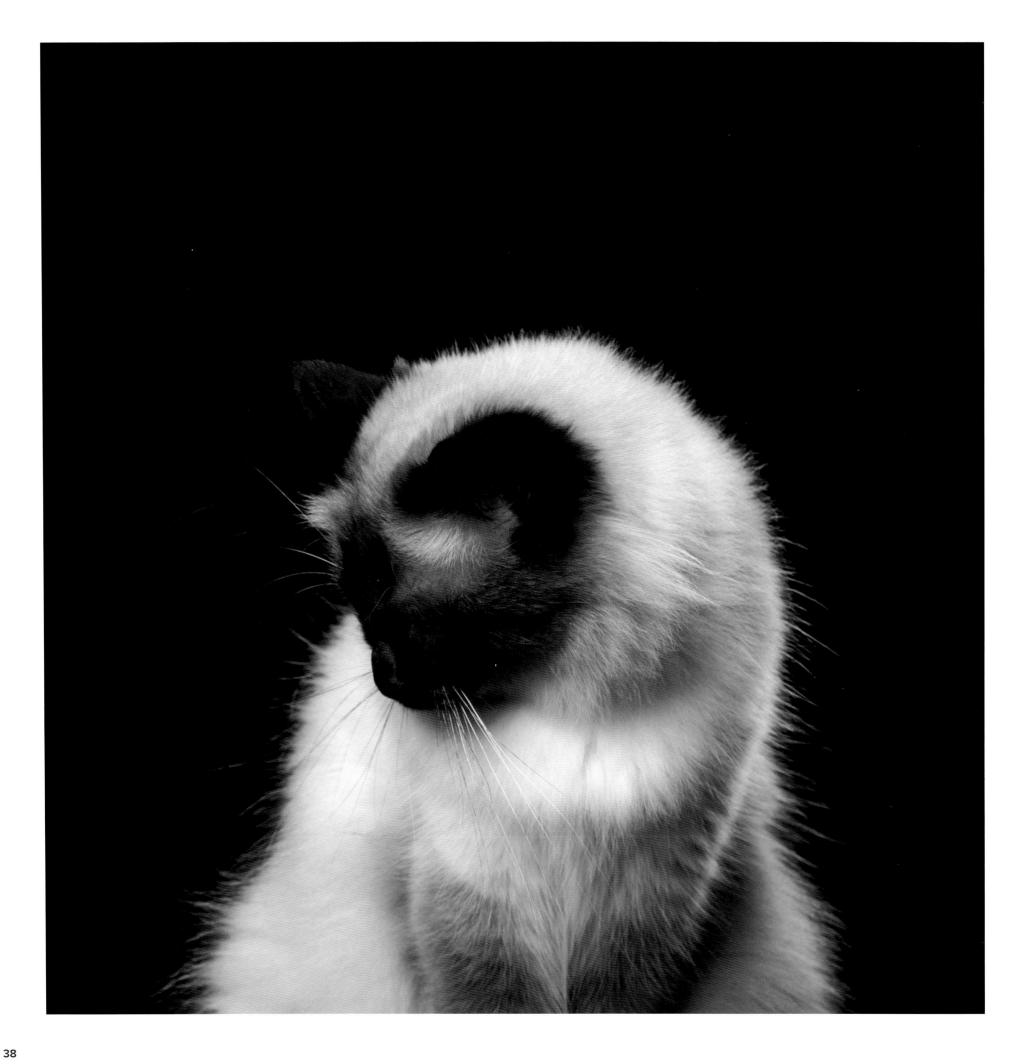

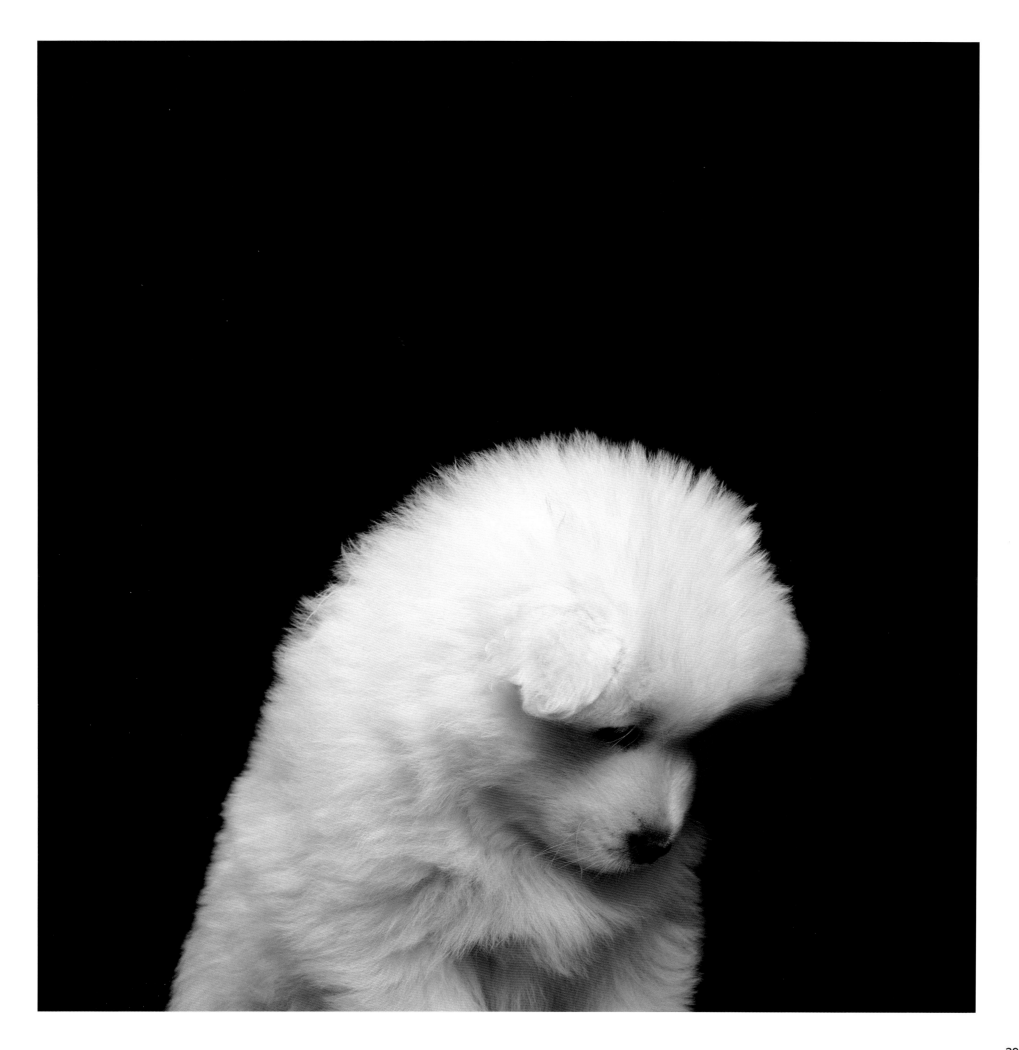

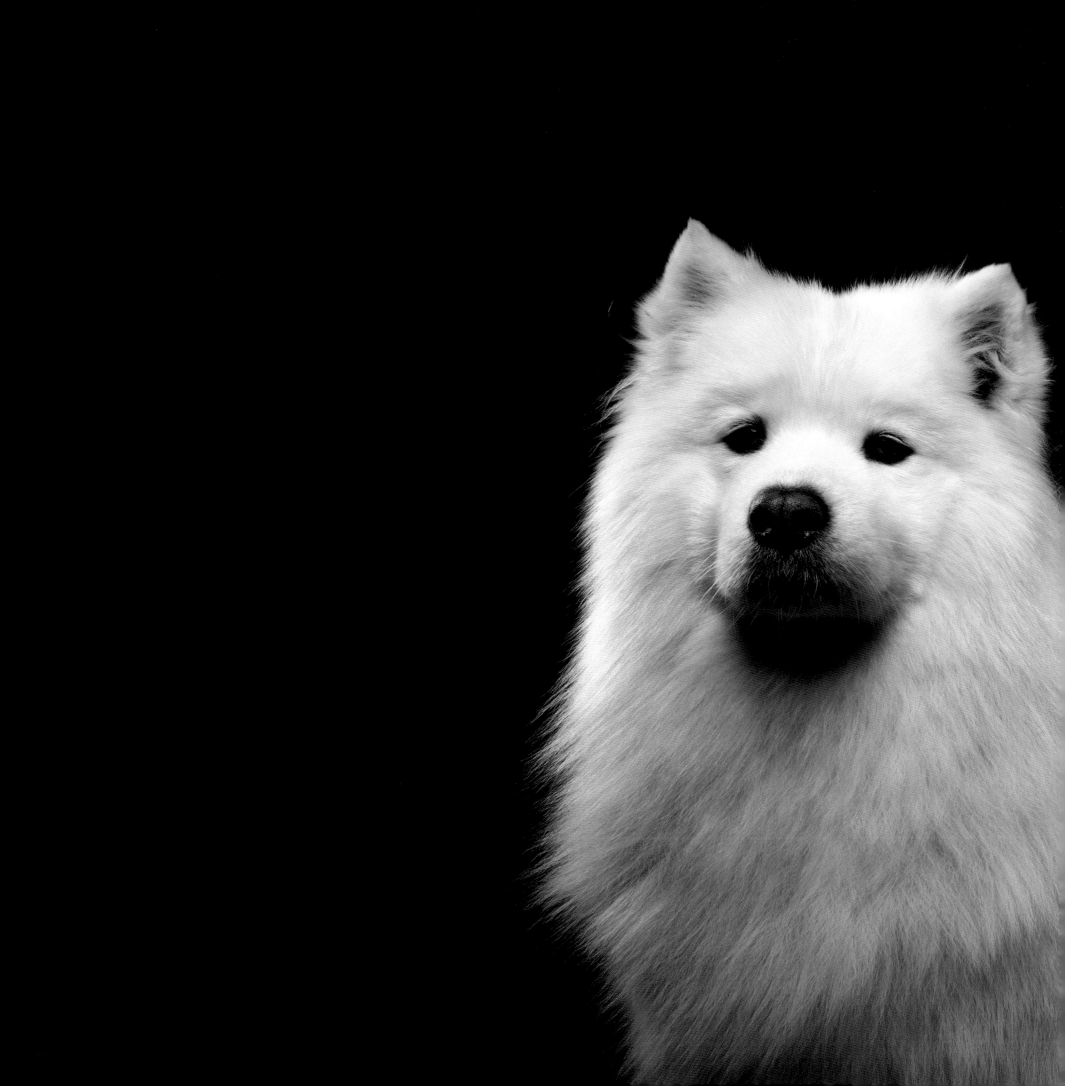

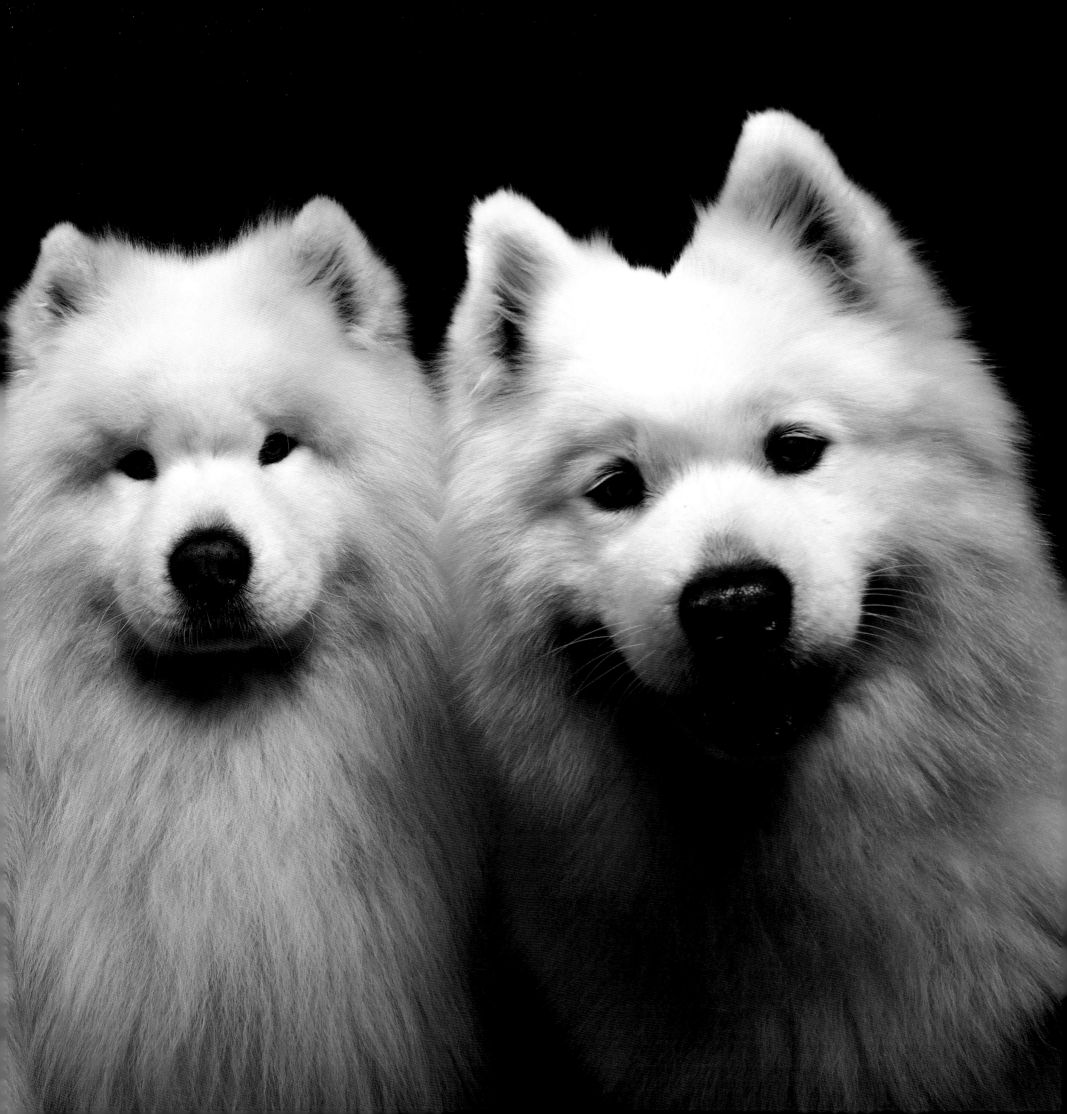

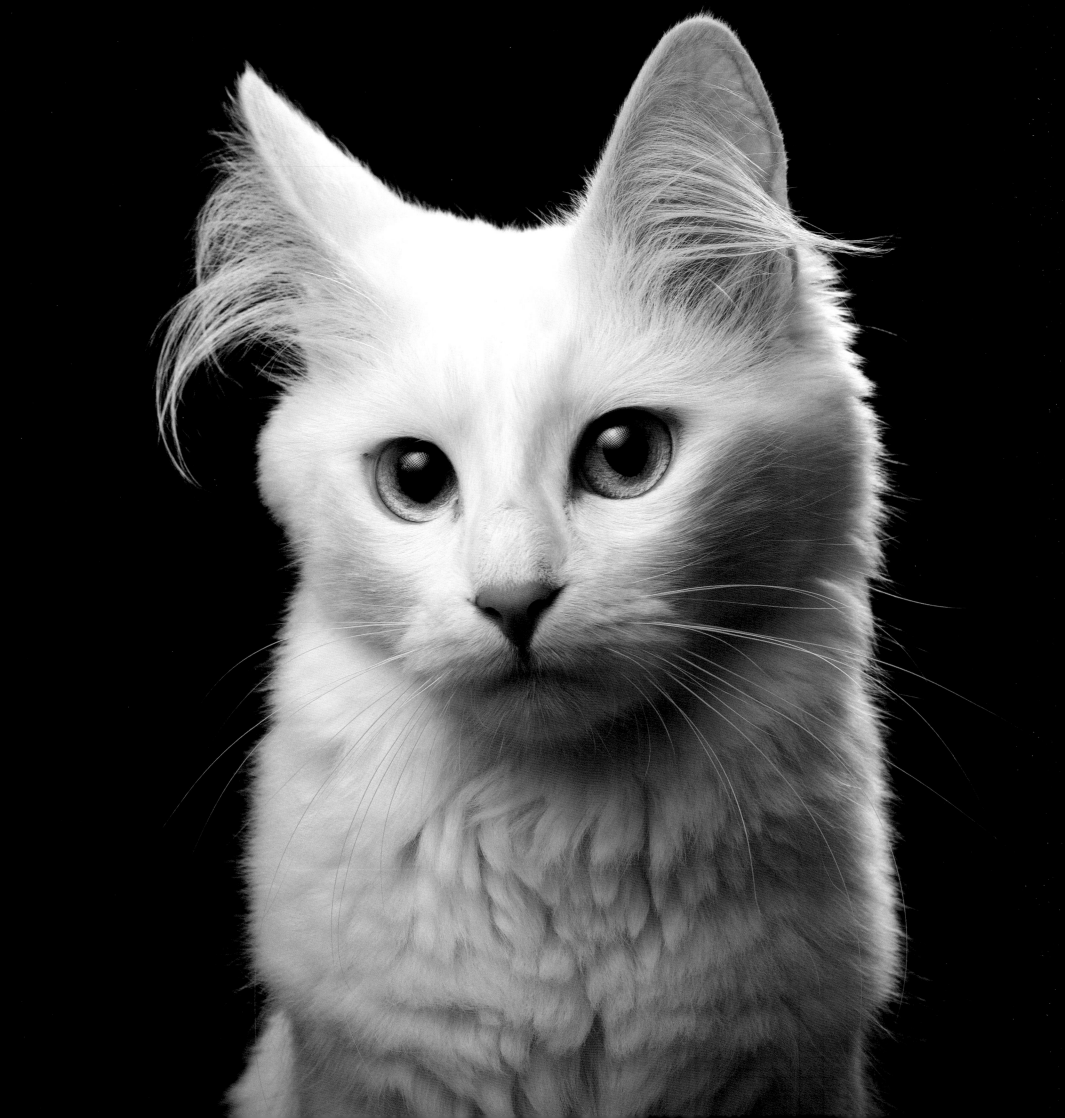

"I believe cats to be spirits come to earth. A cat, I am sure, could walk on a cloud without coming through."

Jules Verne

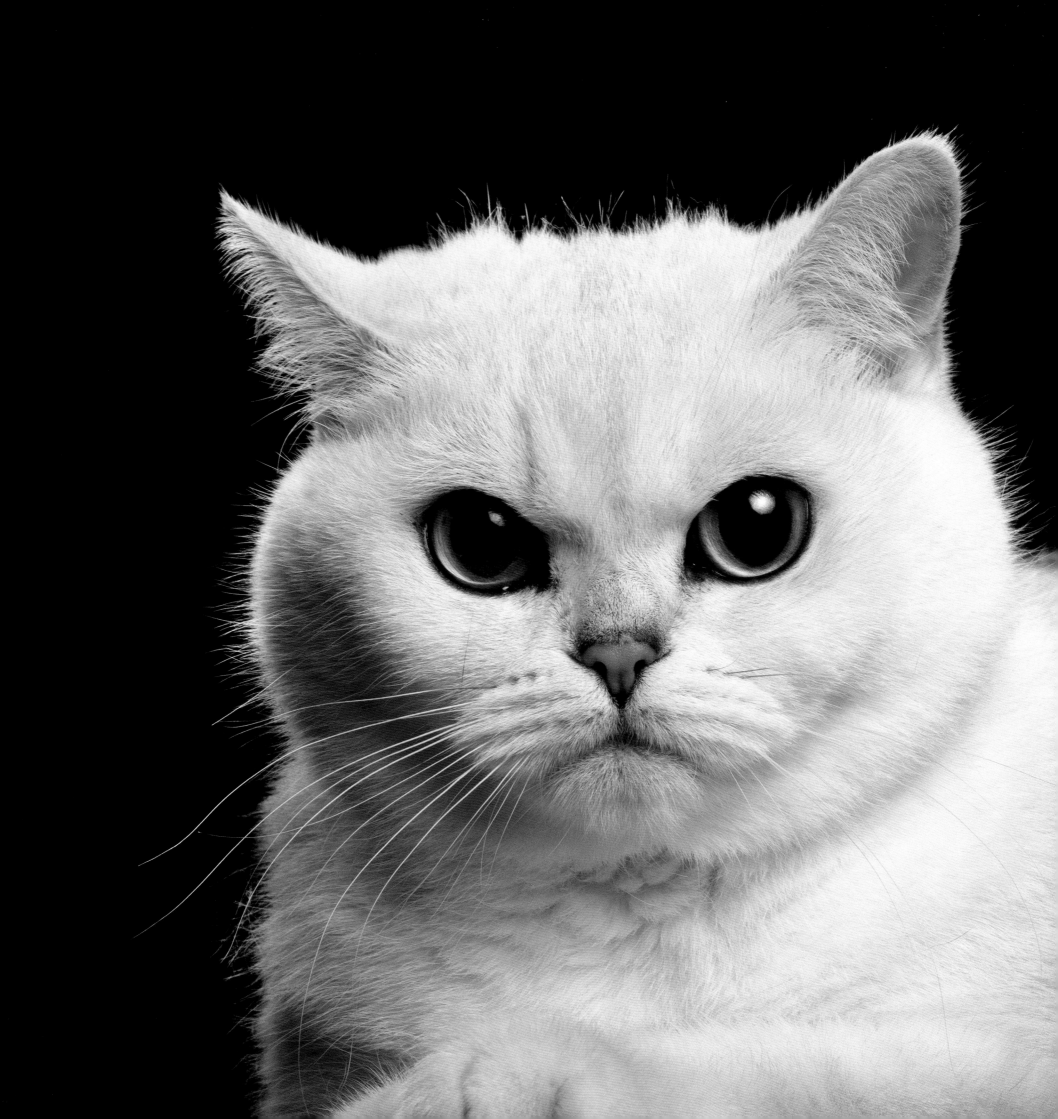

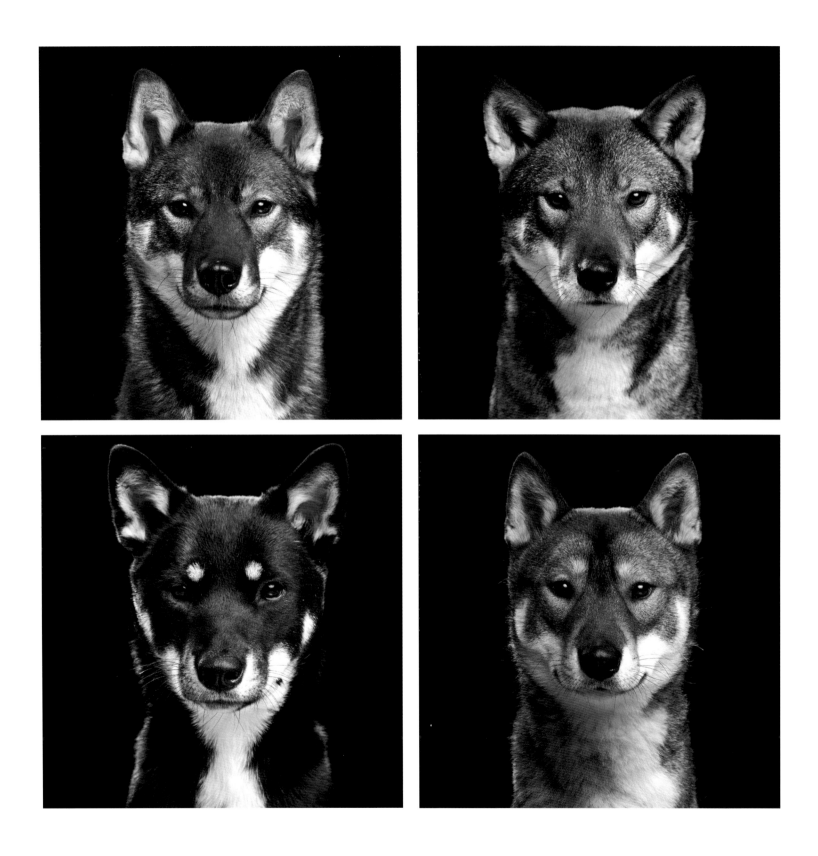

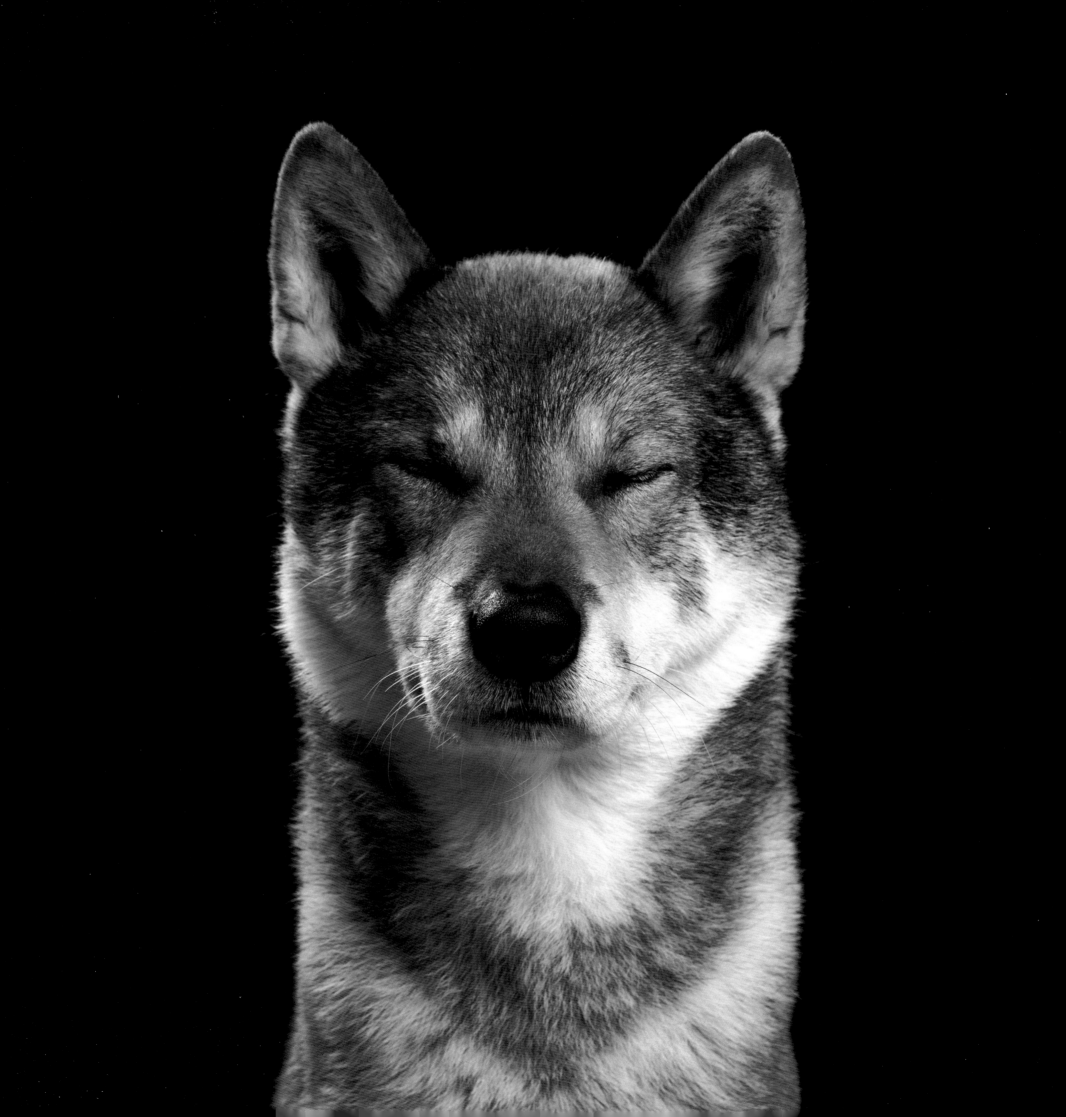

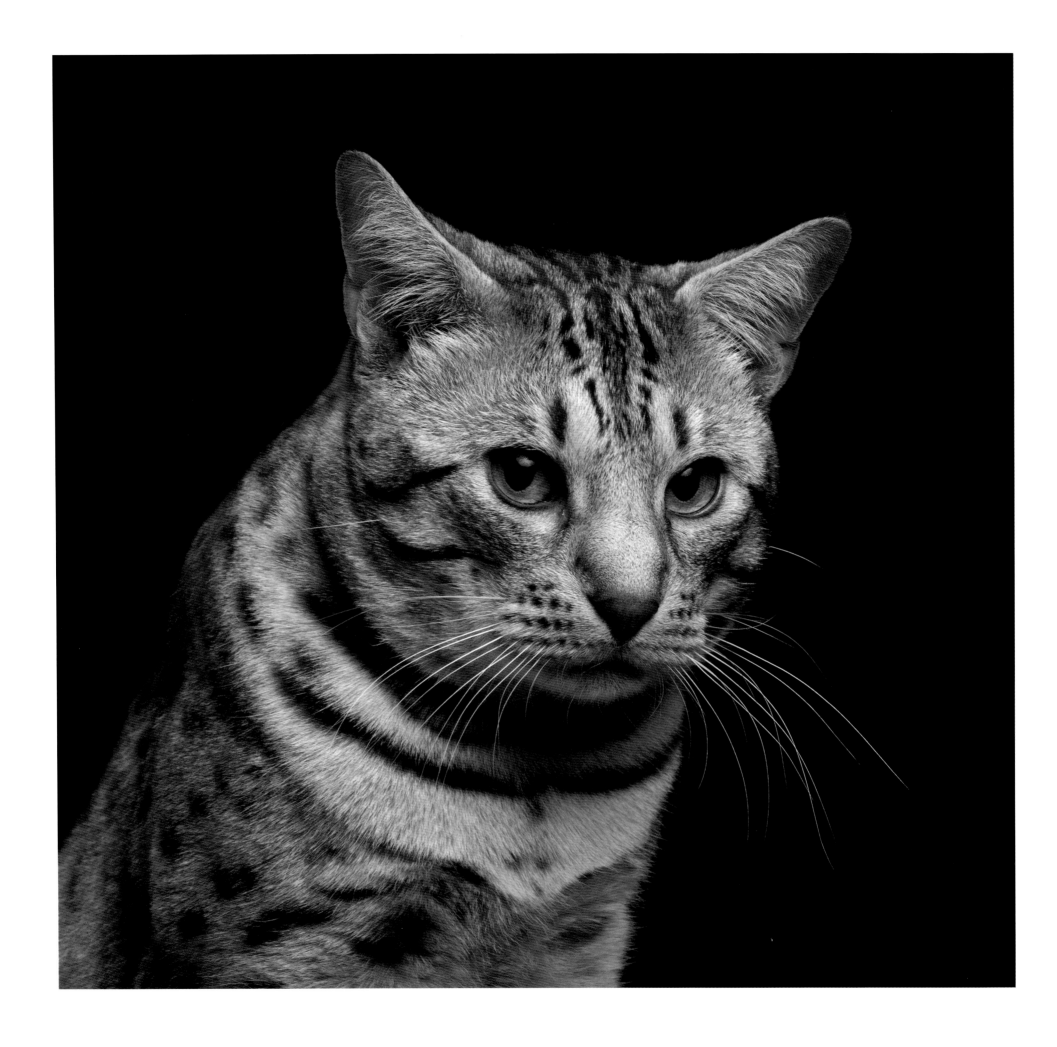

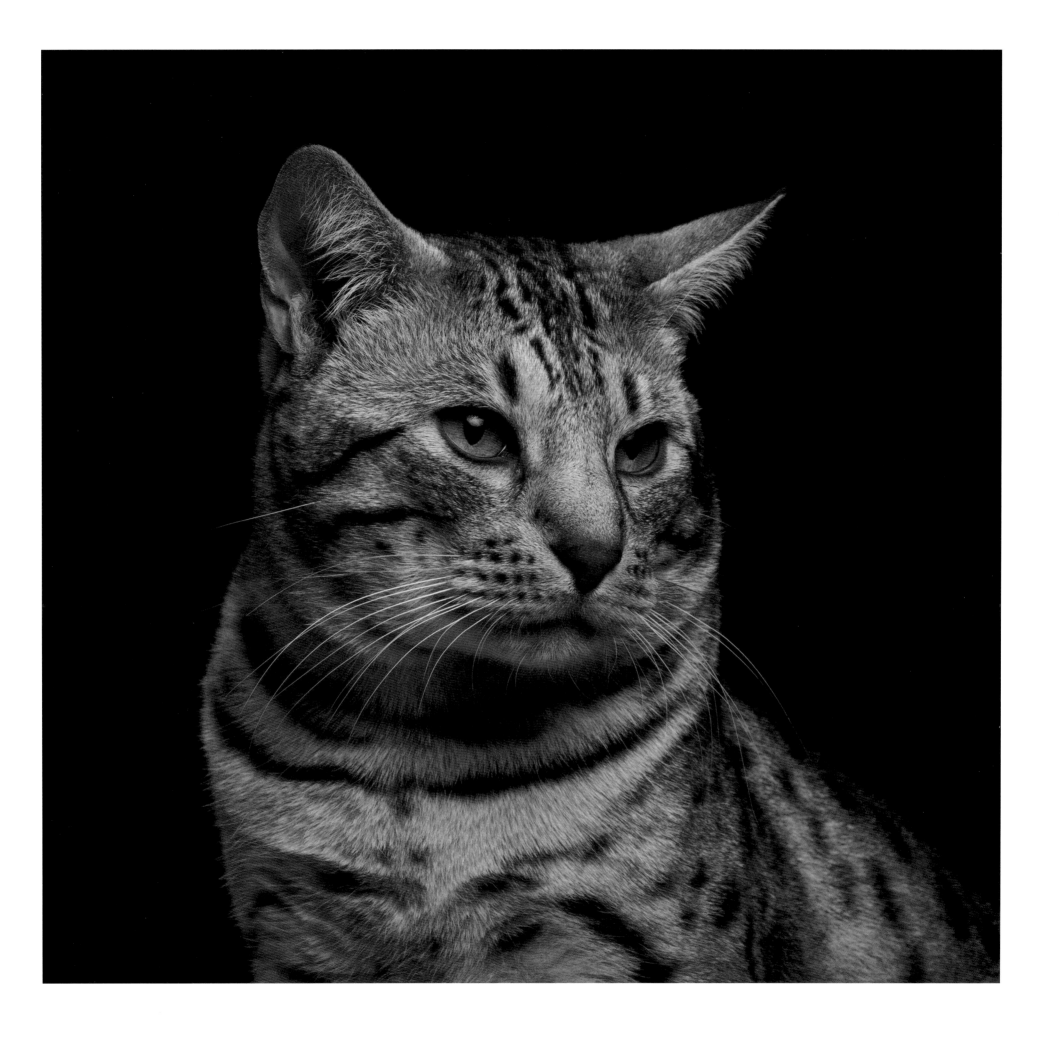

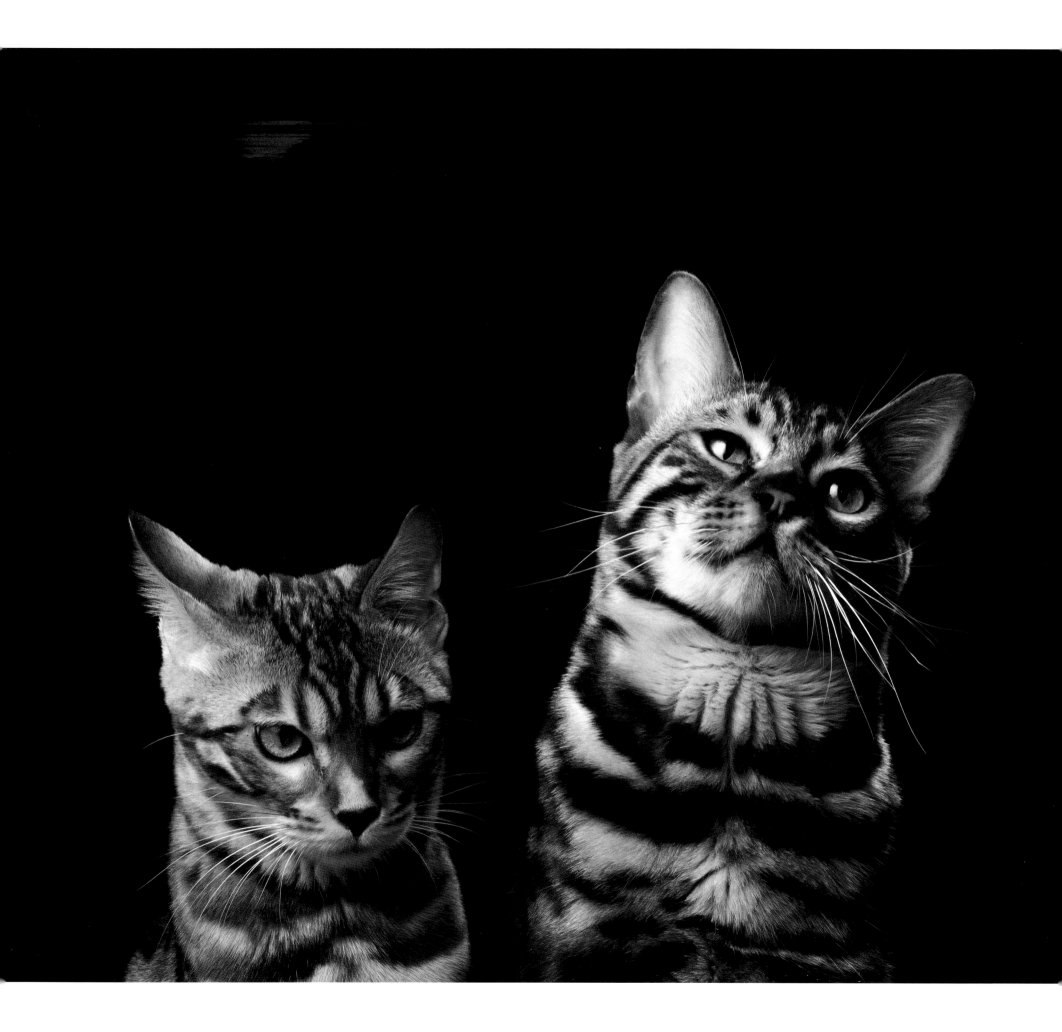

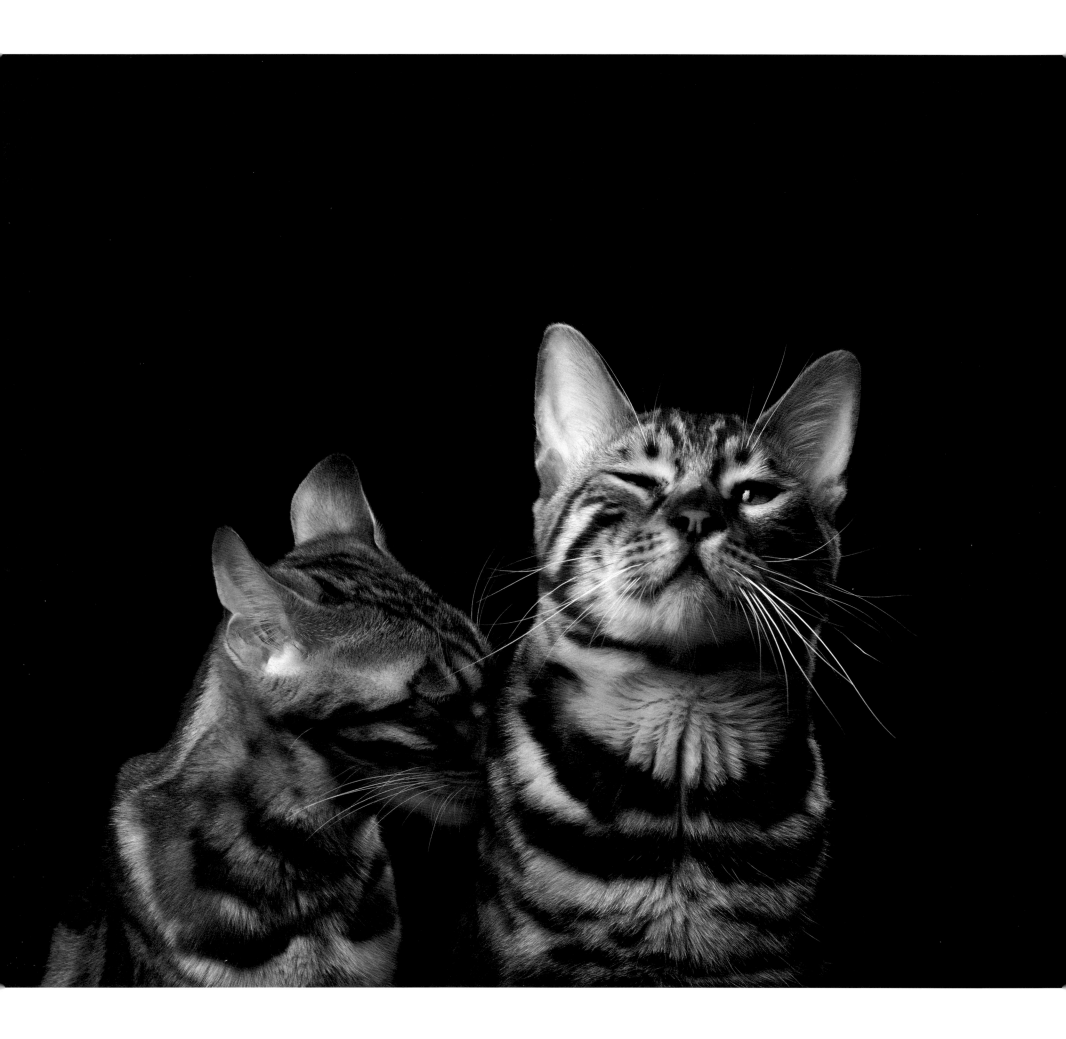

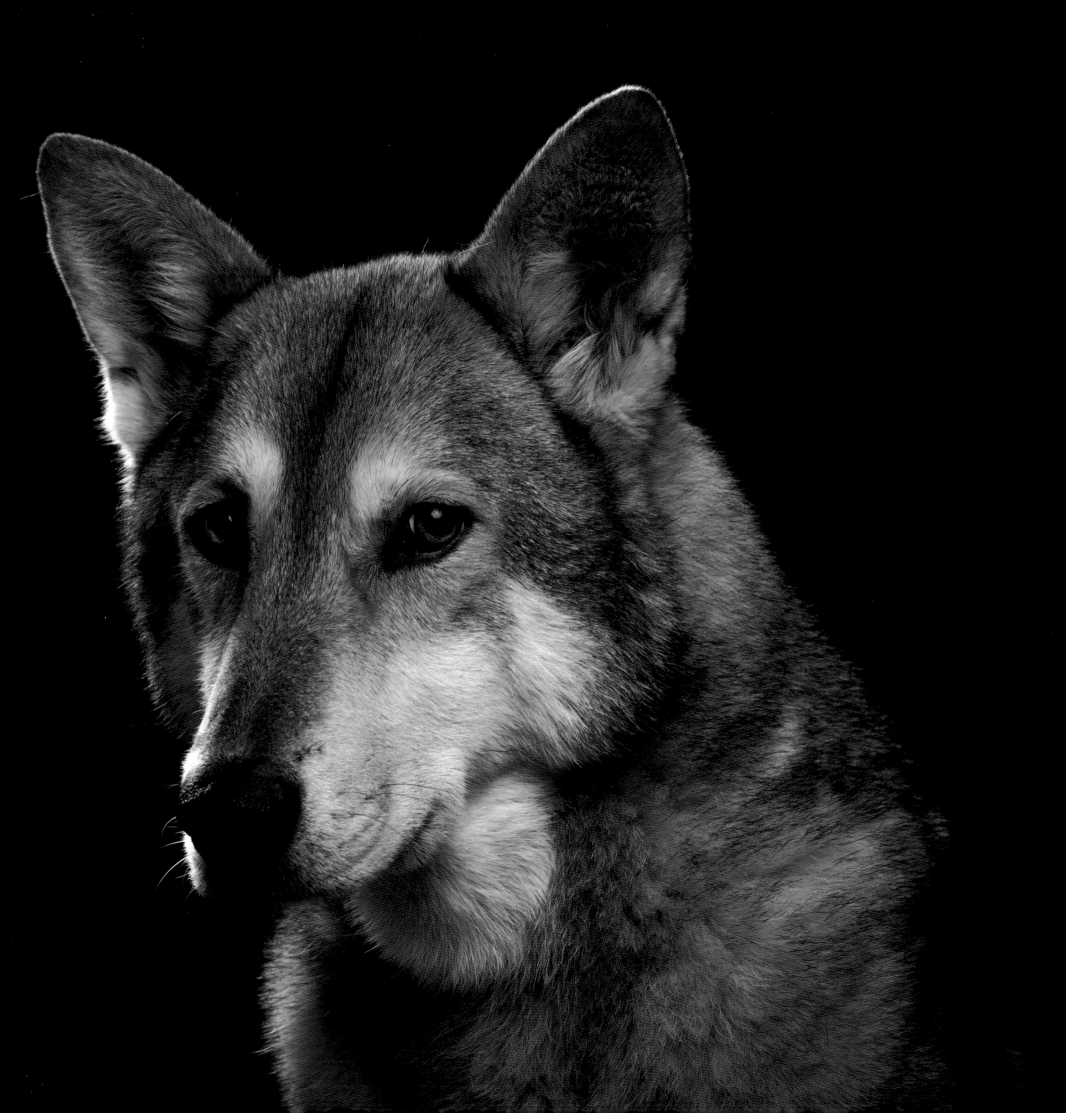

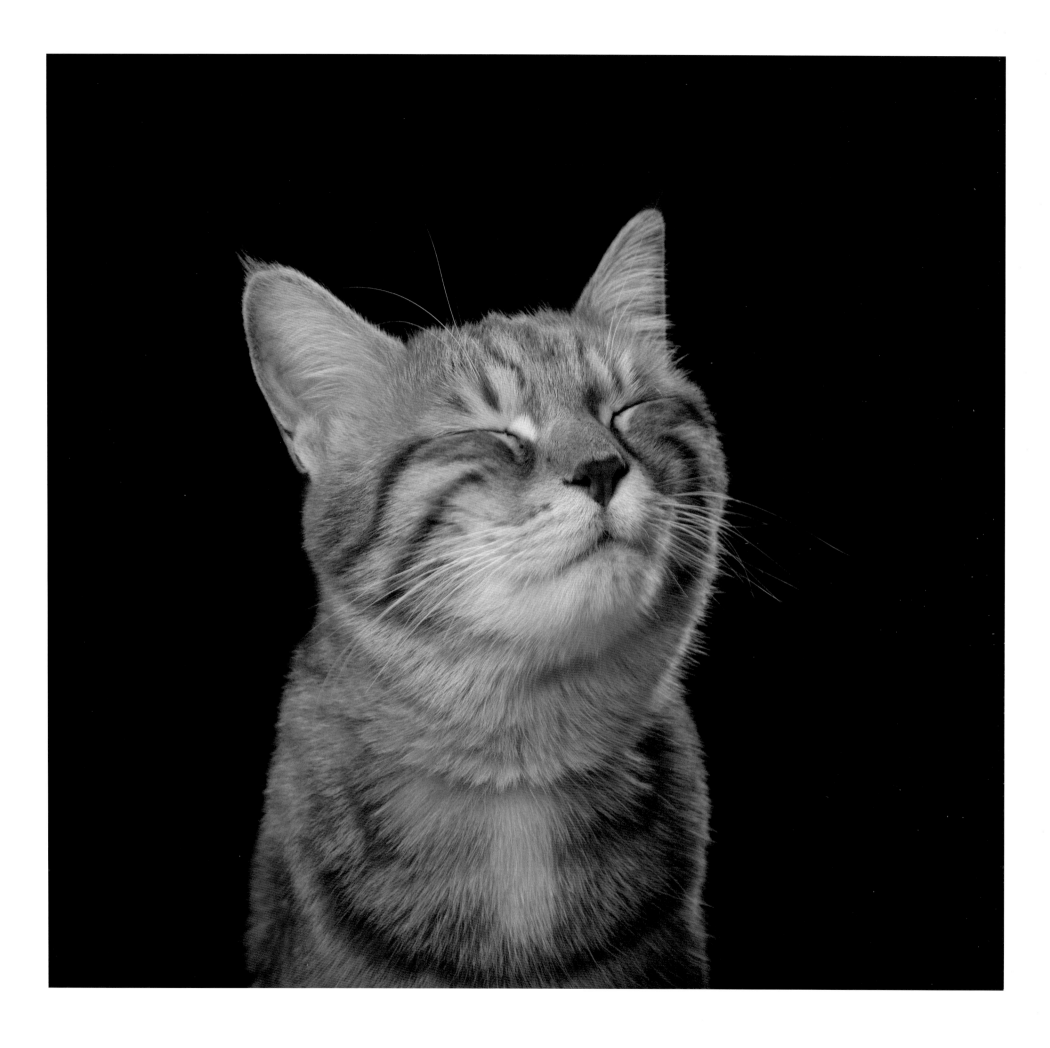

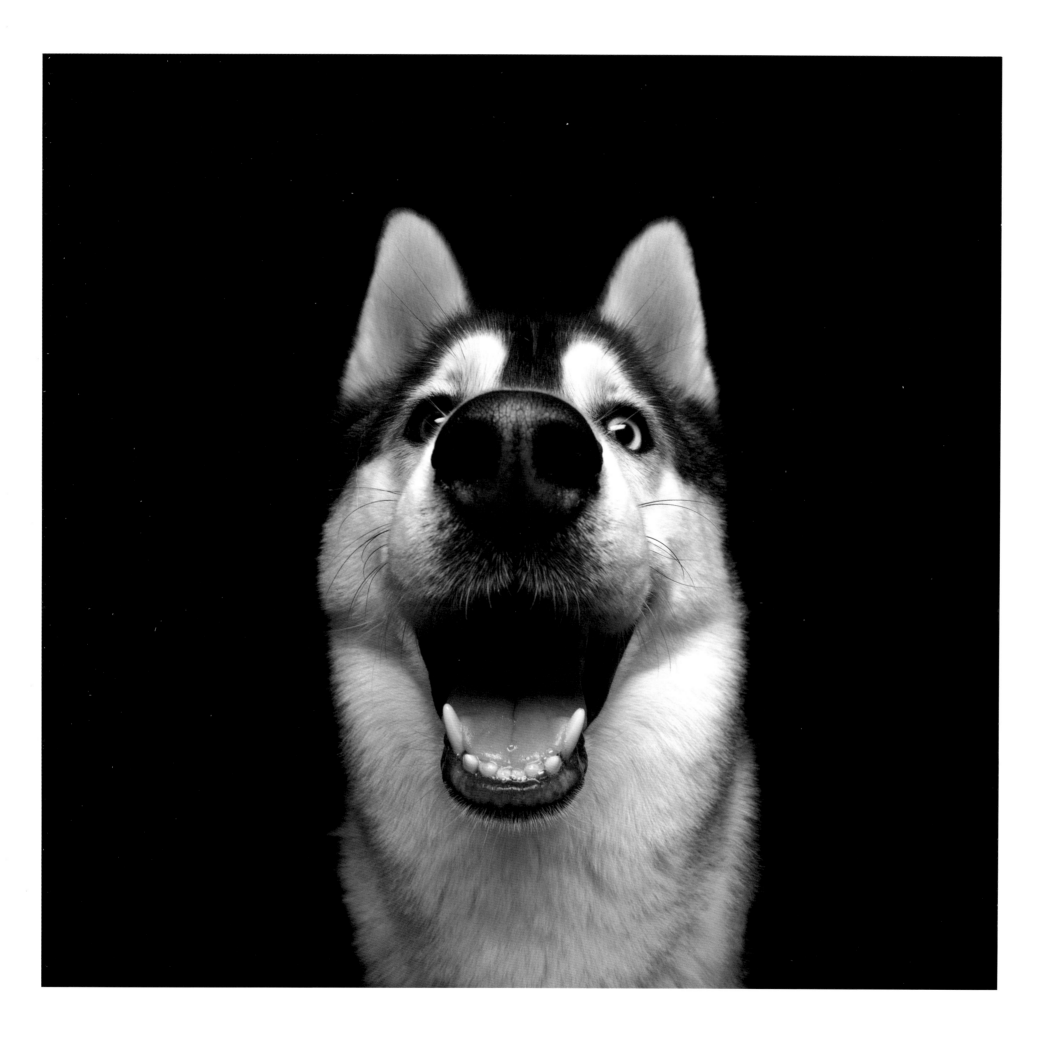

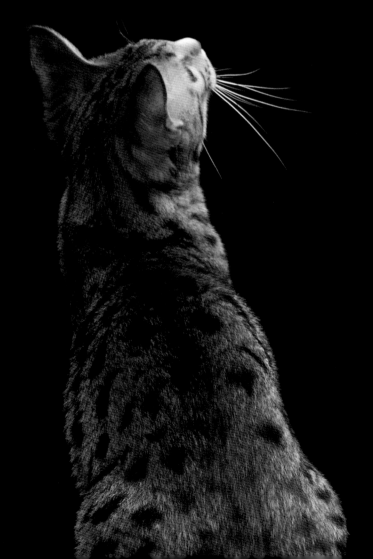

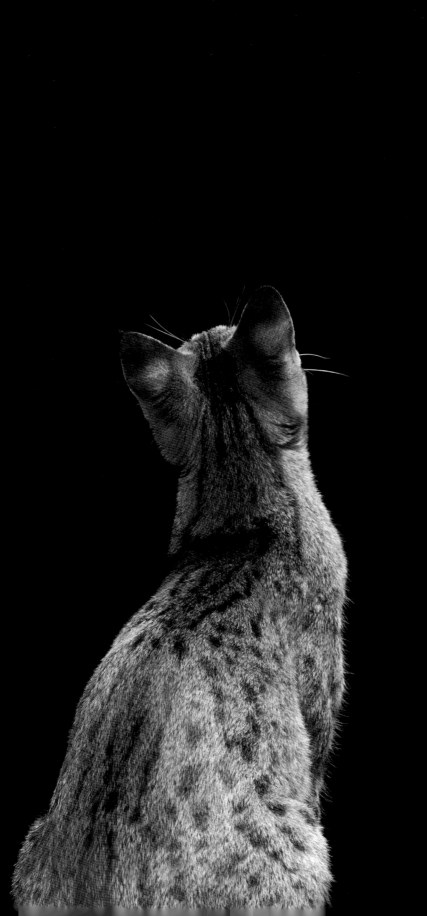

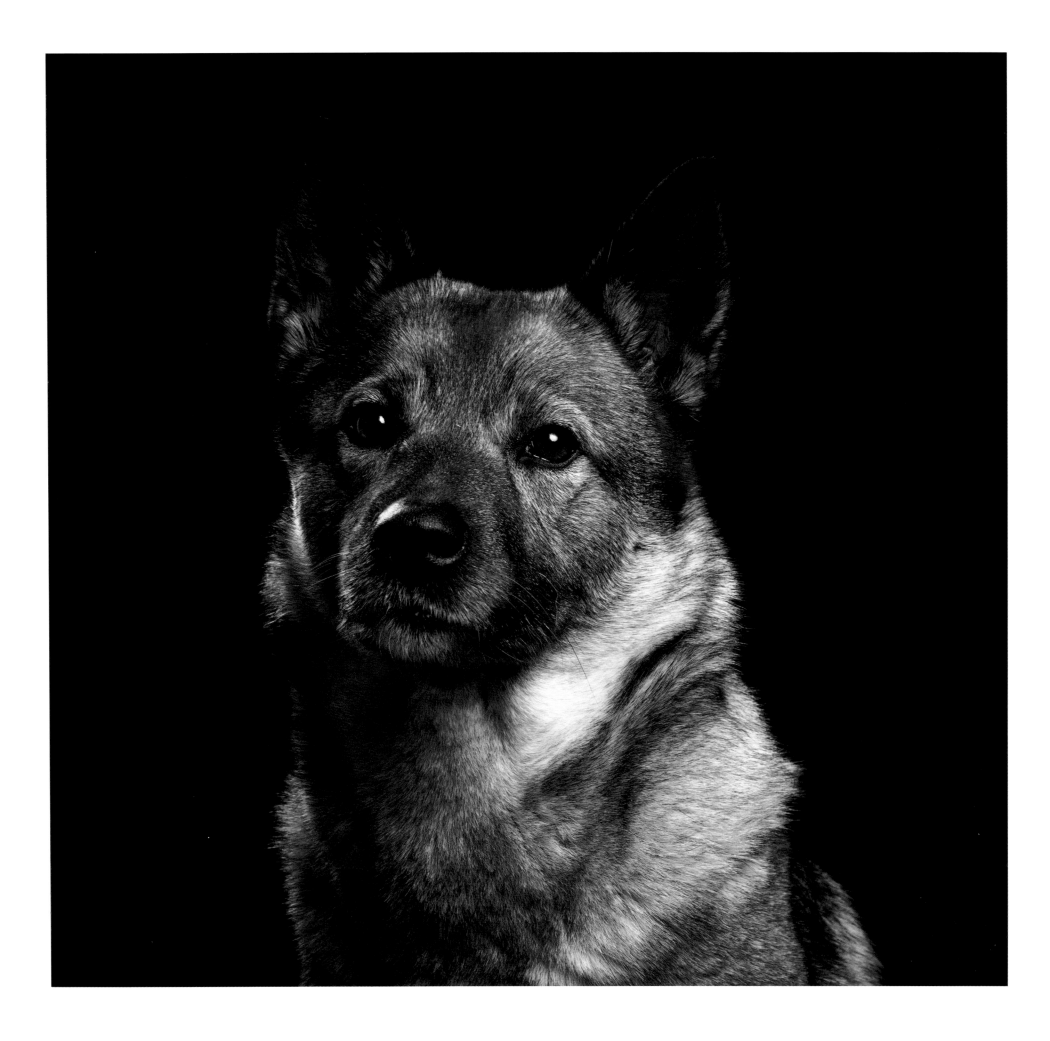

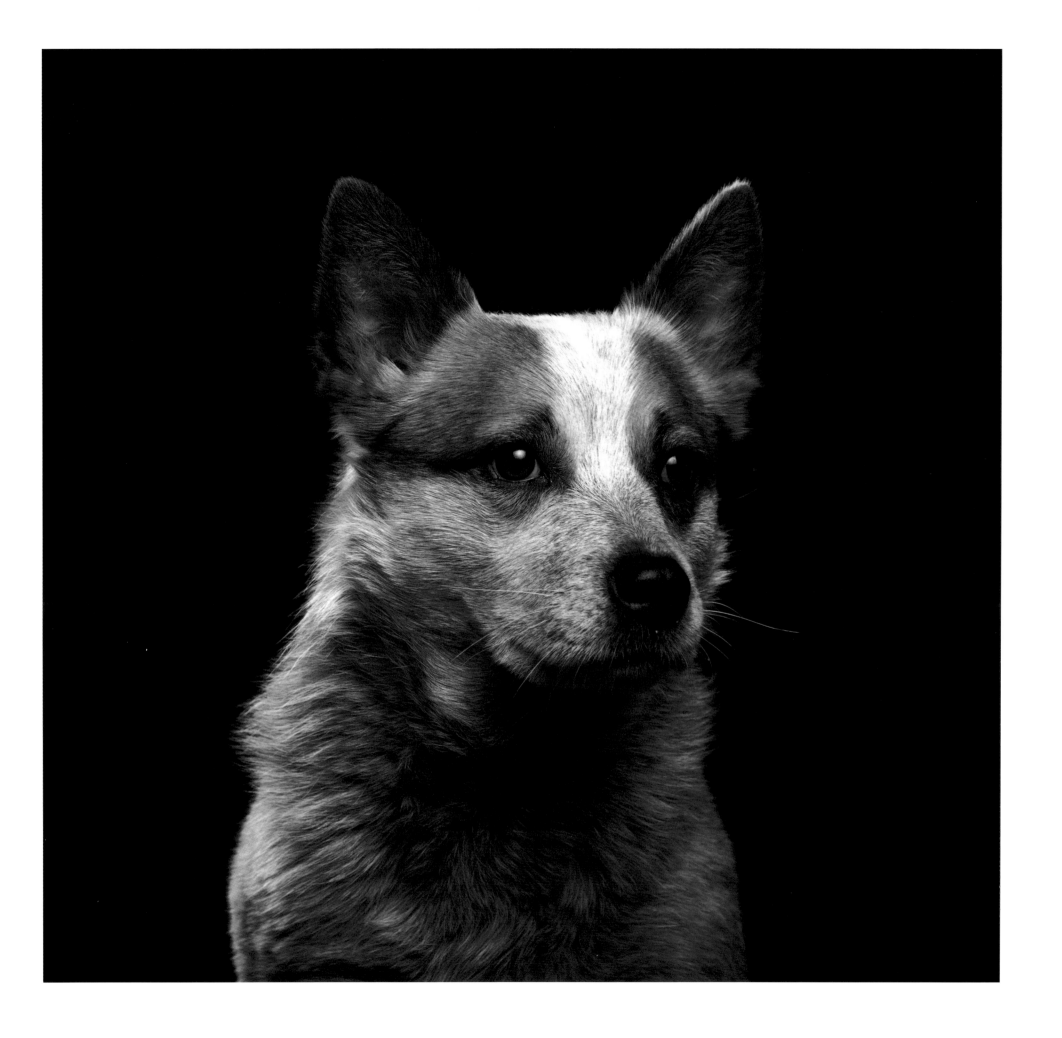

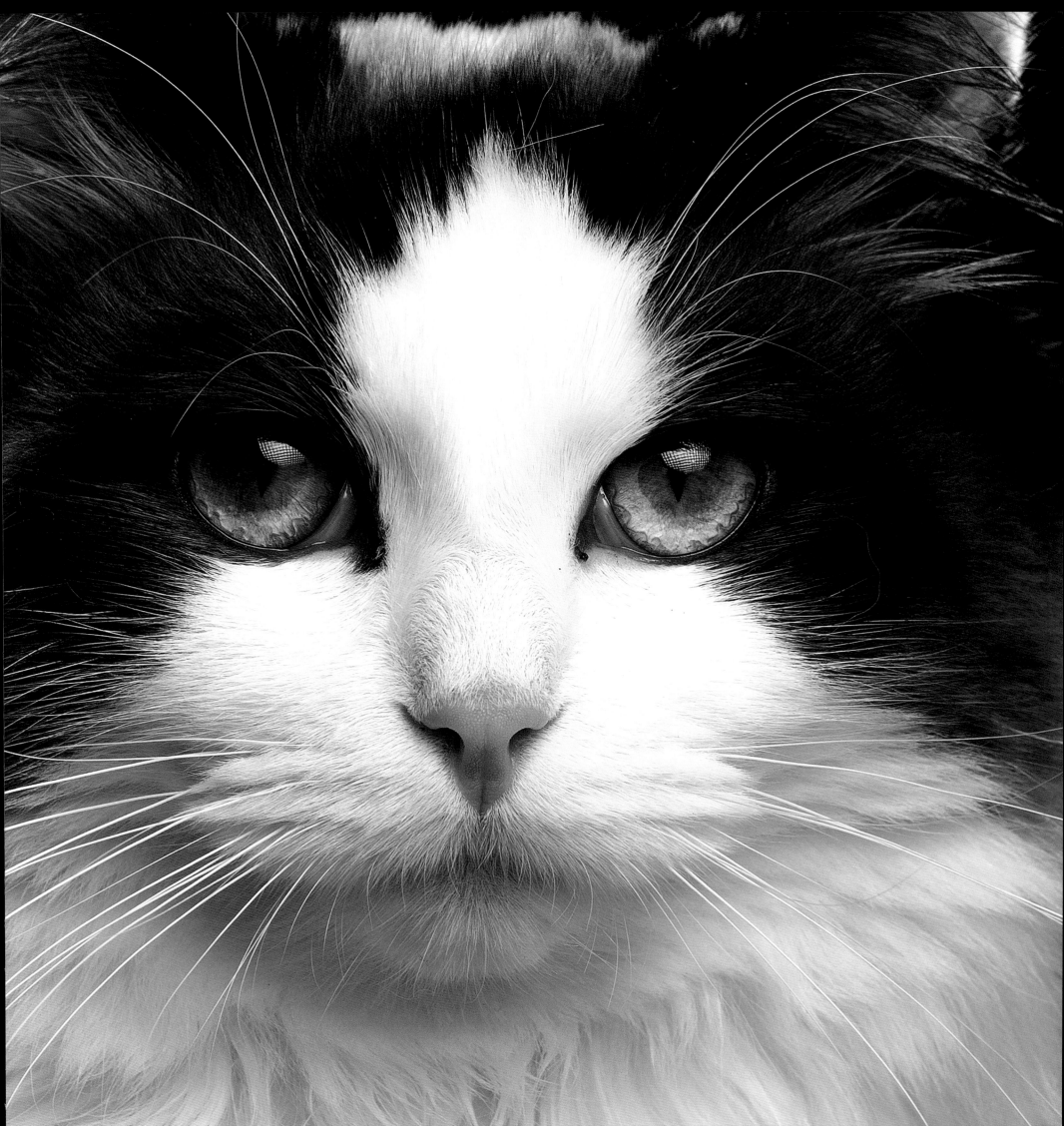

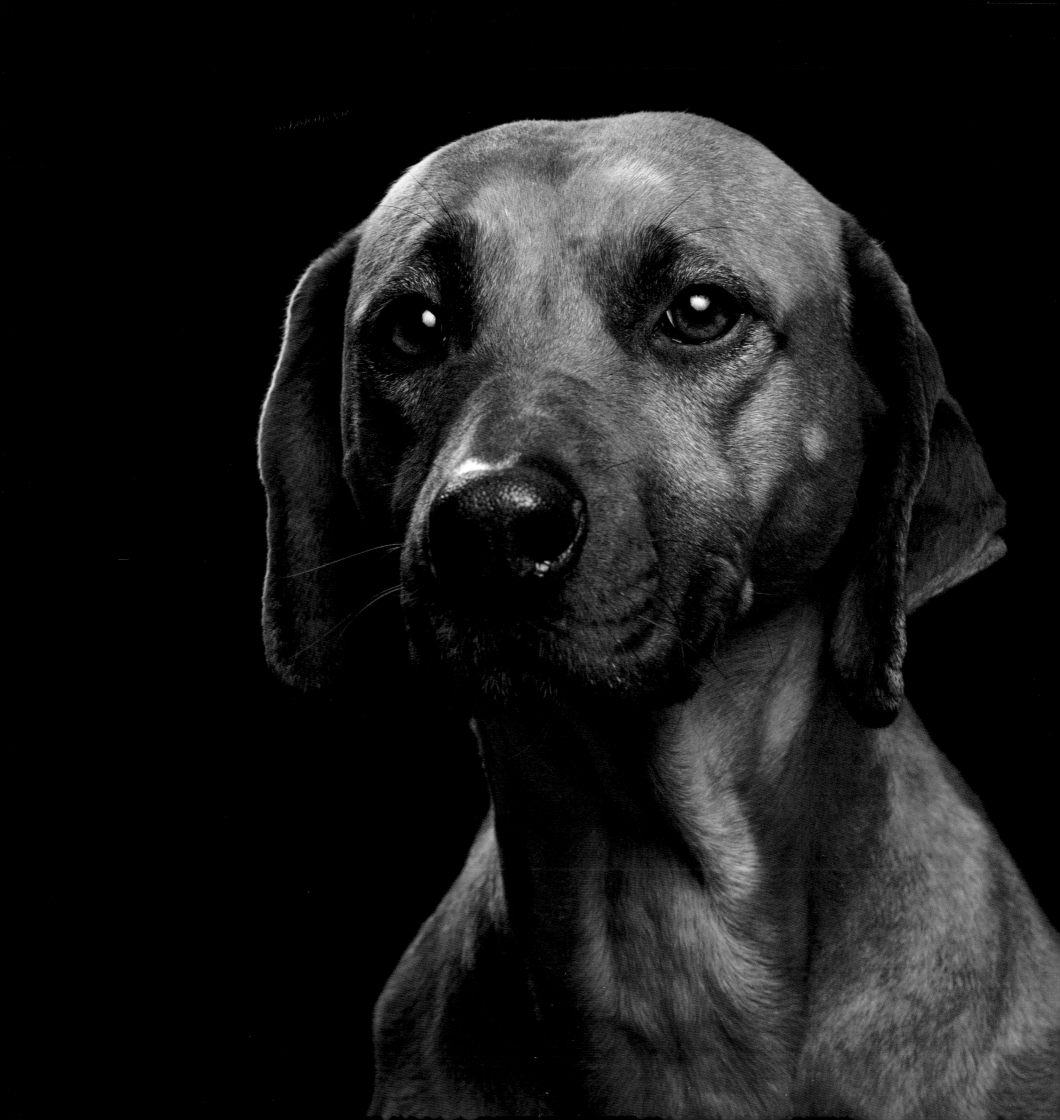

"Dogs are our link to paradise. They don't know evil or jealousy or discontent. To sit with a dog on a hillside on a glorious afternoon is to be back in Eden, where doing nothing was not boring, it was peace."

Milan Kundera

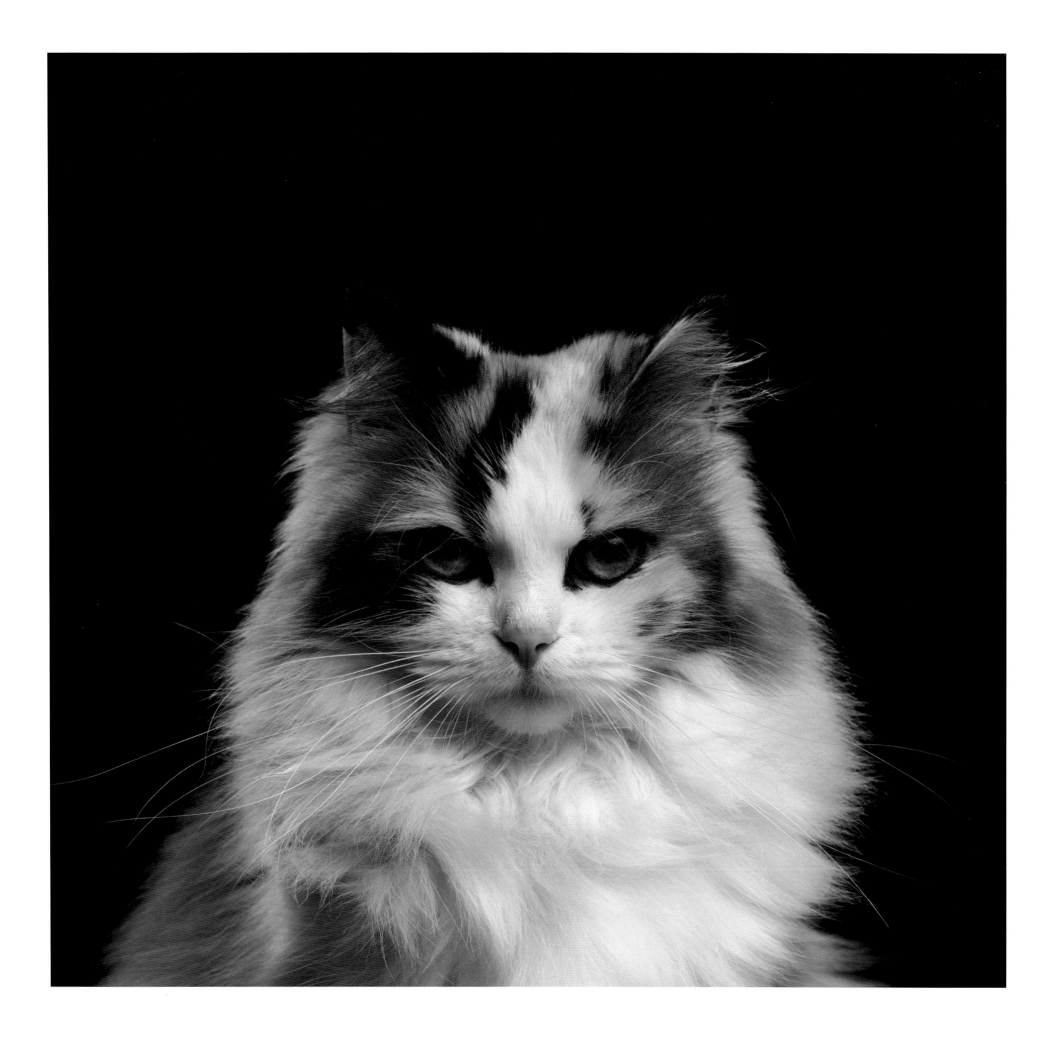

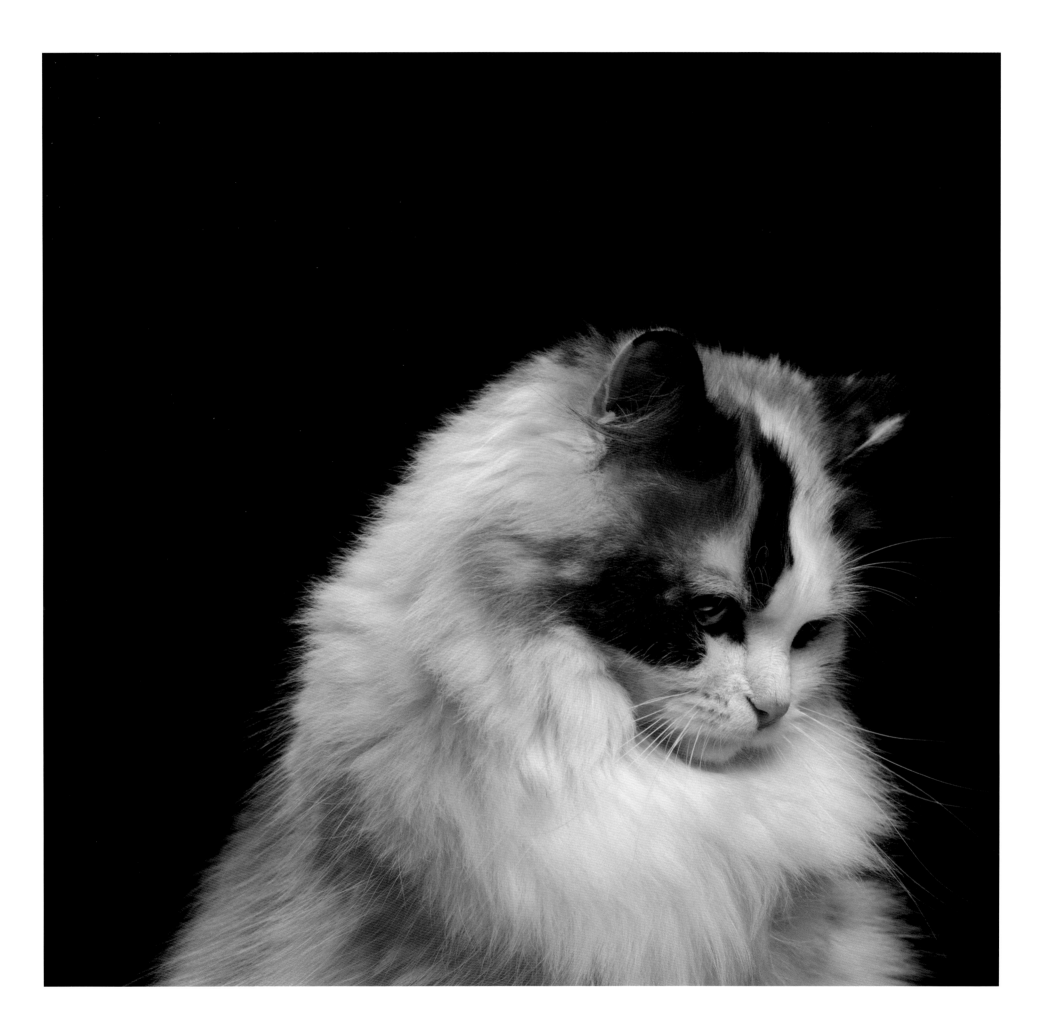

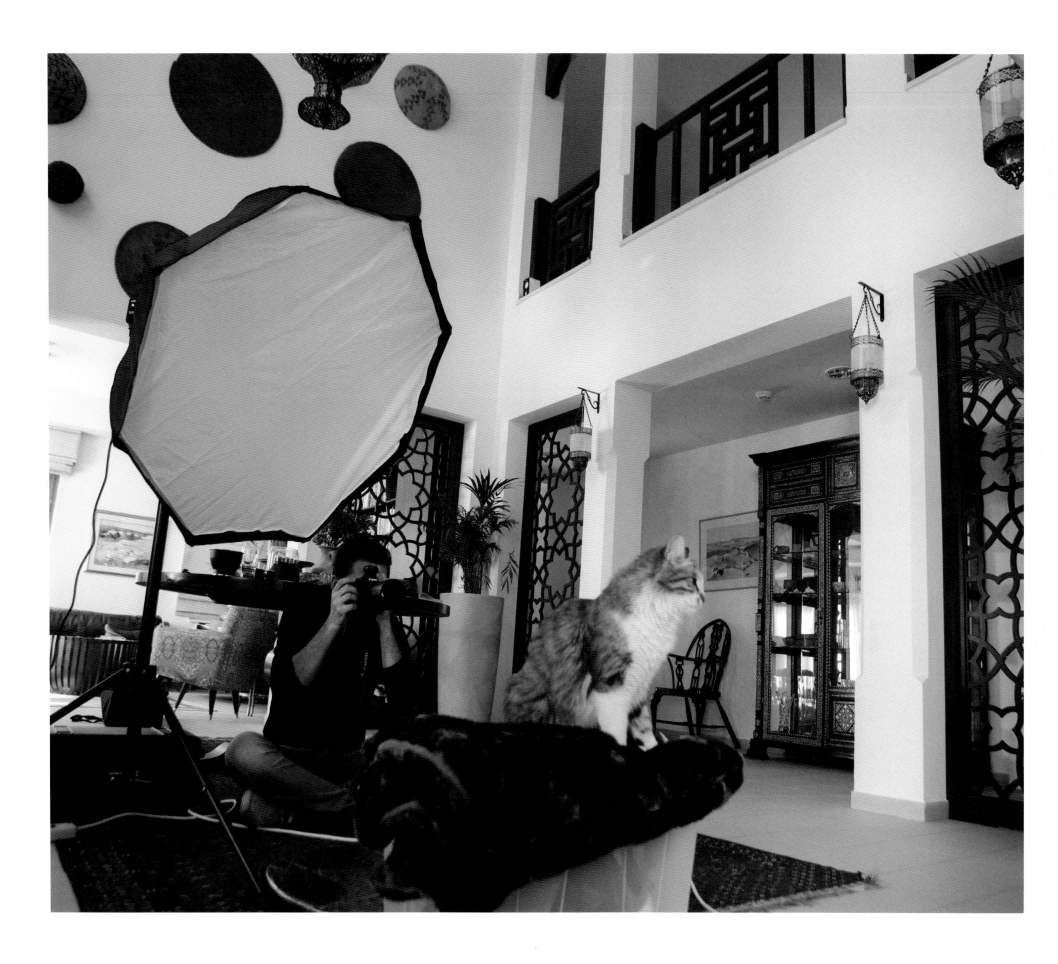

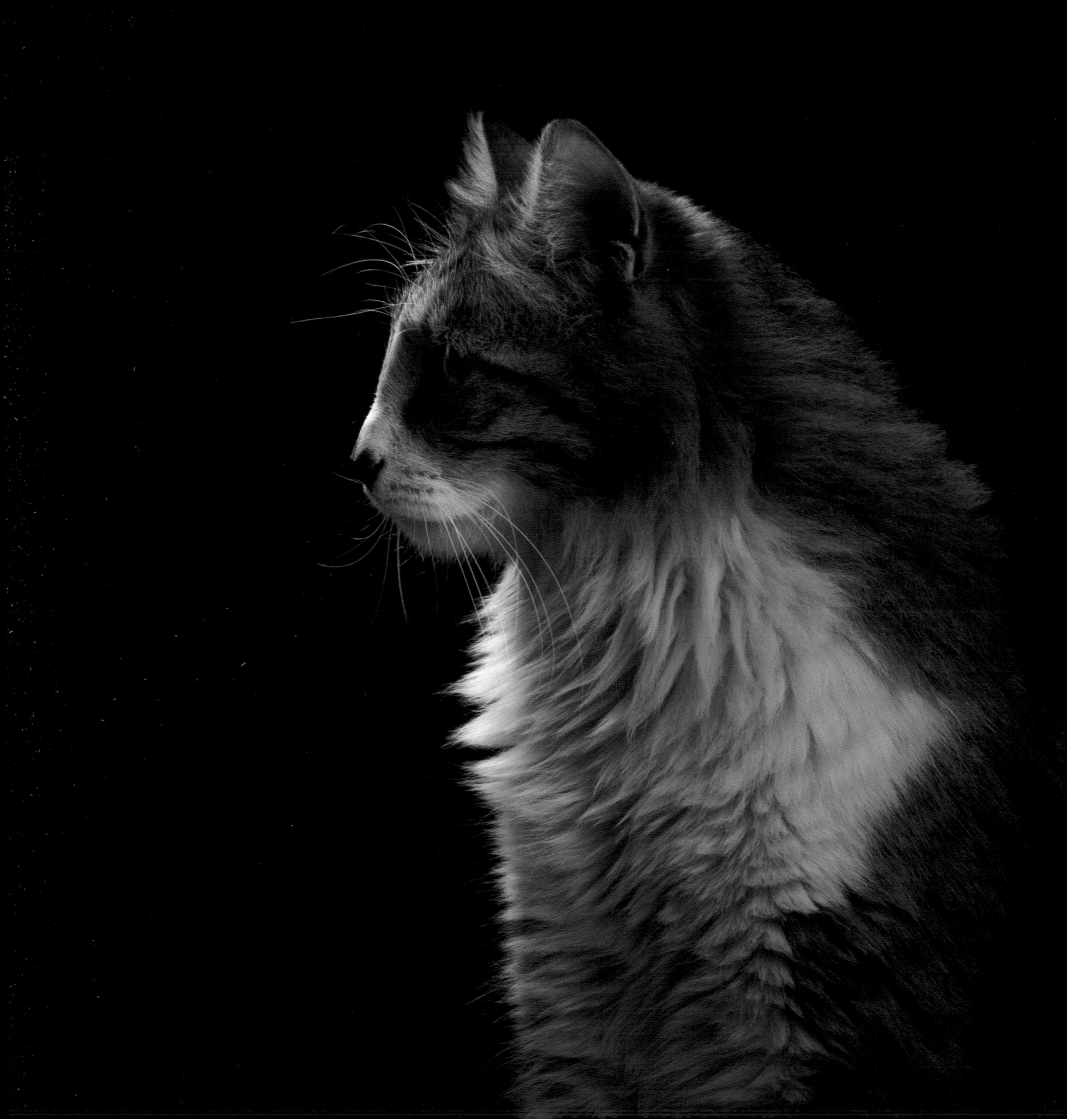

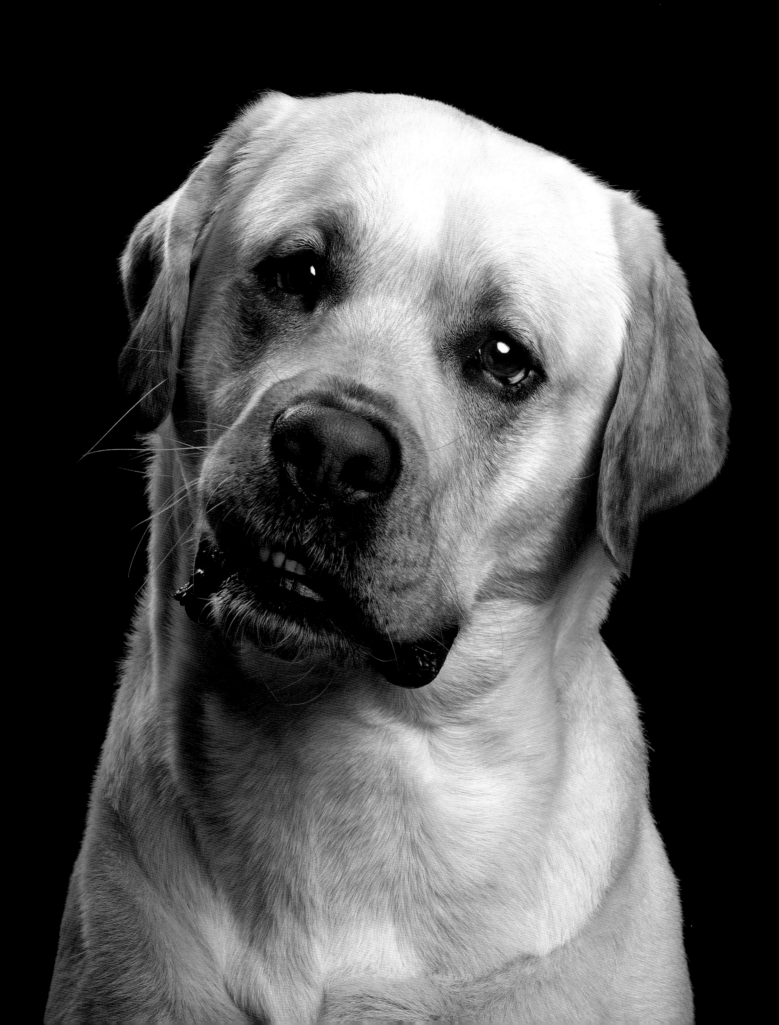

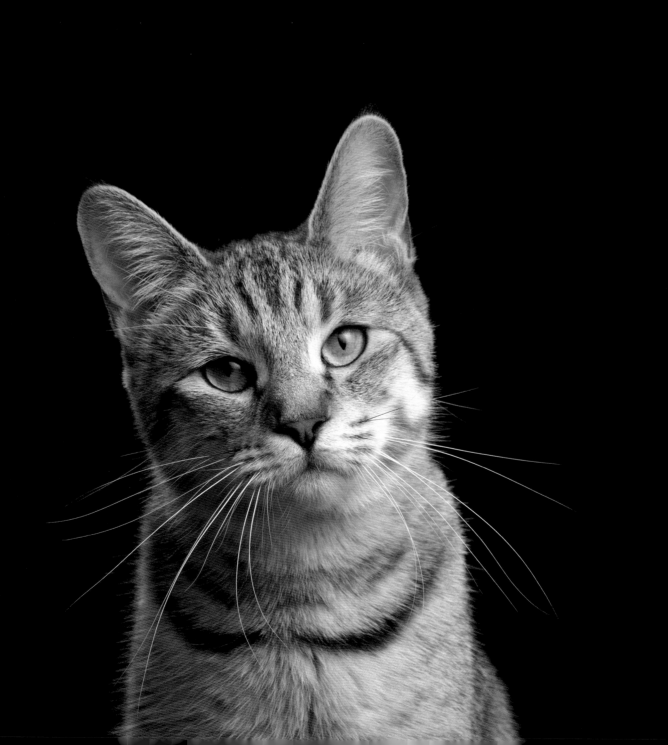

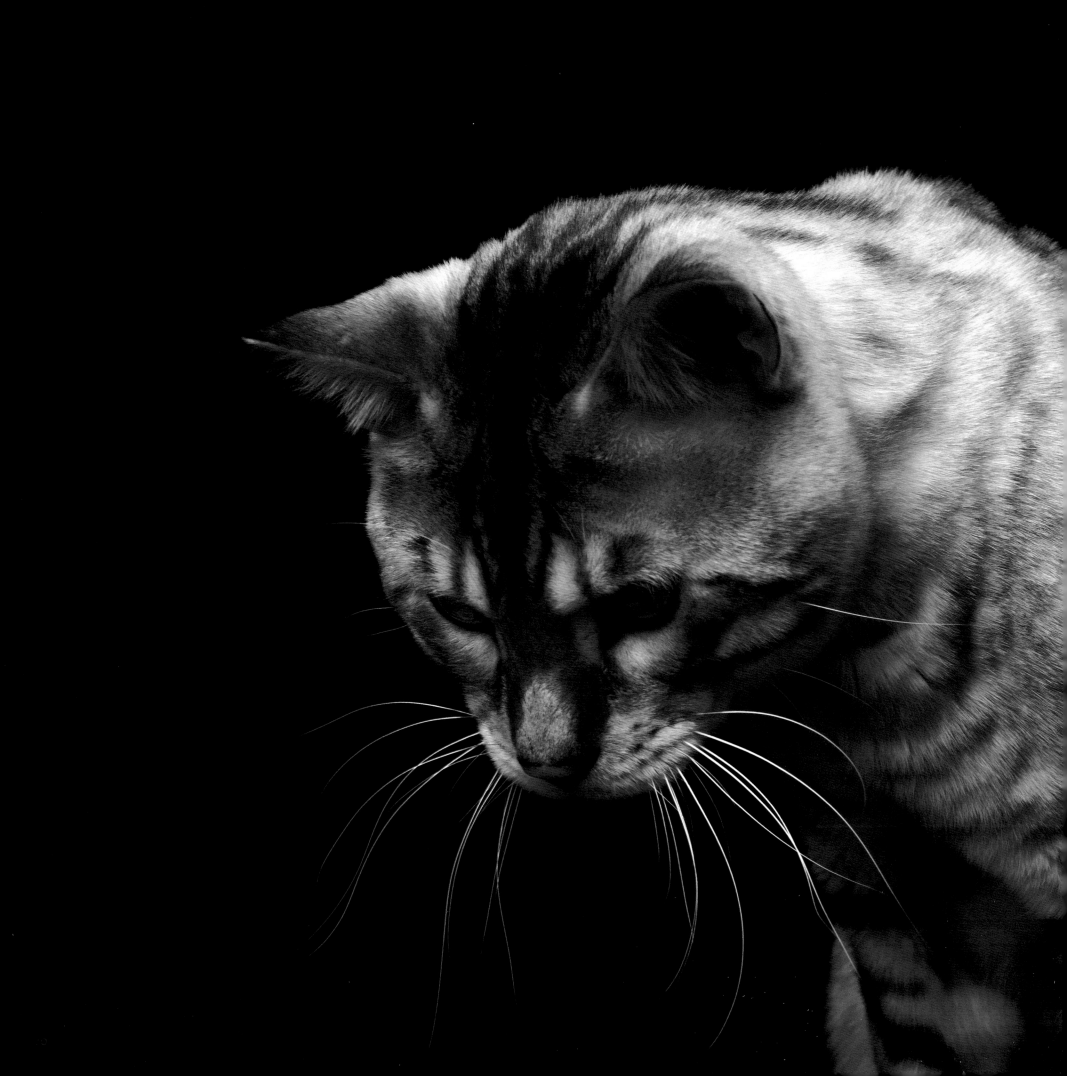

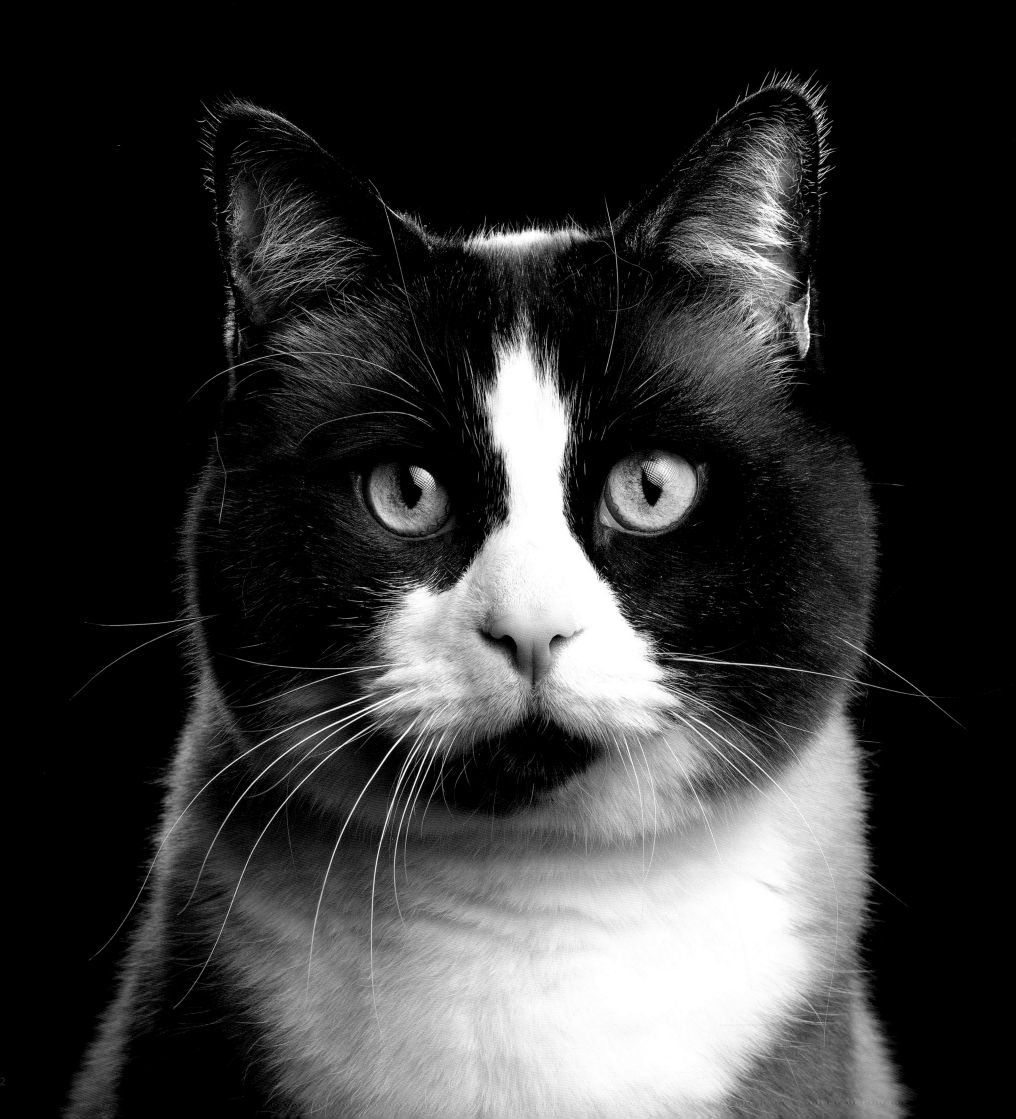

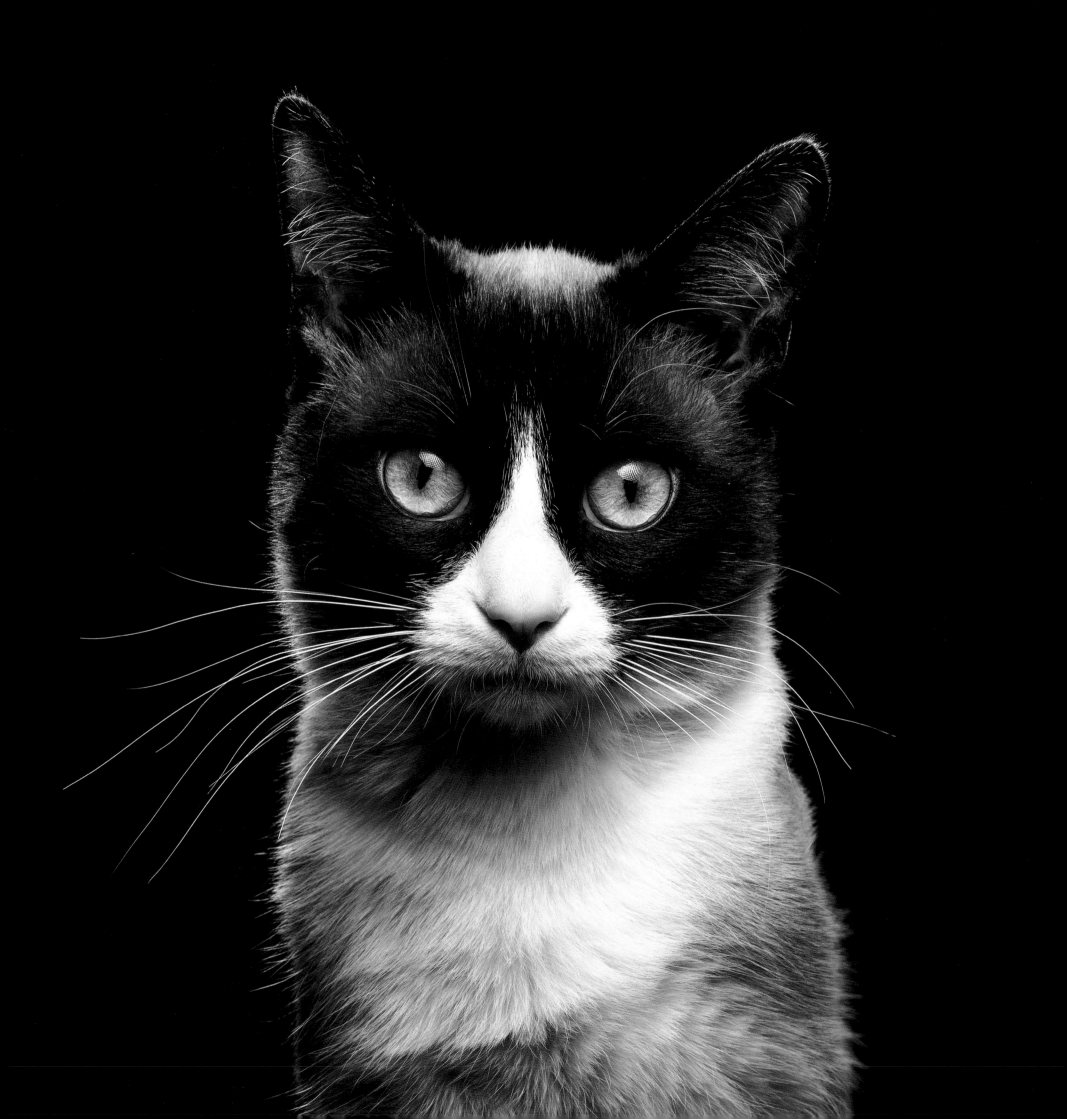

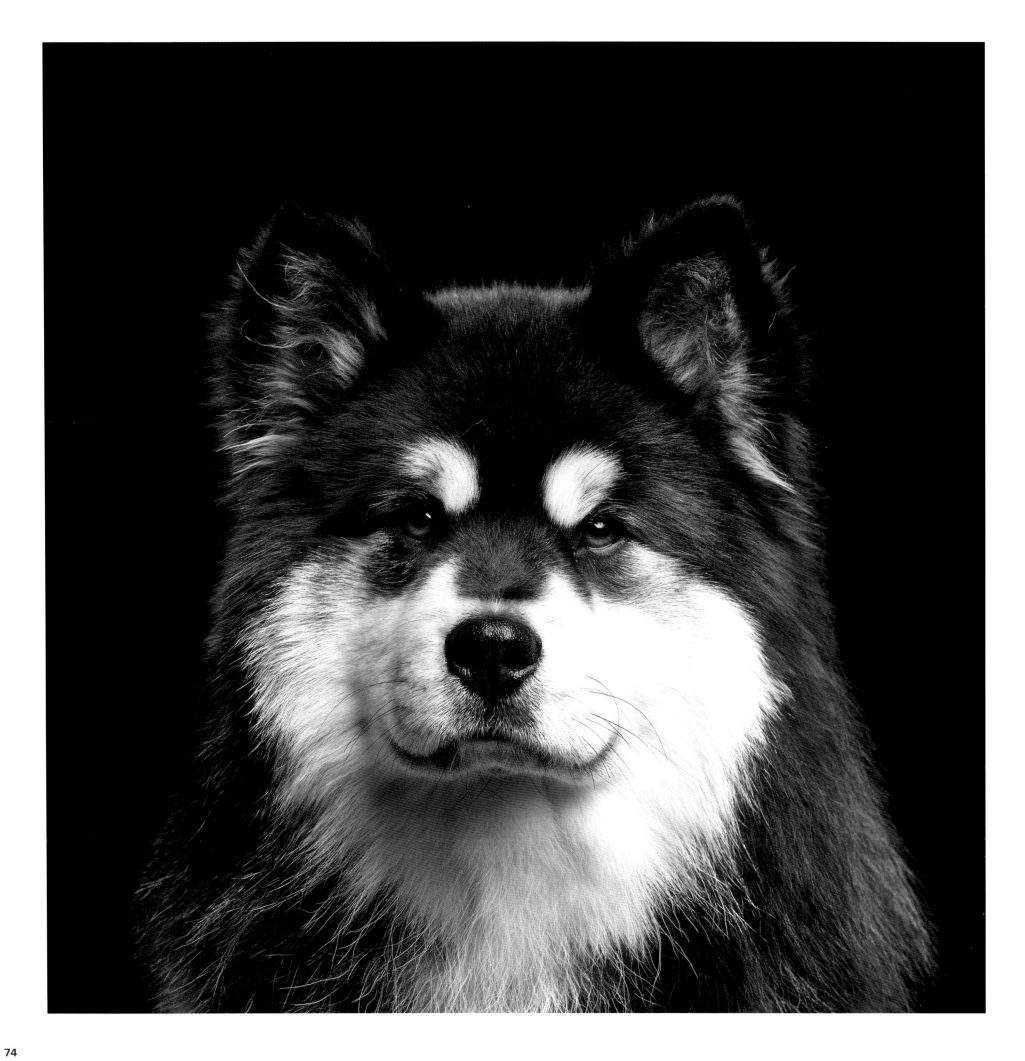

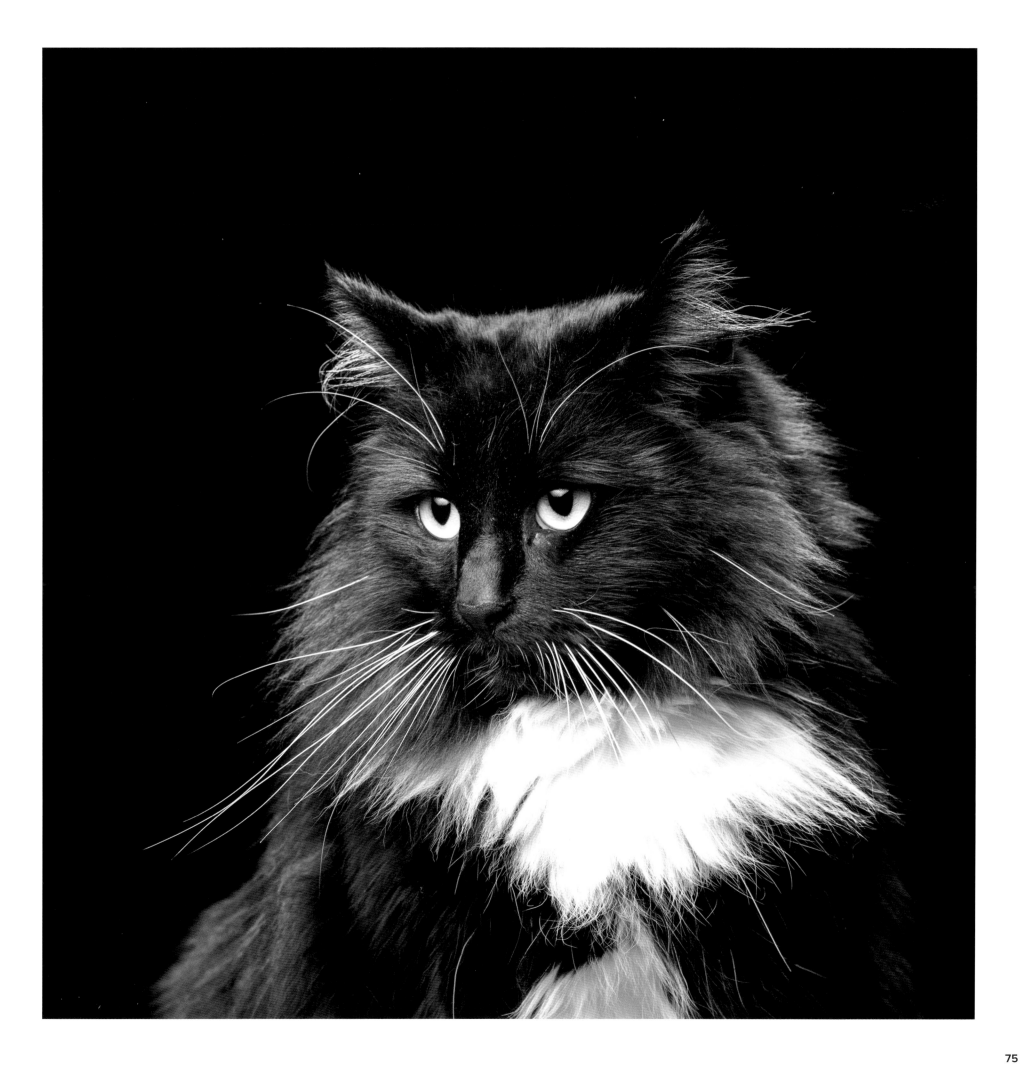

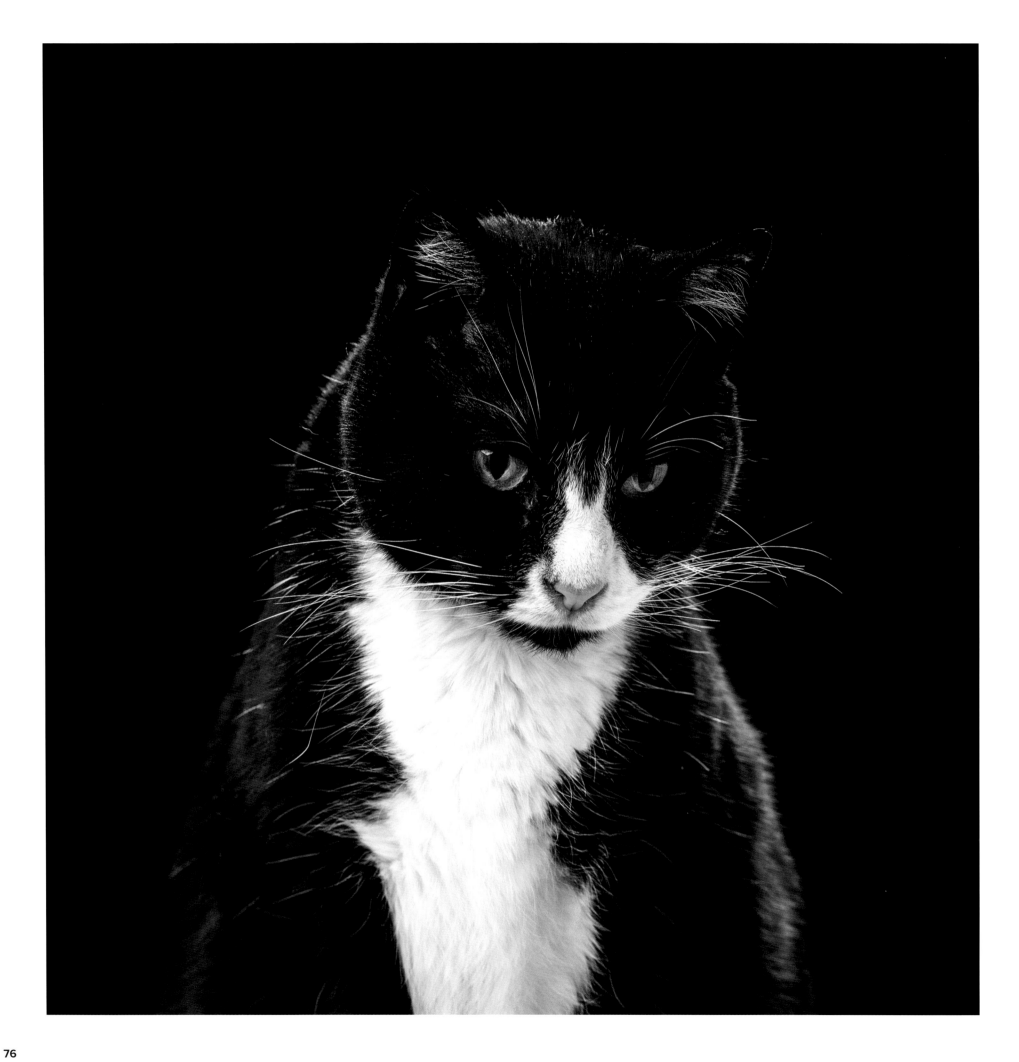

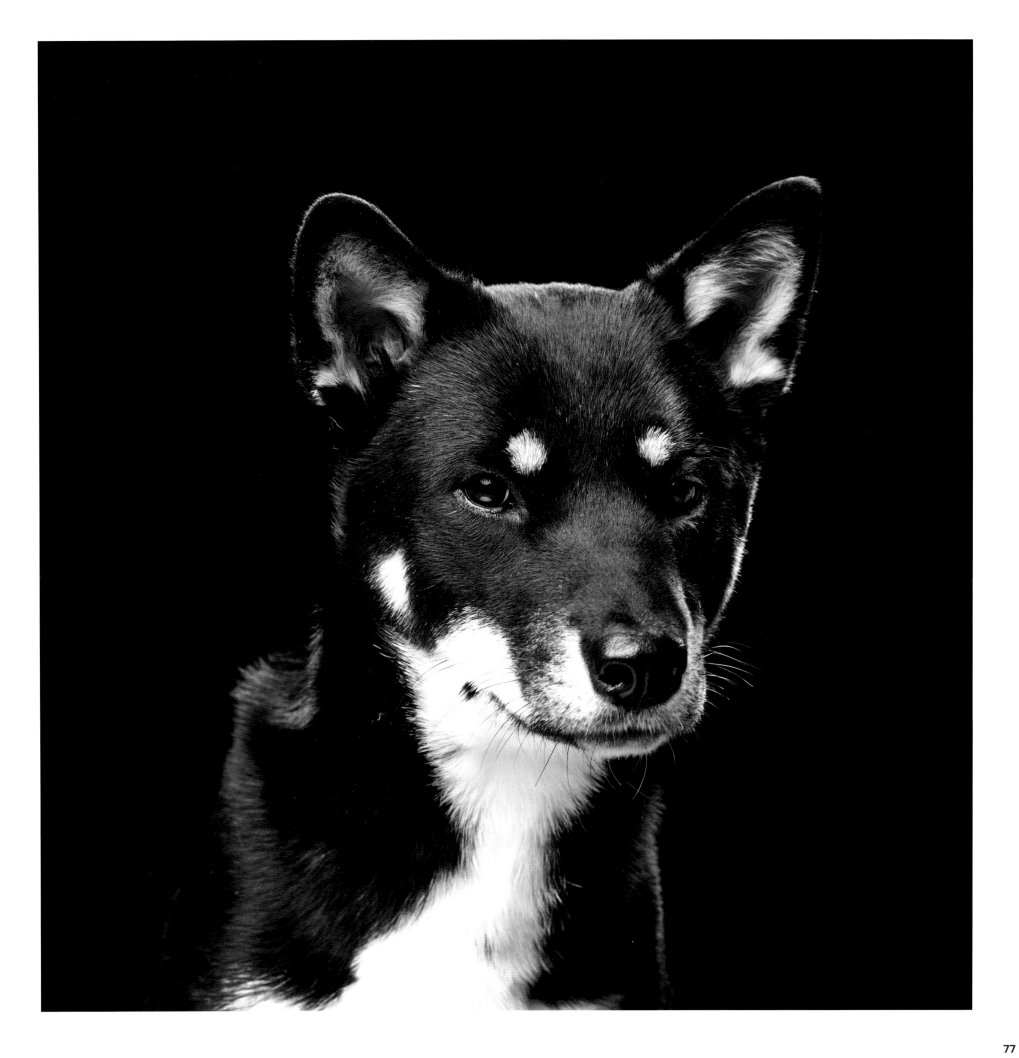

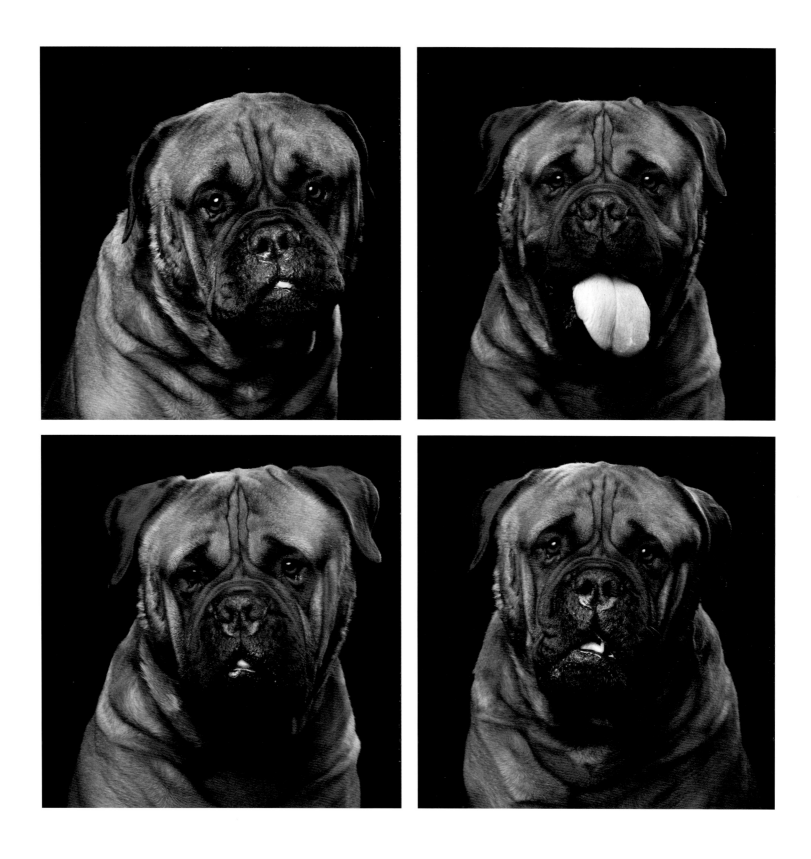

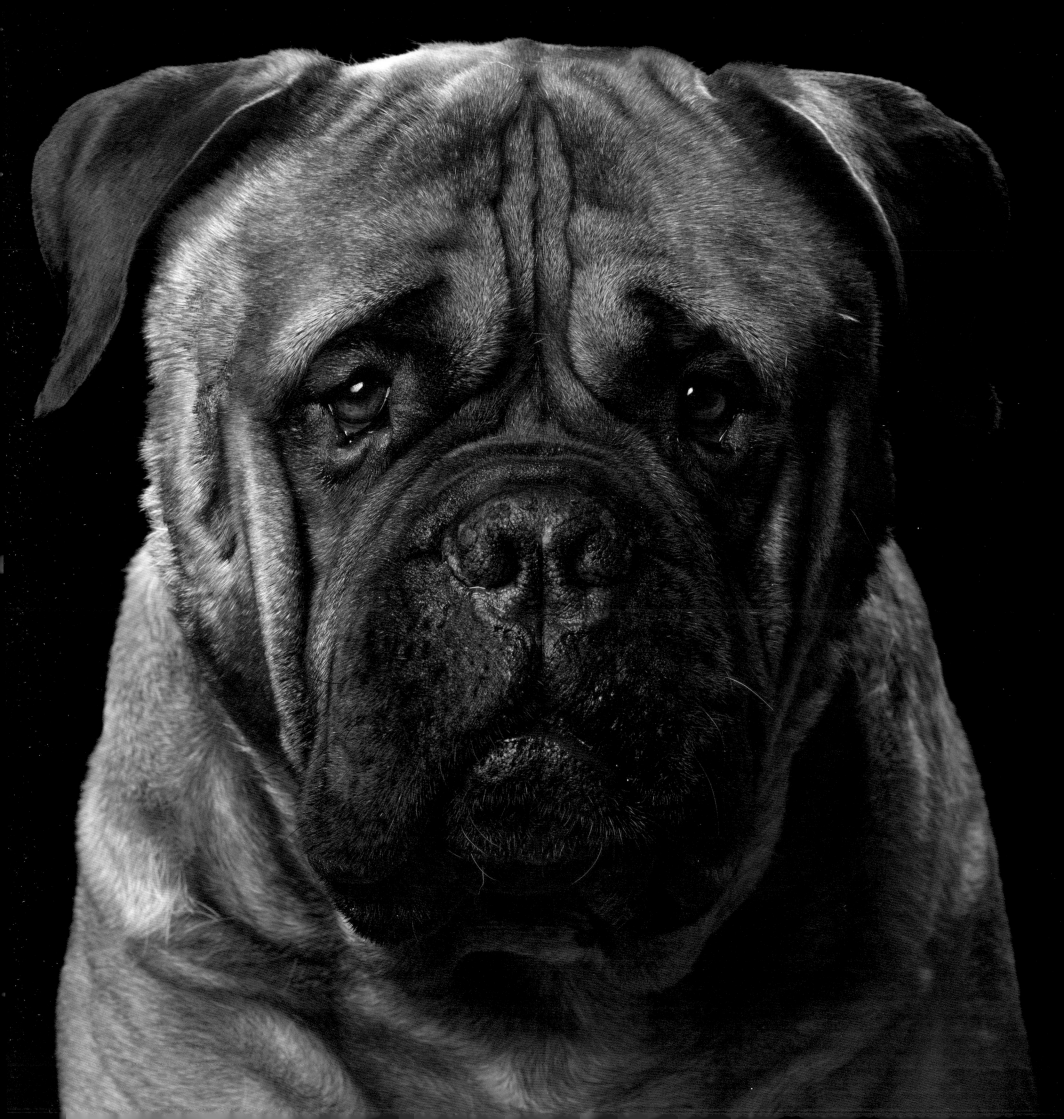

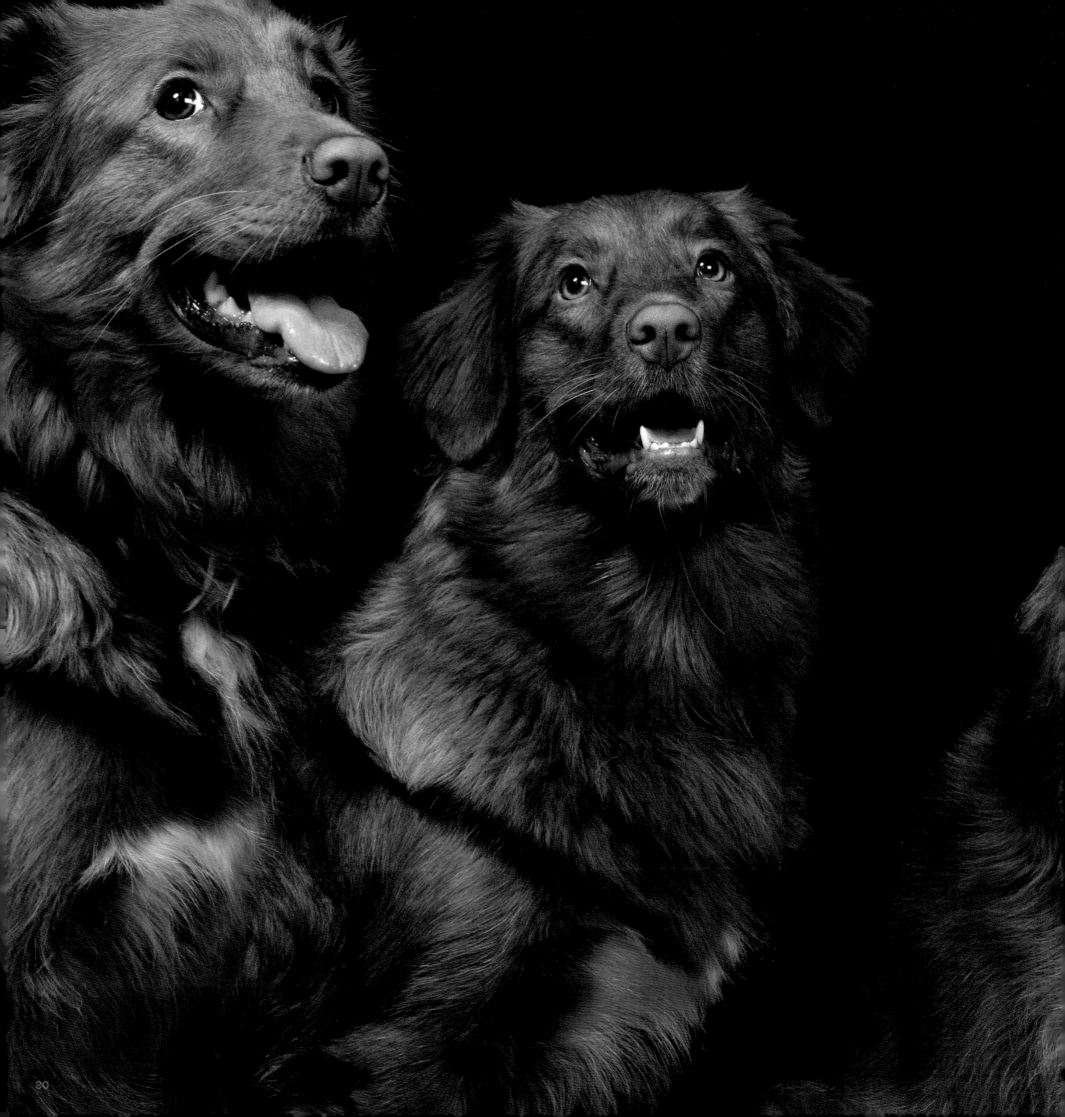

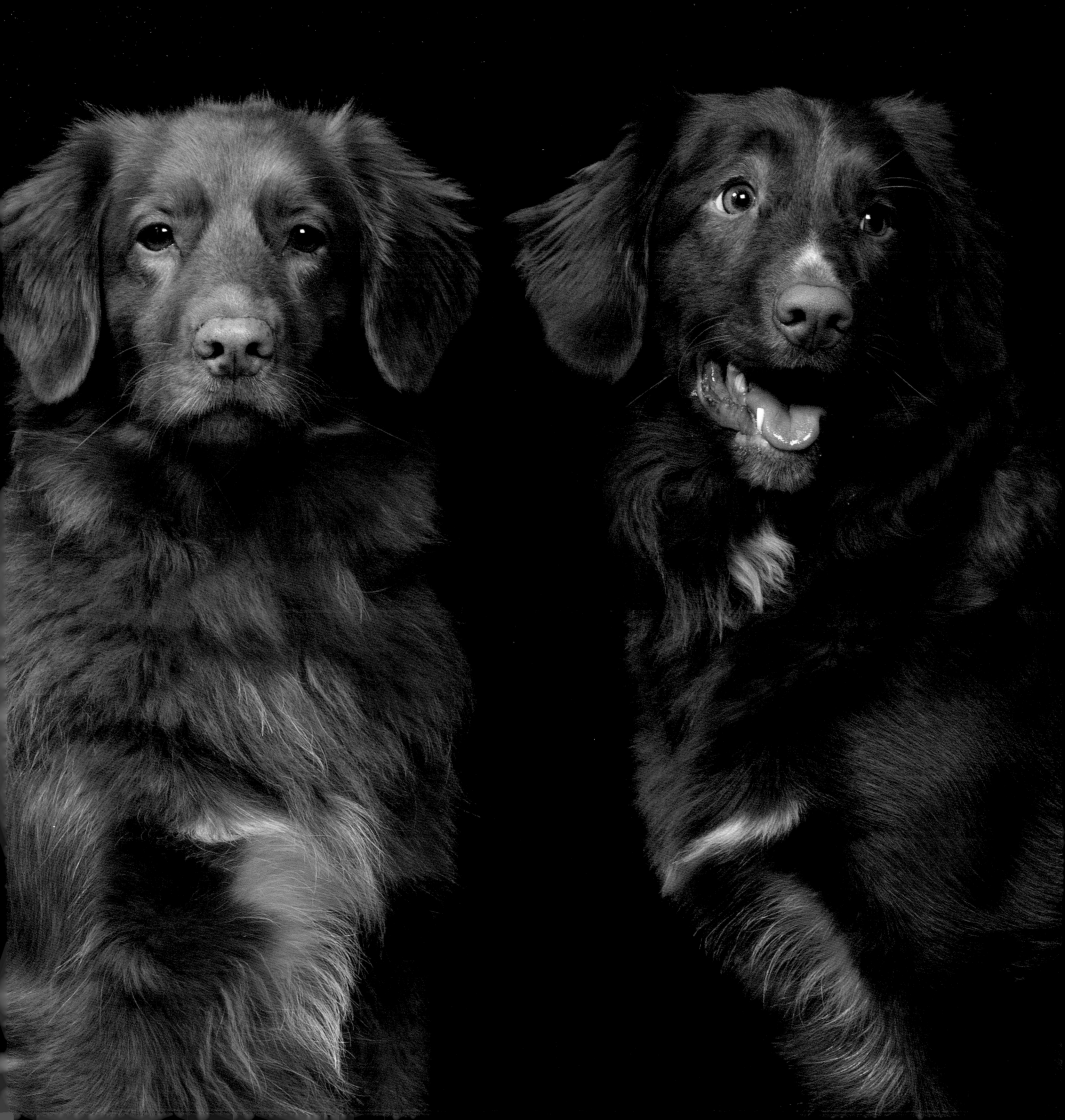

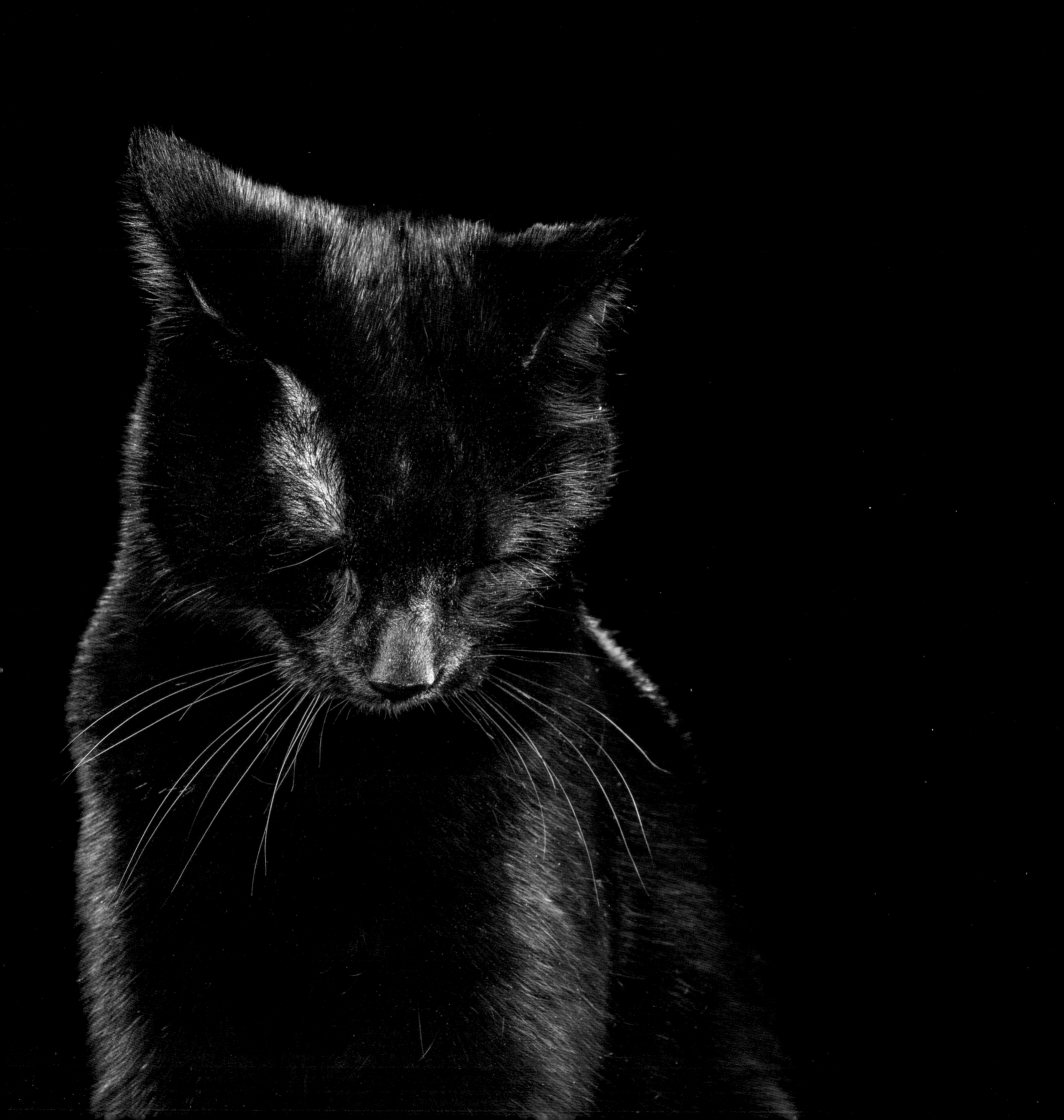

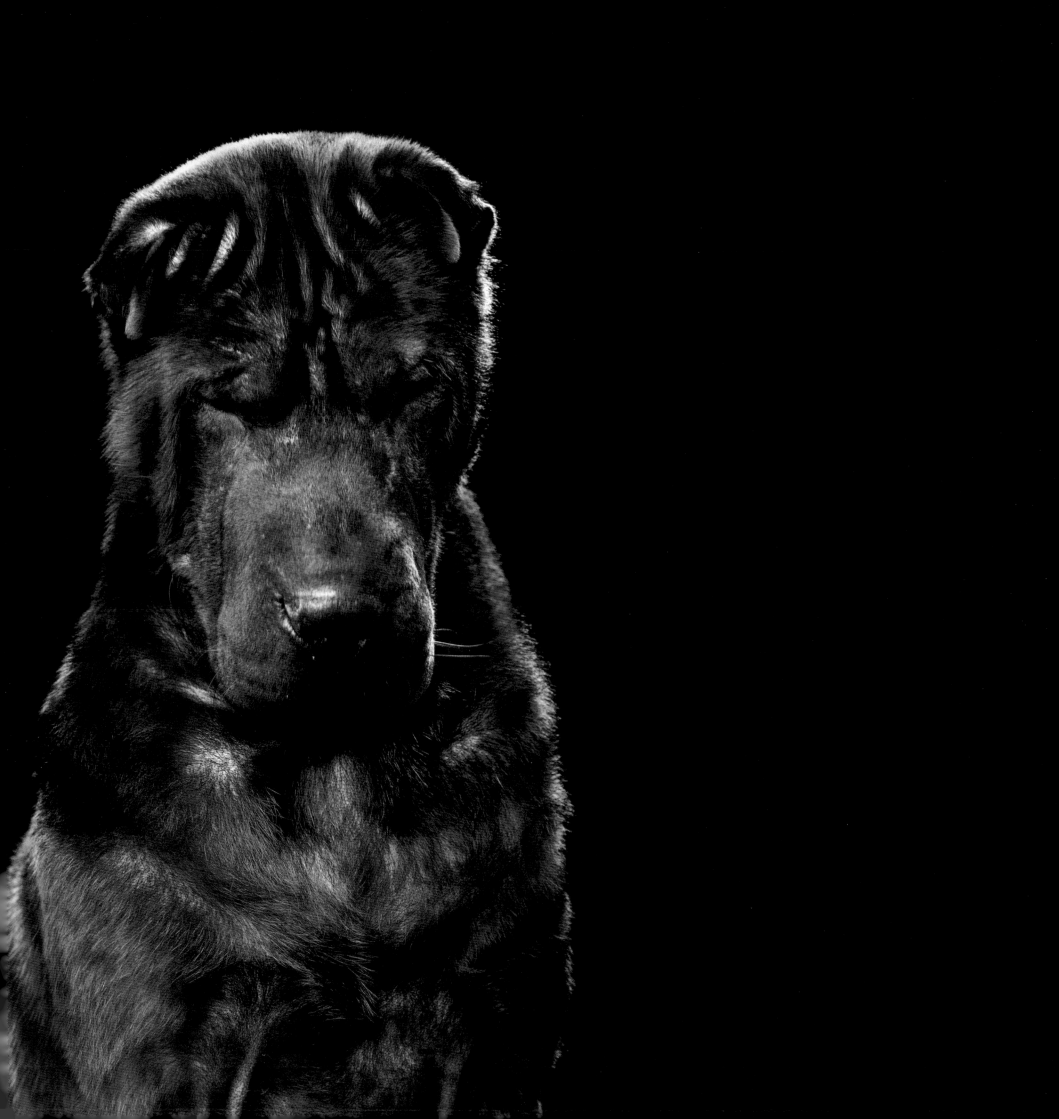

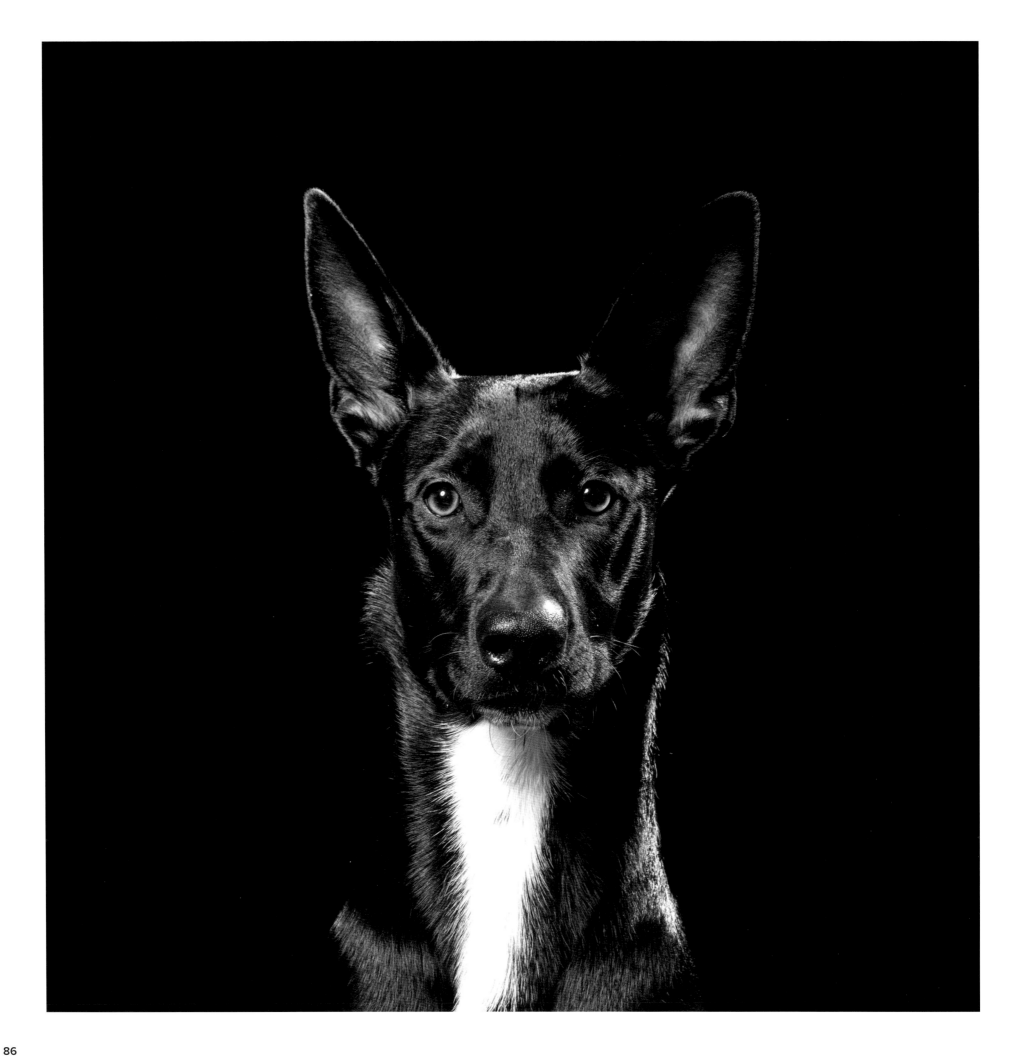

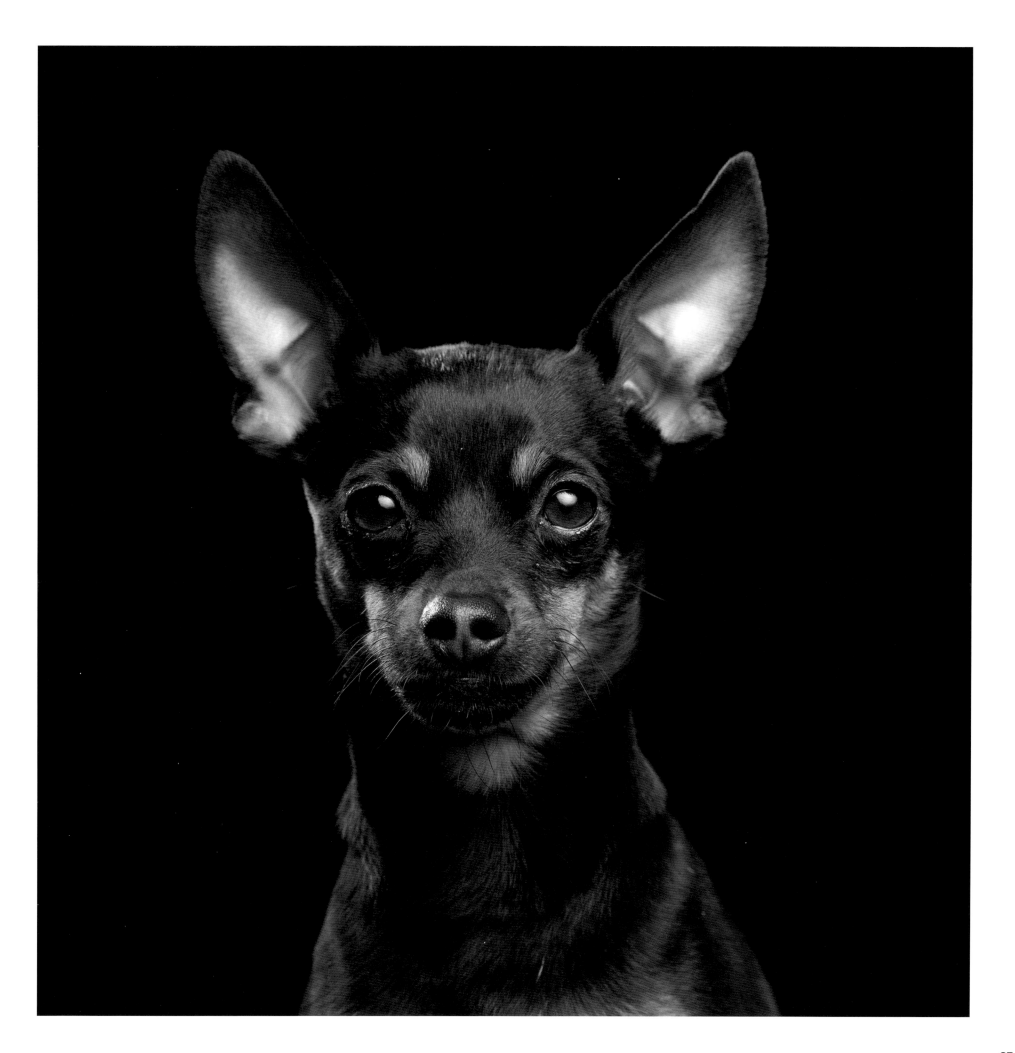

"To his dog, every man is Napoleon;
hence the constant popularity of dogs."

Aldous Huxley

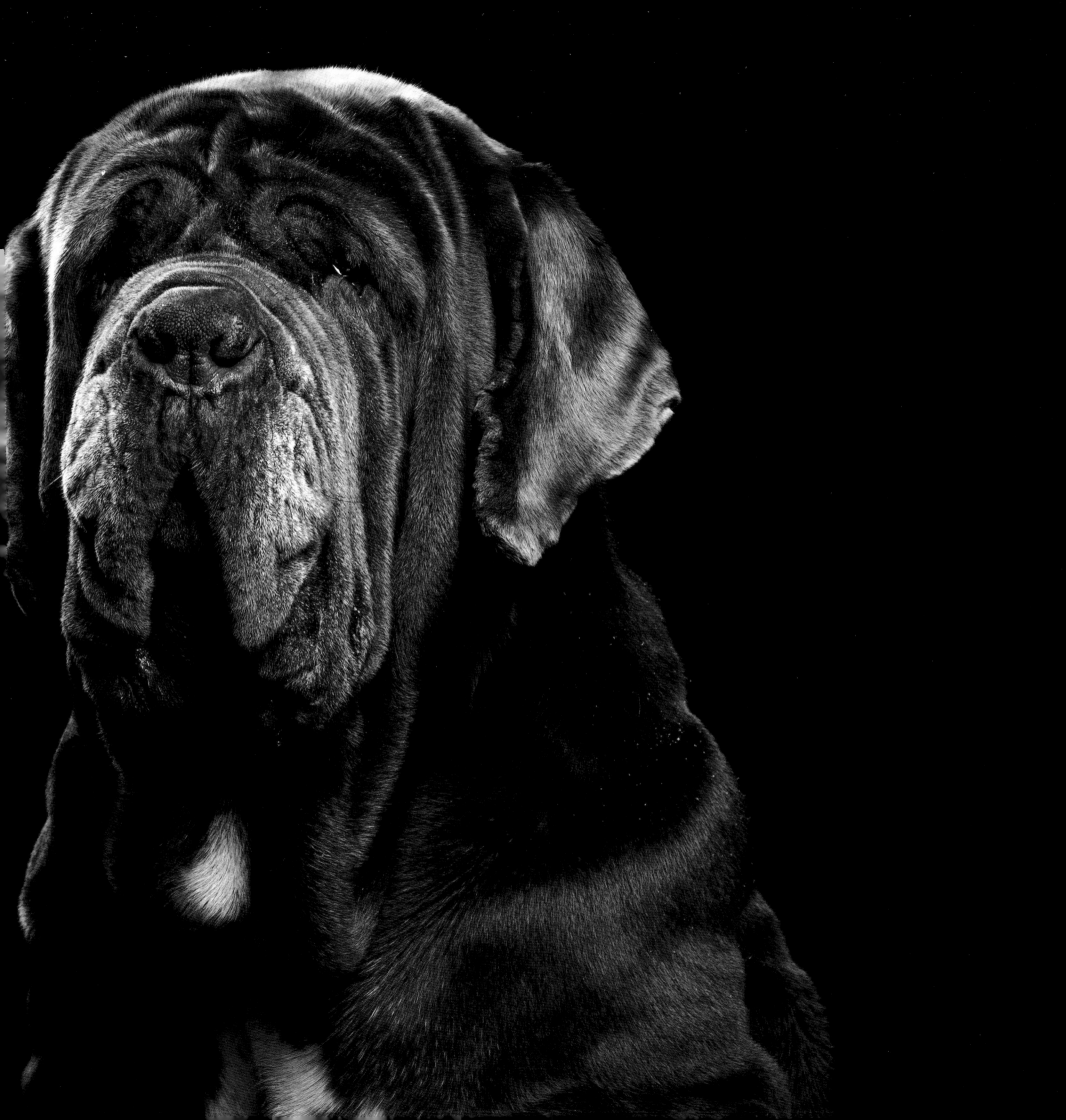

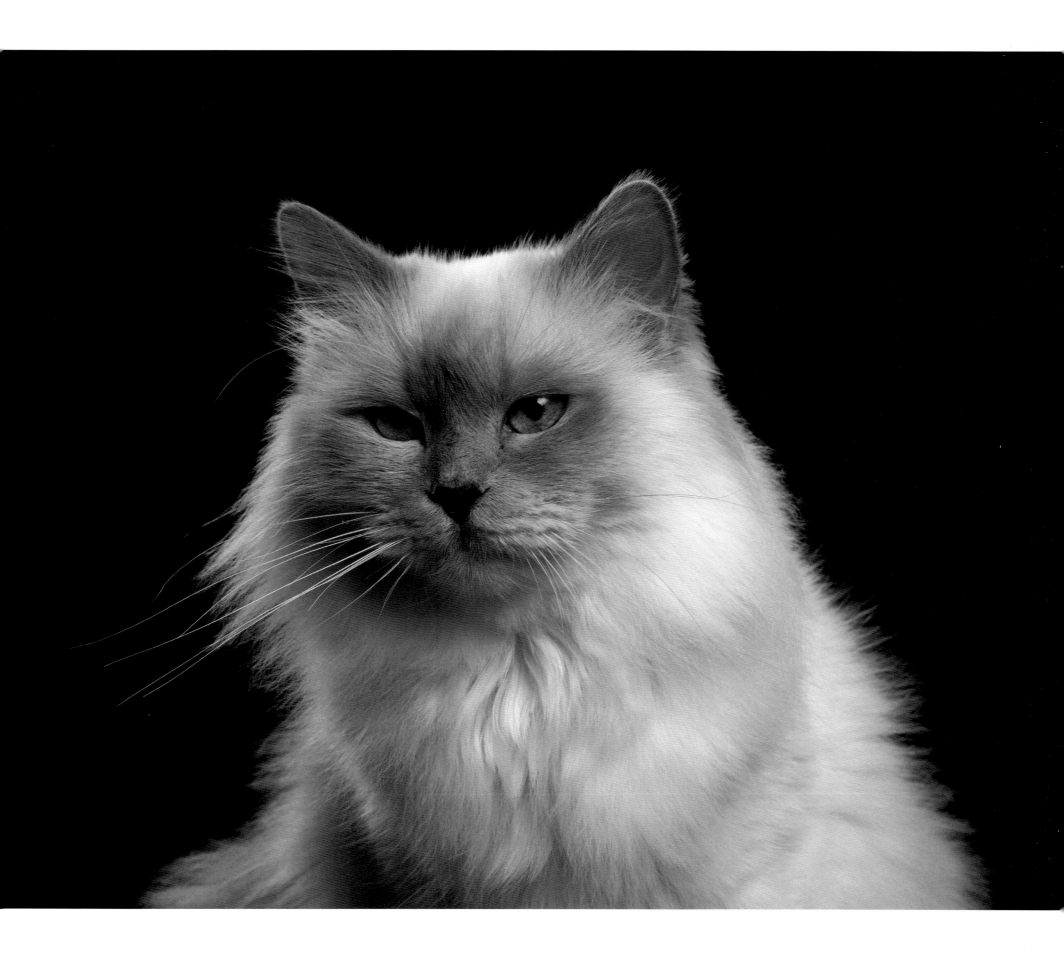

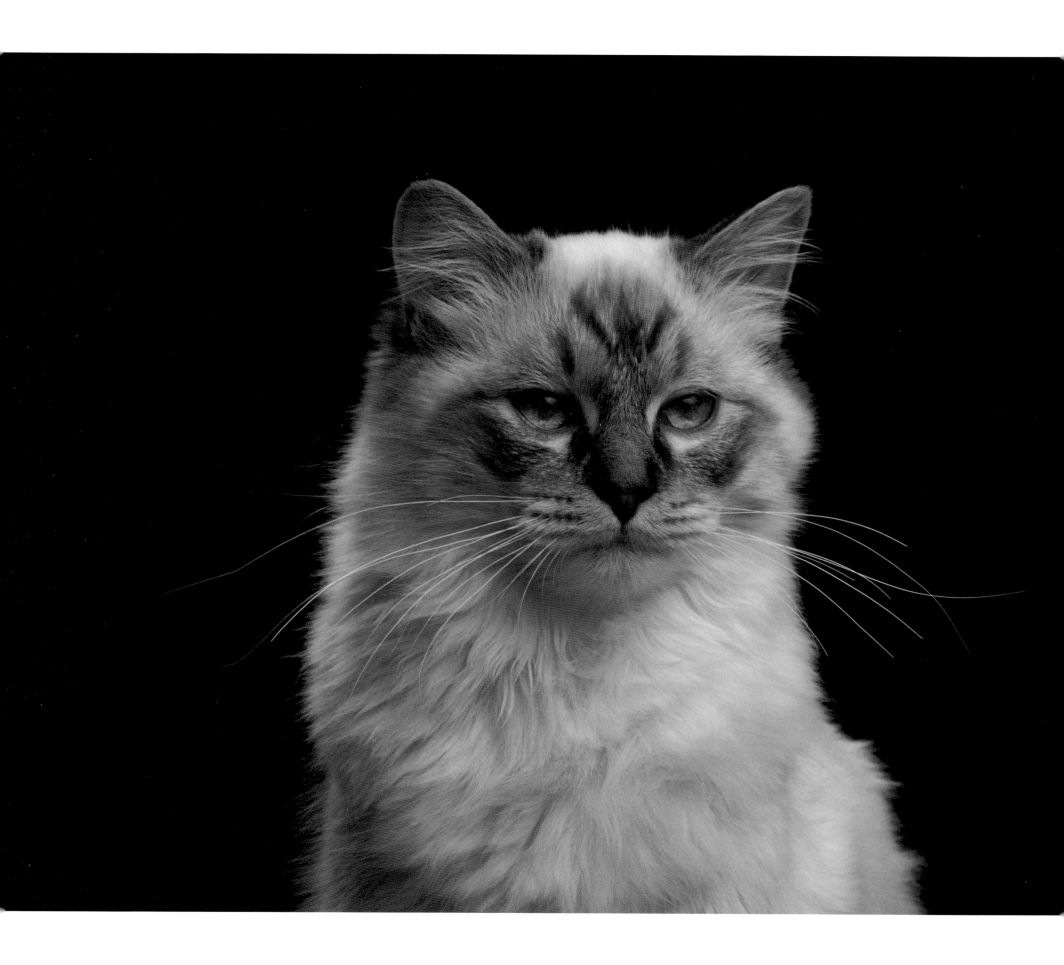

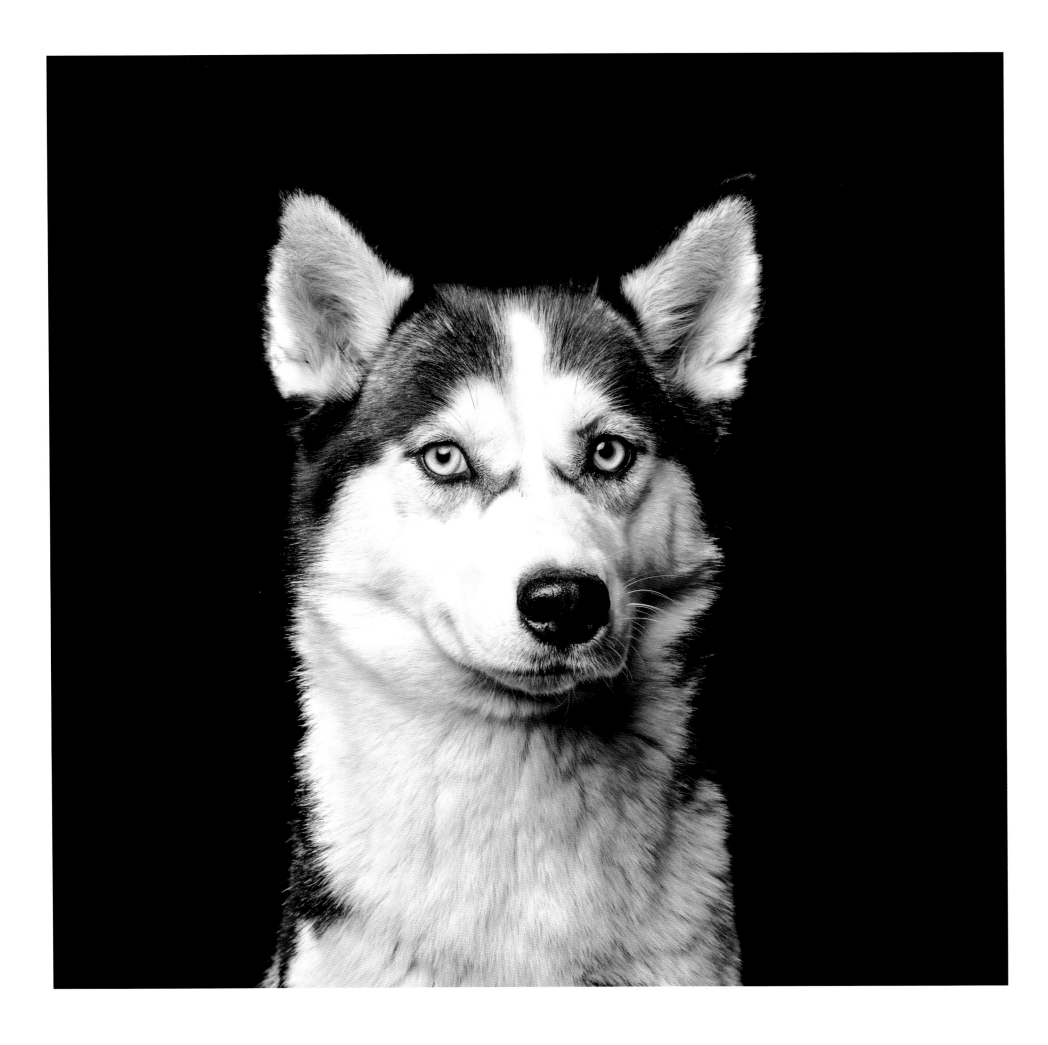

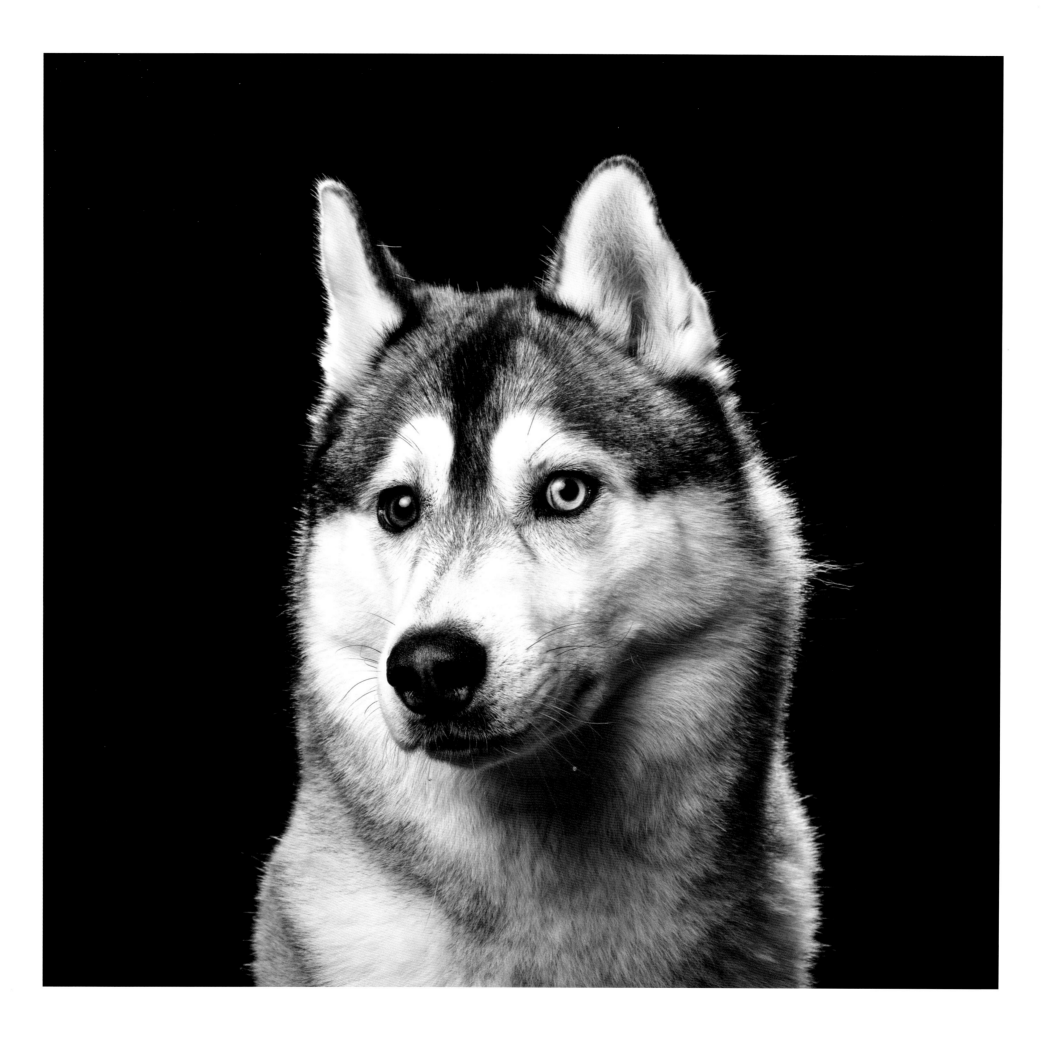

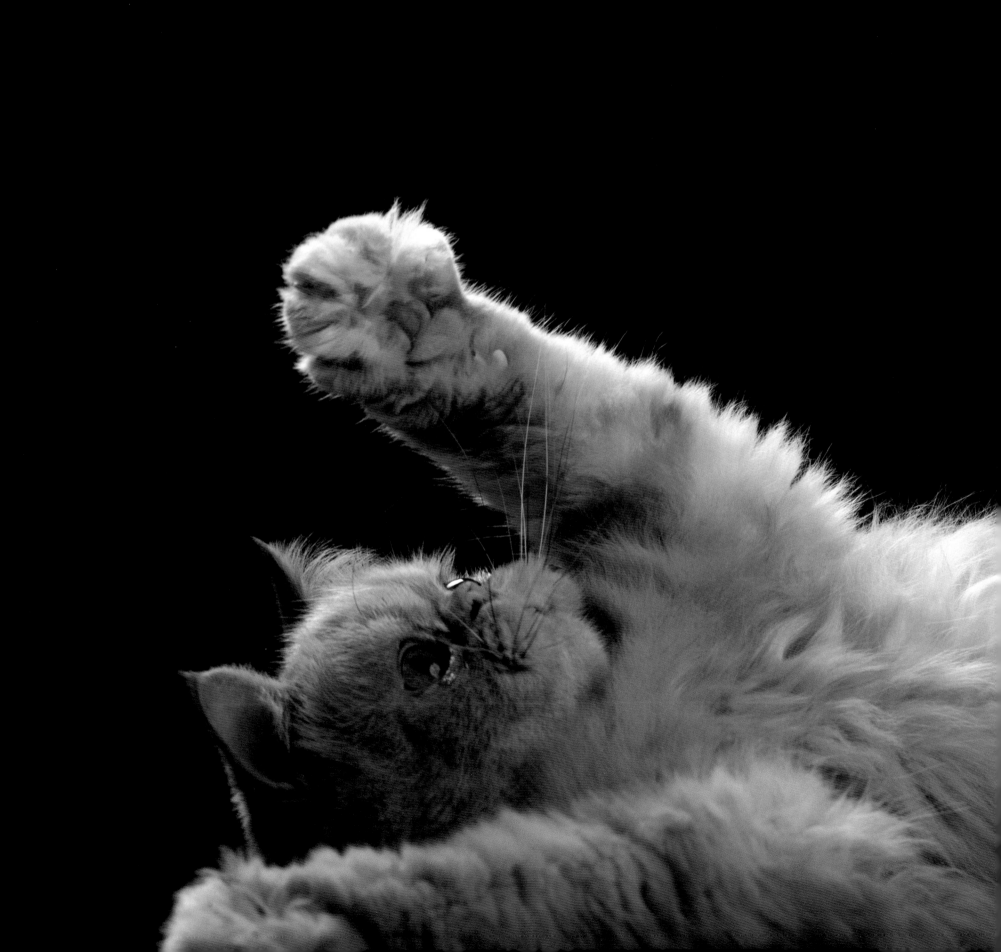

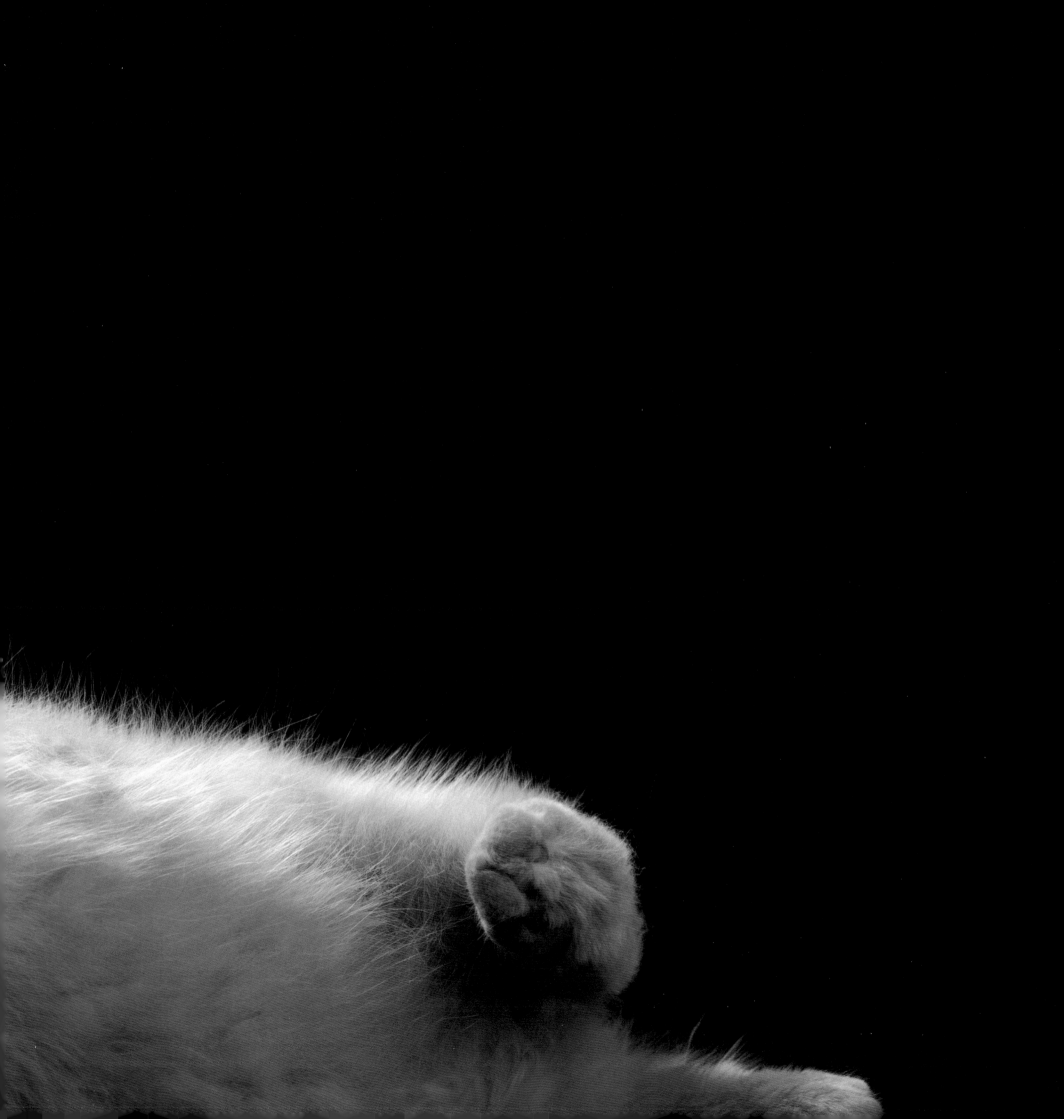

"Deep down we all have the same urges.
Cats have the courage to live by them."

Jim Davis

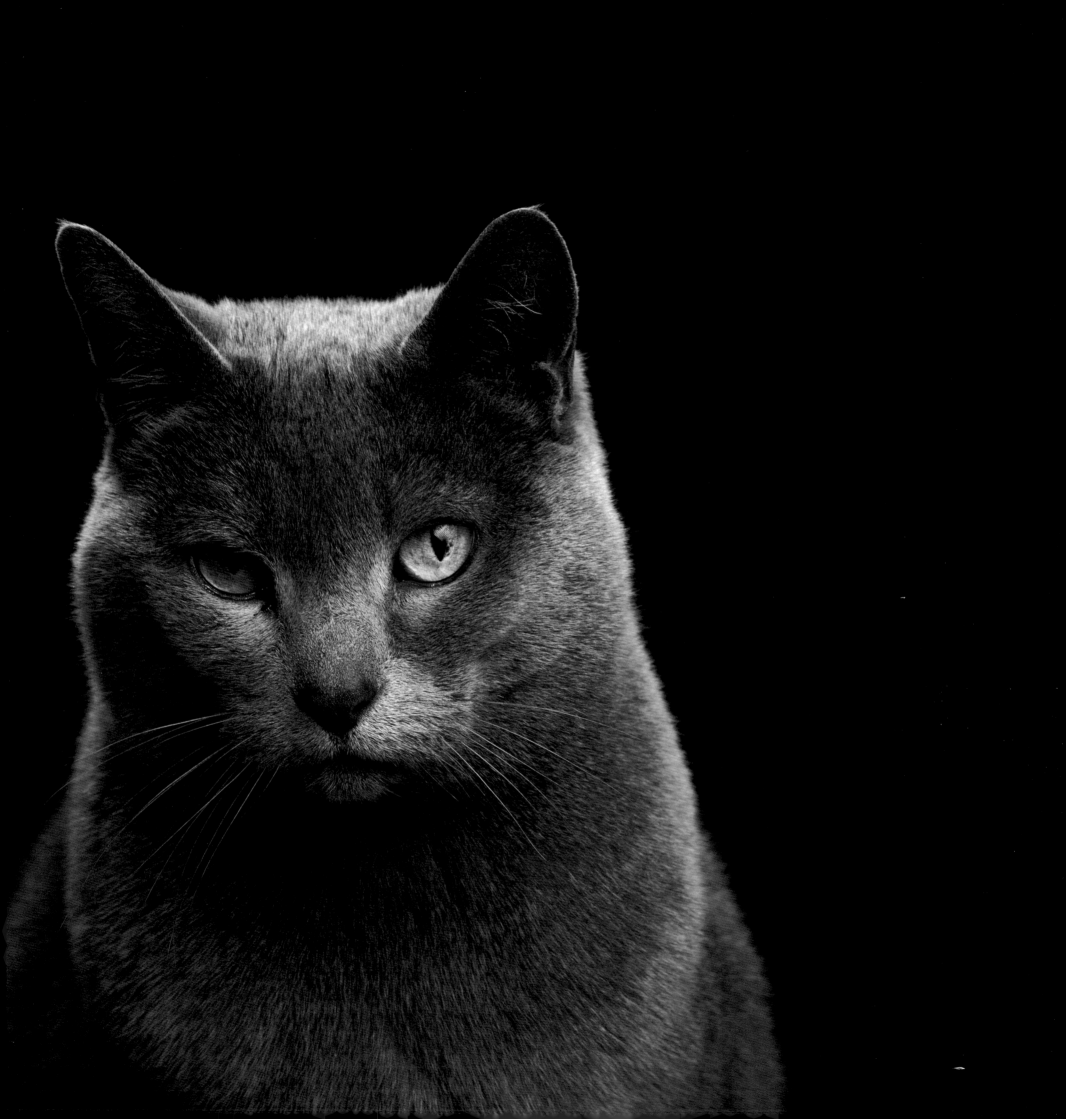

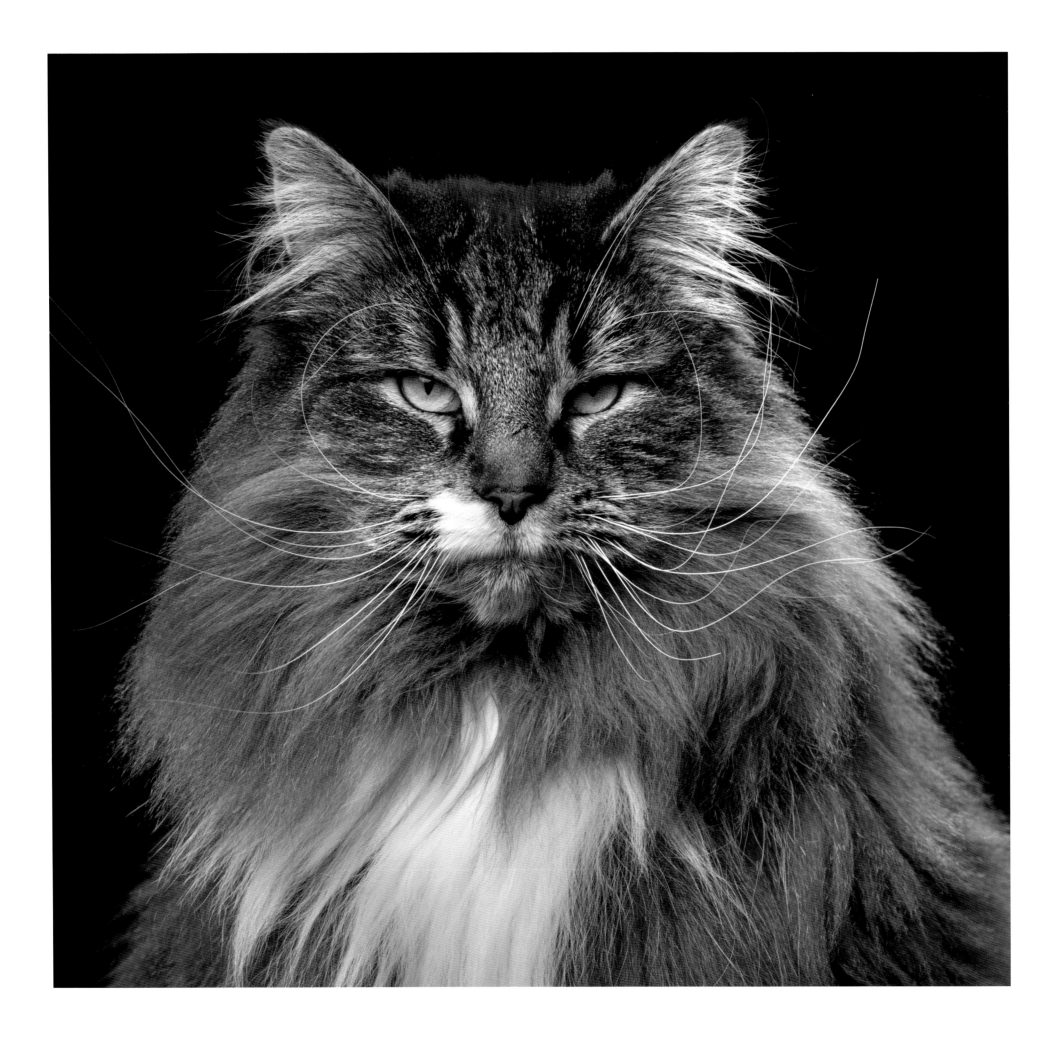

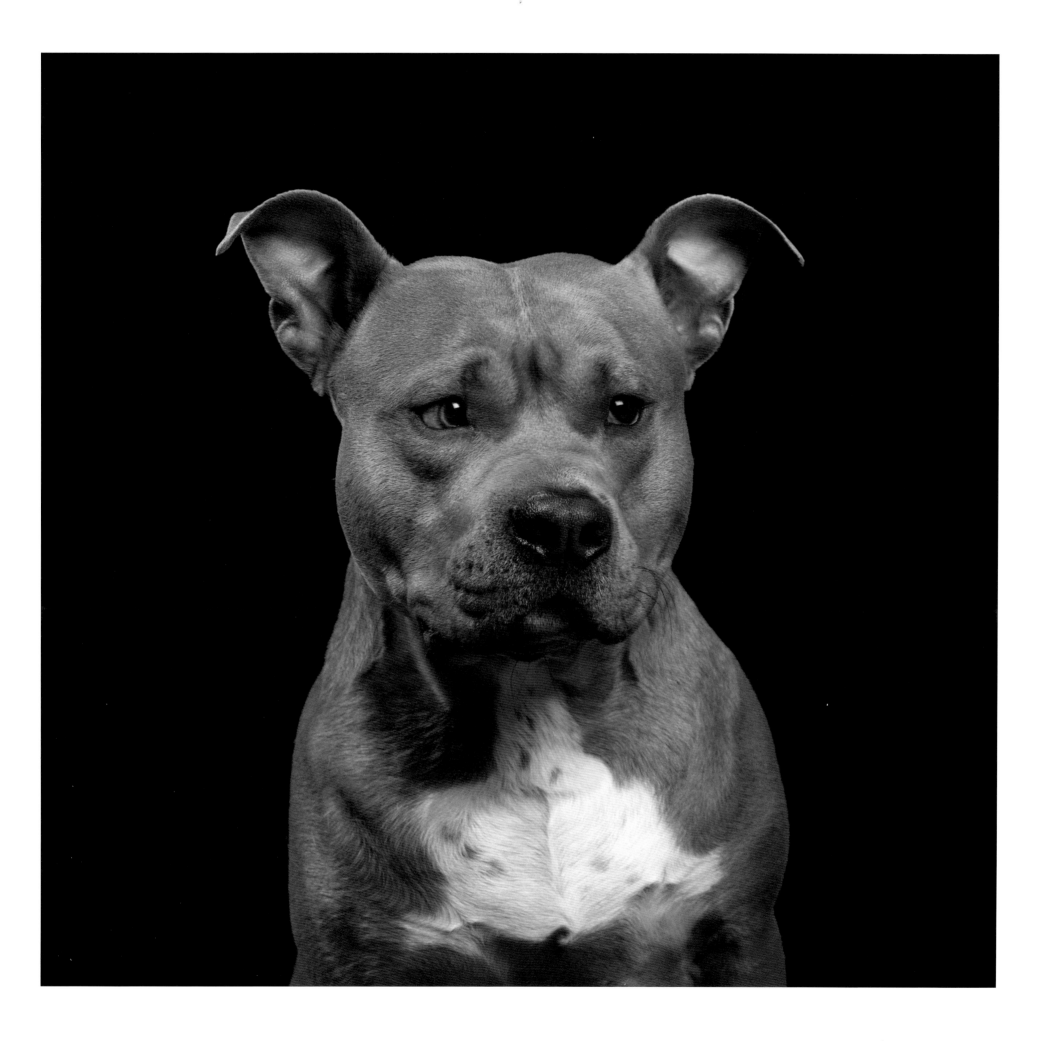

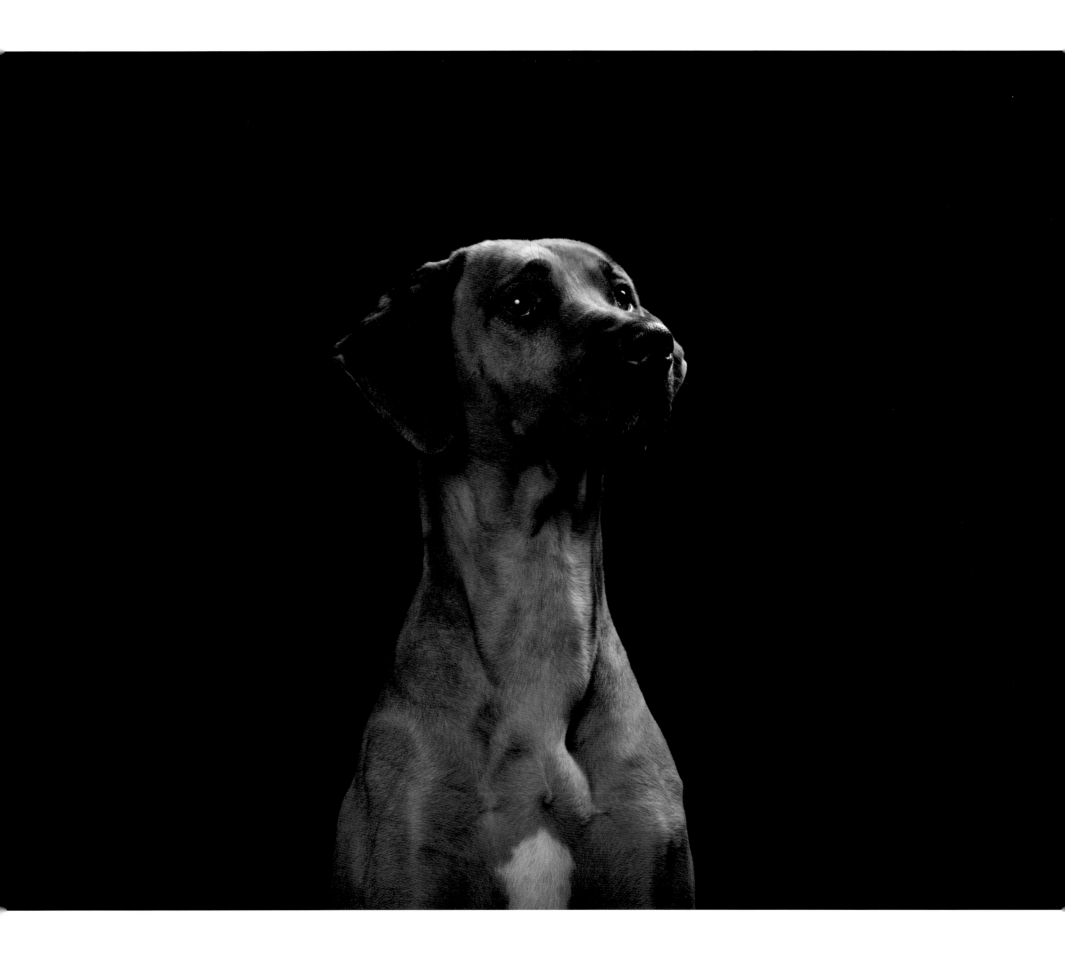

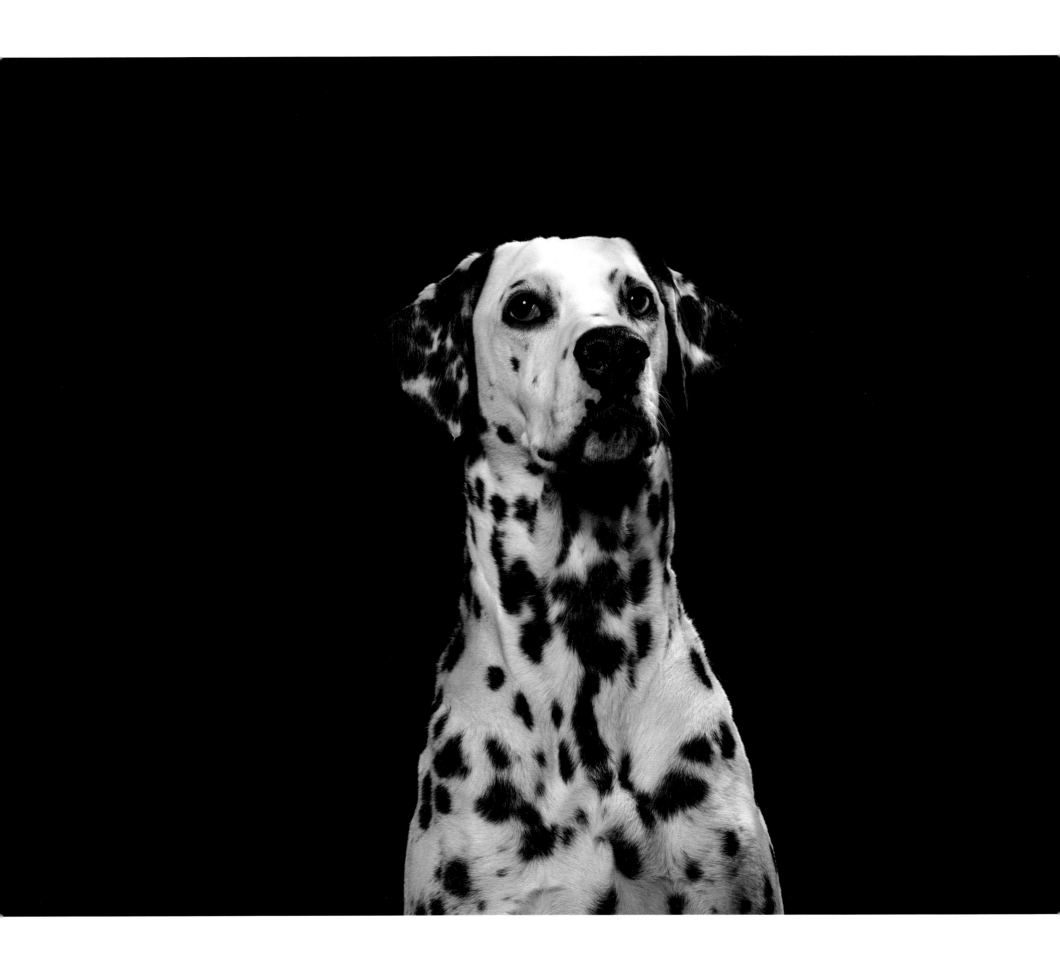

"A cat has absolute emotional honesty: human beings, for one reason or another, may hide their feelings, but a cat does not."

Ernest Hemingway

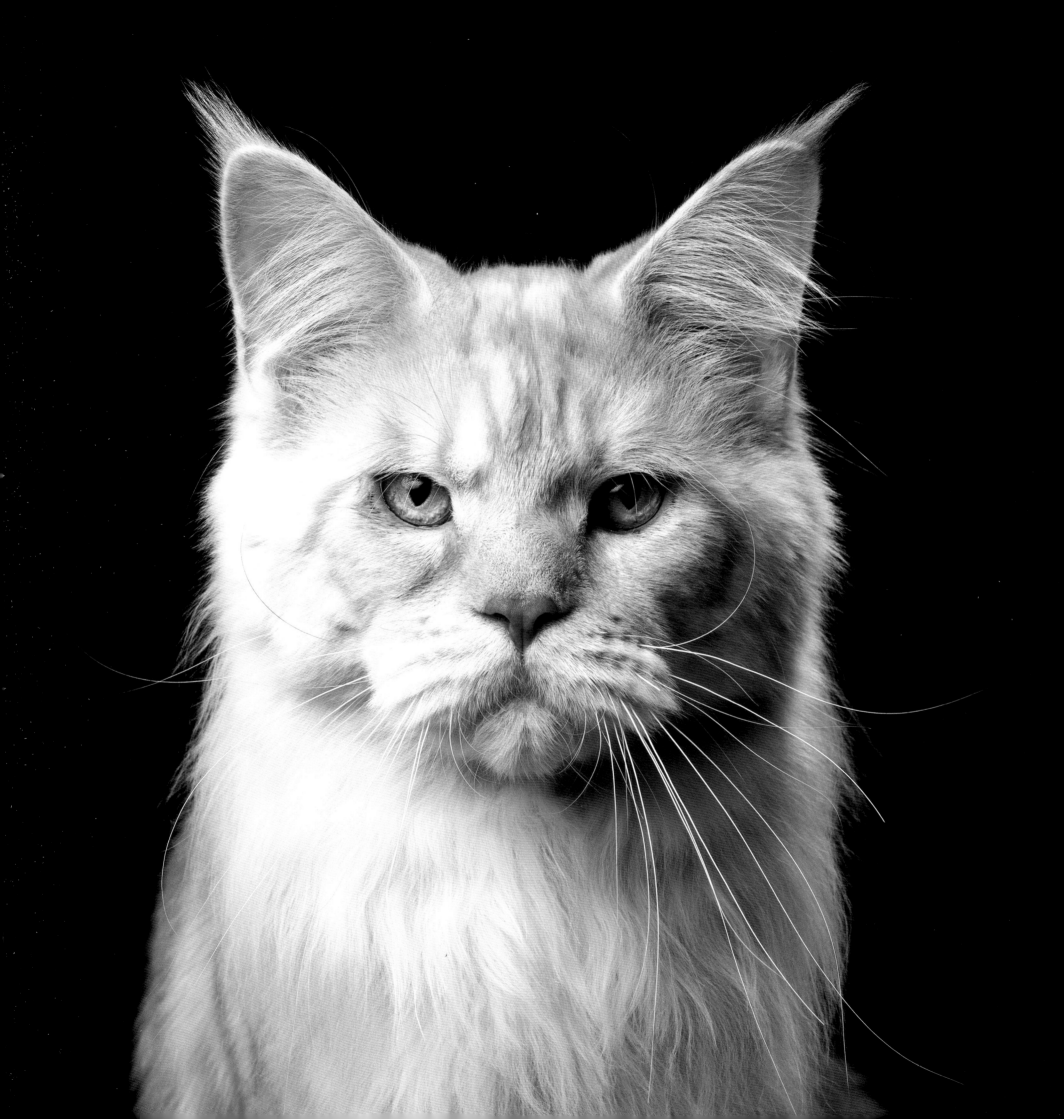

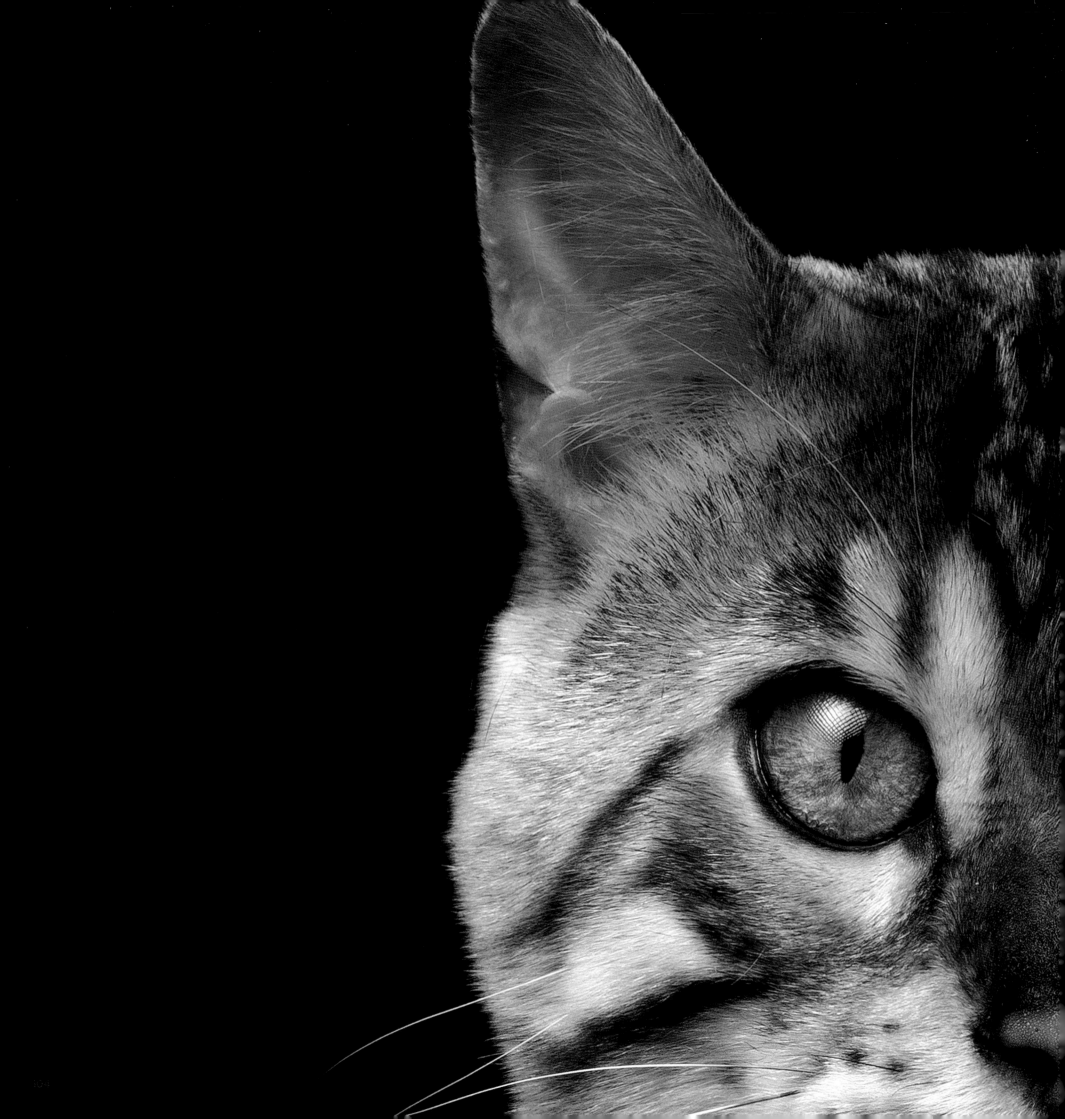

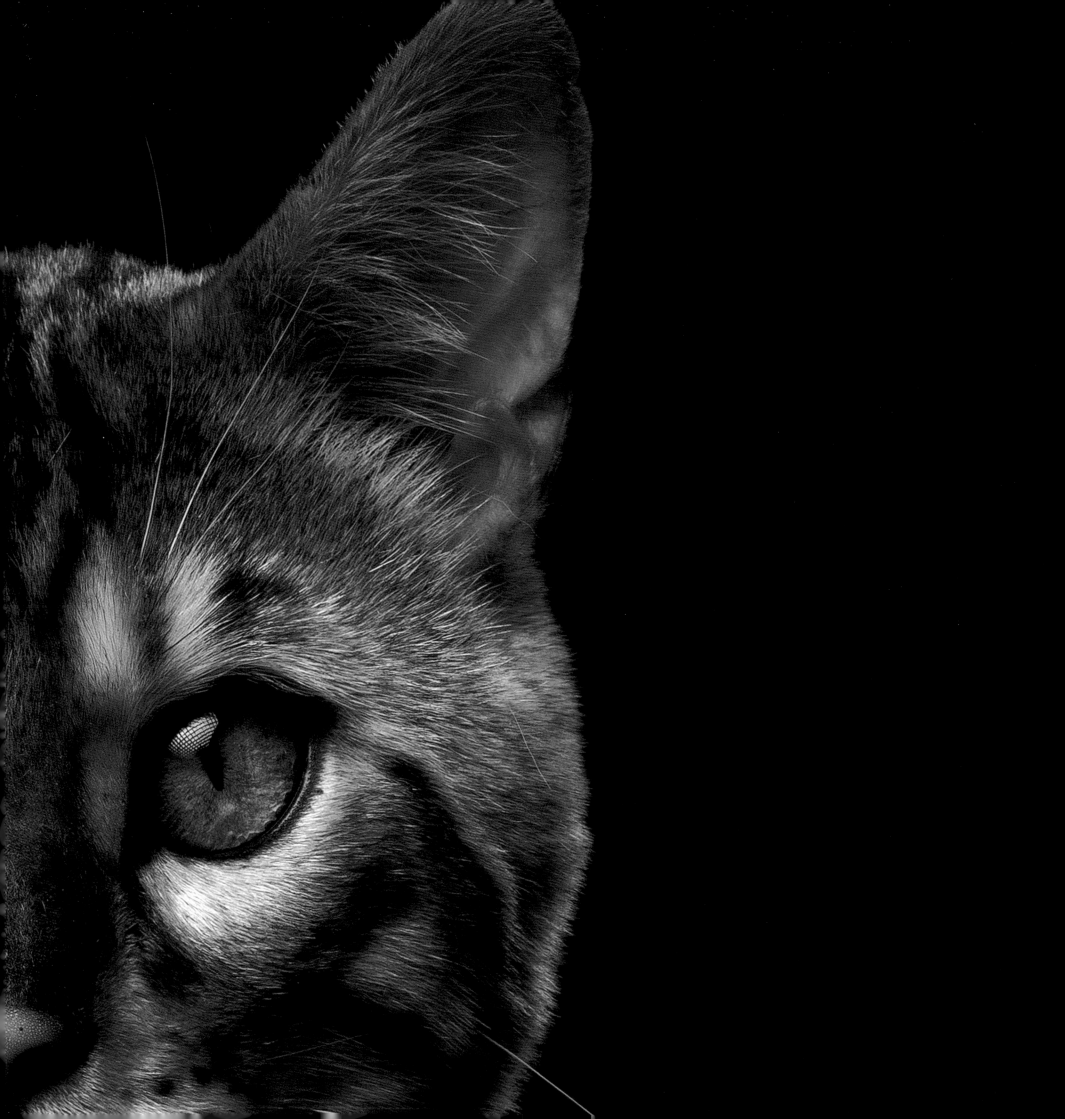

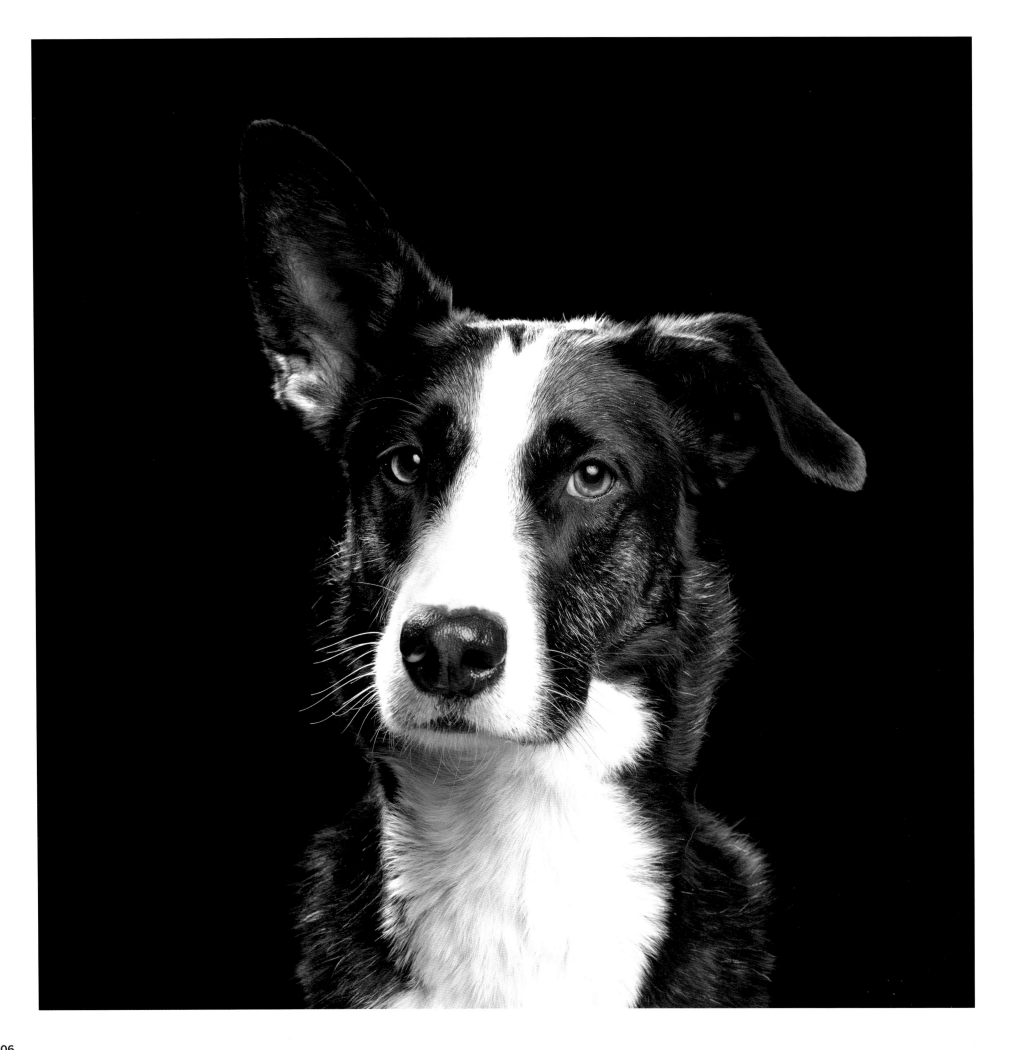

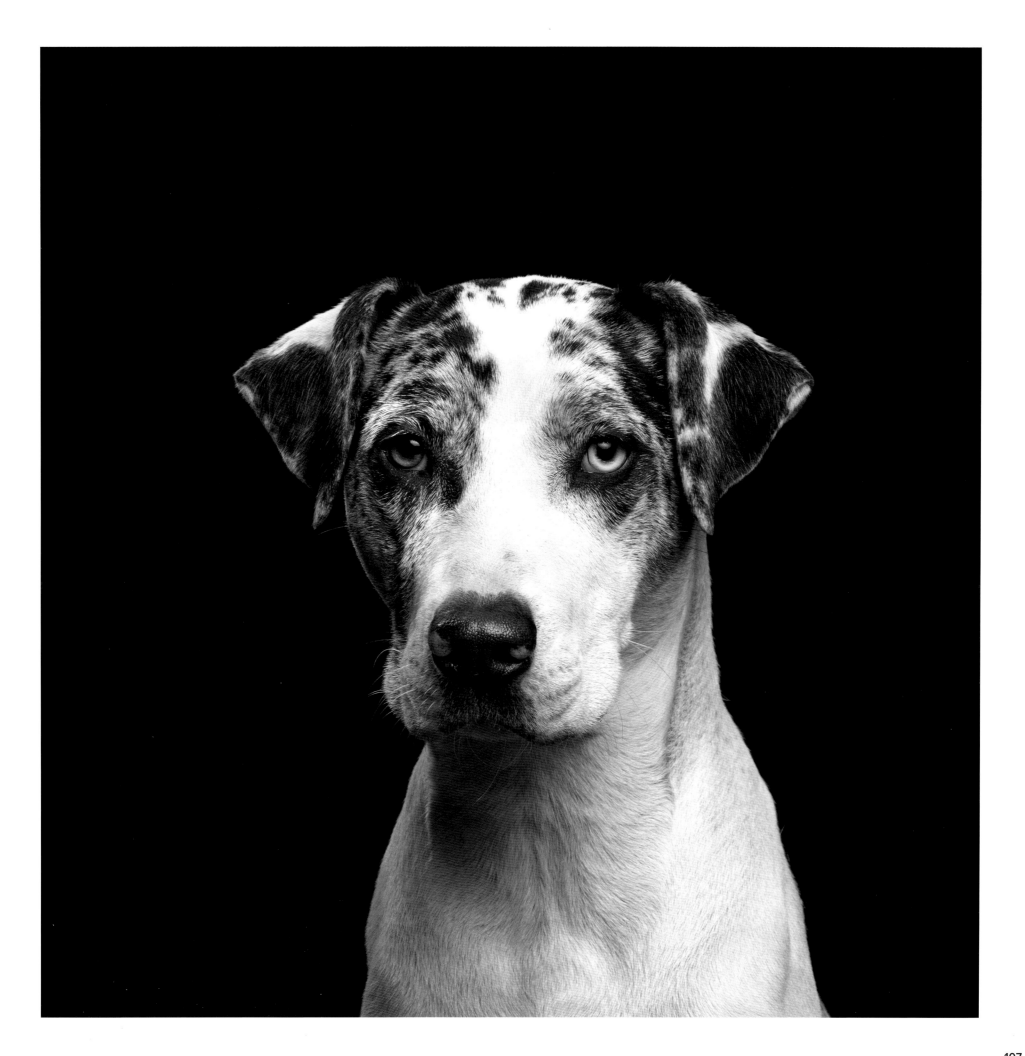

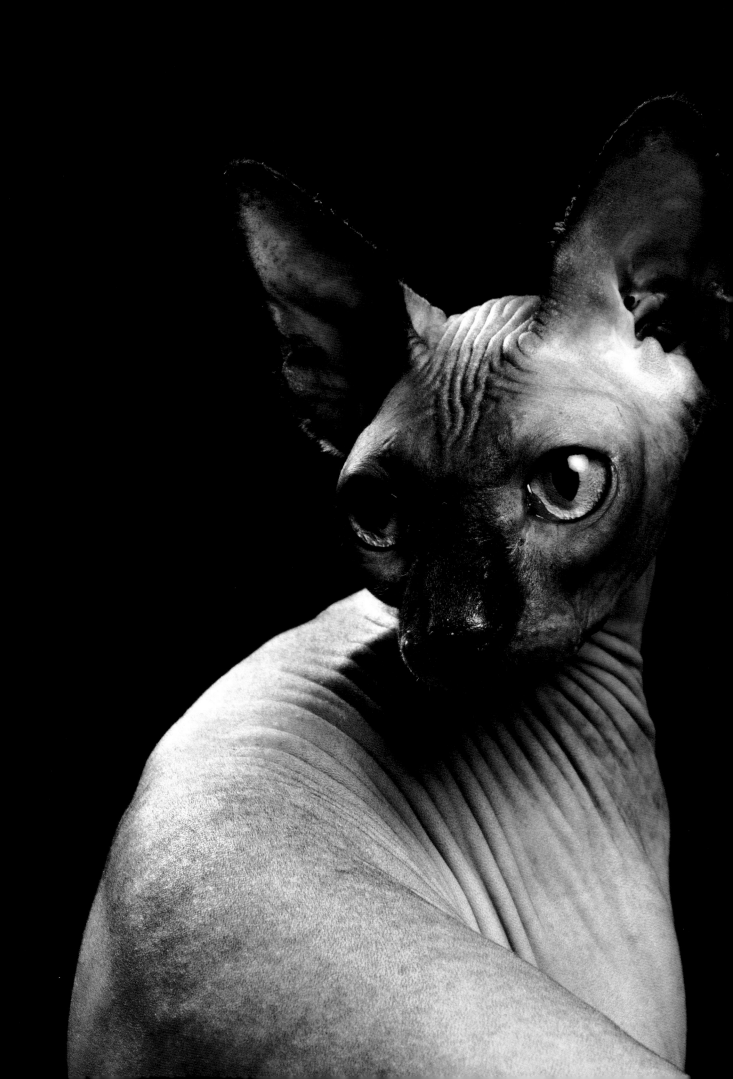

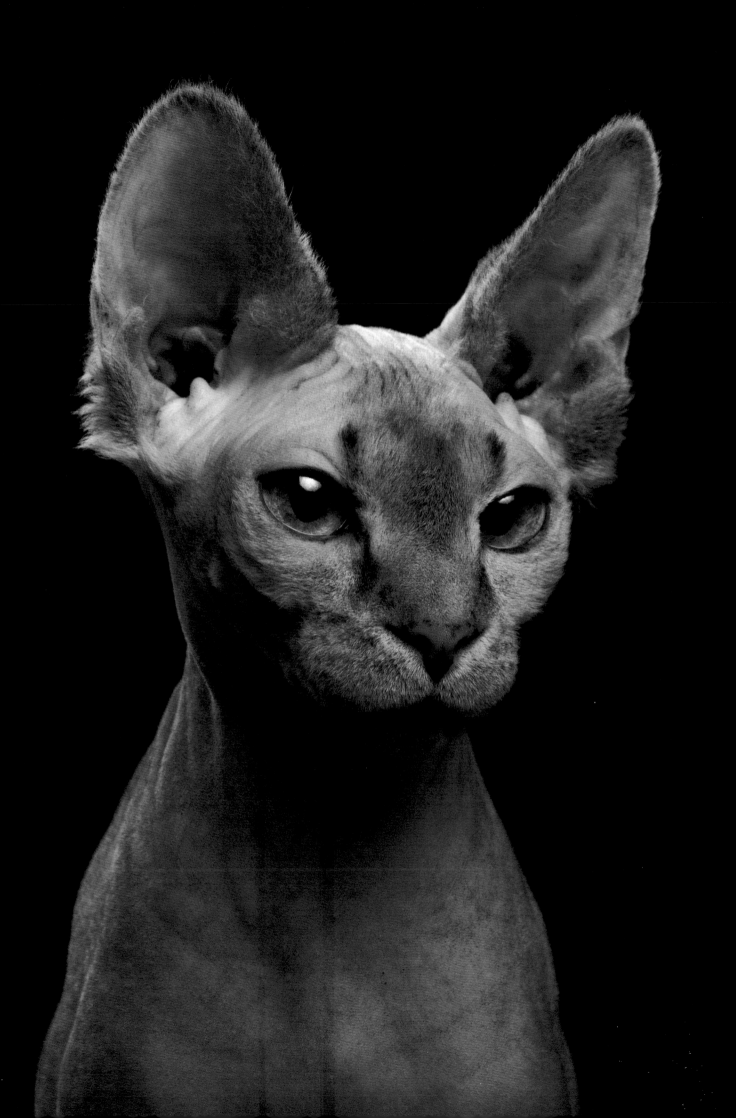

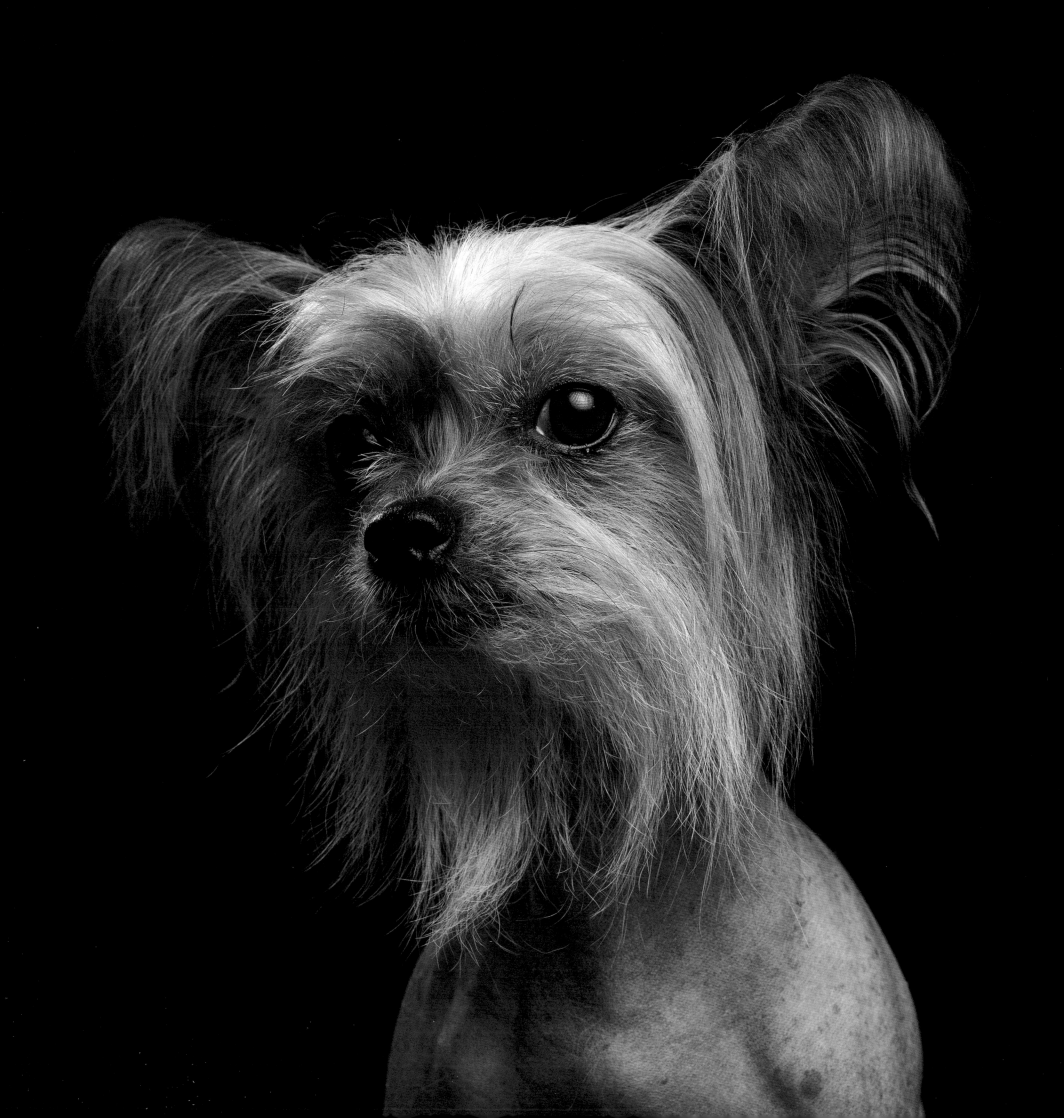

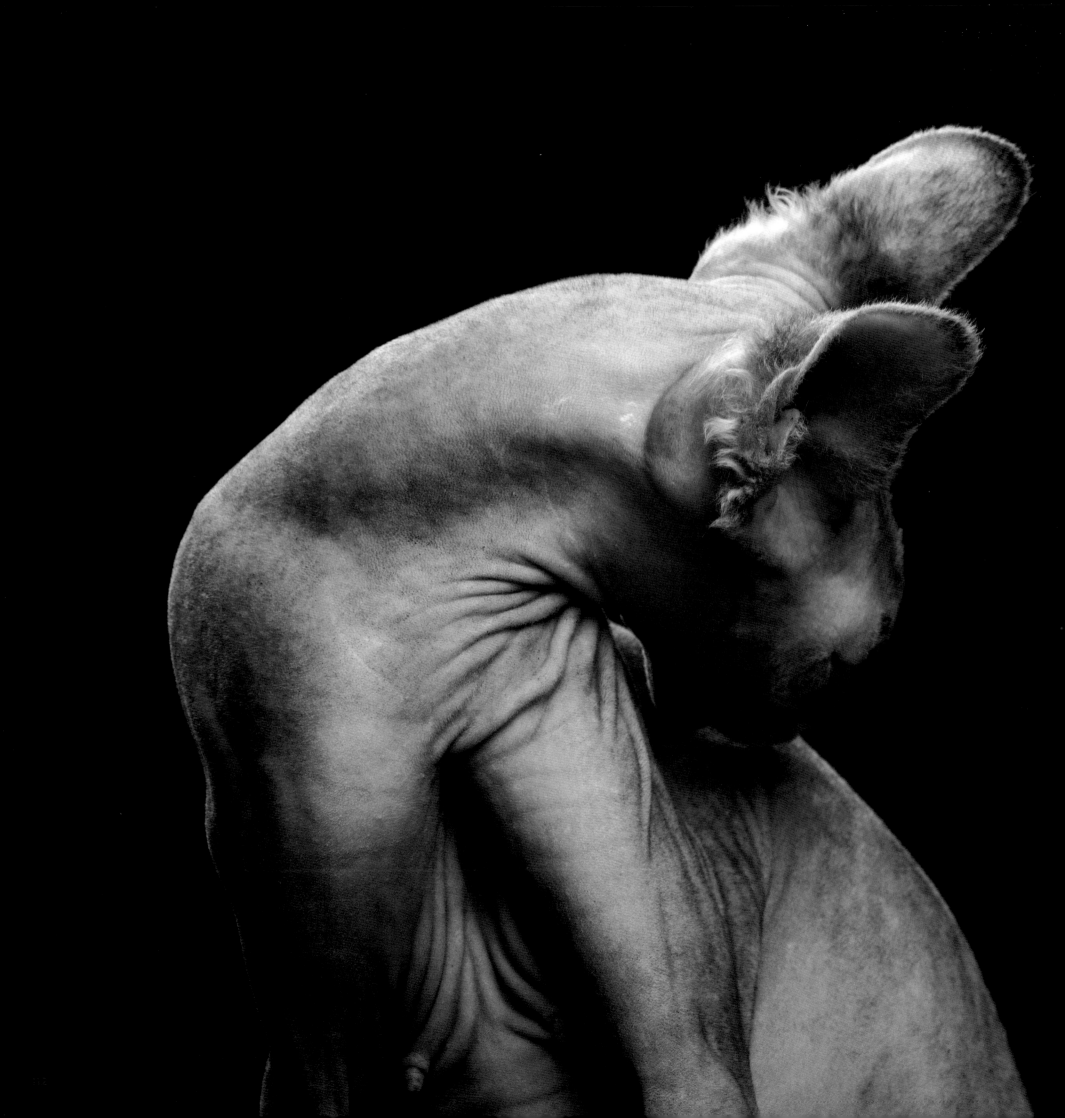

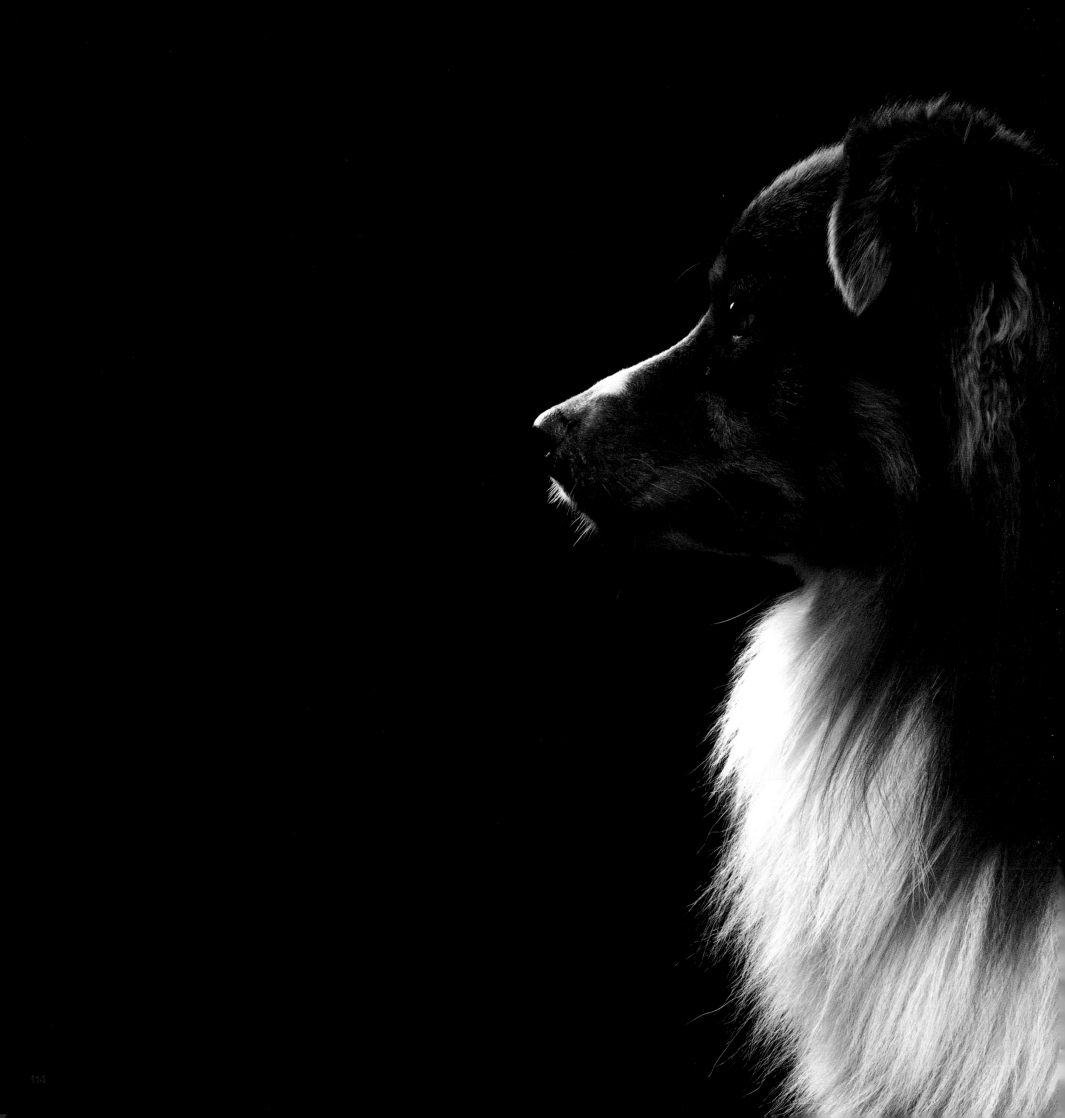

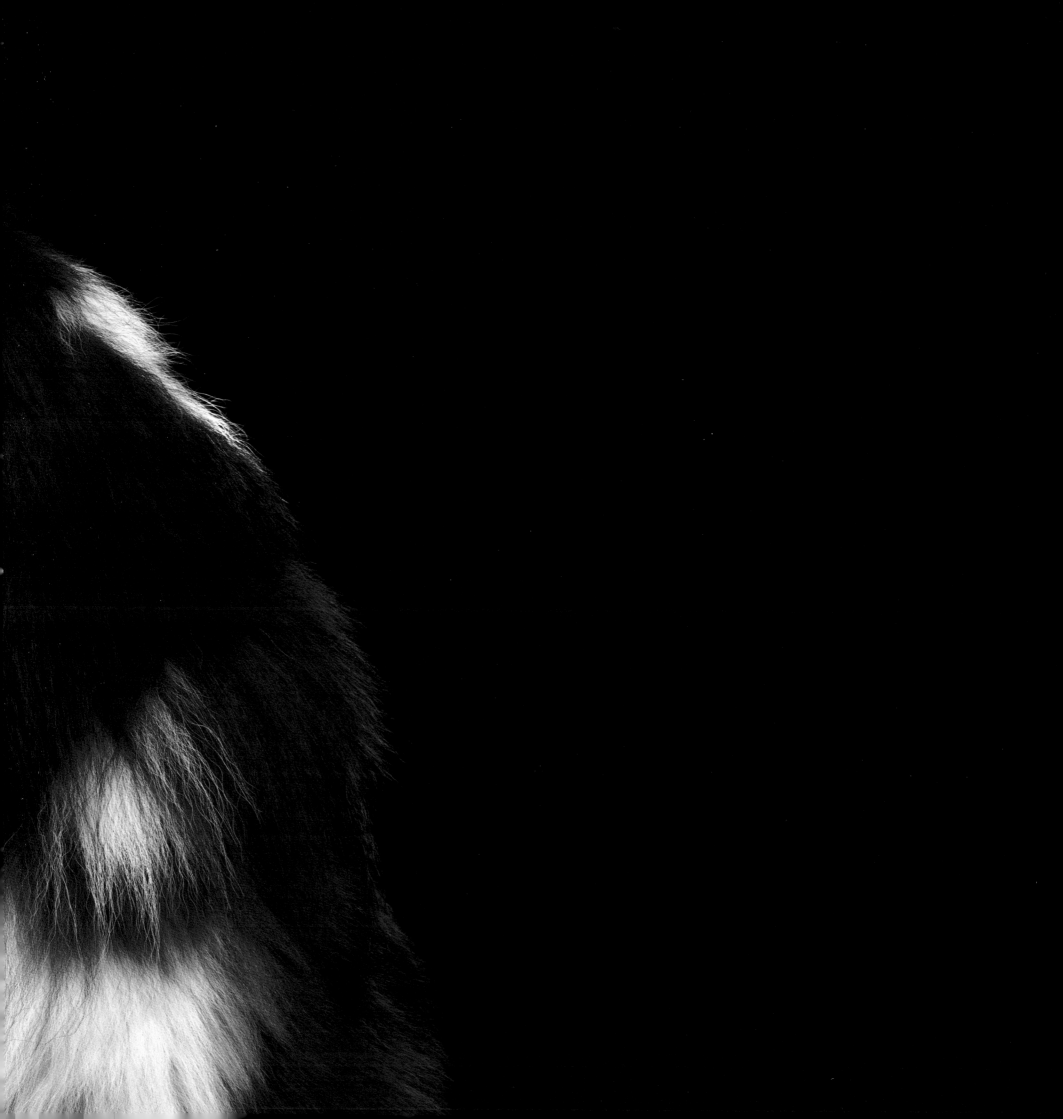

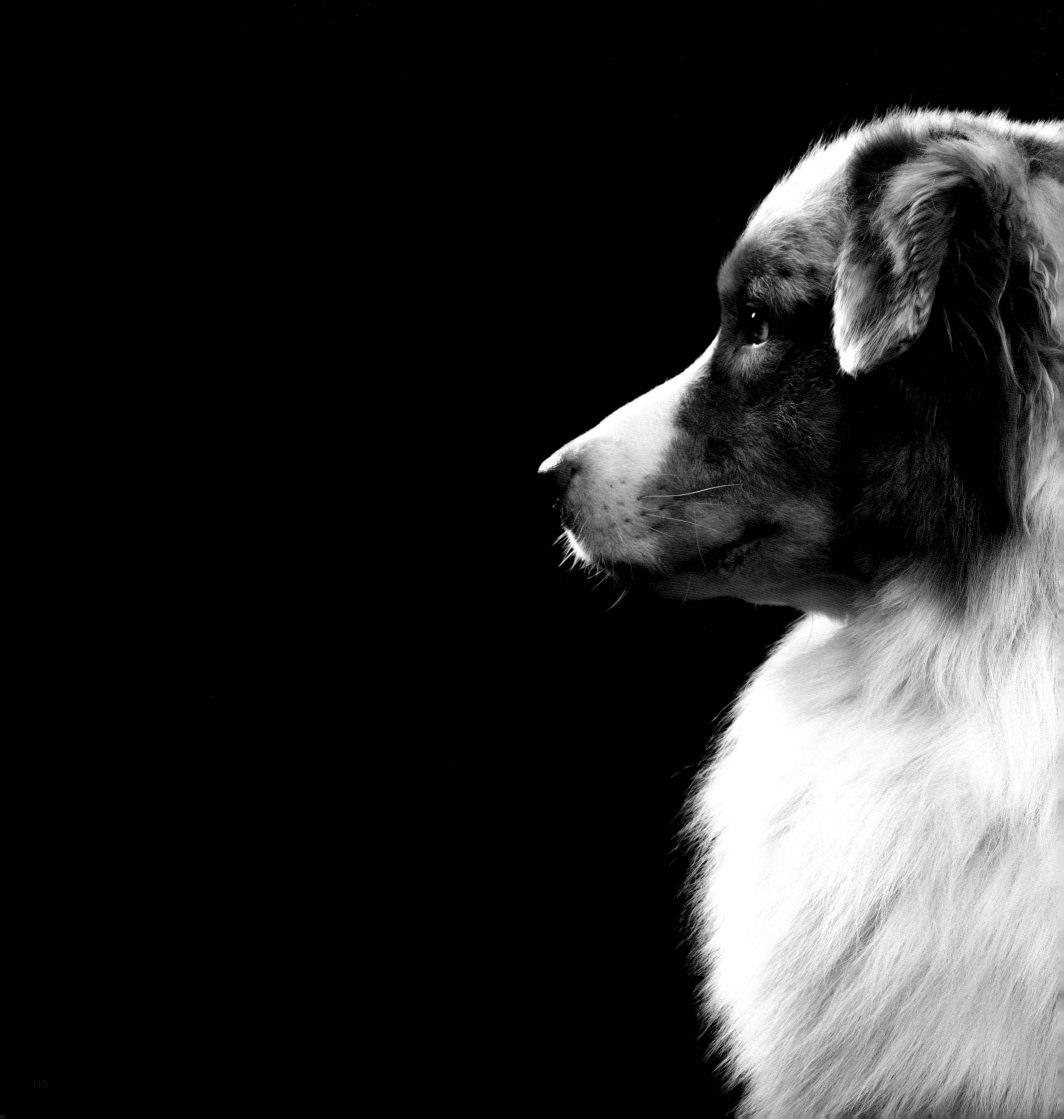

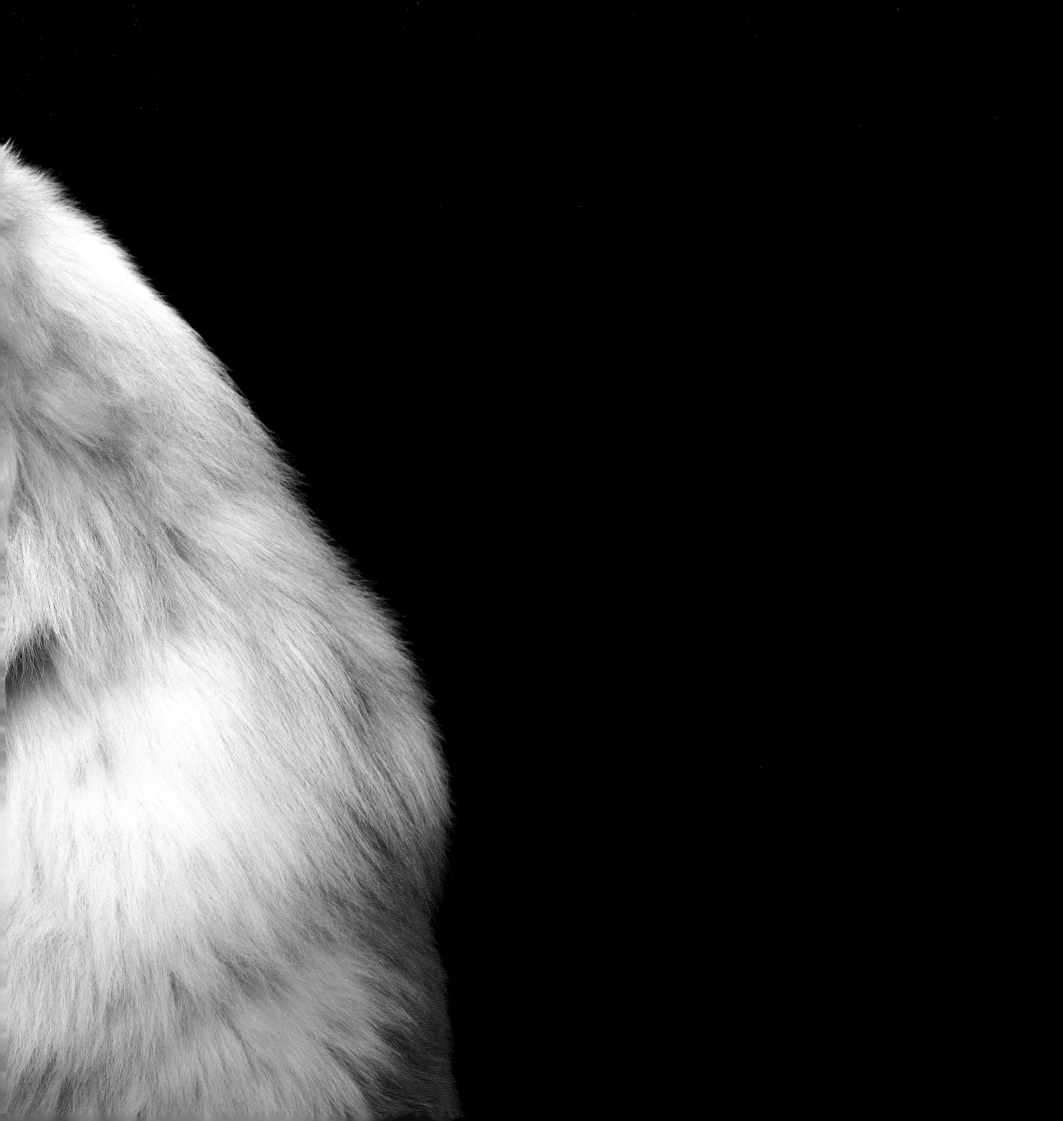

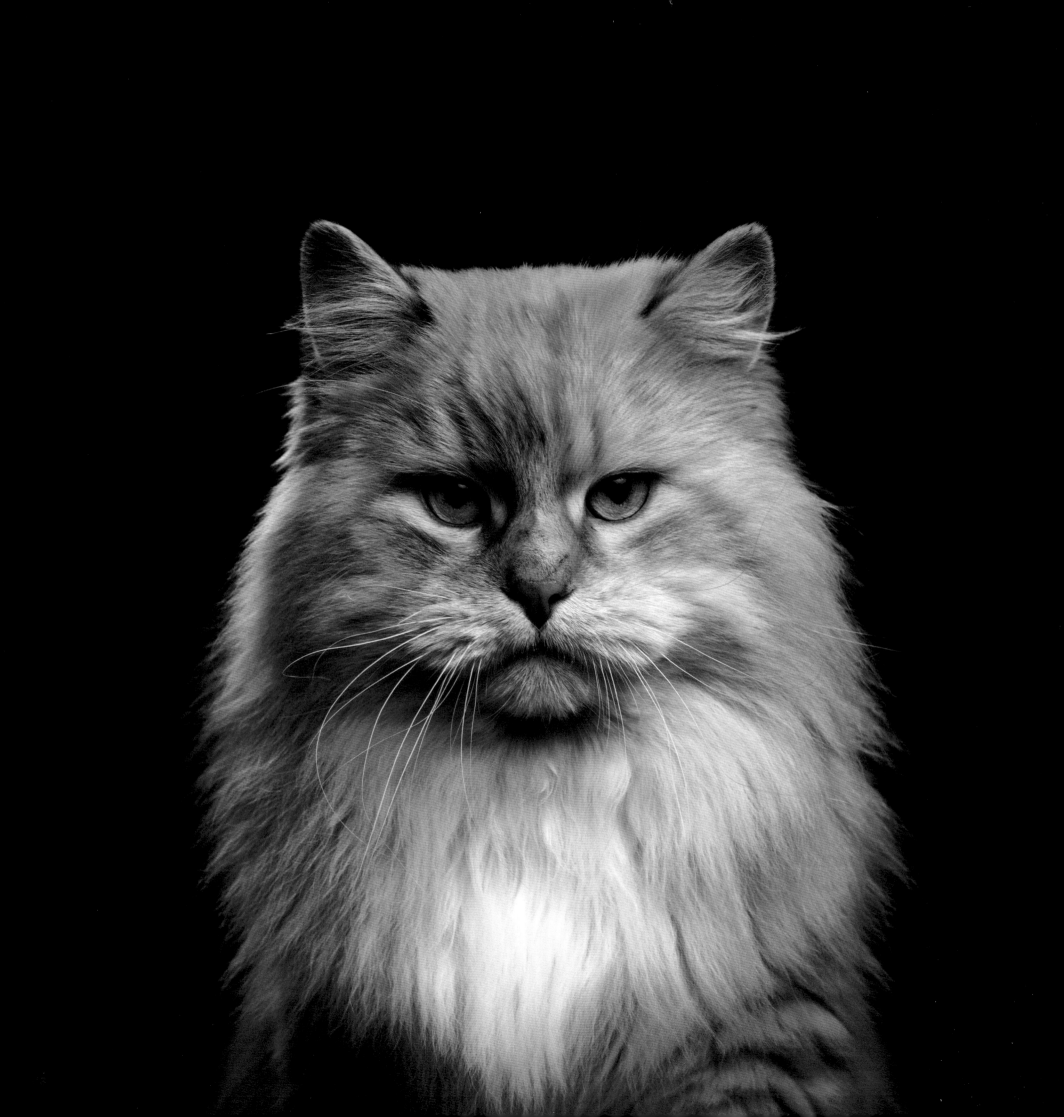

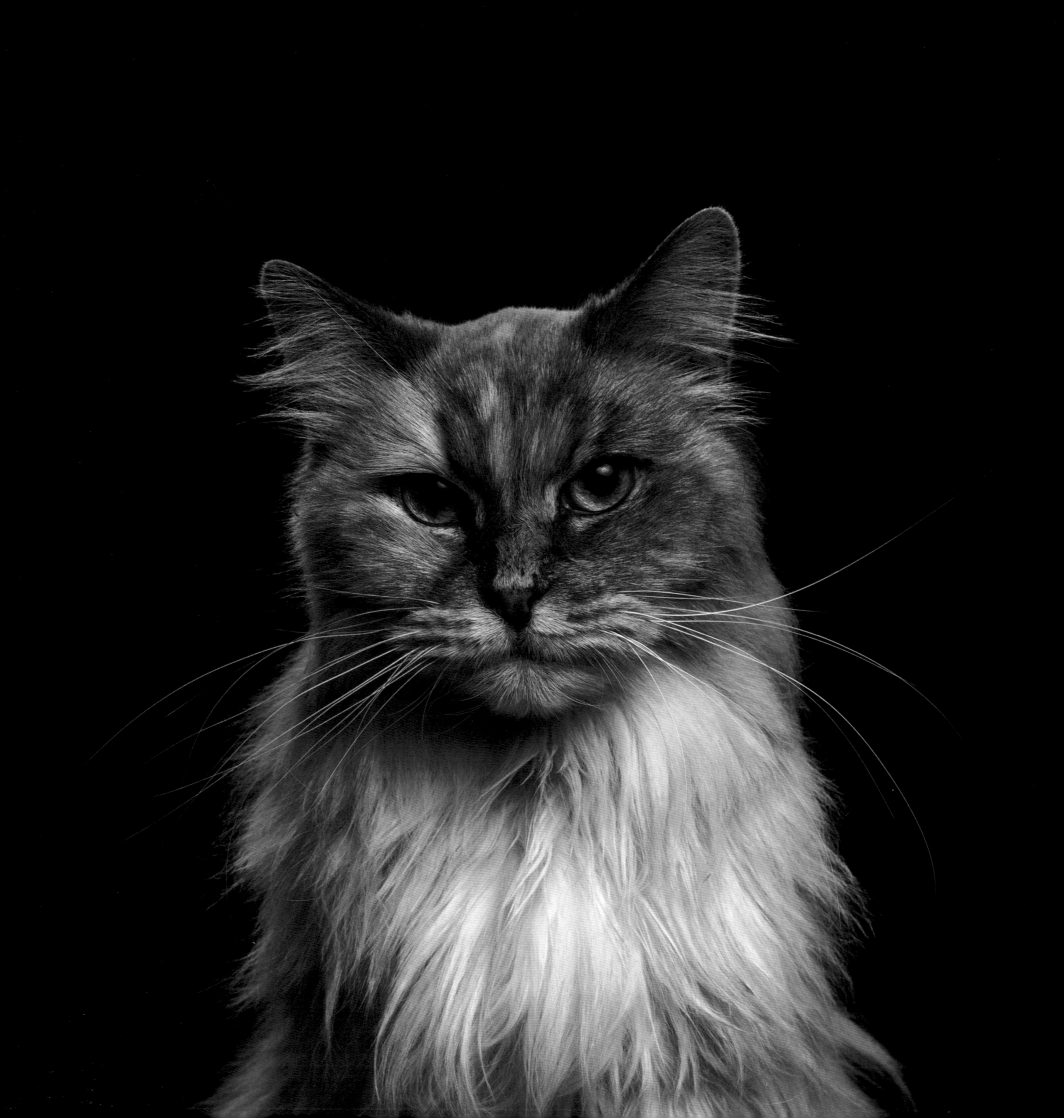

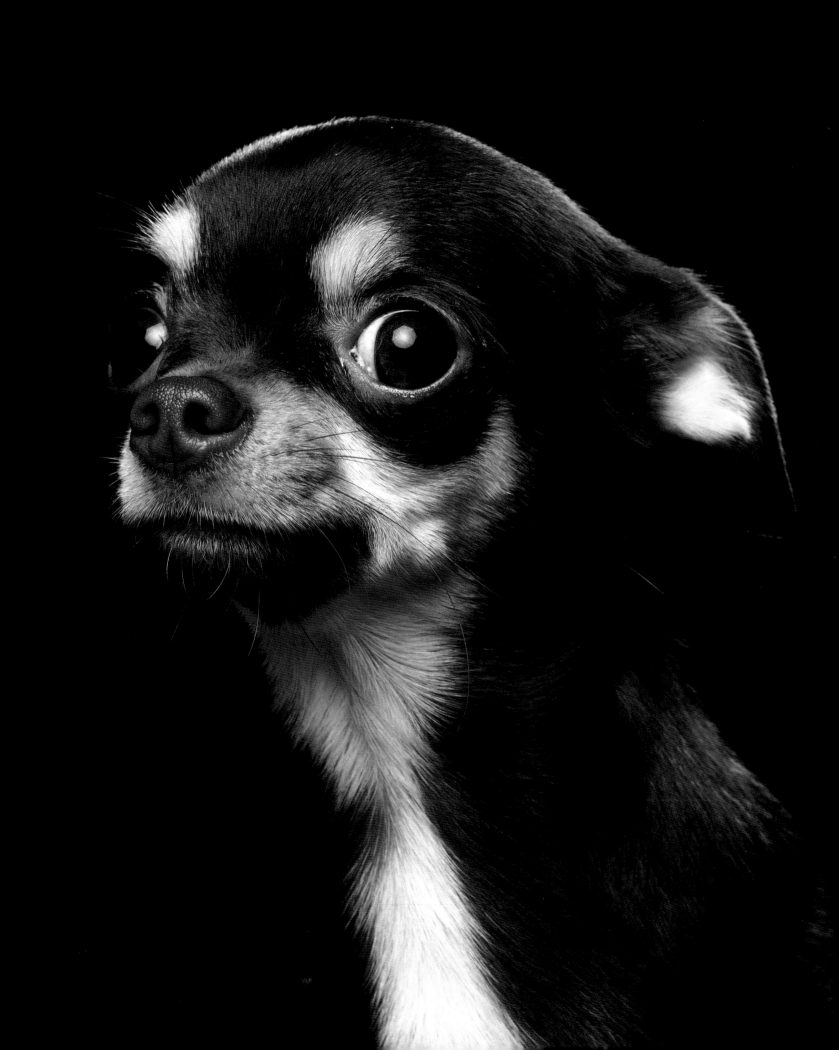

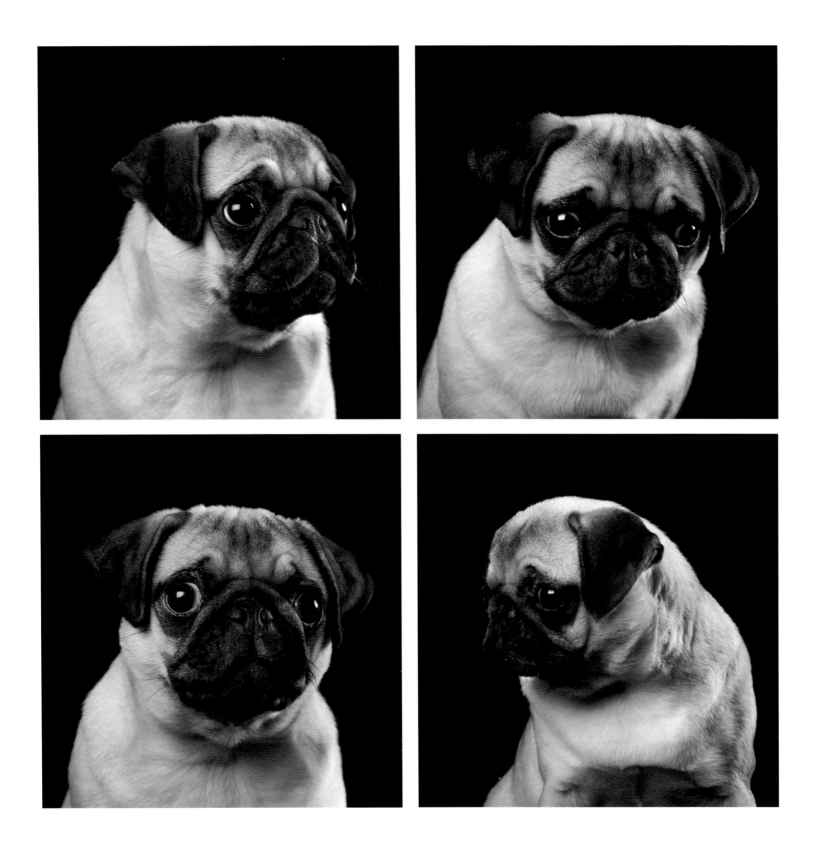

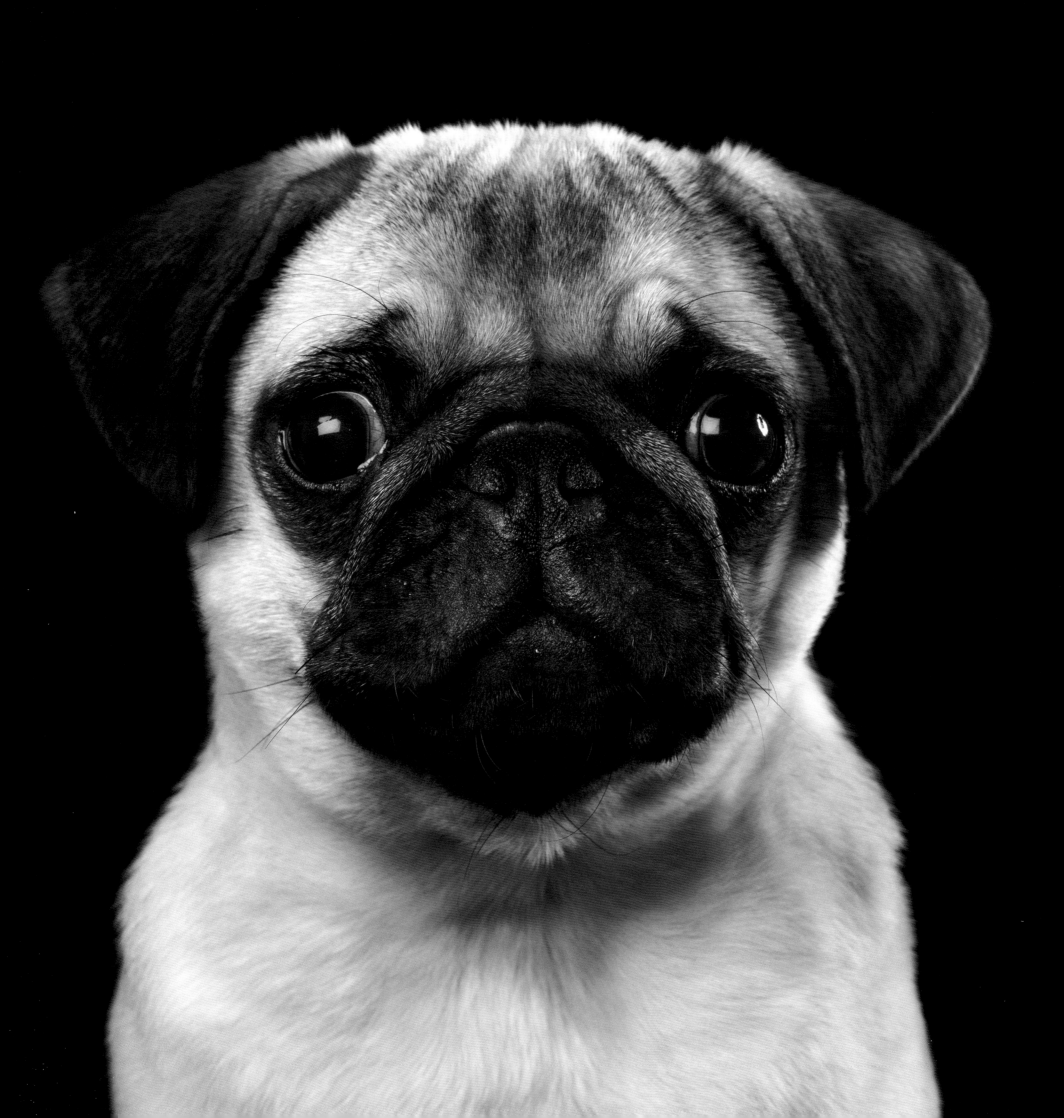

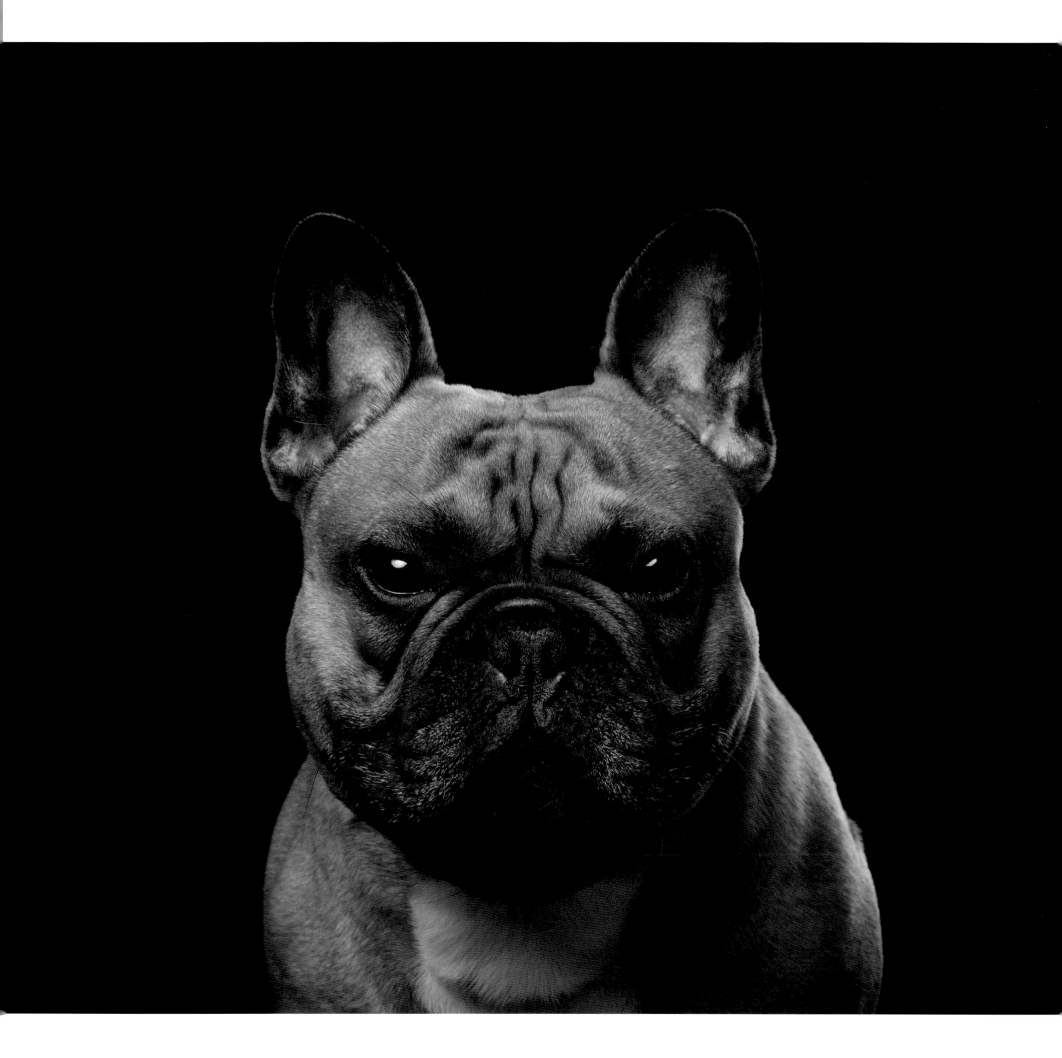

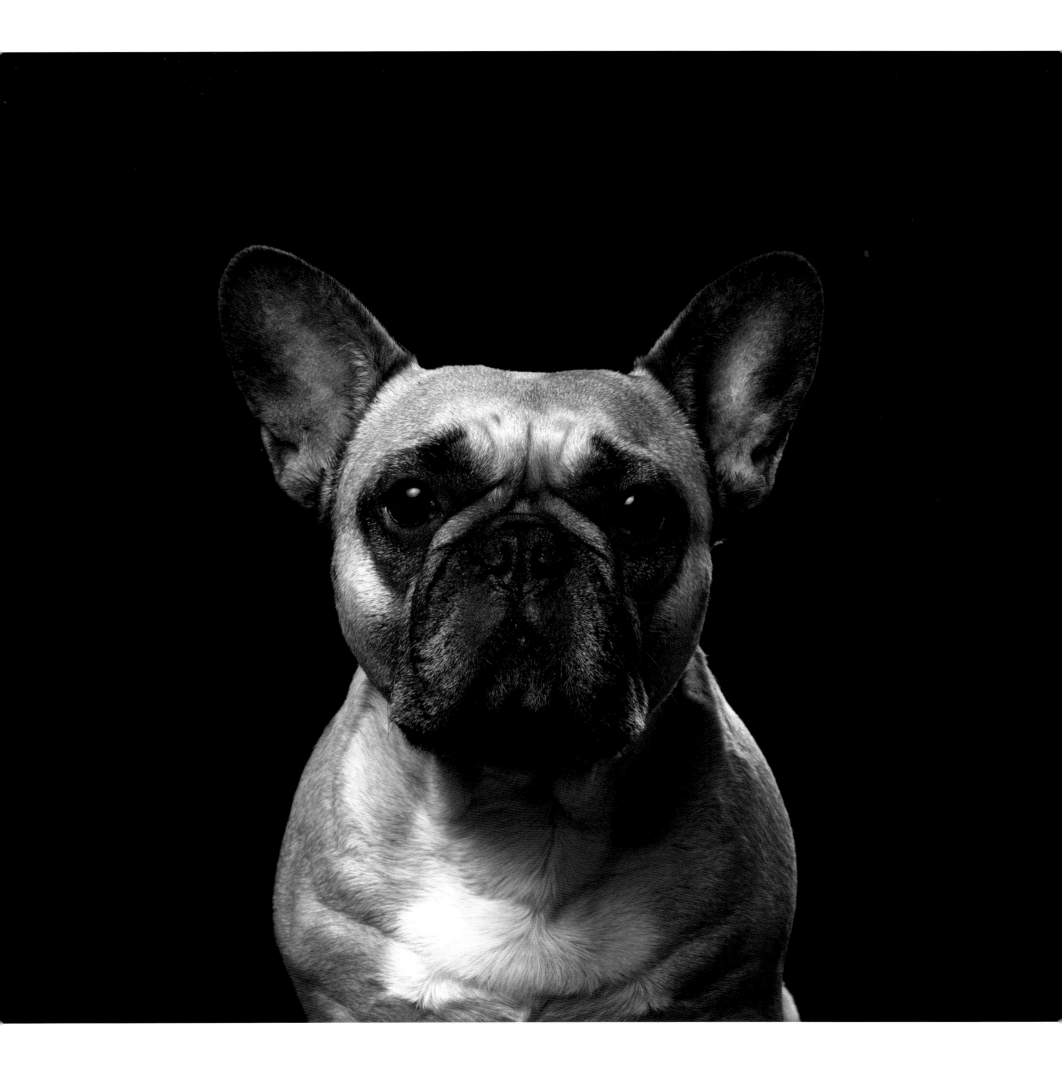

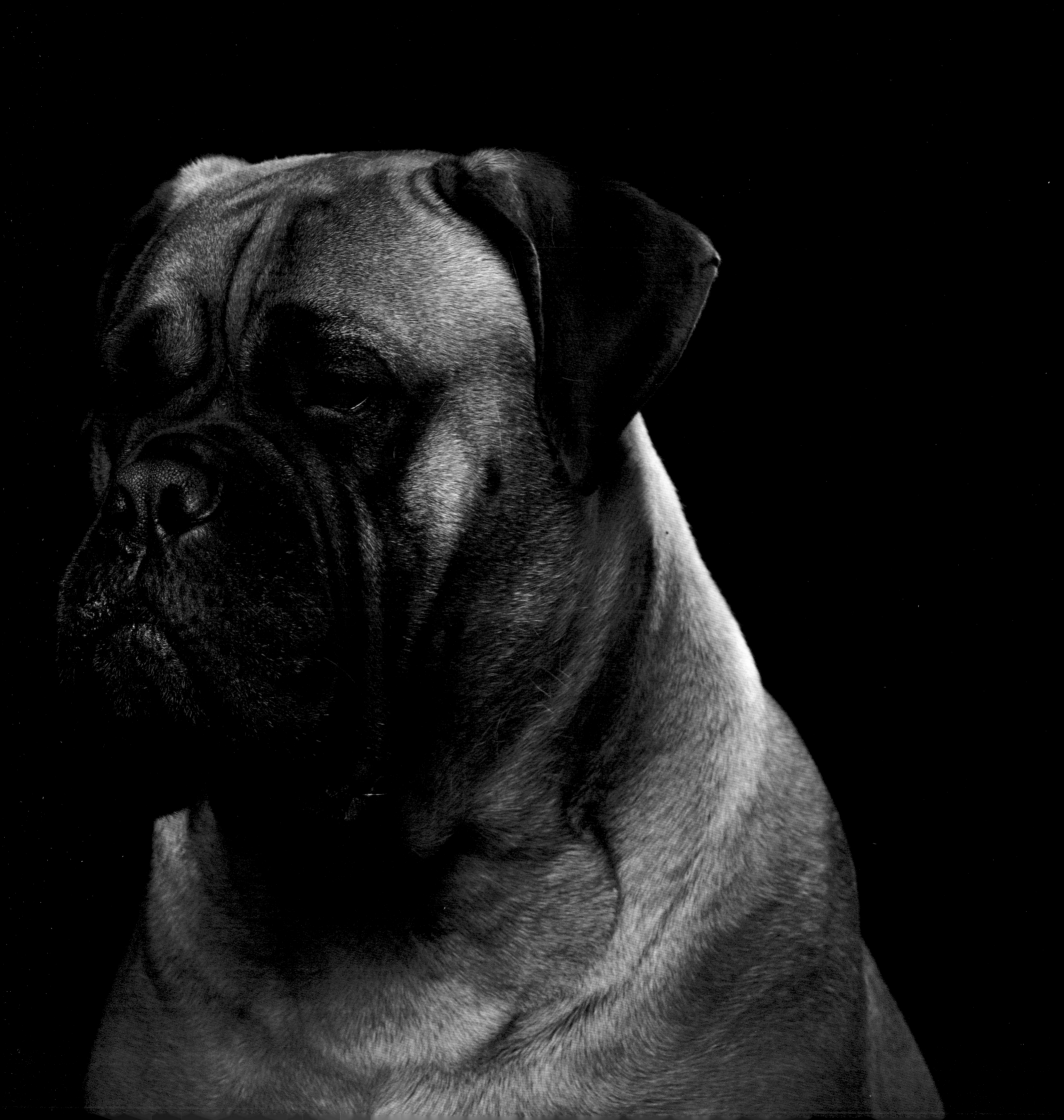

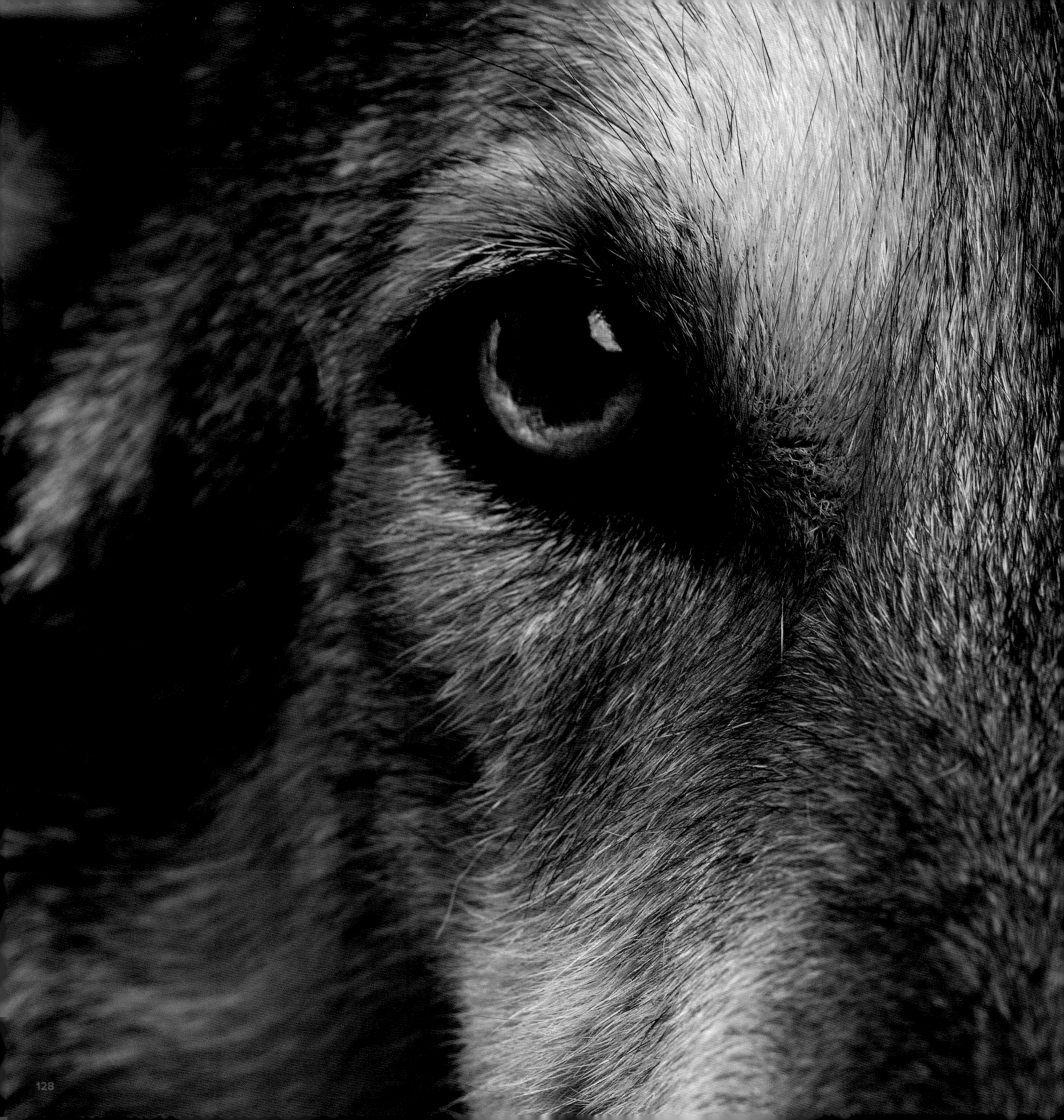

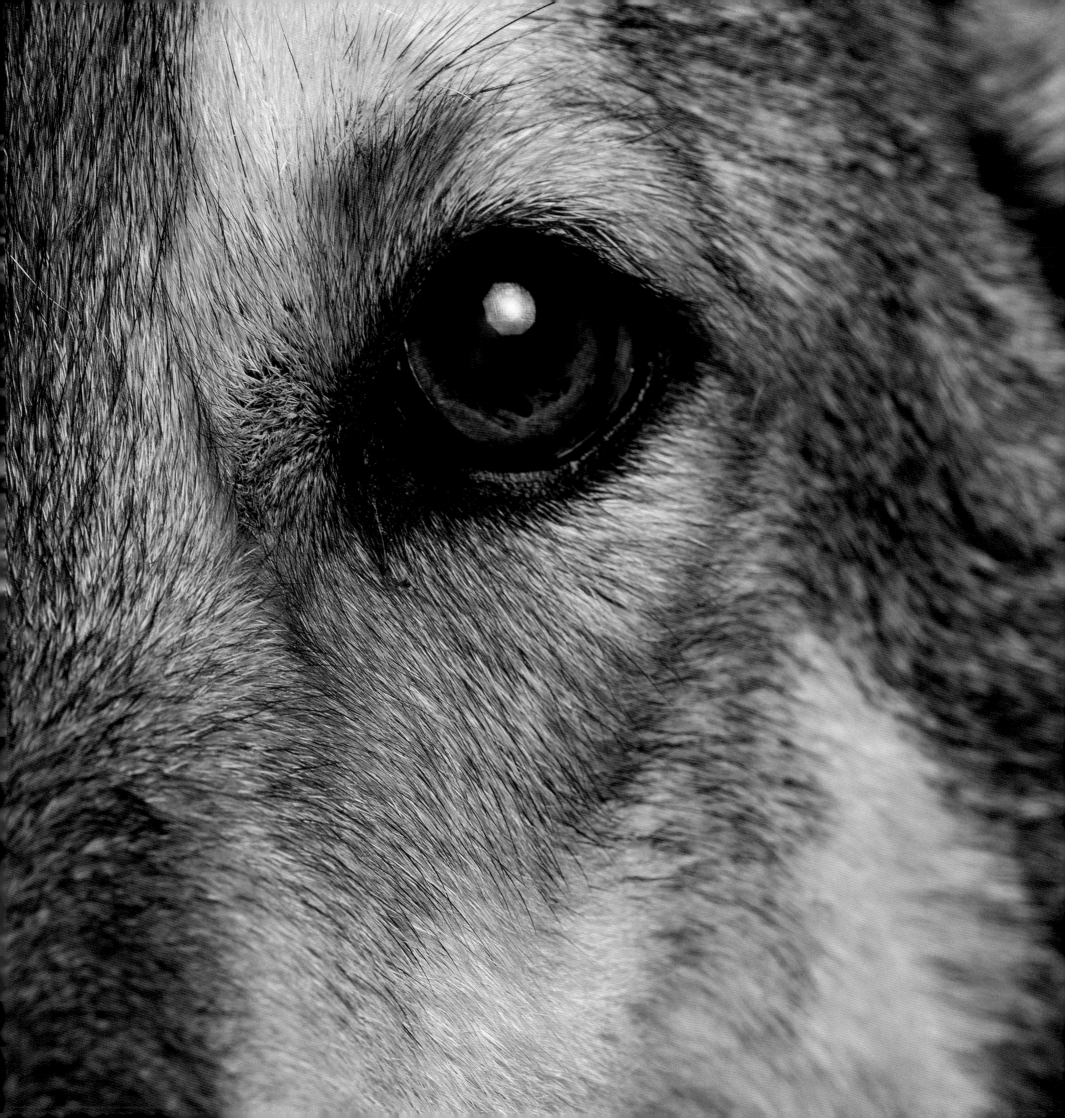

"After scolding one's cat one looks into its face and is seized by the ugly suspicion that it understood every word. And has filed it for reference."

Charlotte Gray

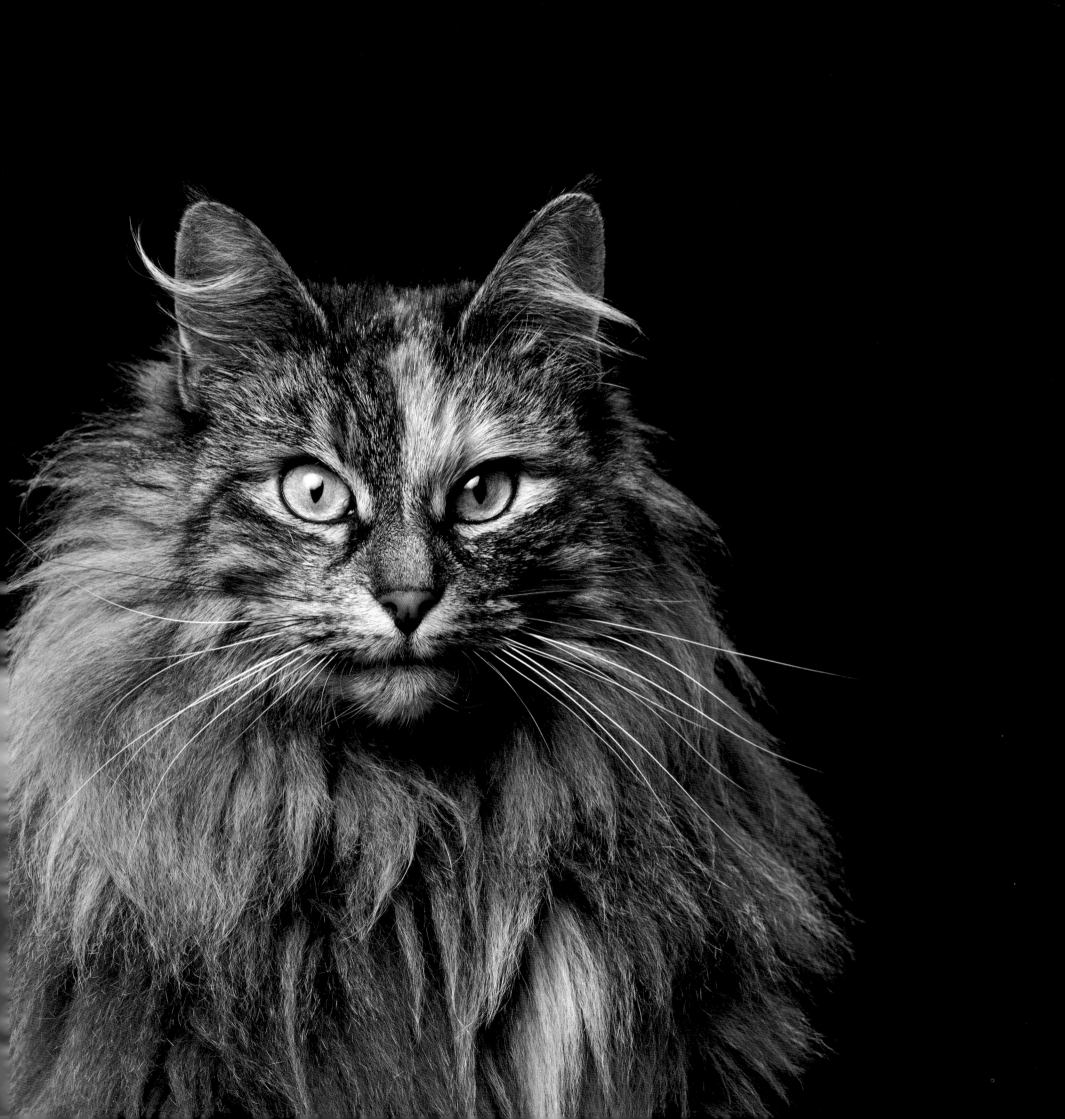

"The smallest feline is a masterpiece."

Leonardo da Vinci

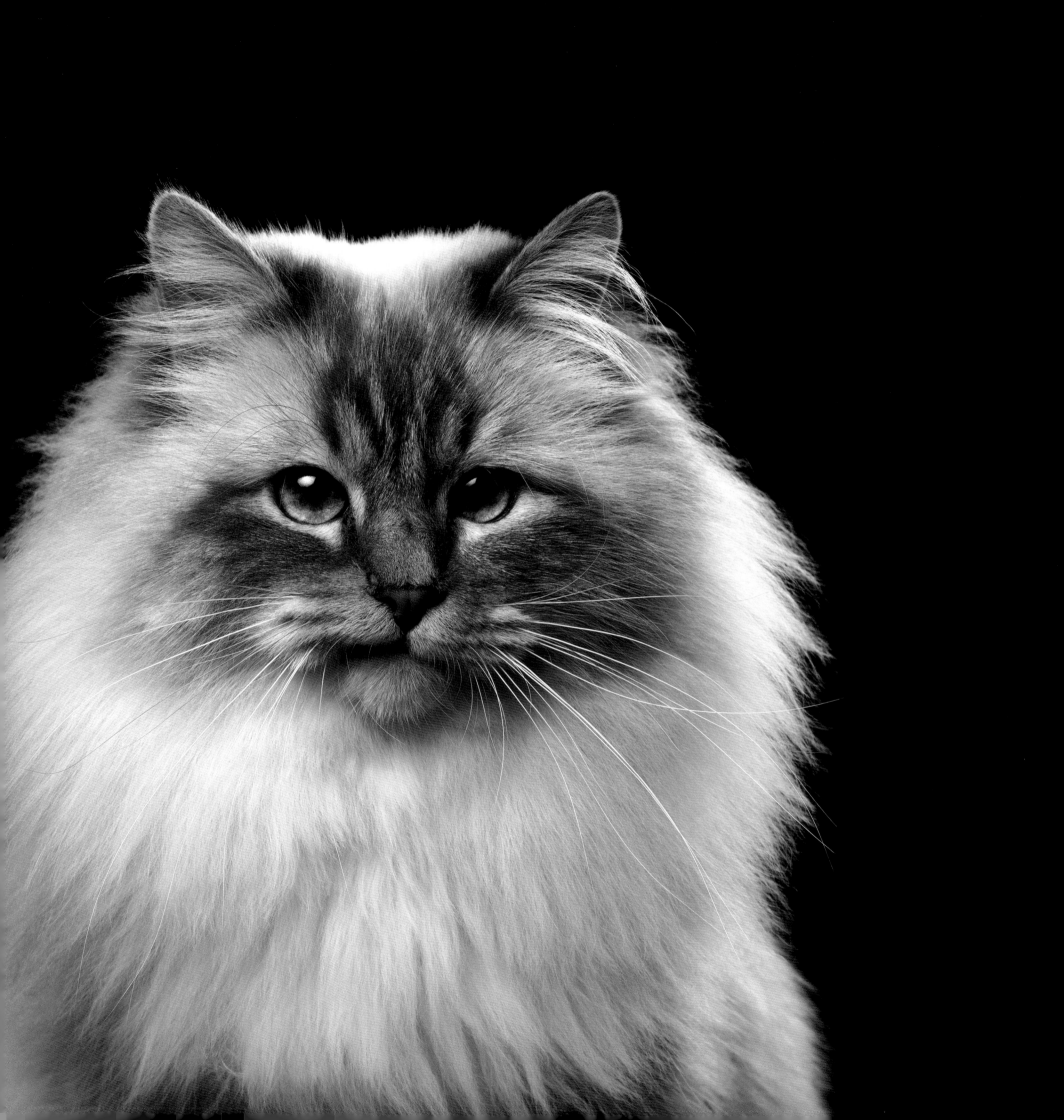

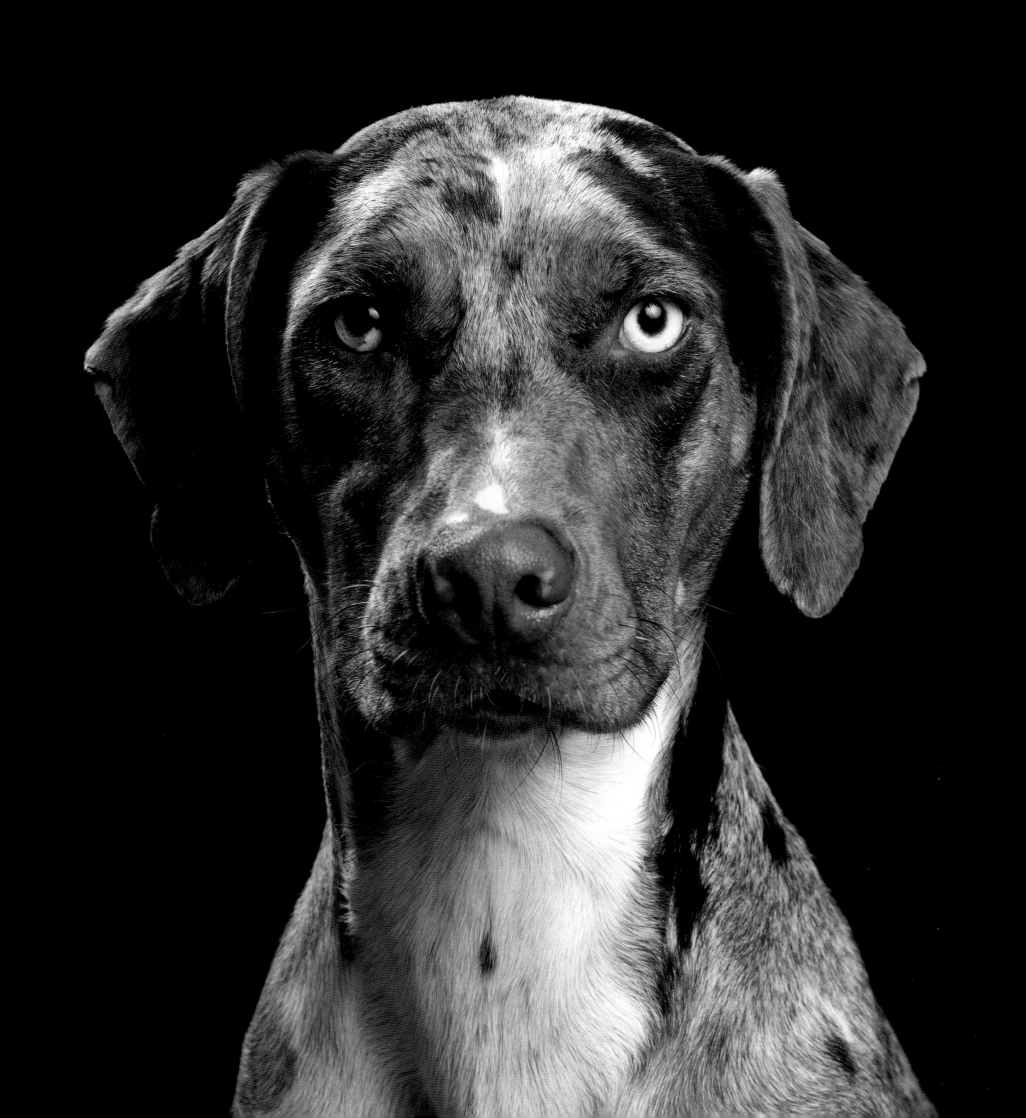

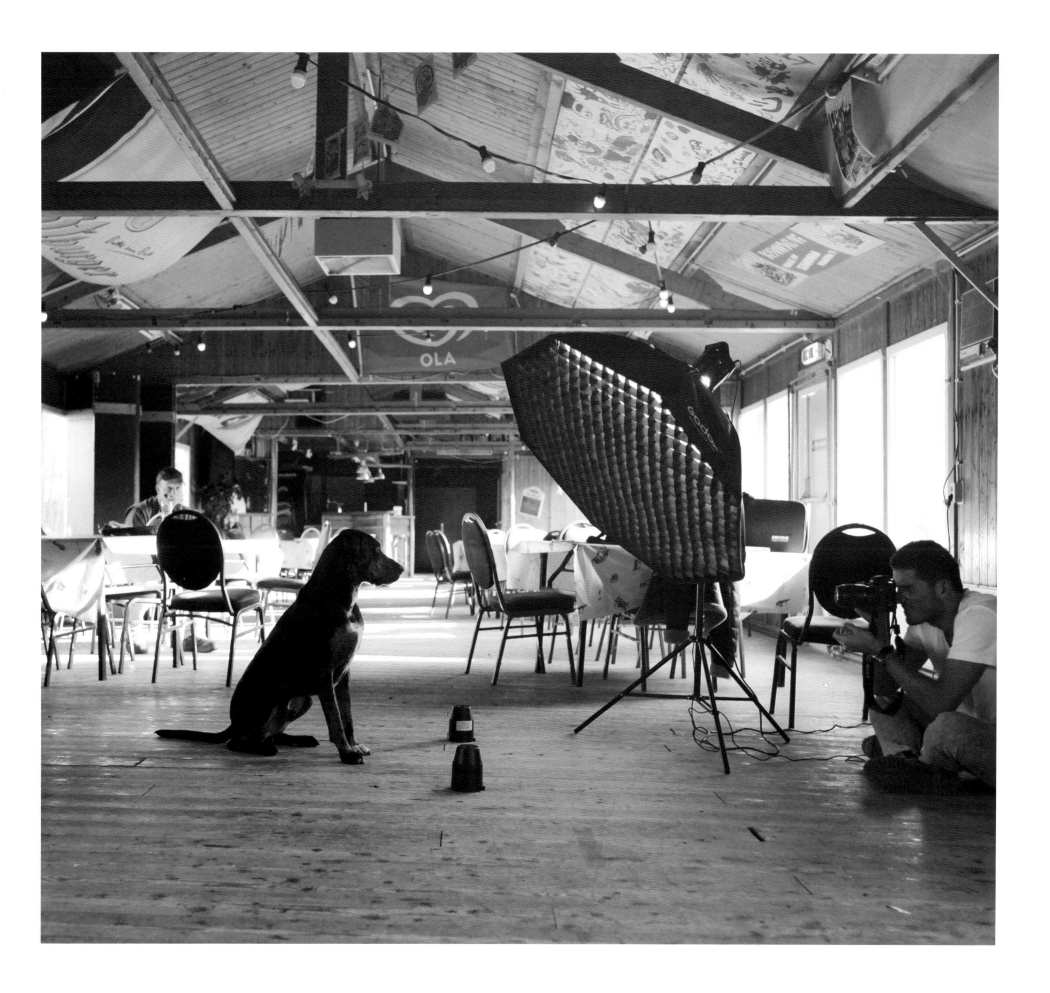

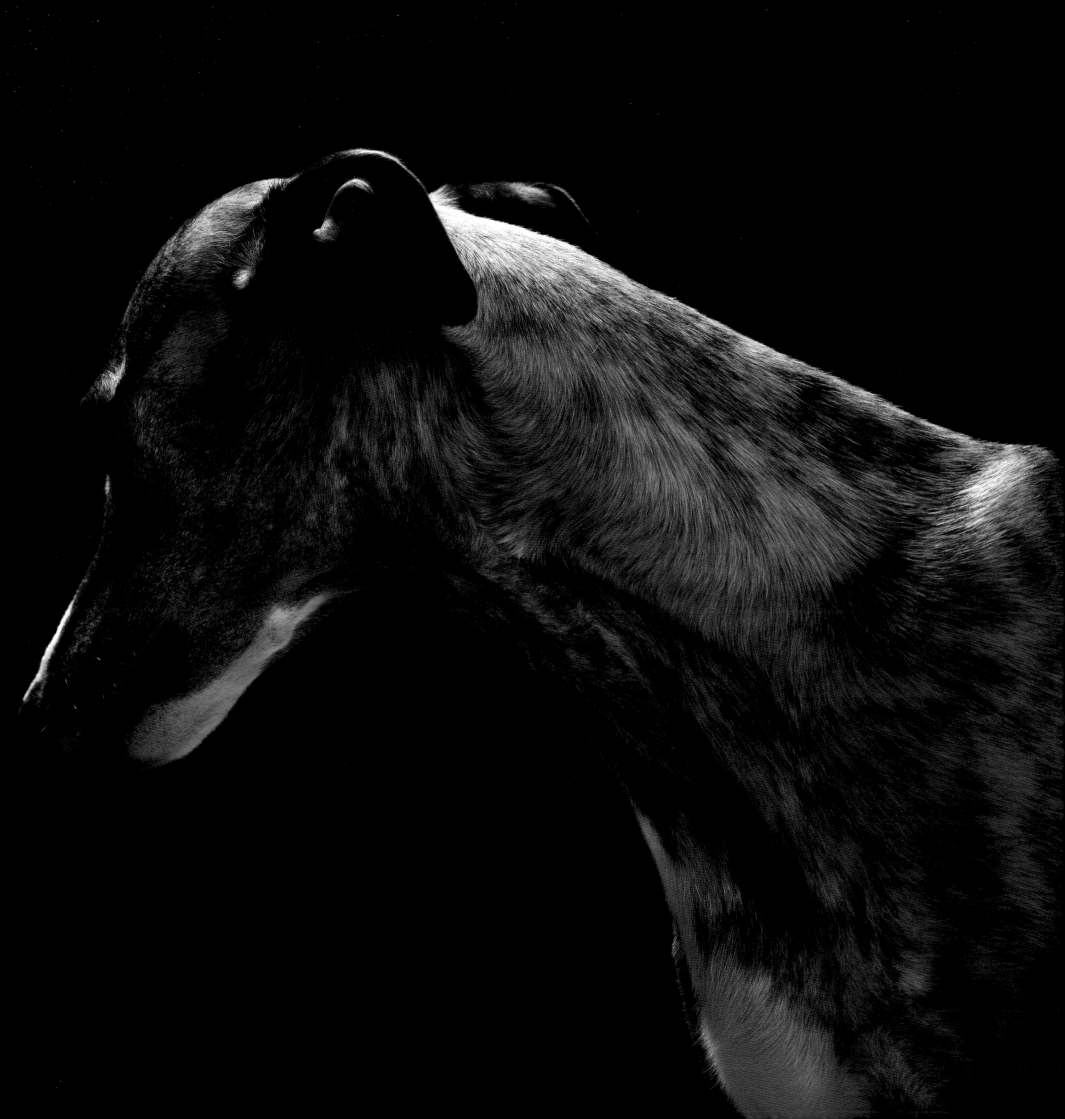

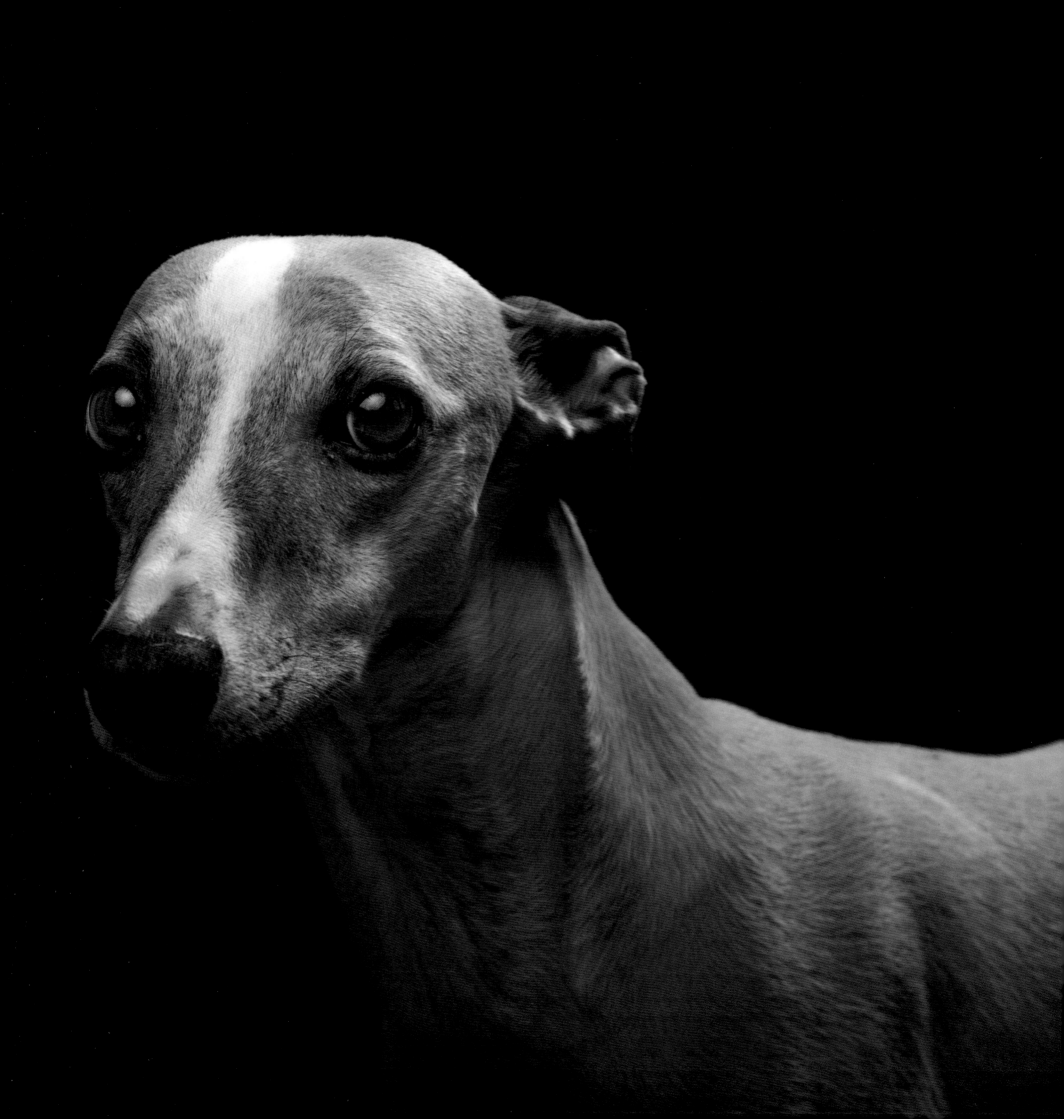

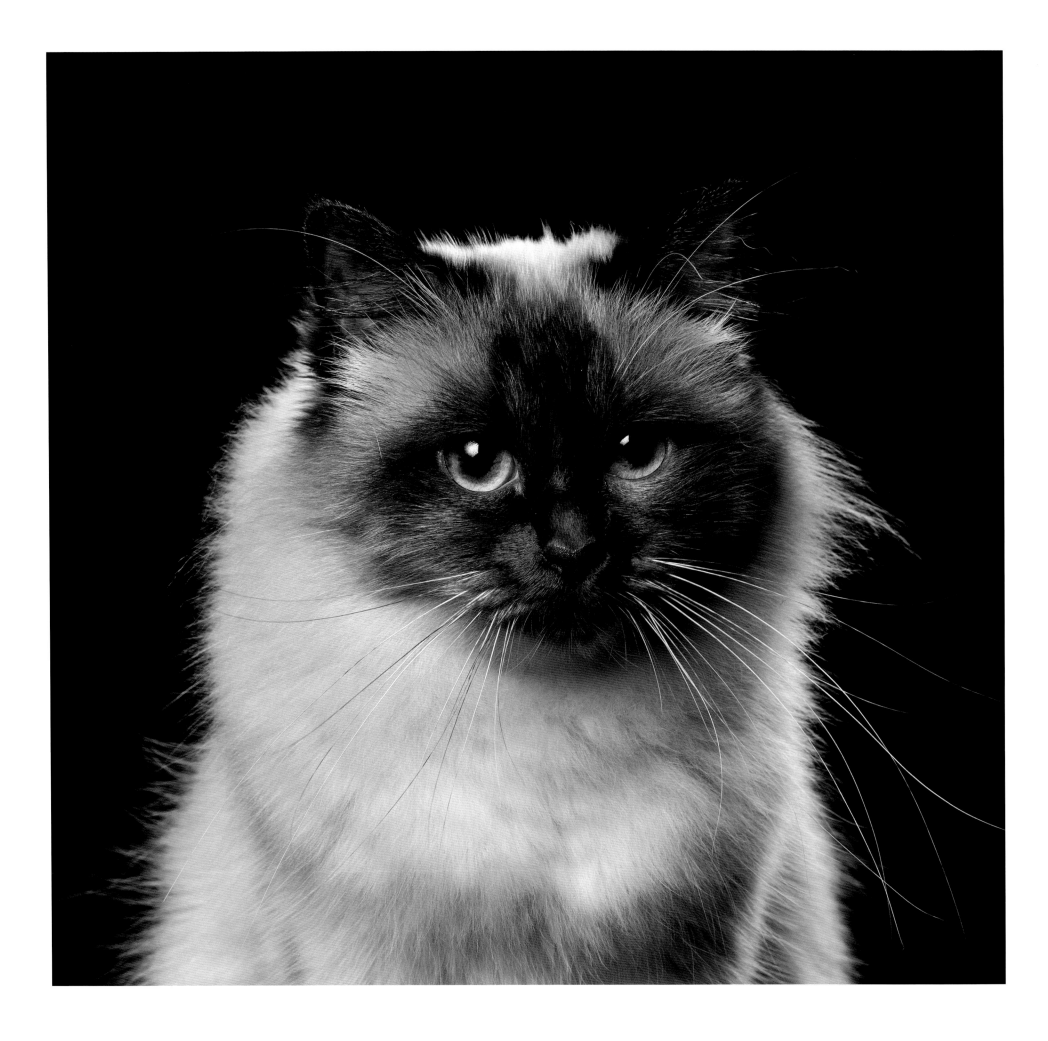

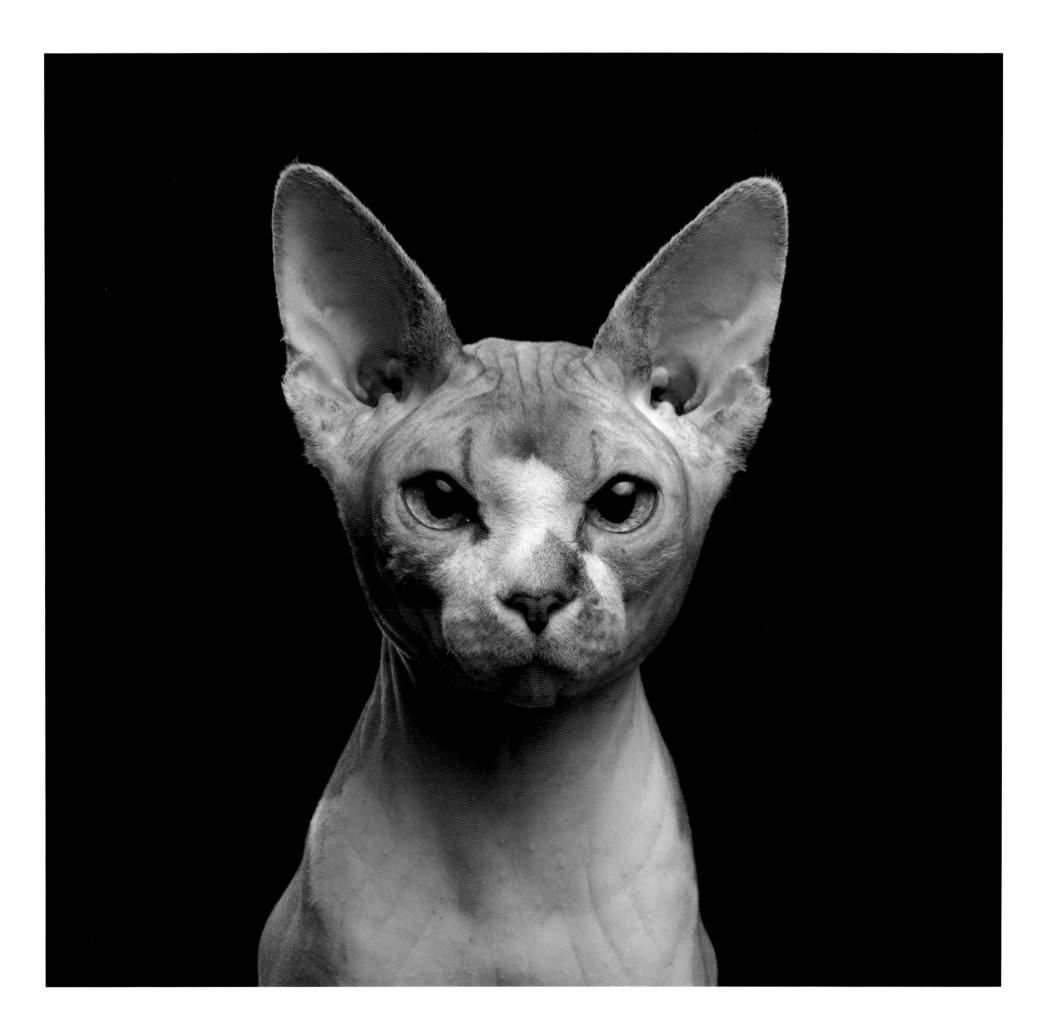

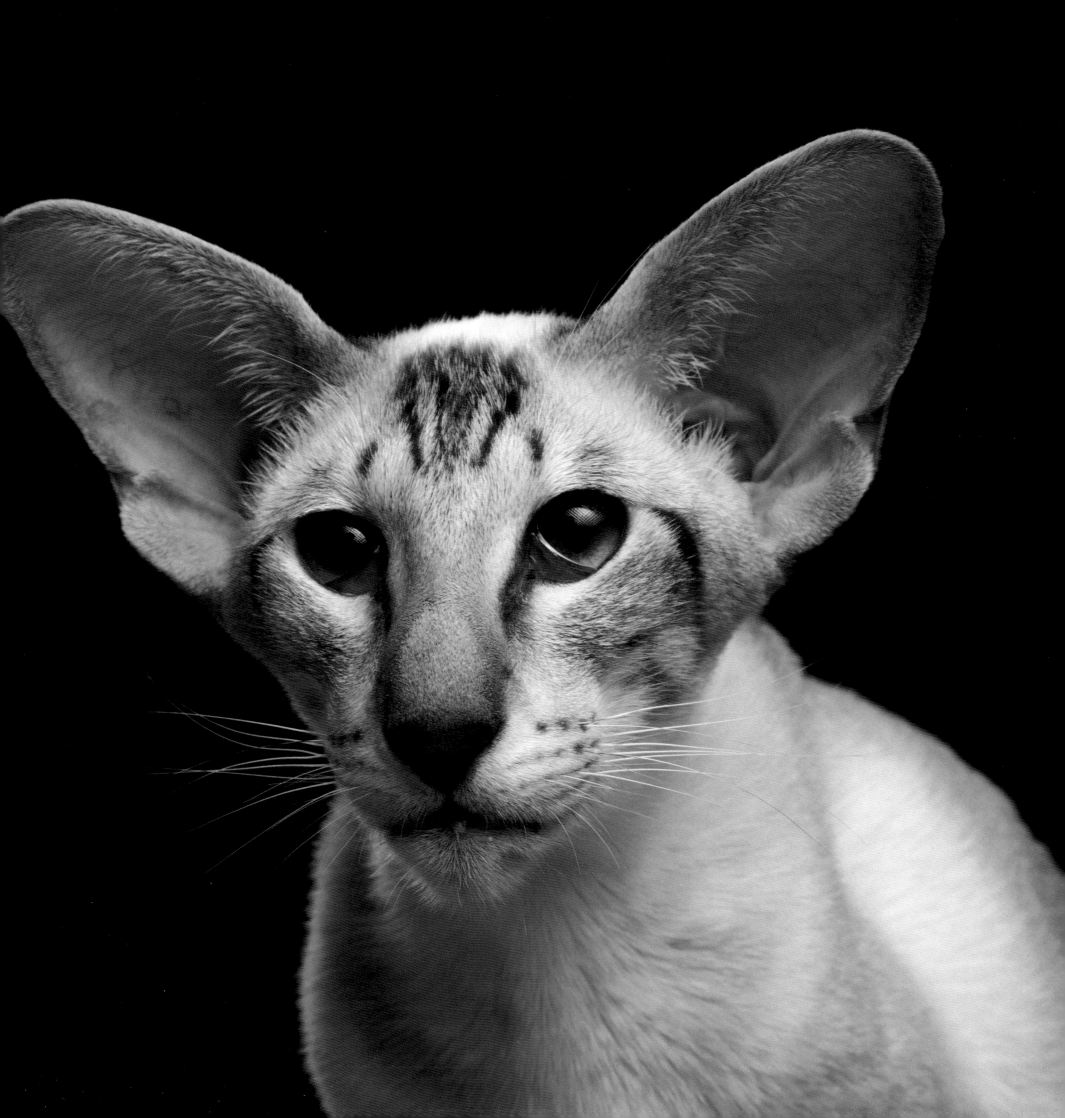

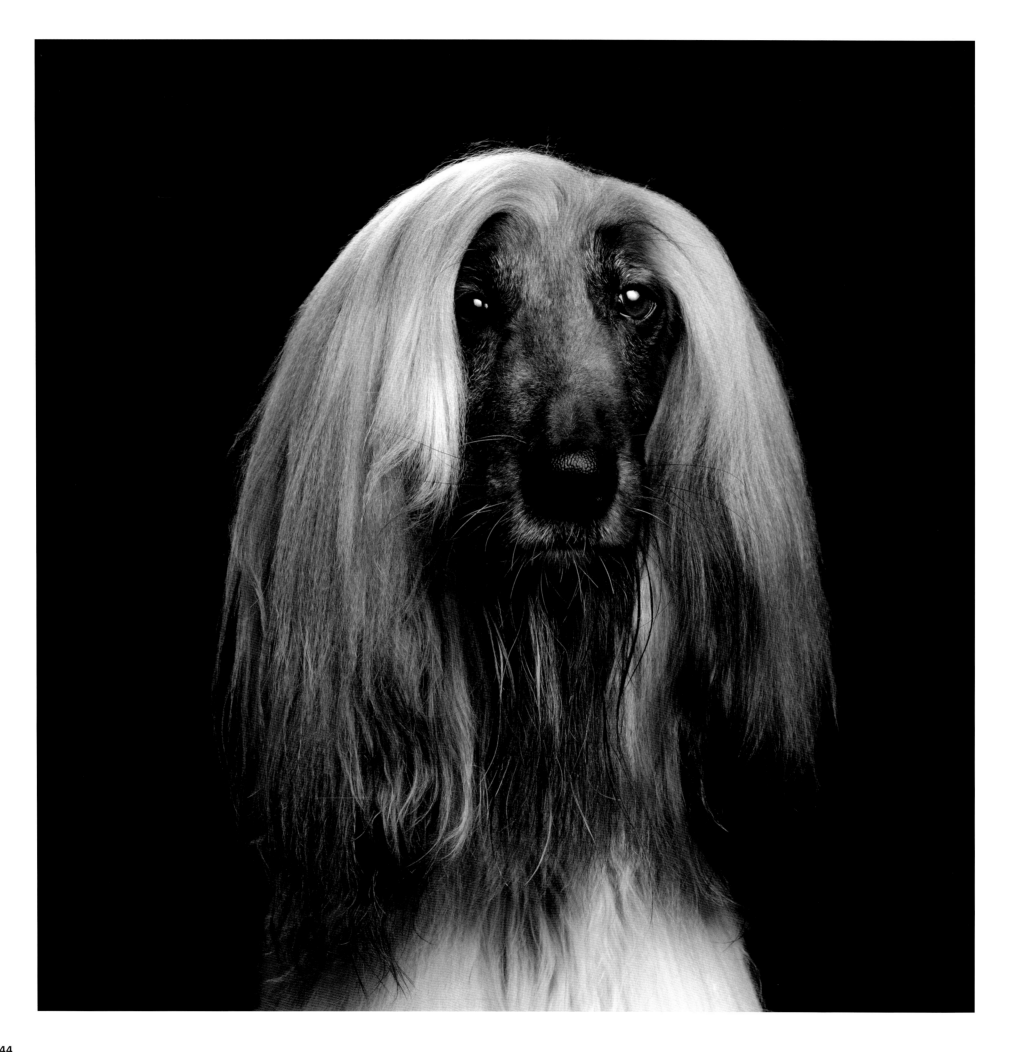

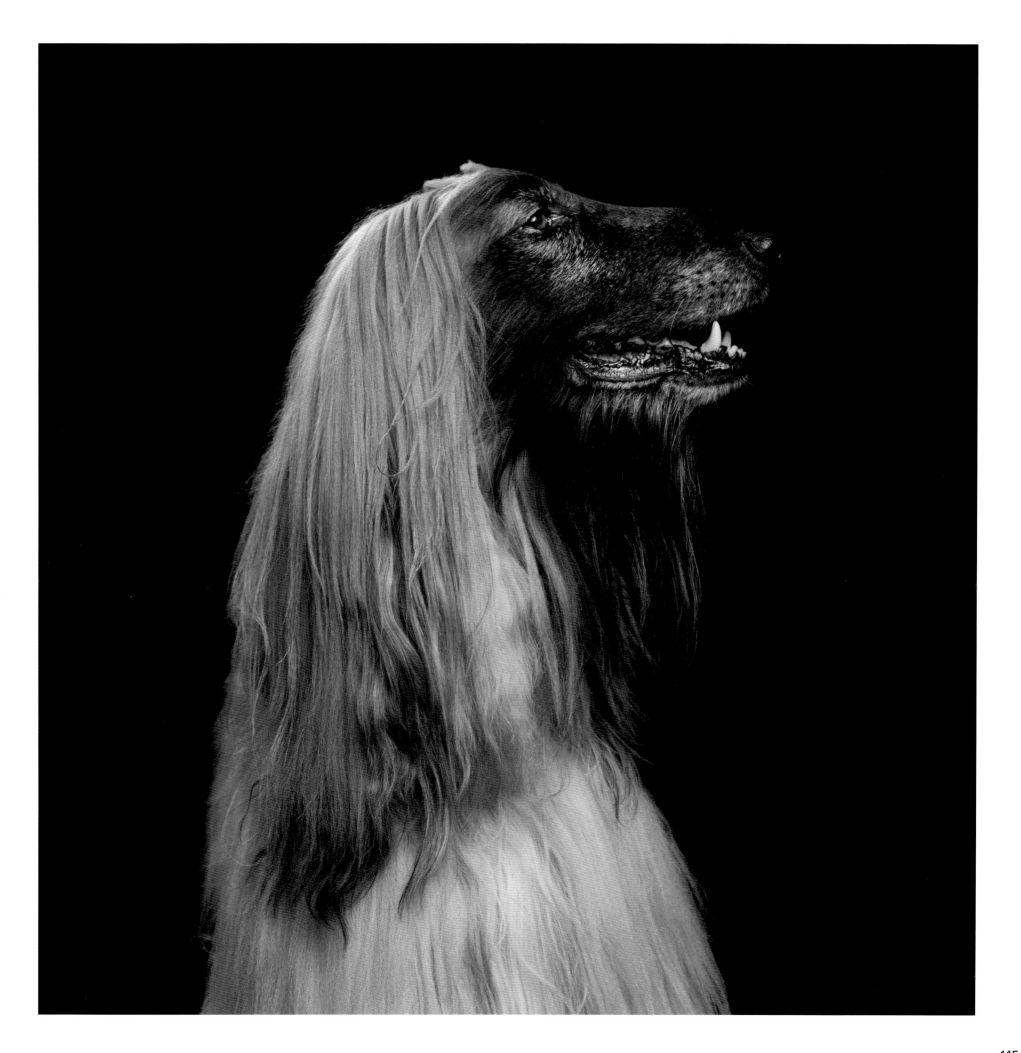

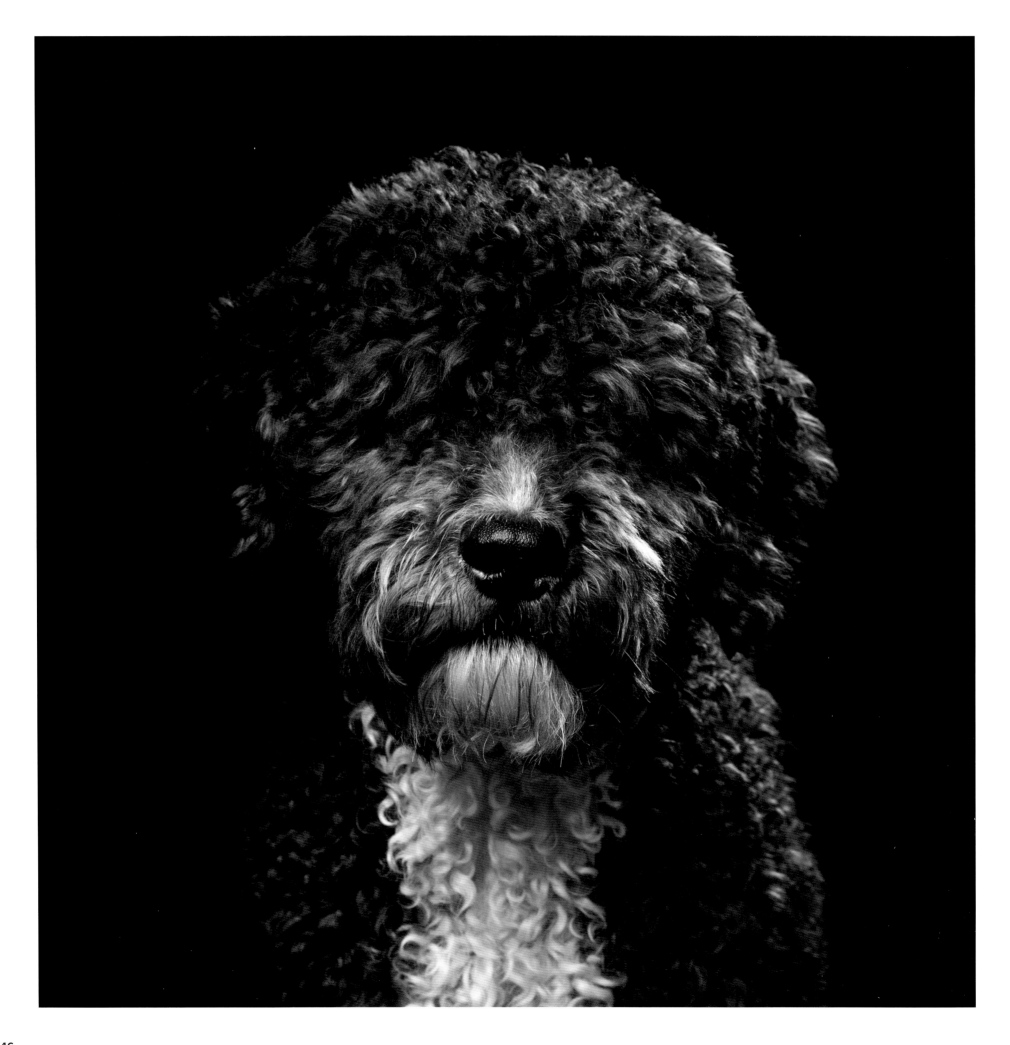

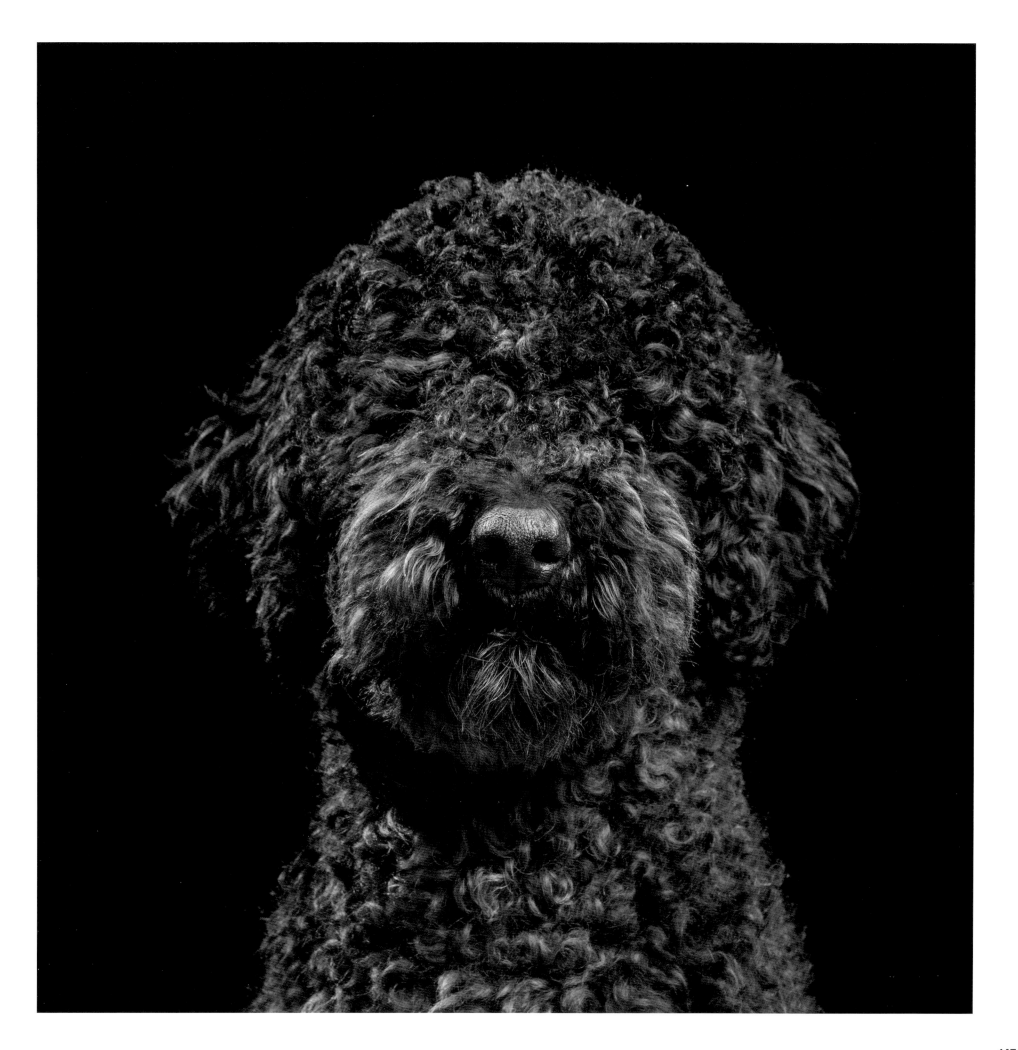

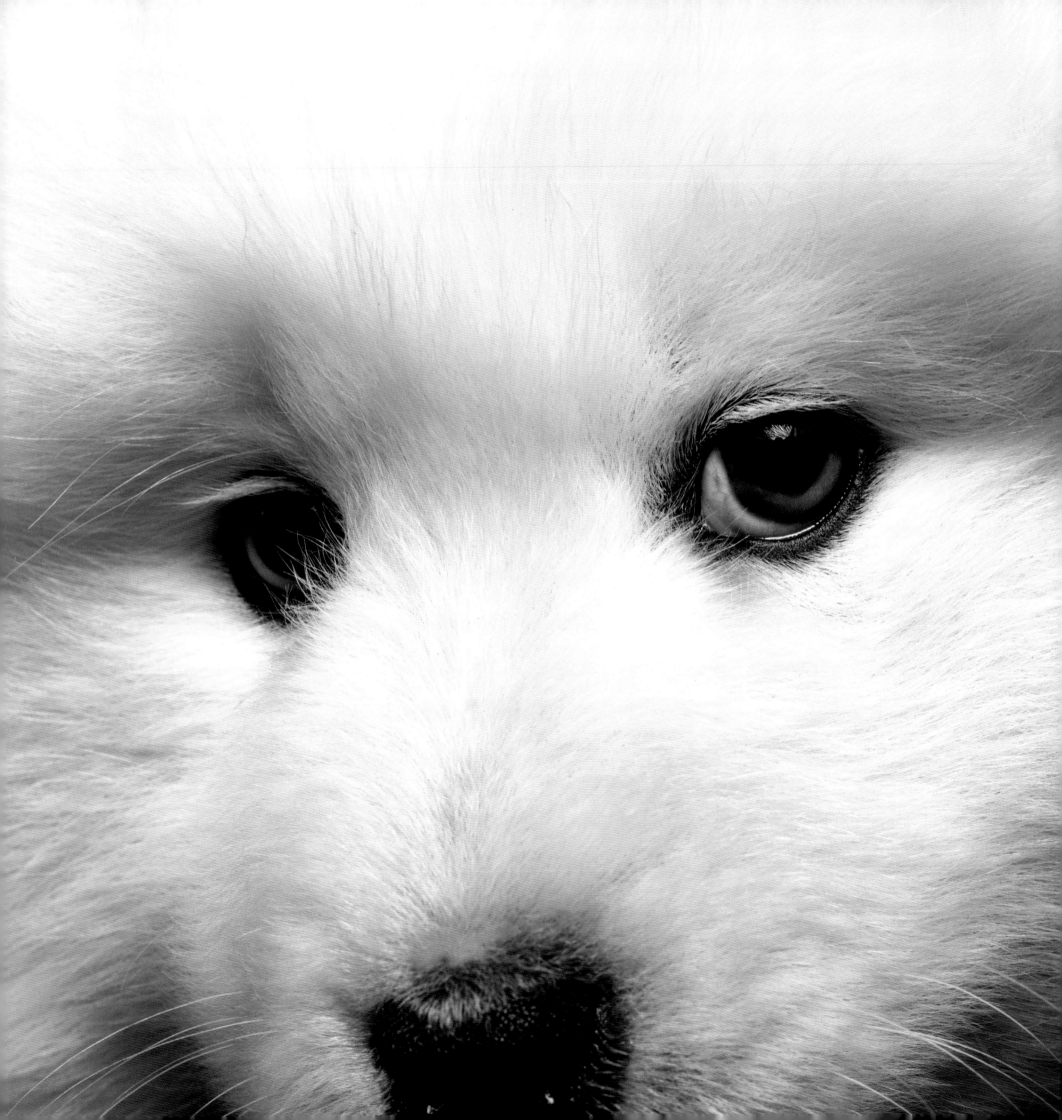

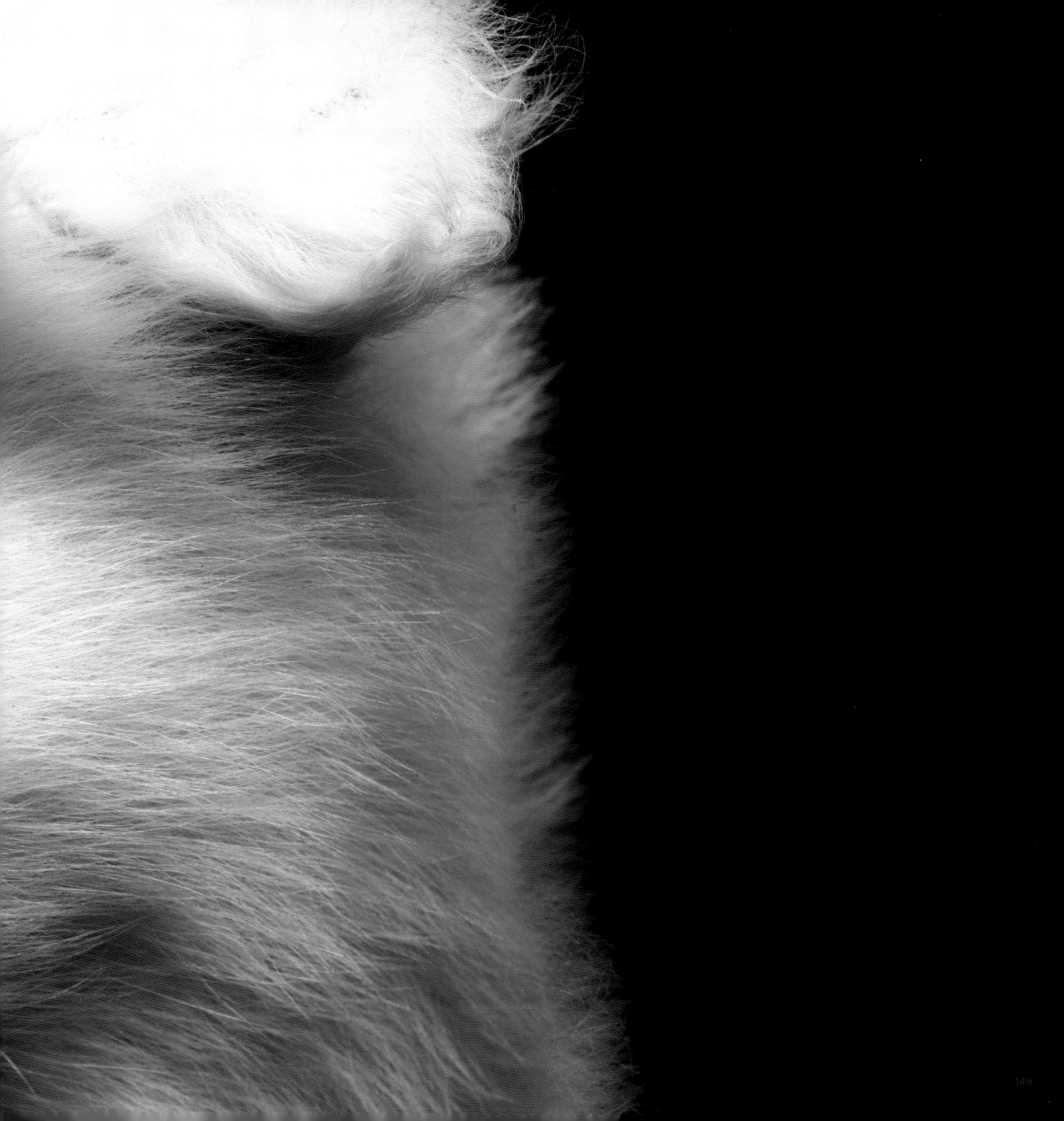

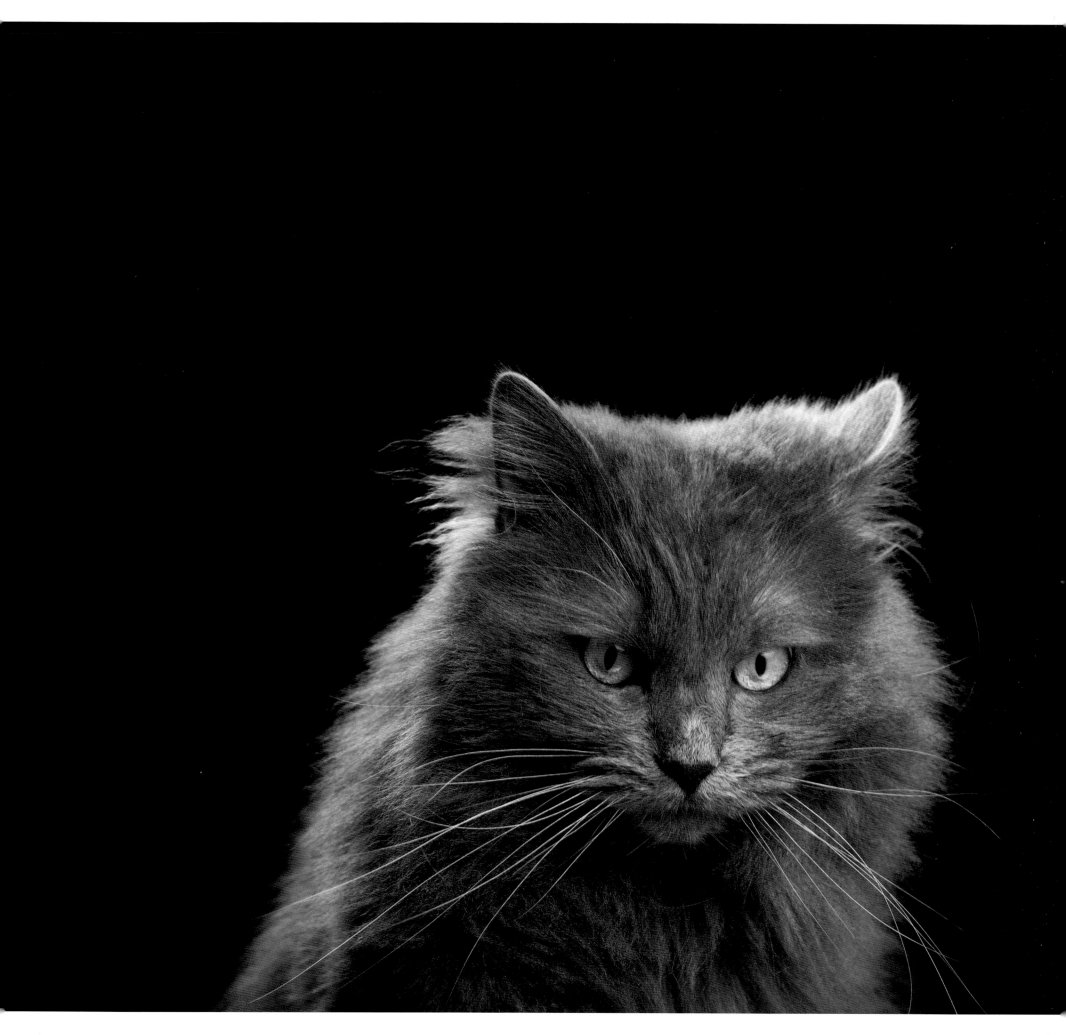

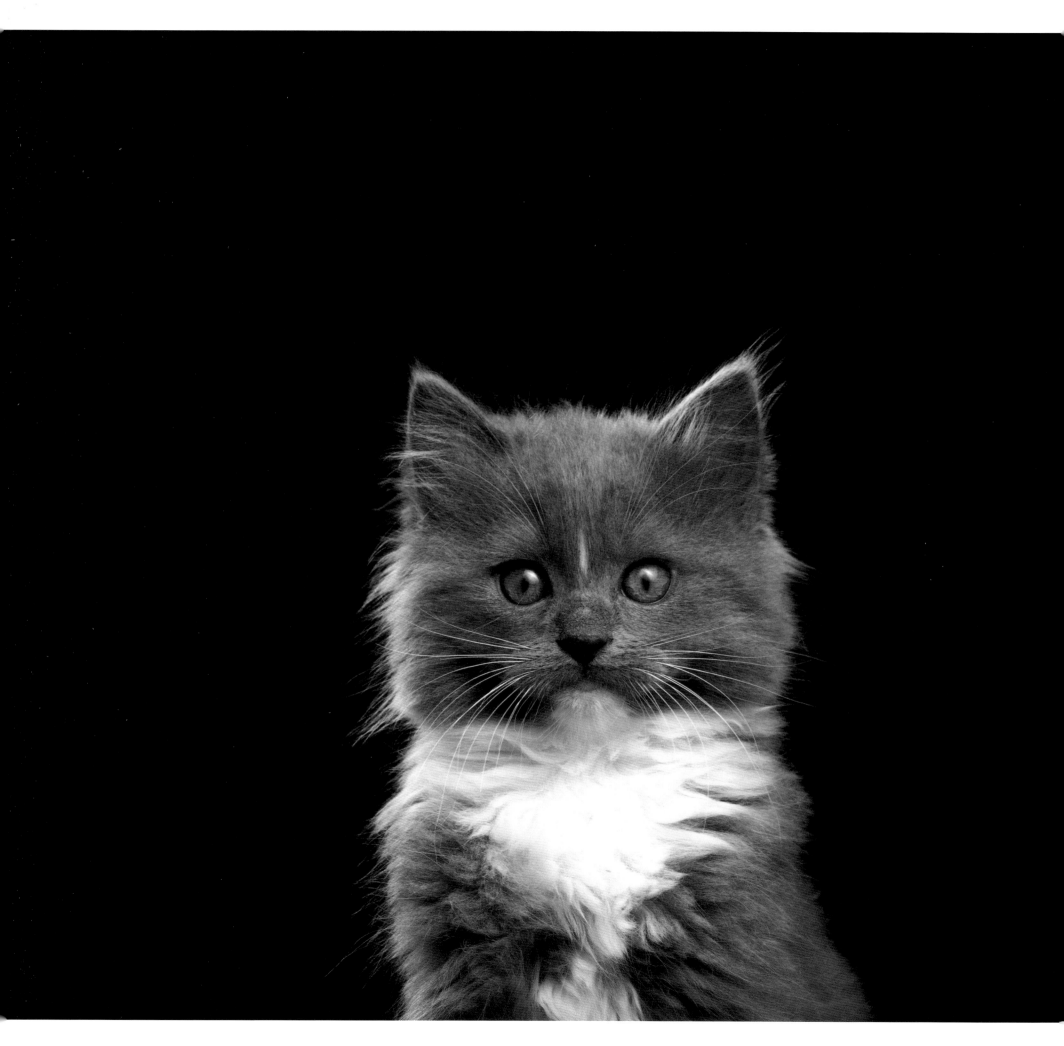

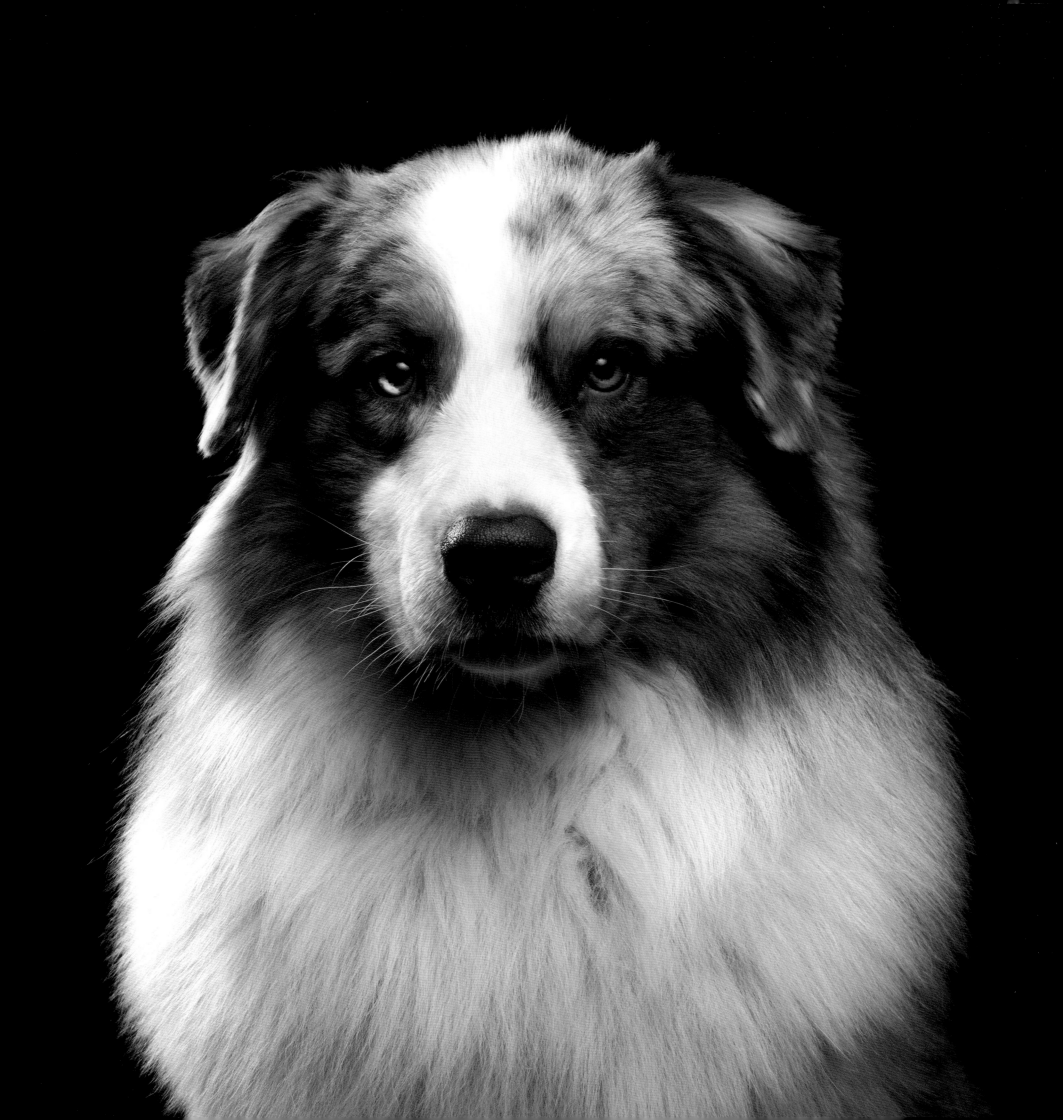

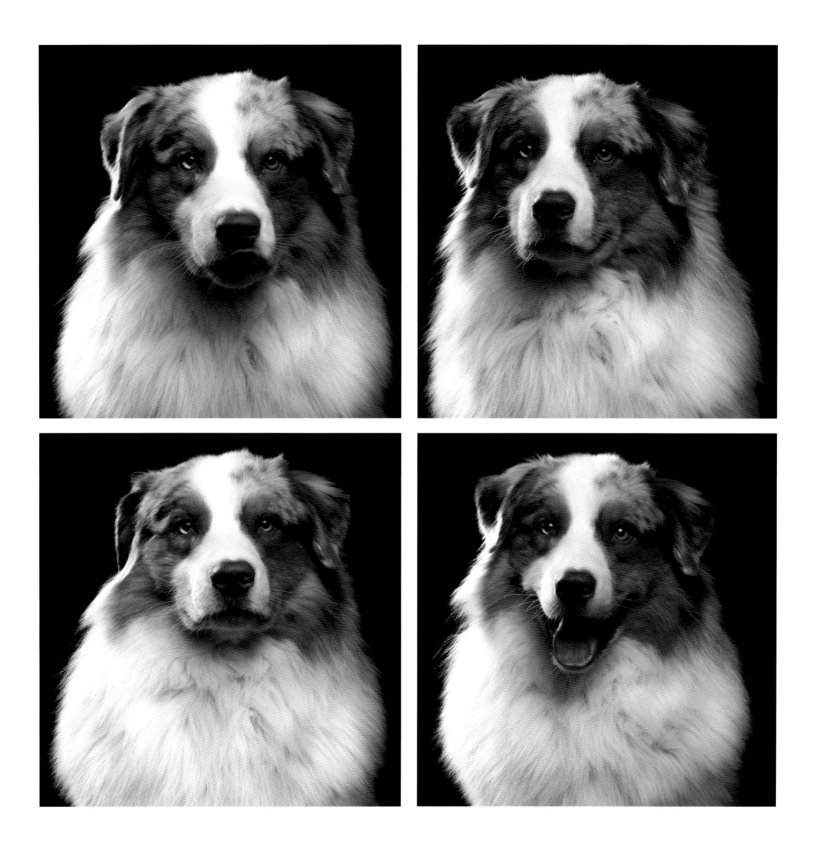

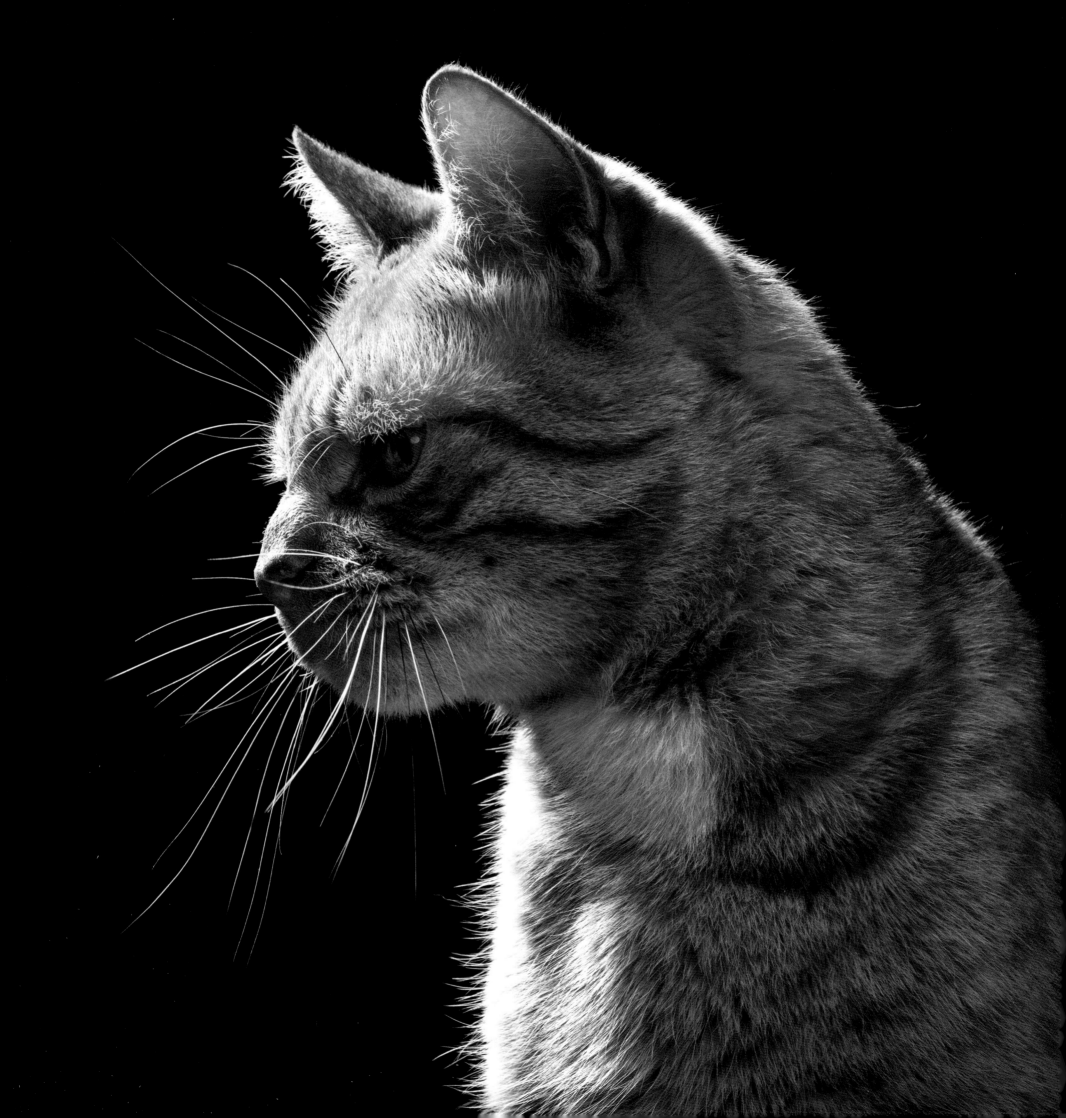

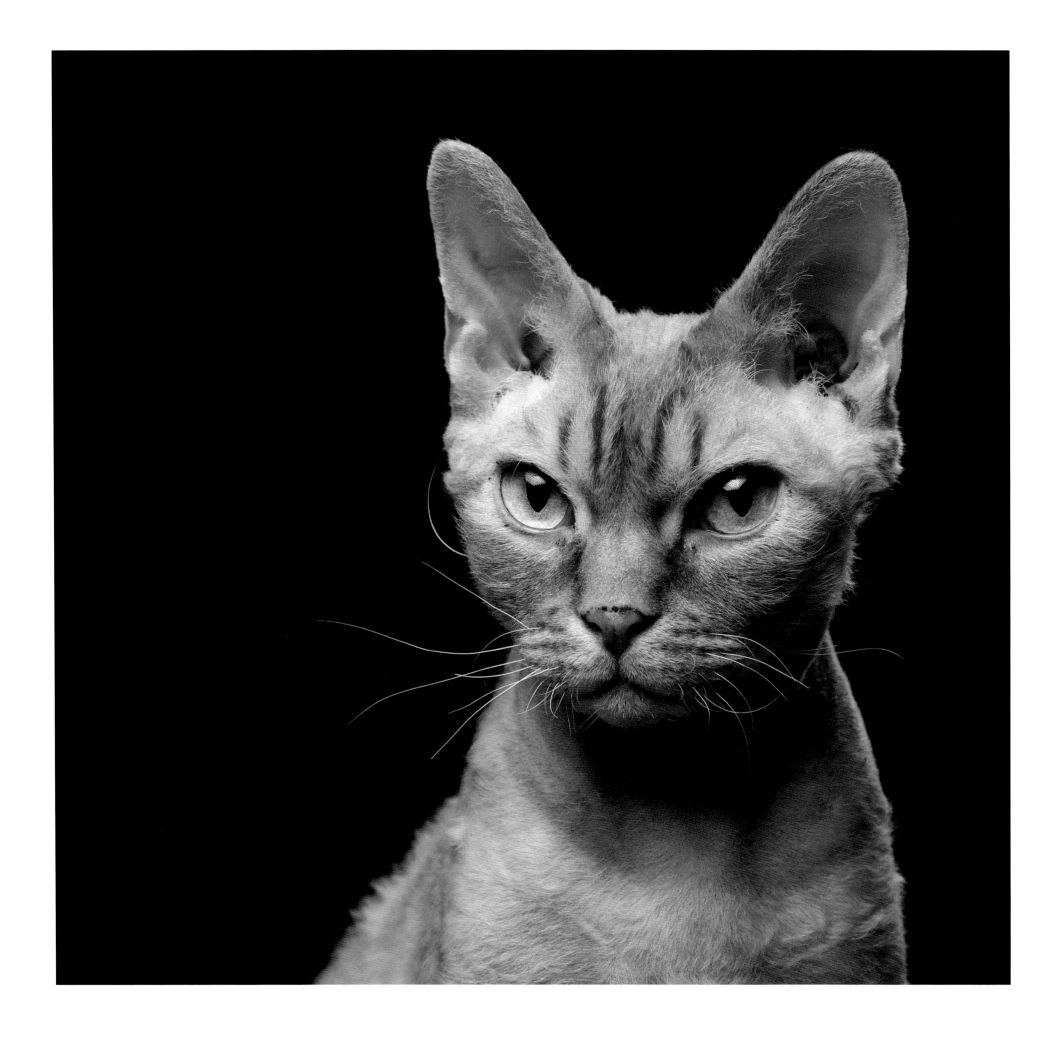

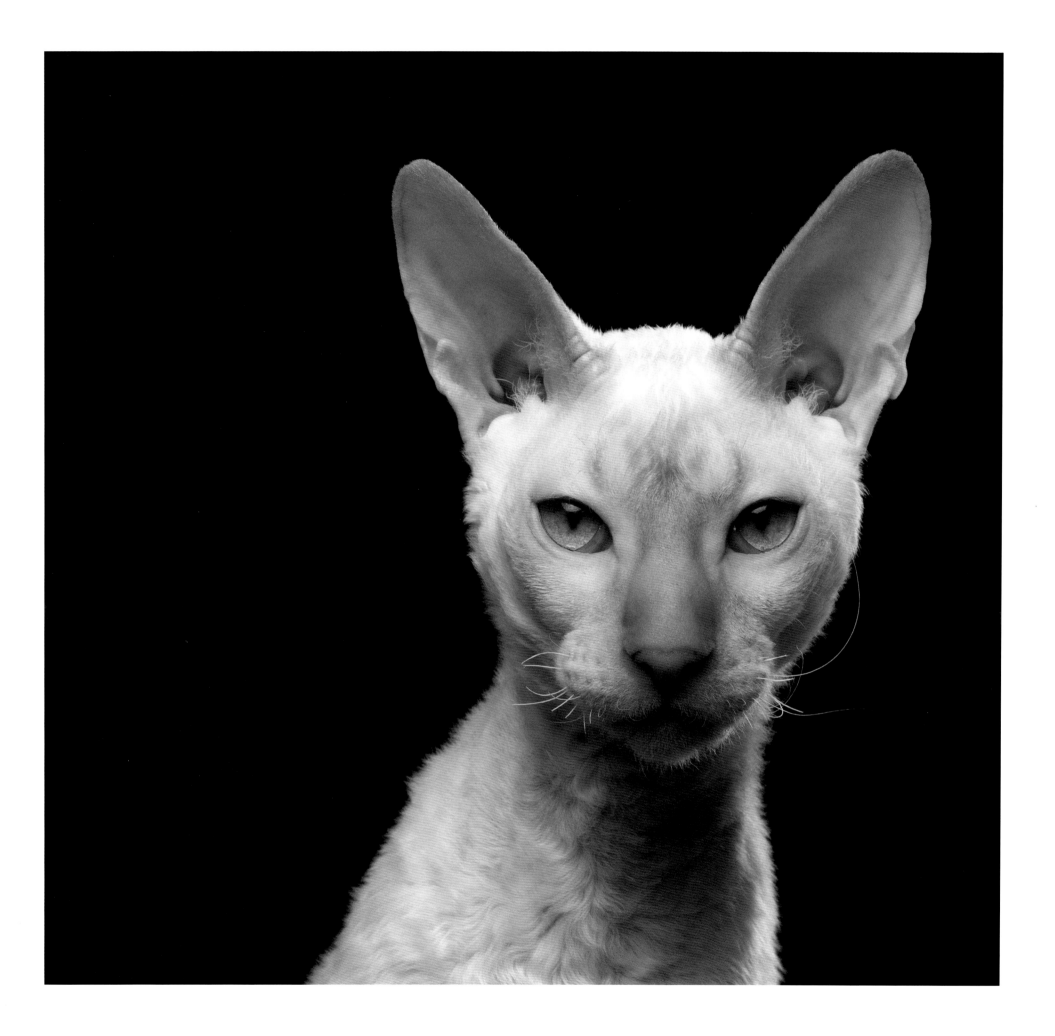

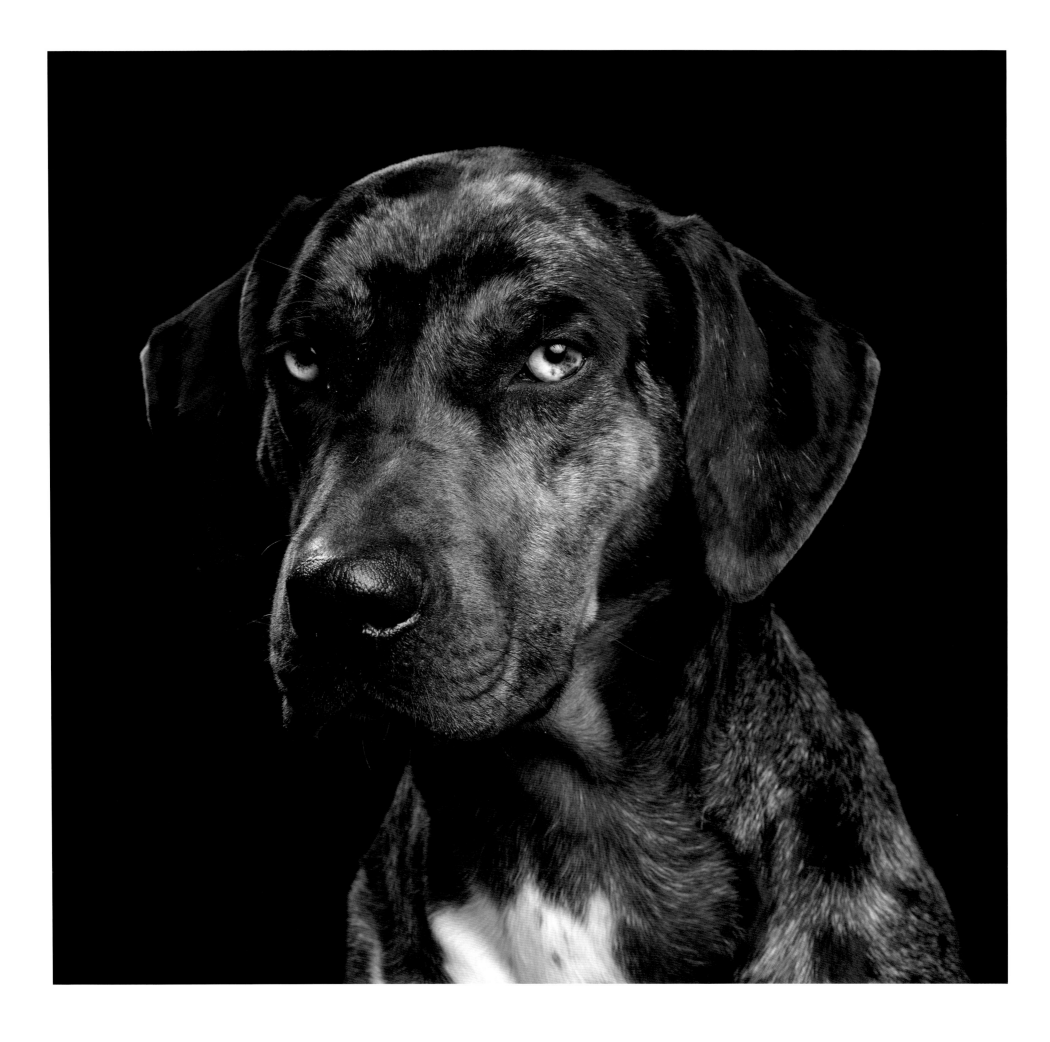

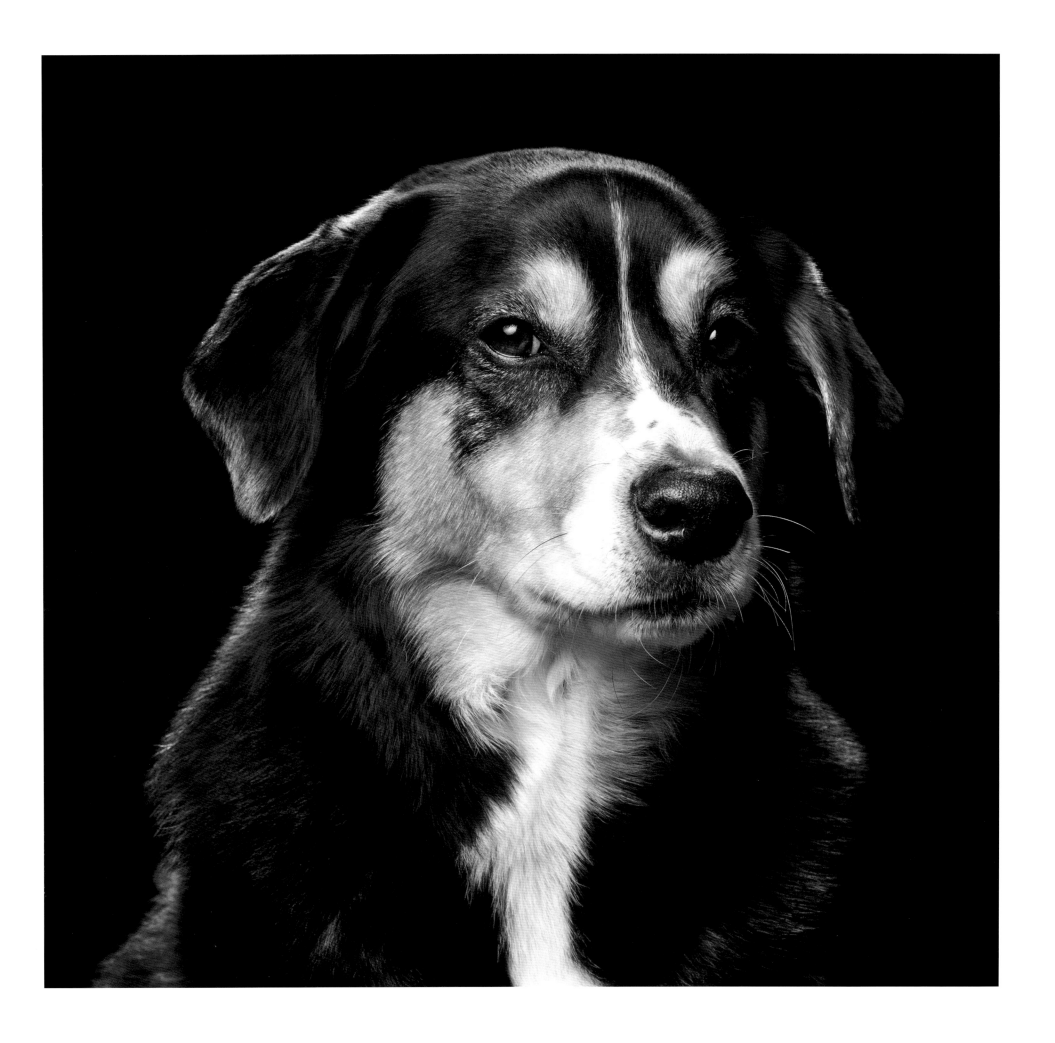

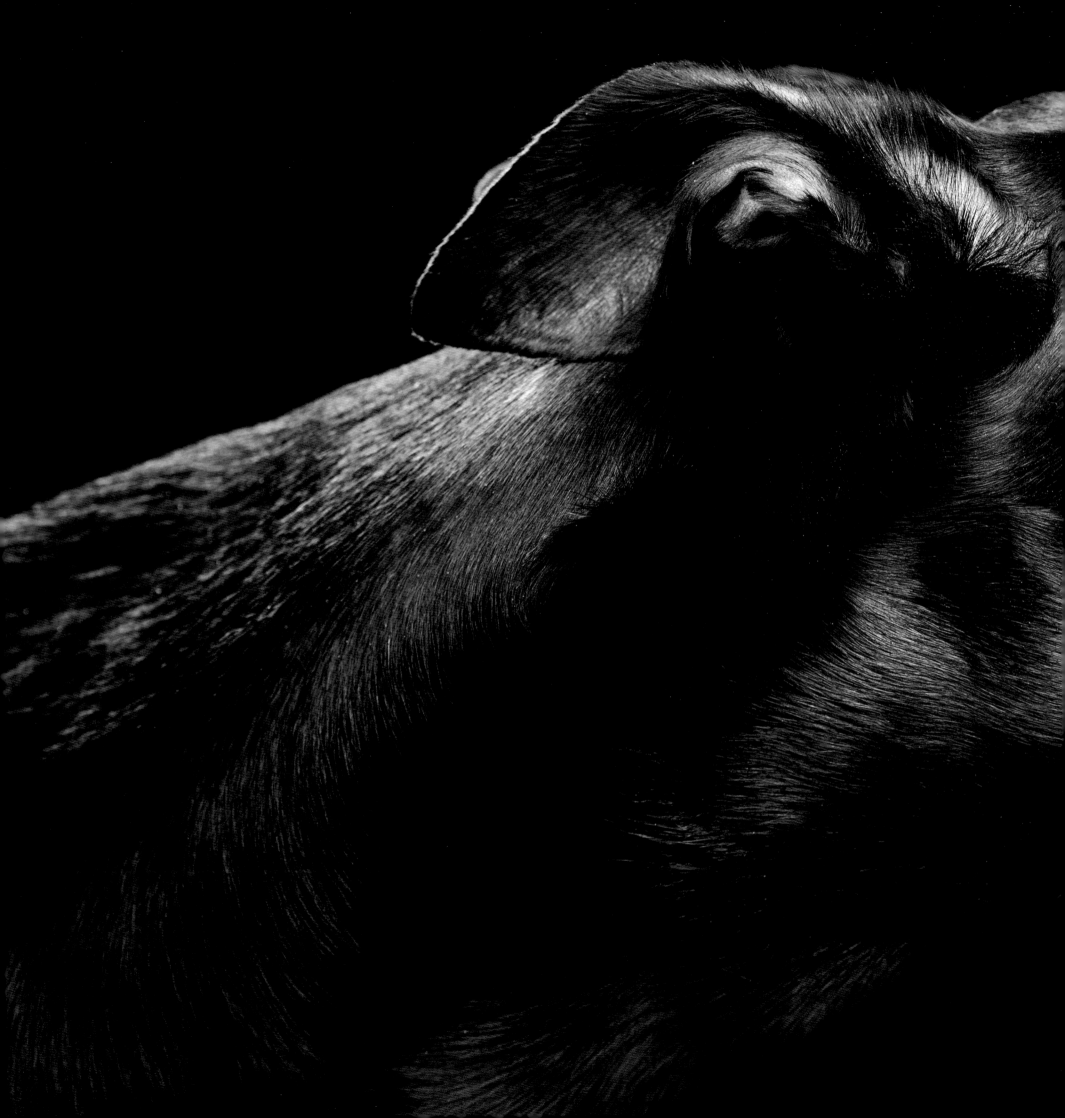

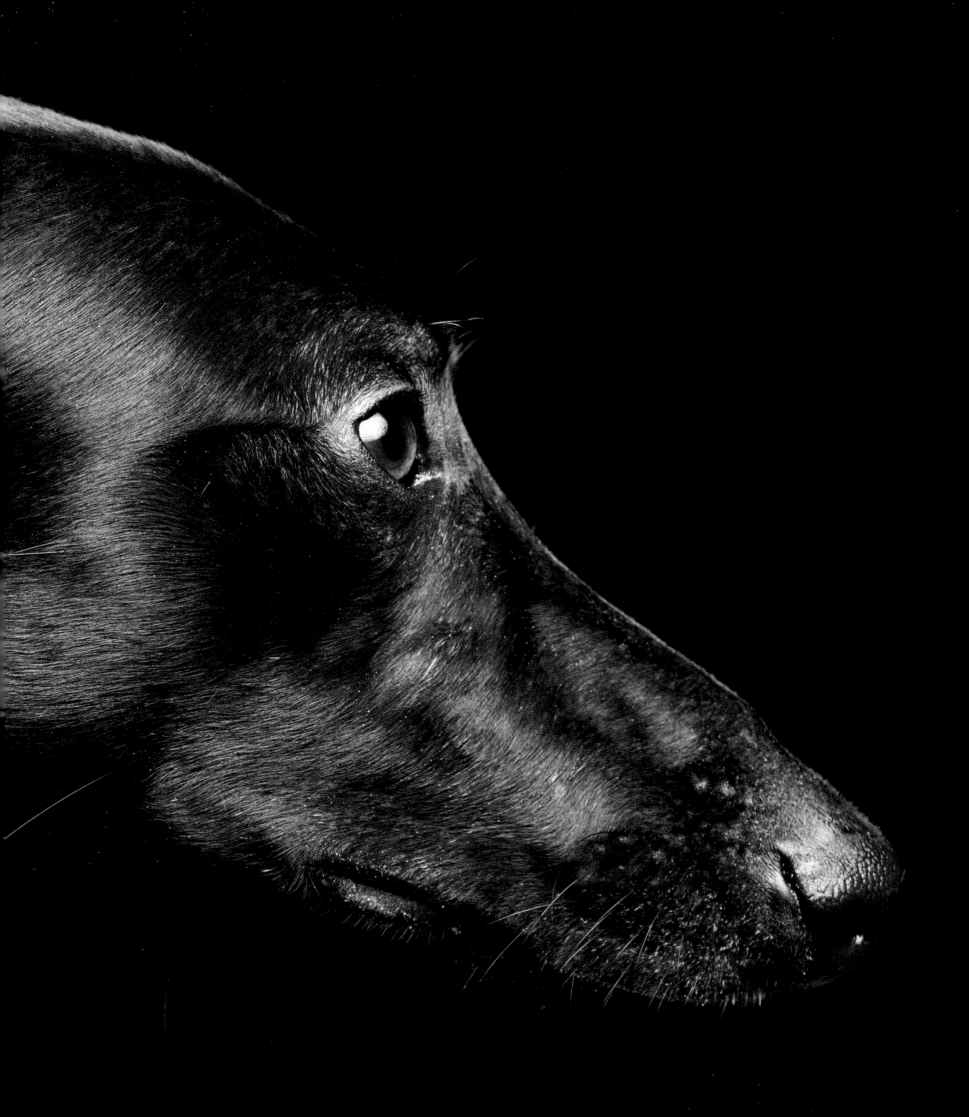

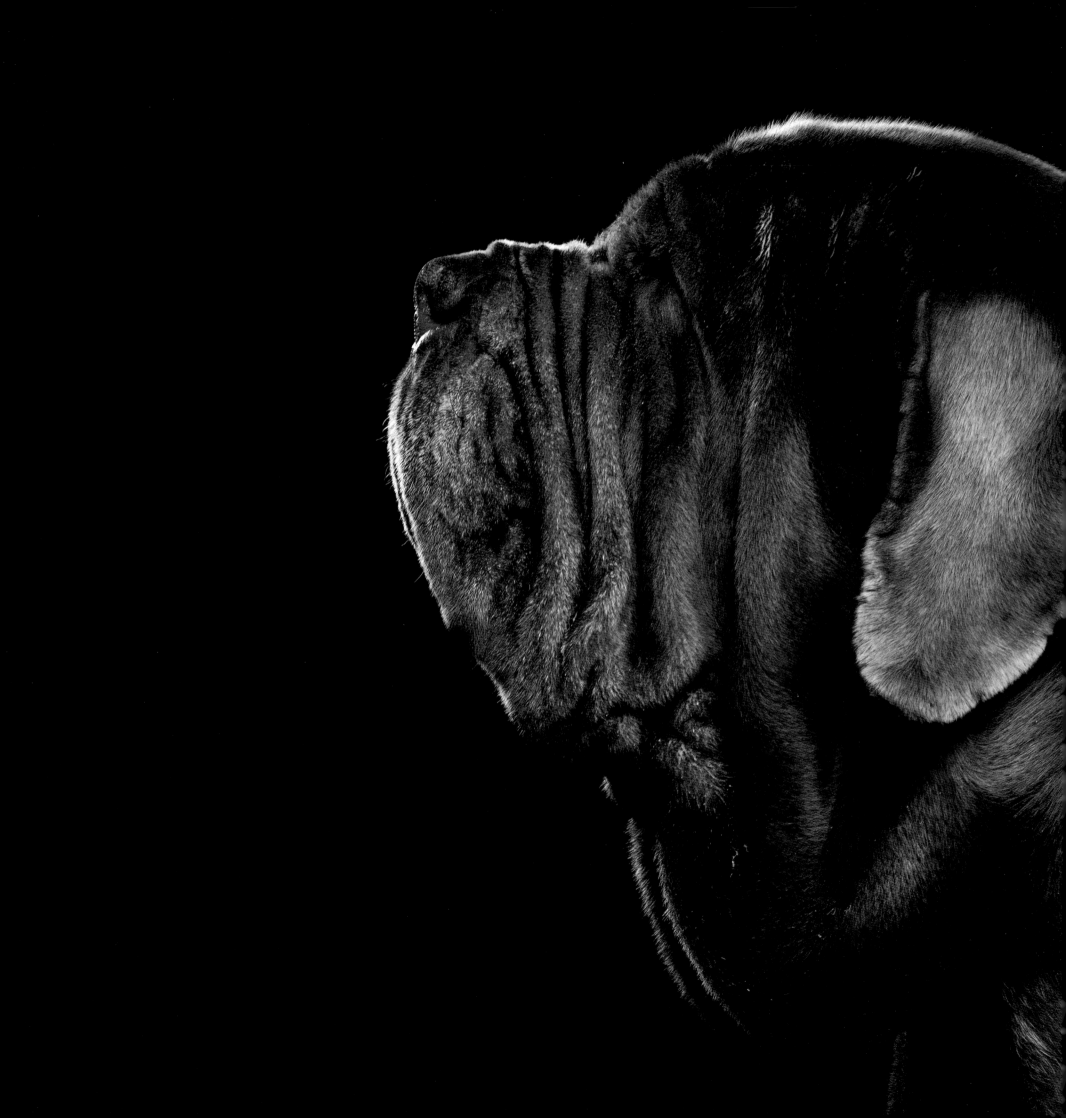

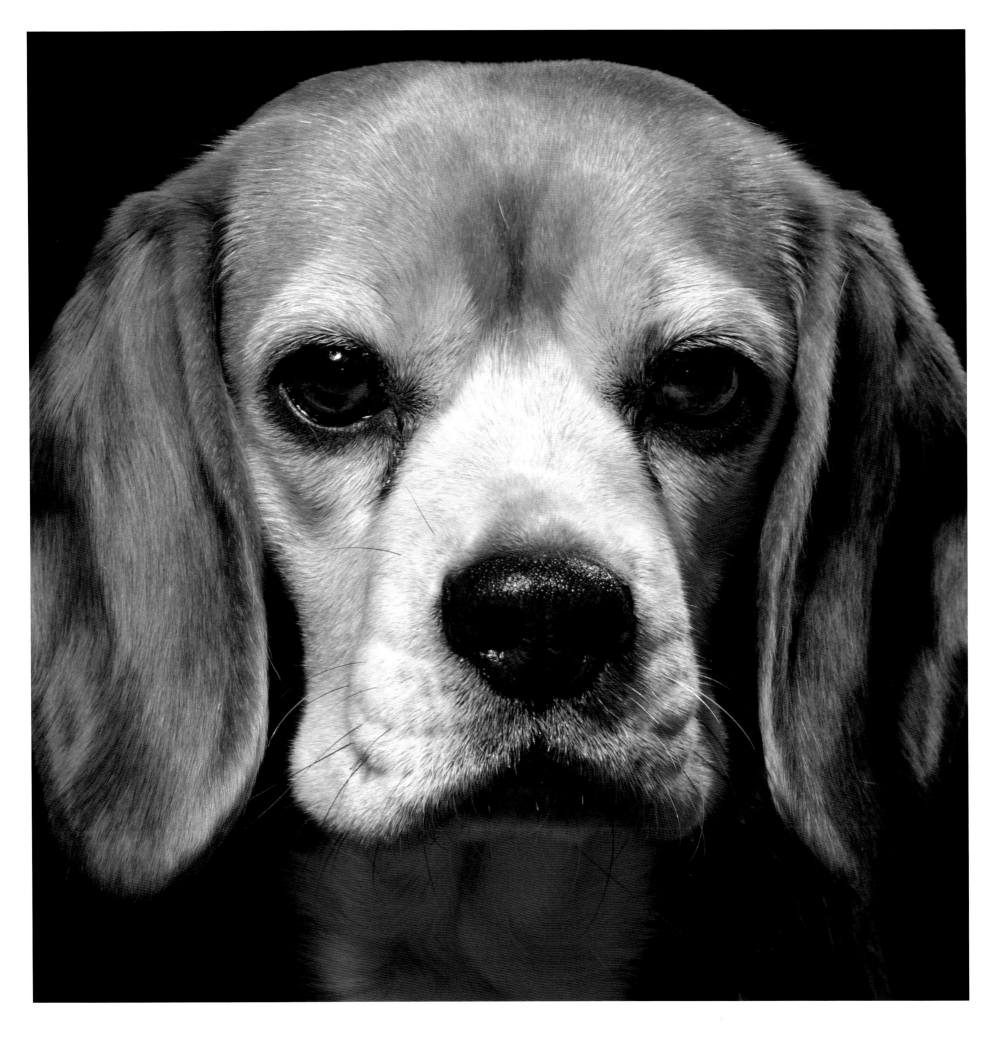

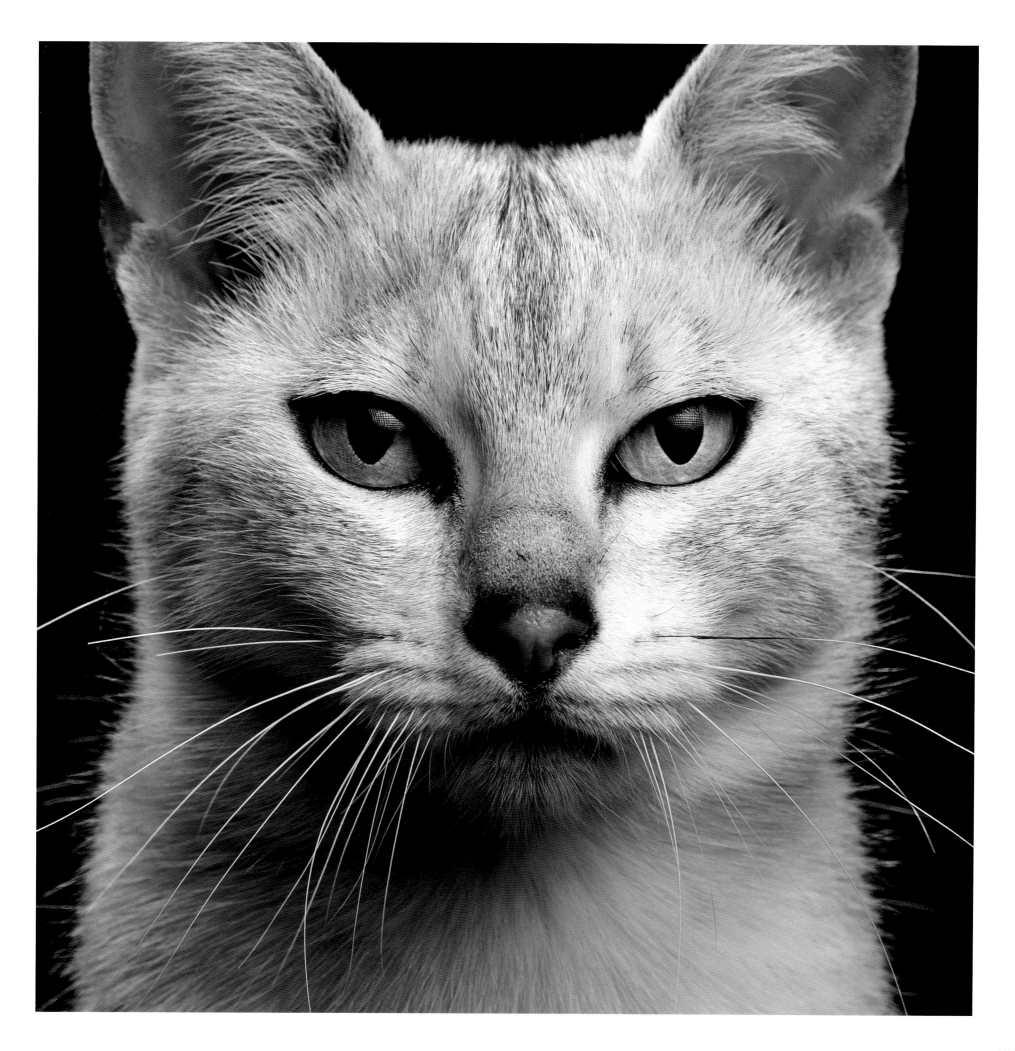

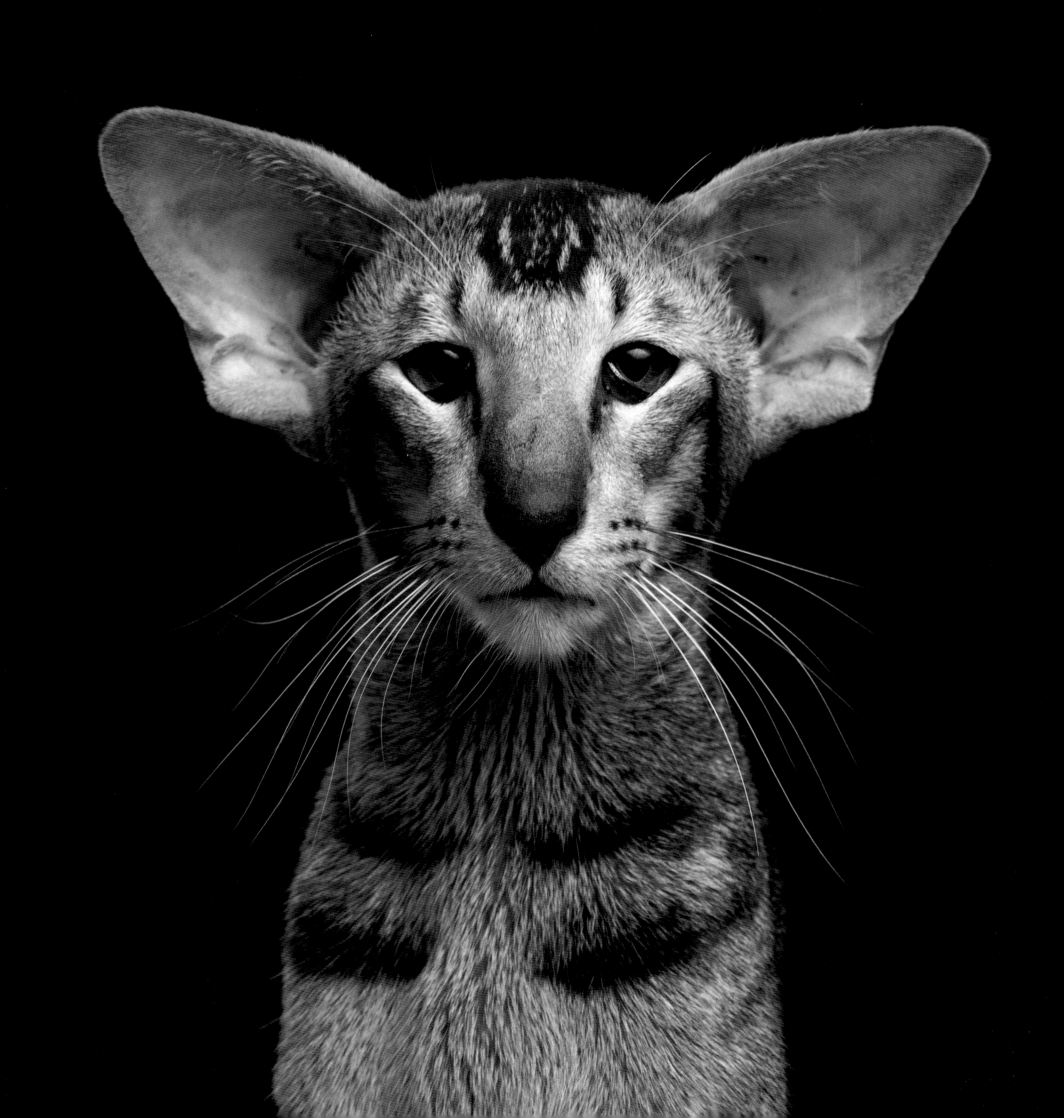

"The ideal of calm exists in a sitting cat."

Jules Renard

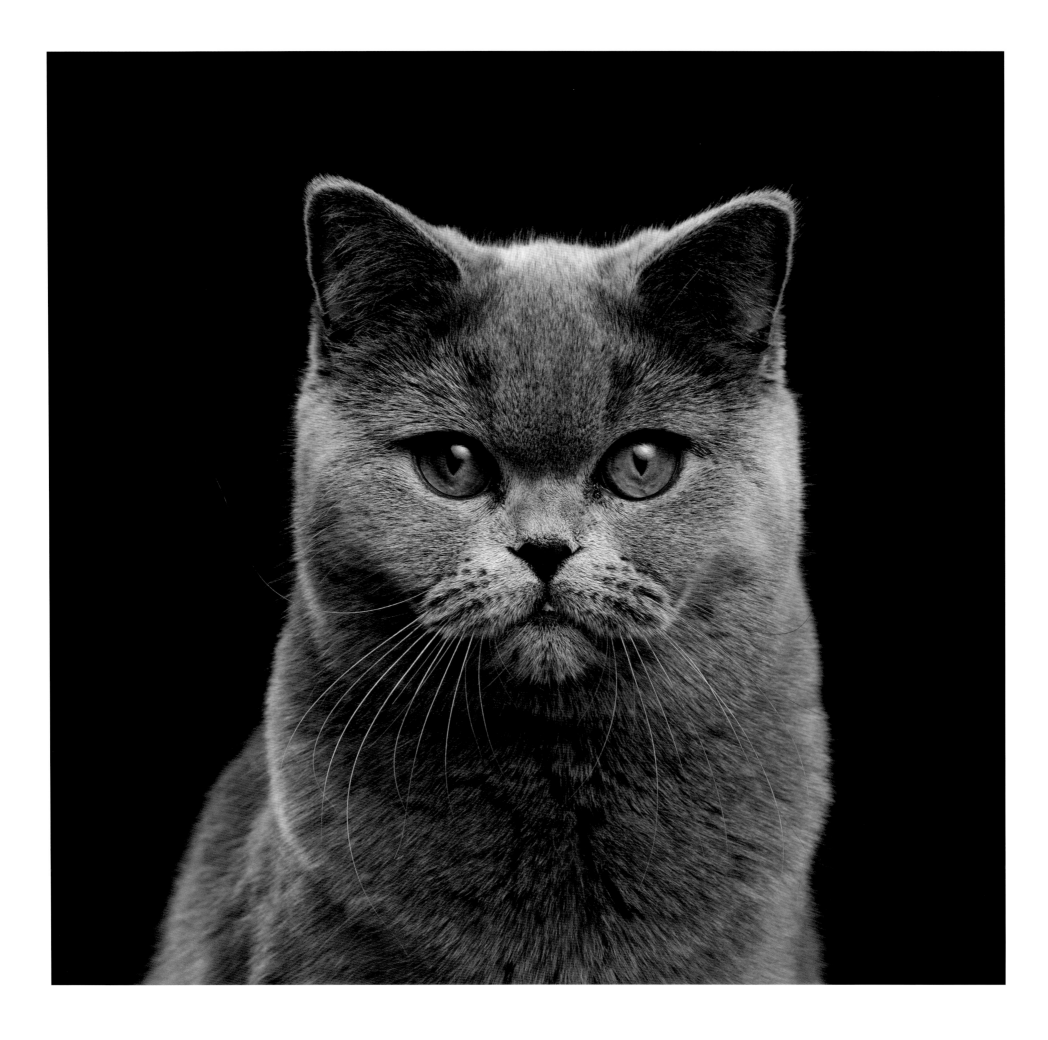

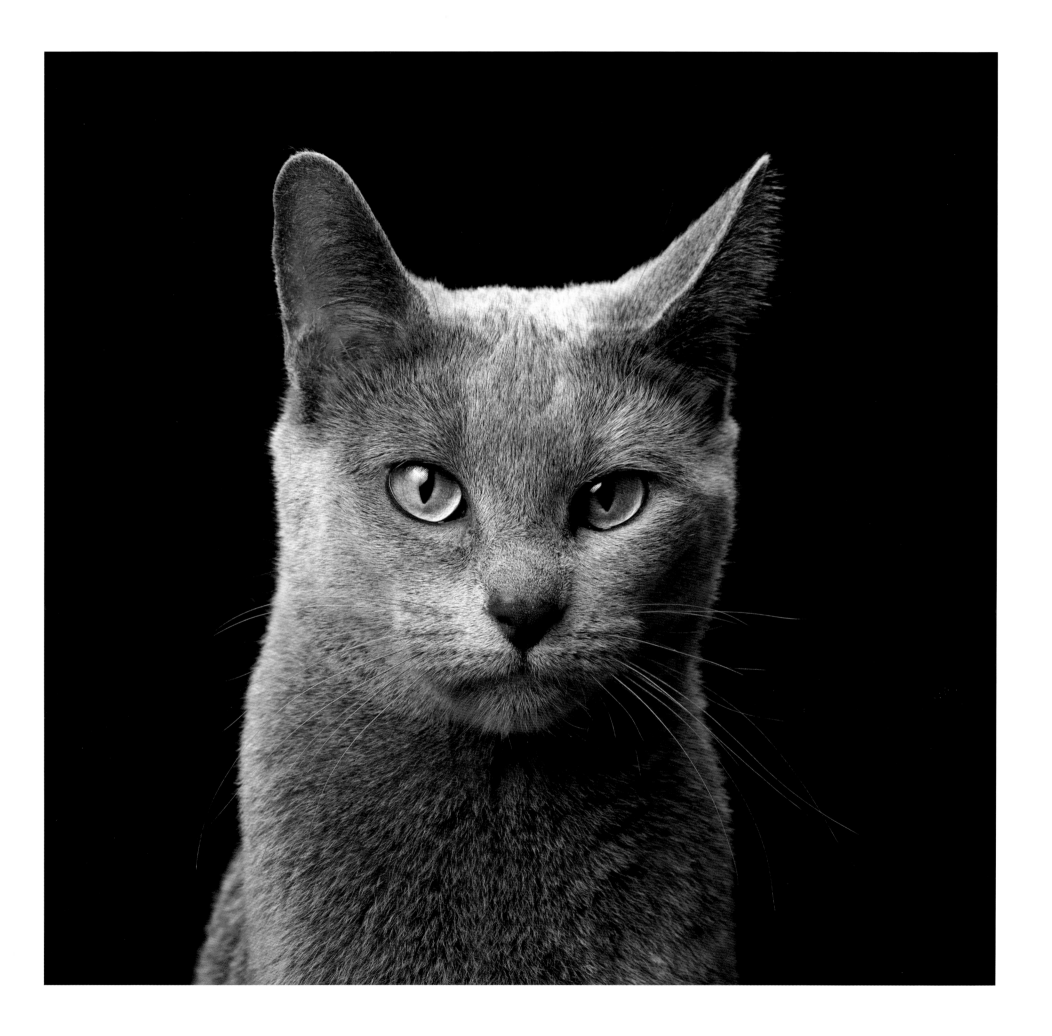

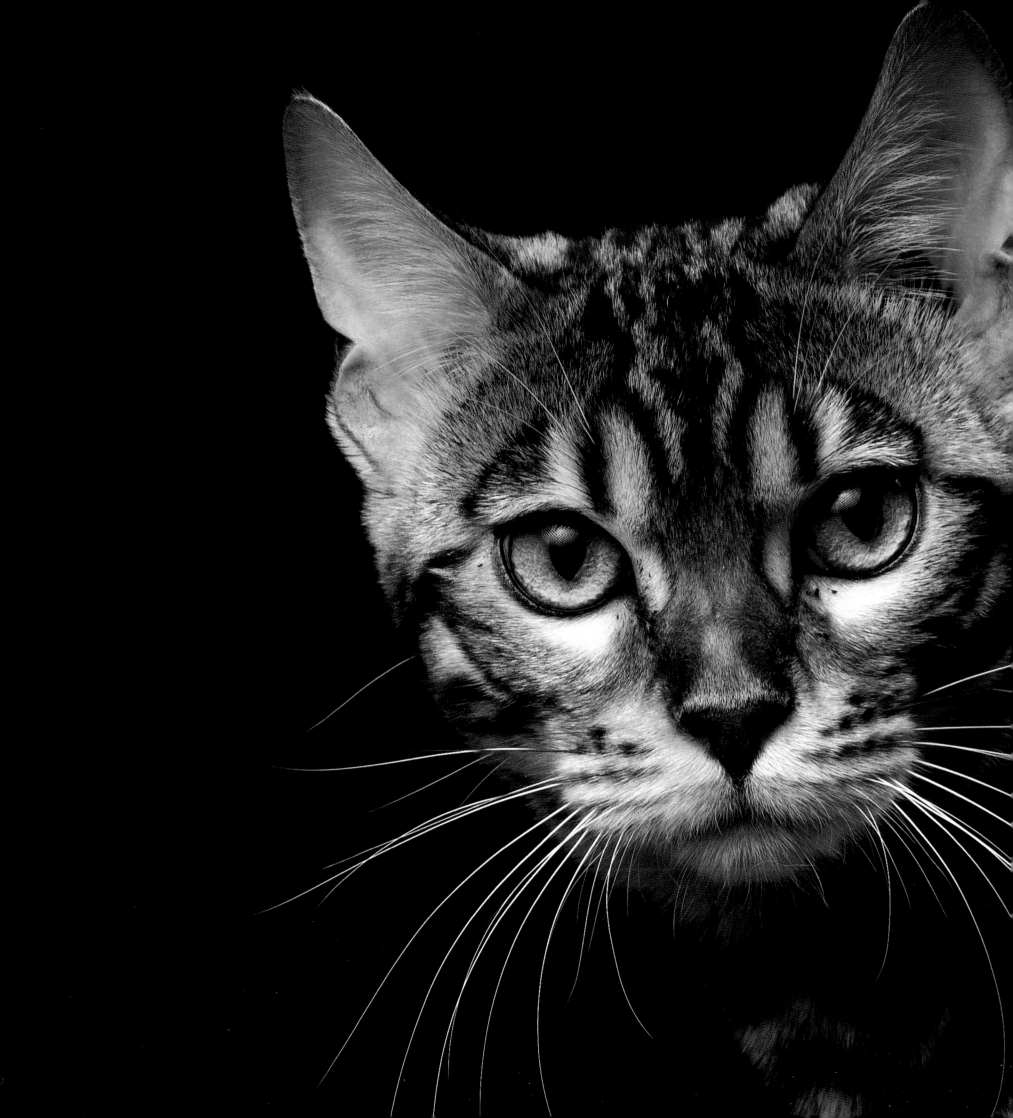

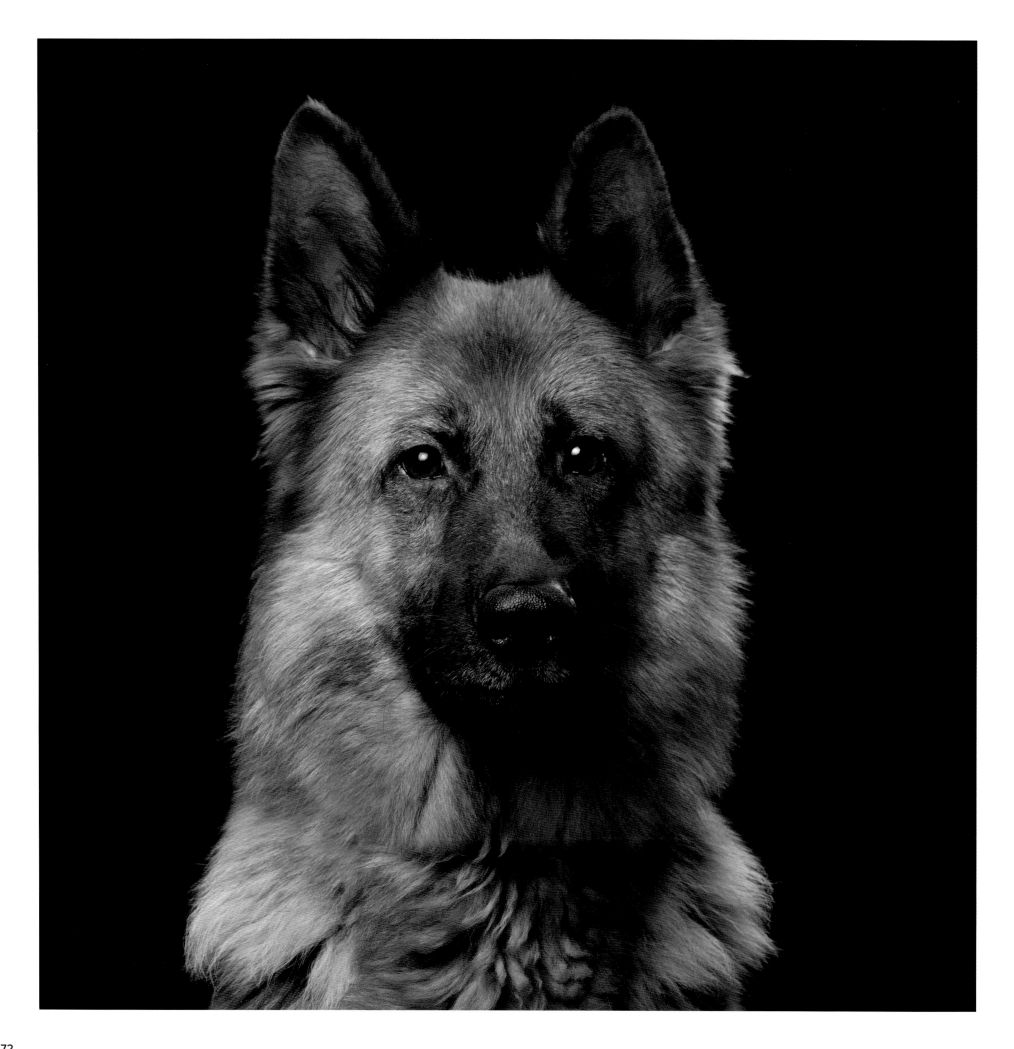

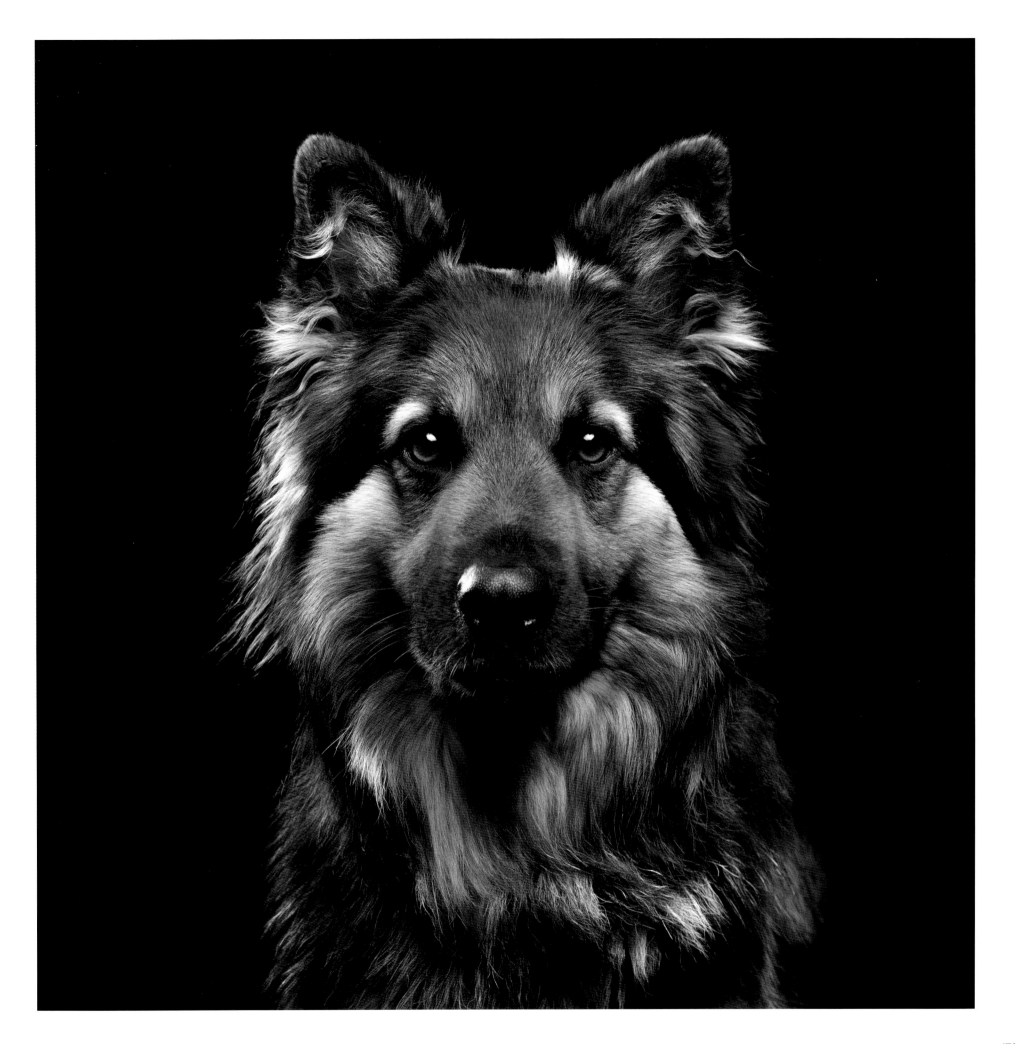

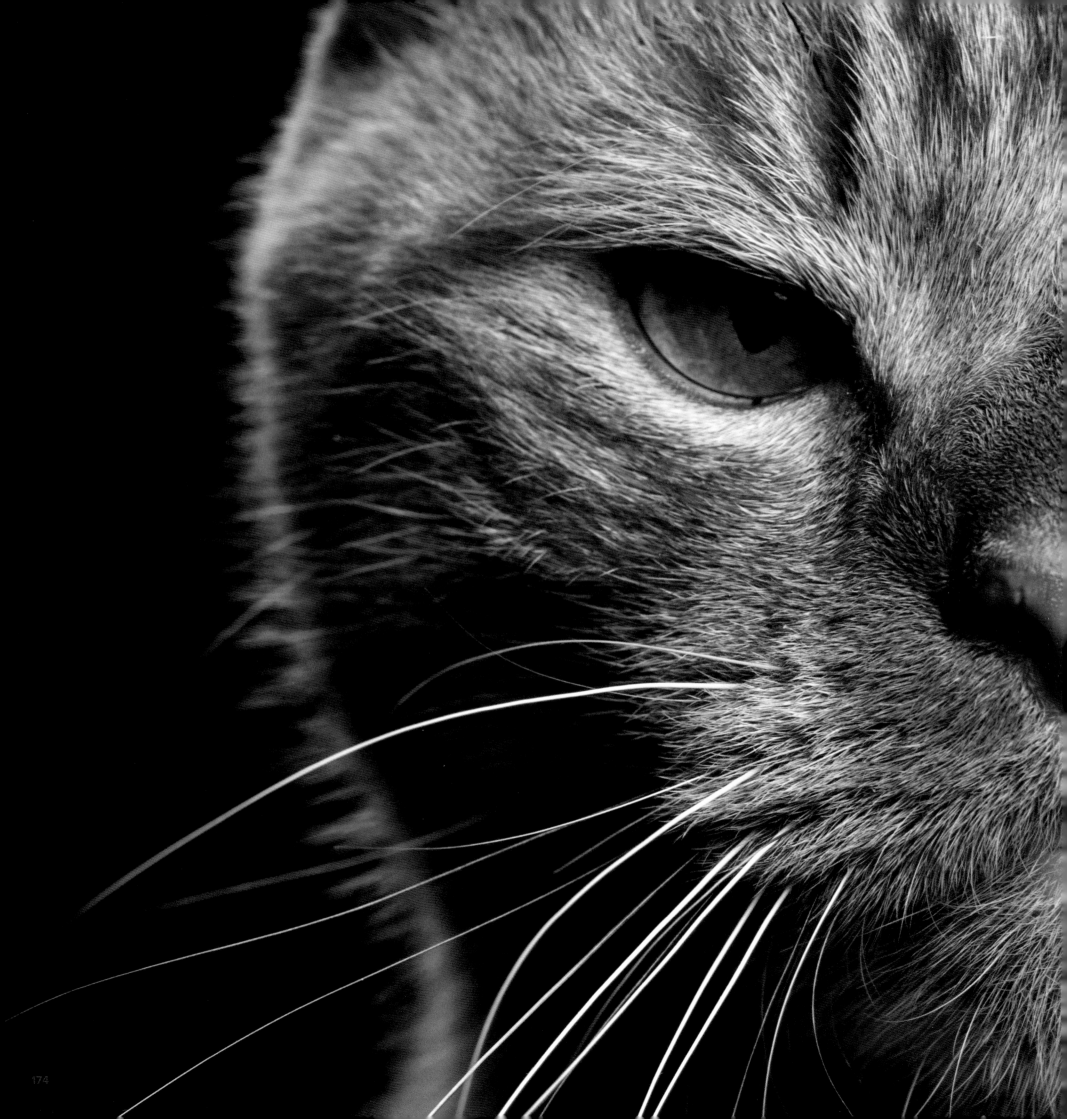

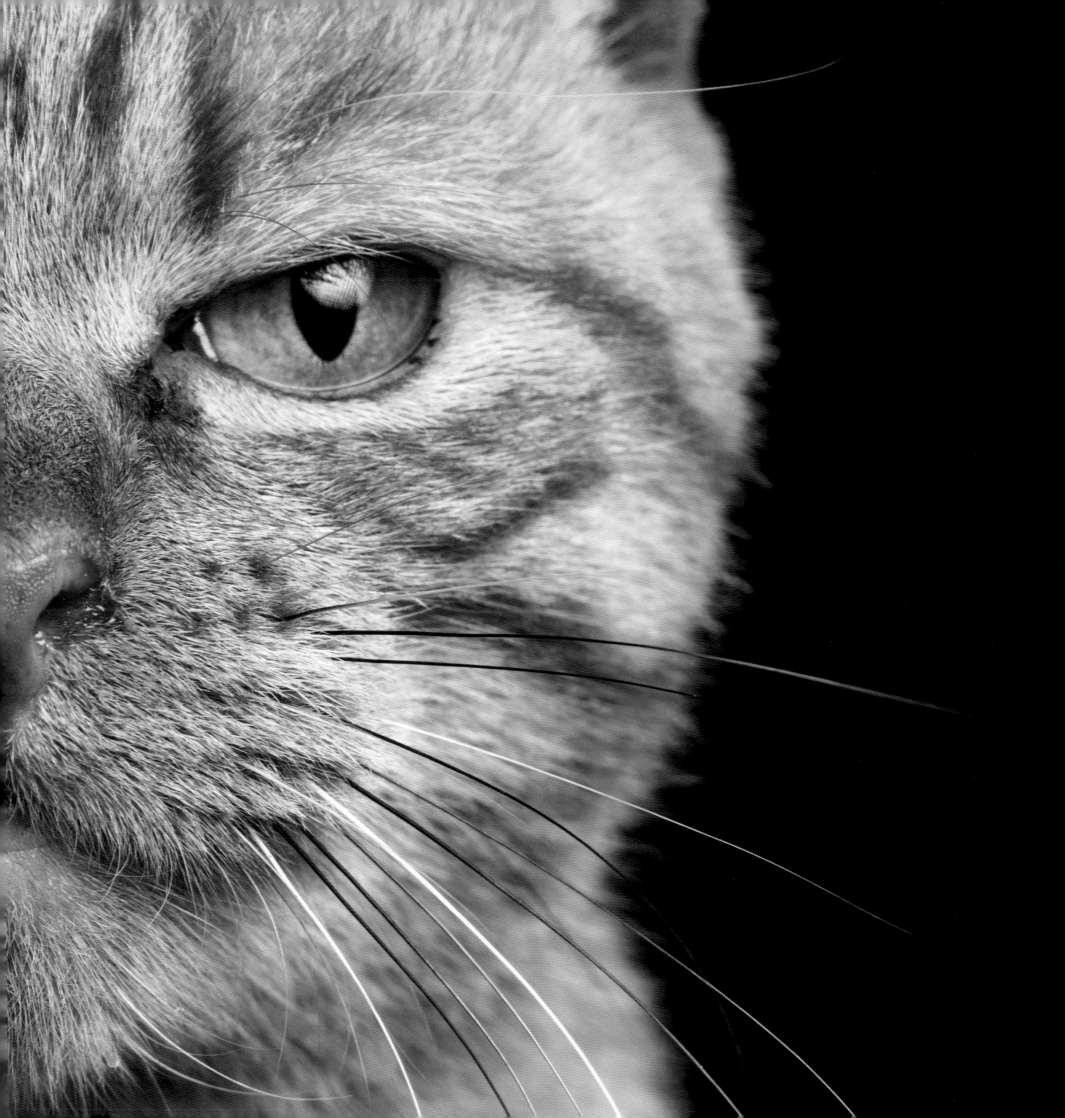

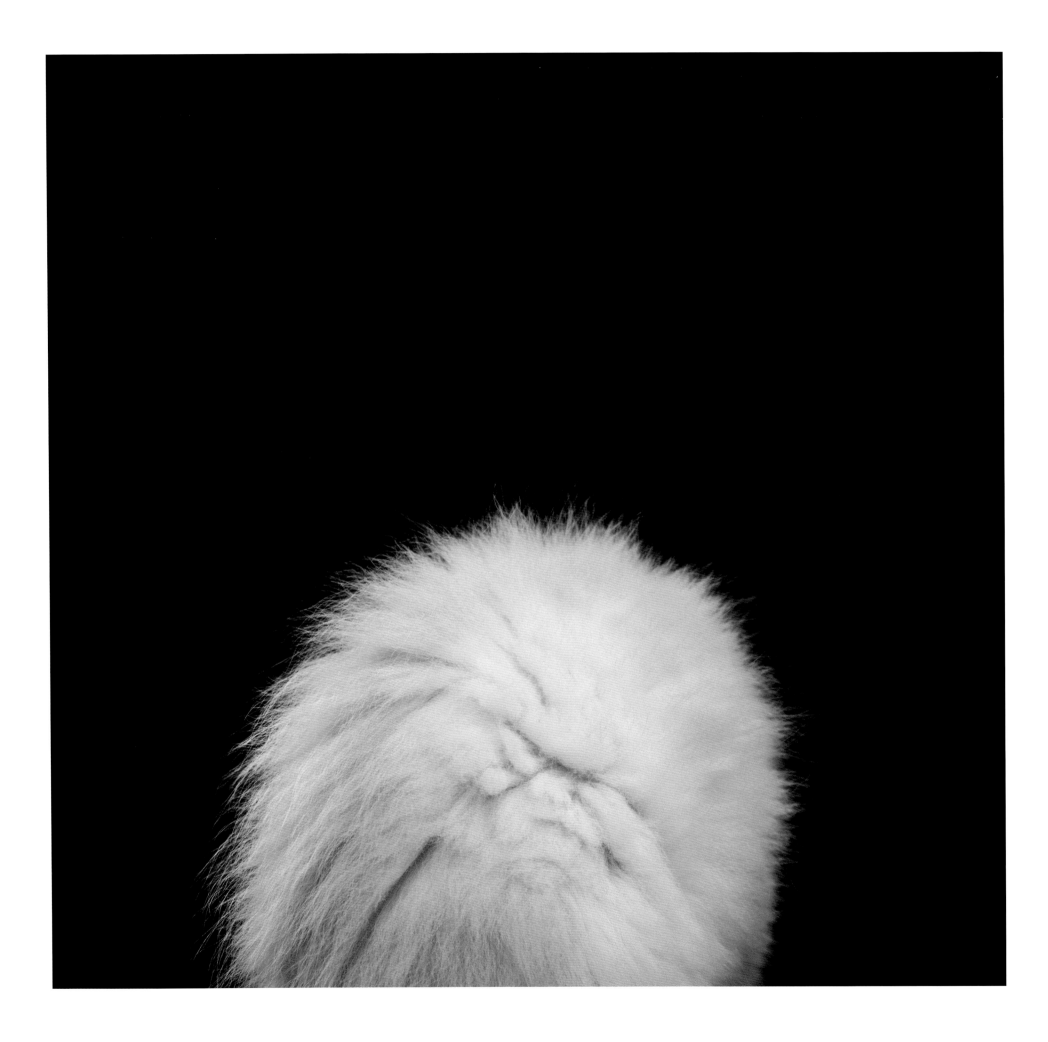

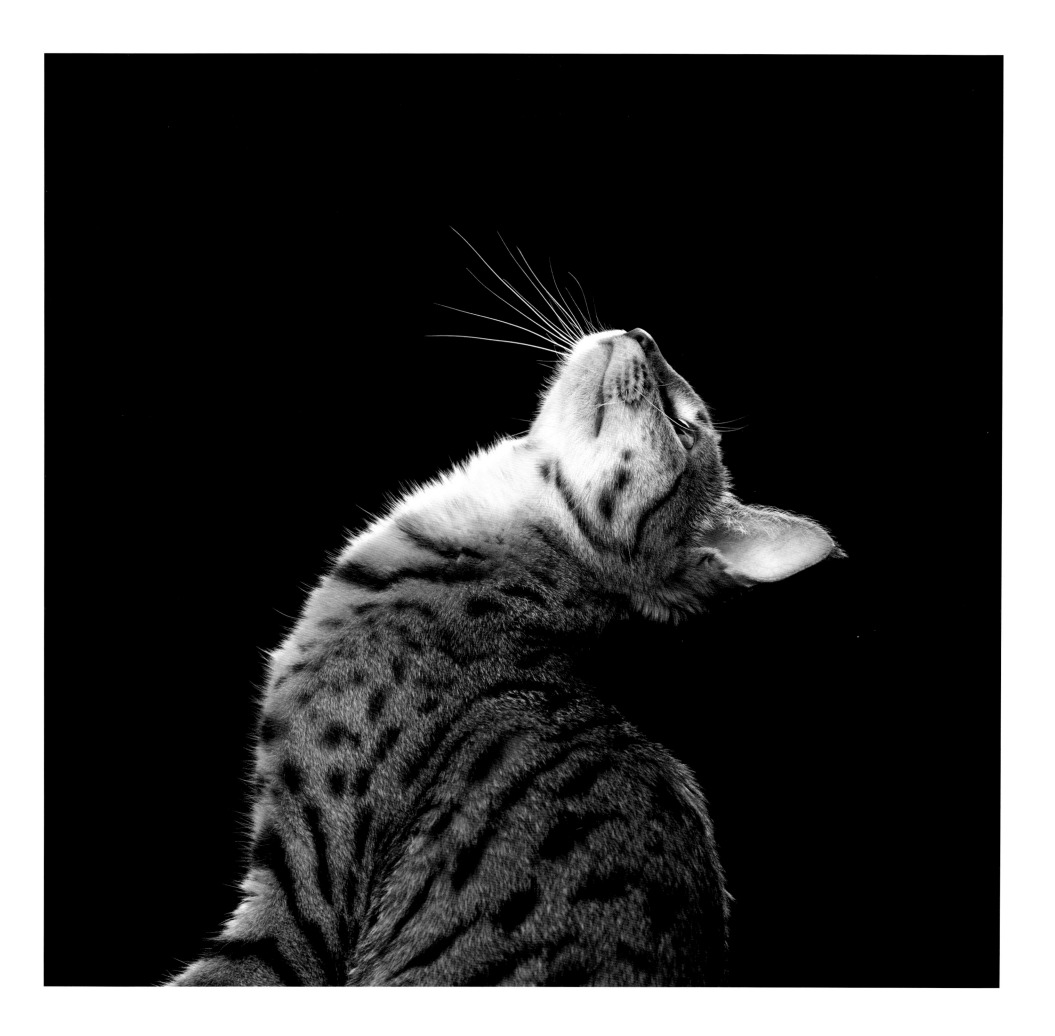

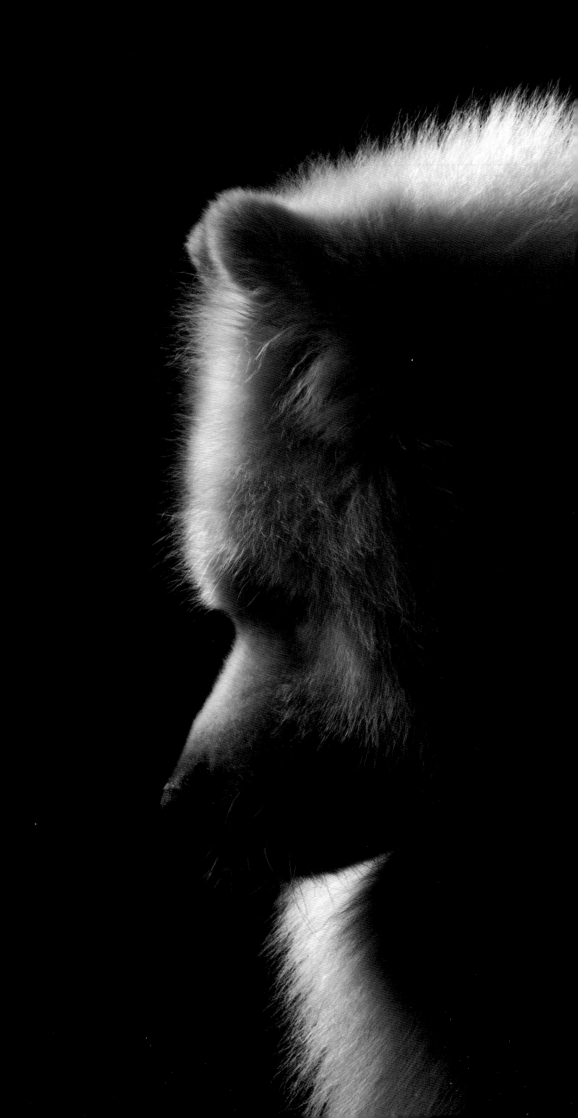

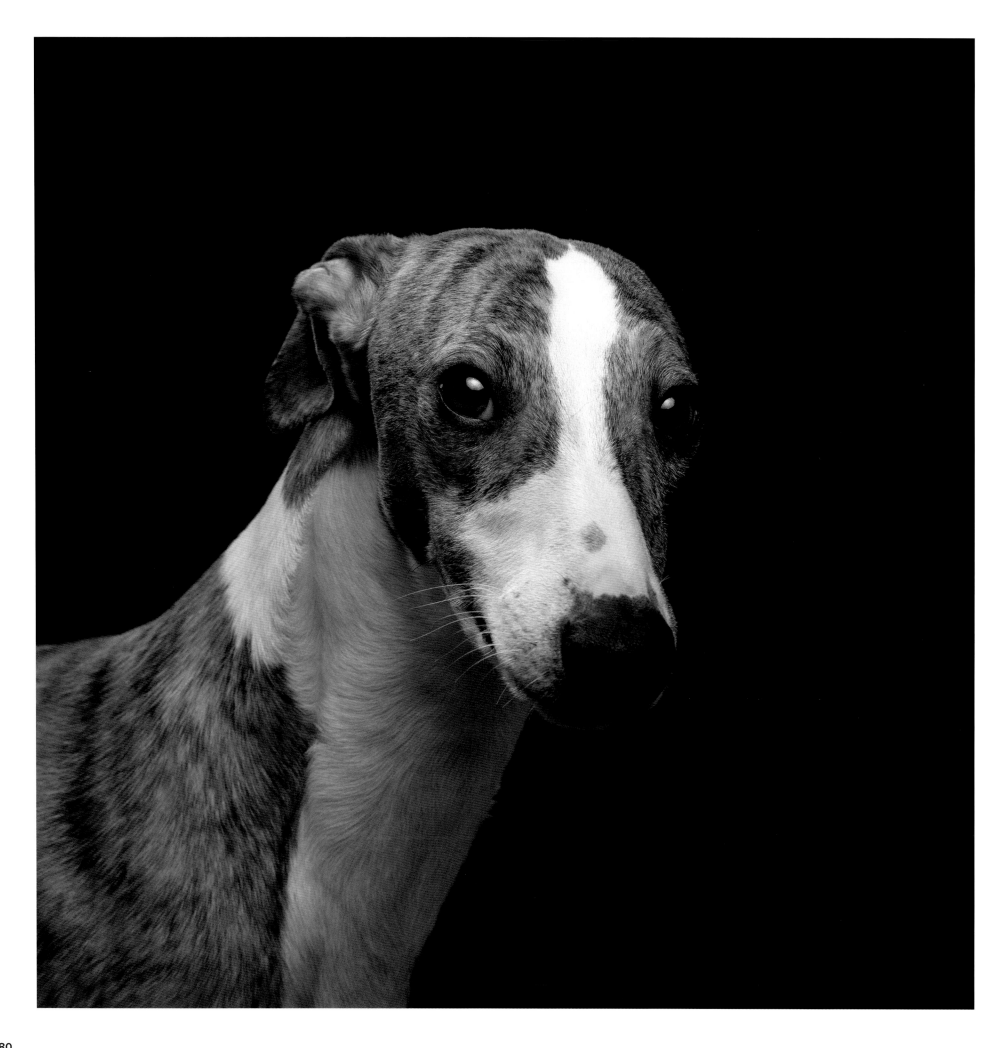

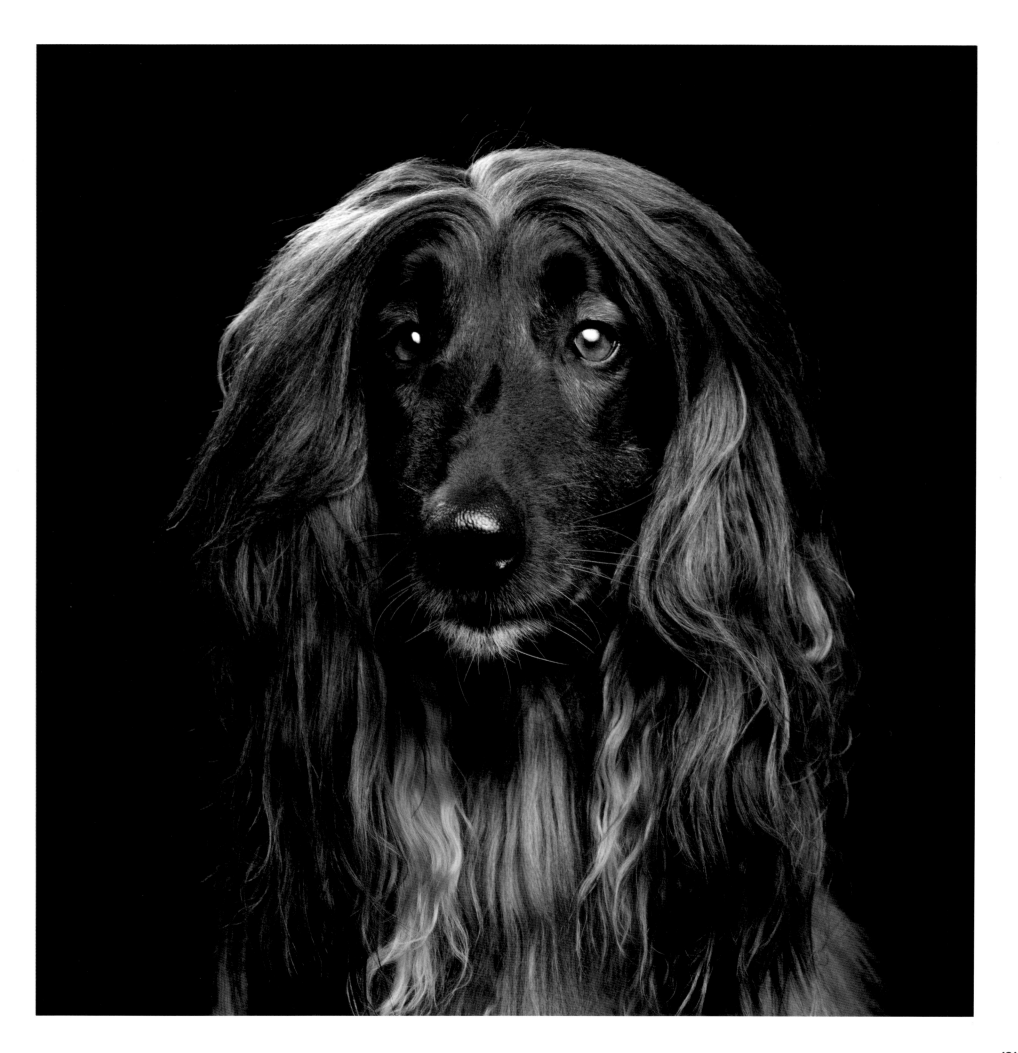

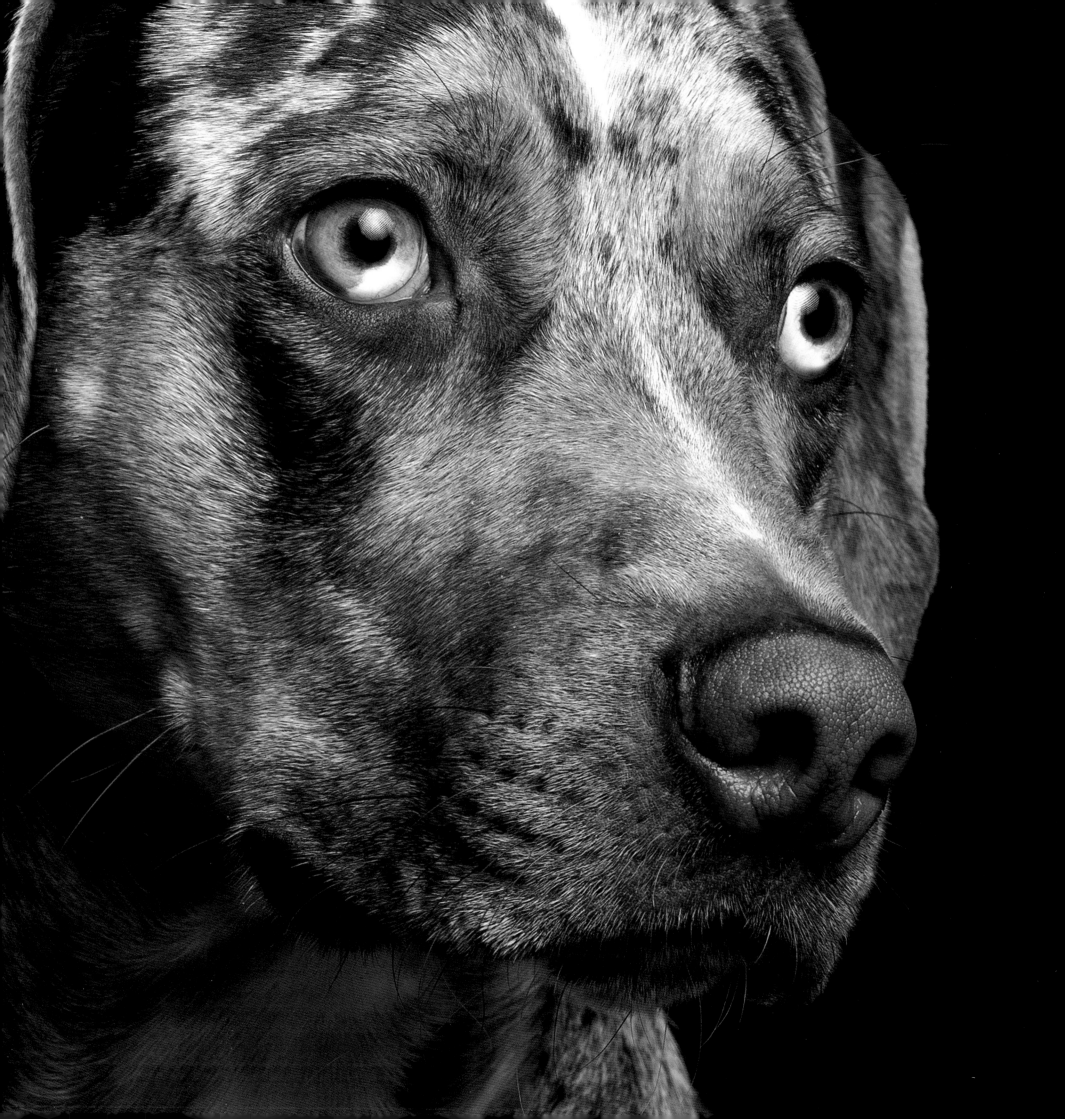

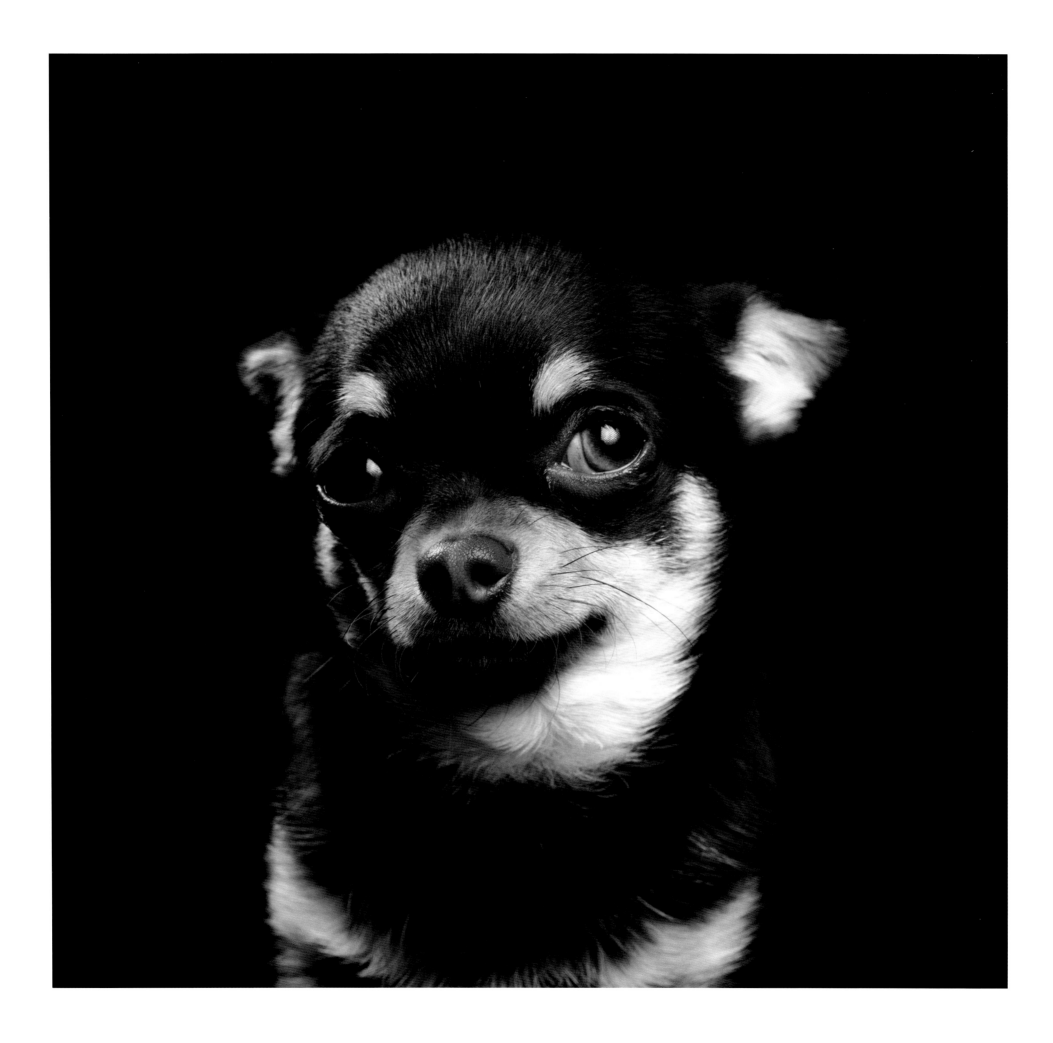

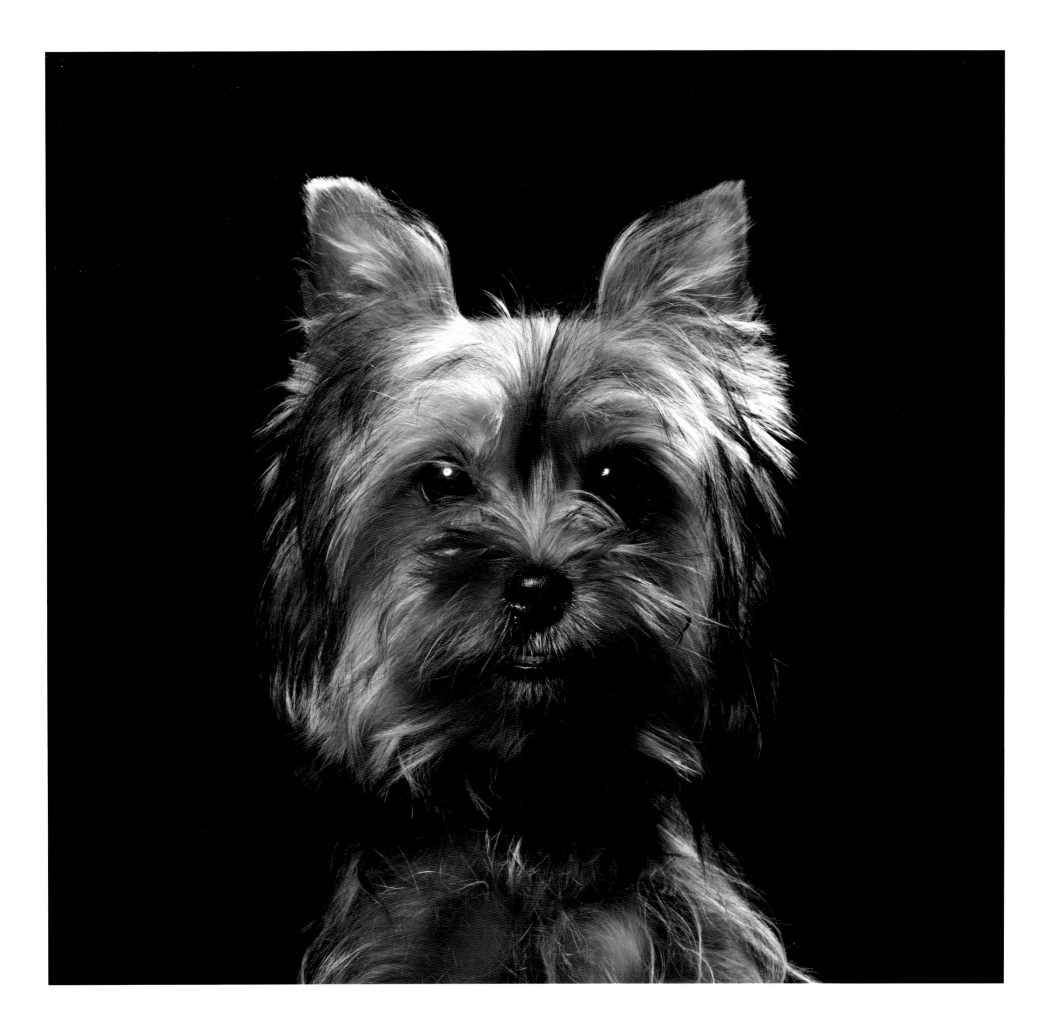

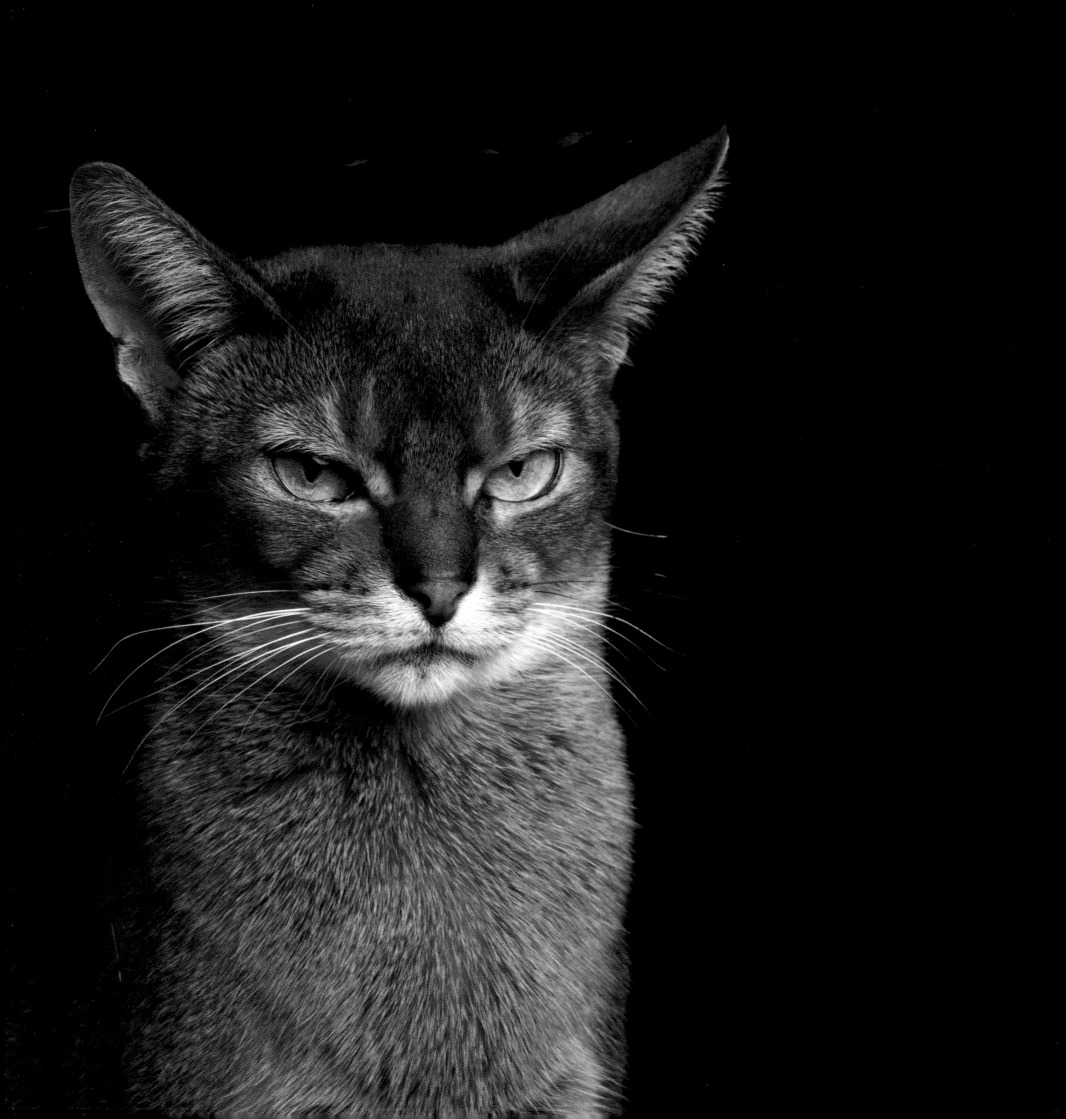

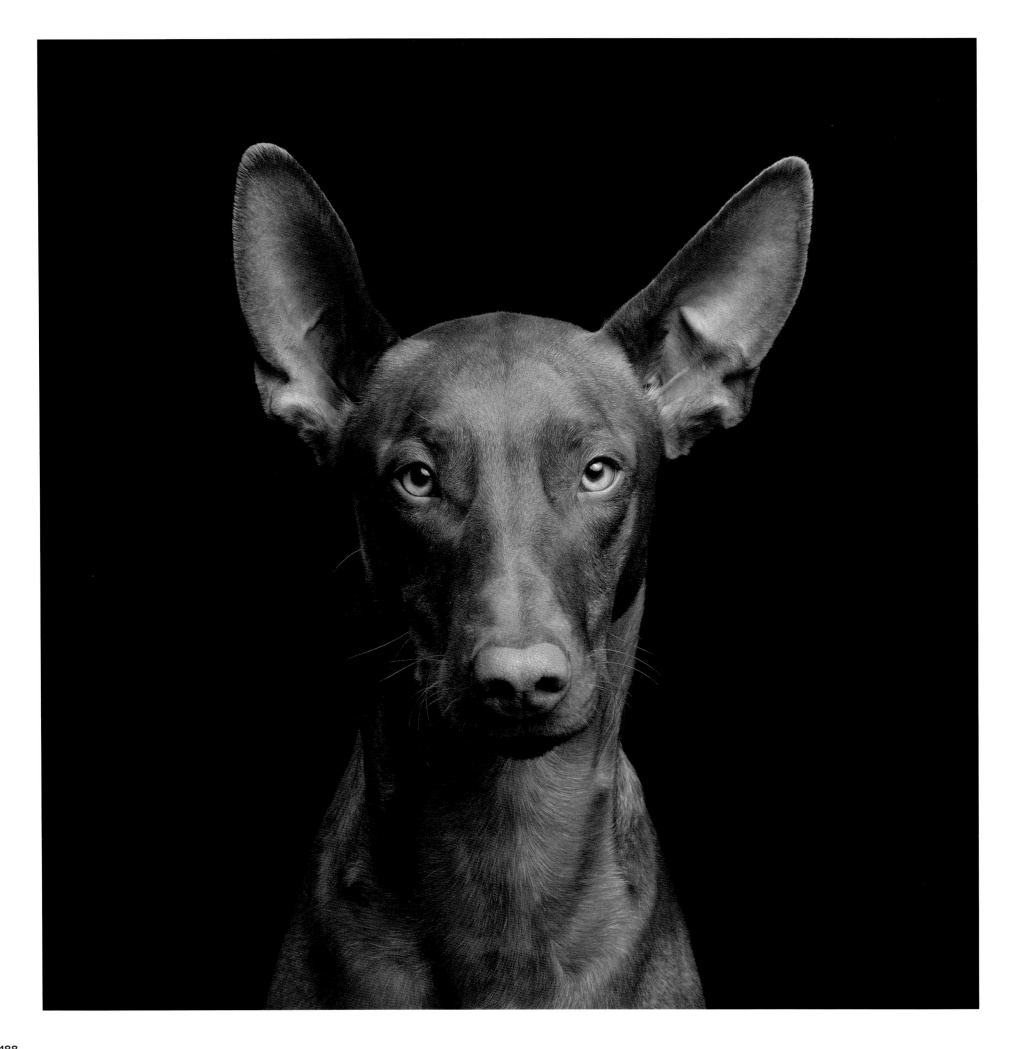

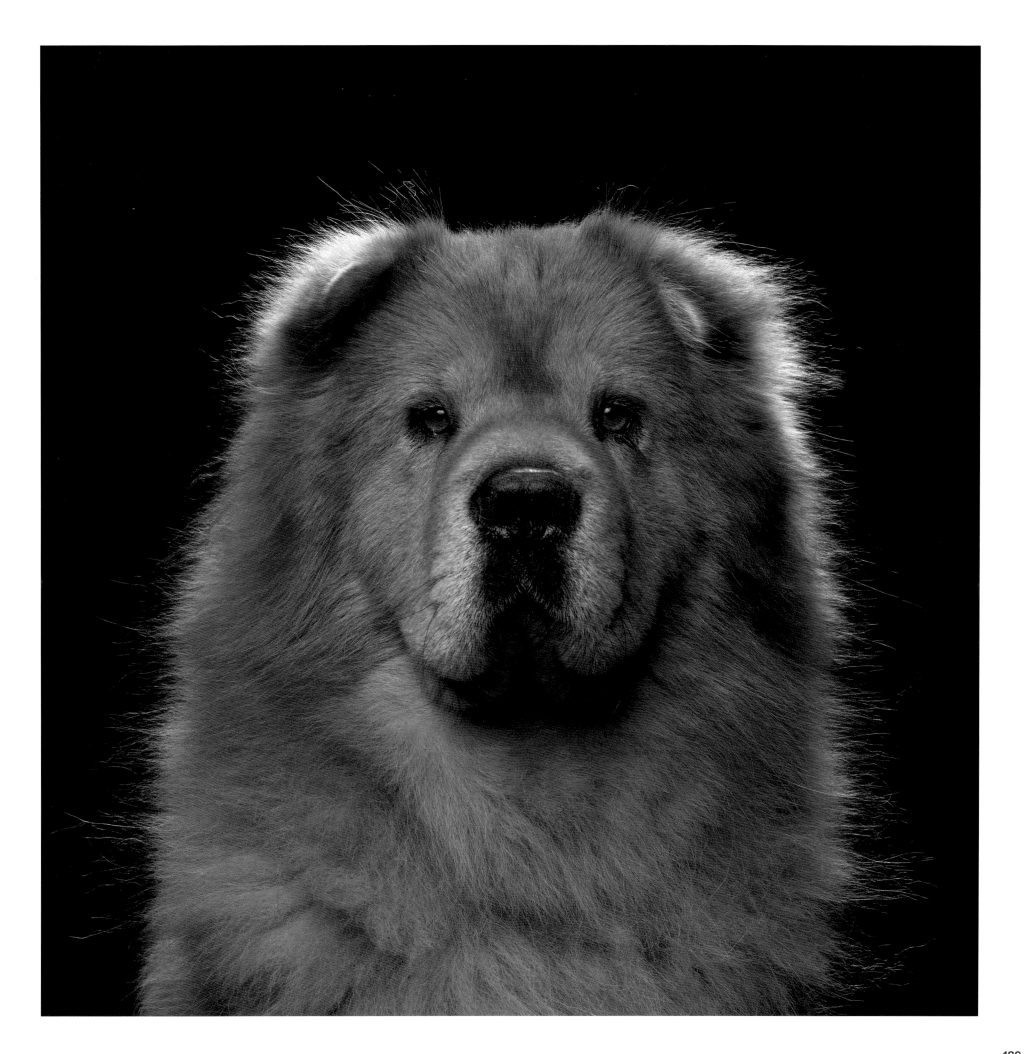

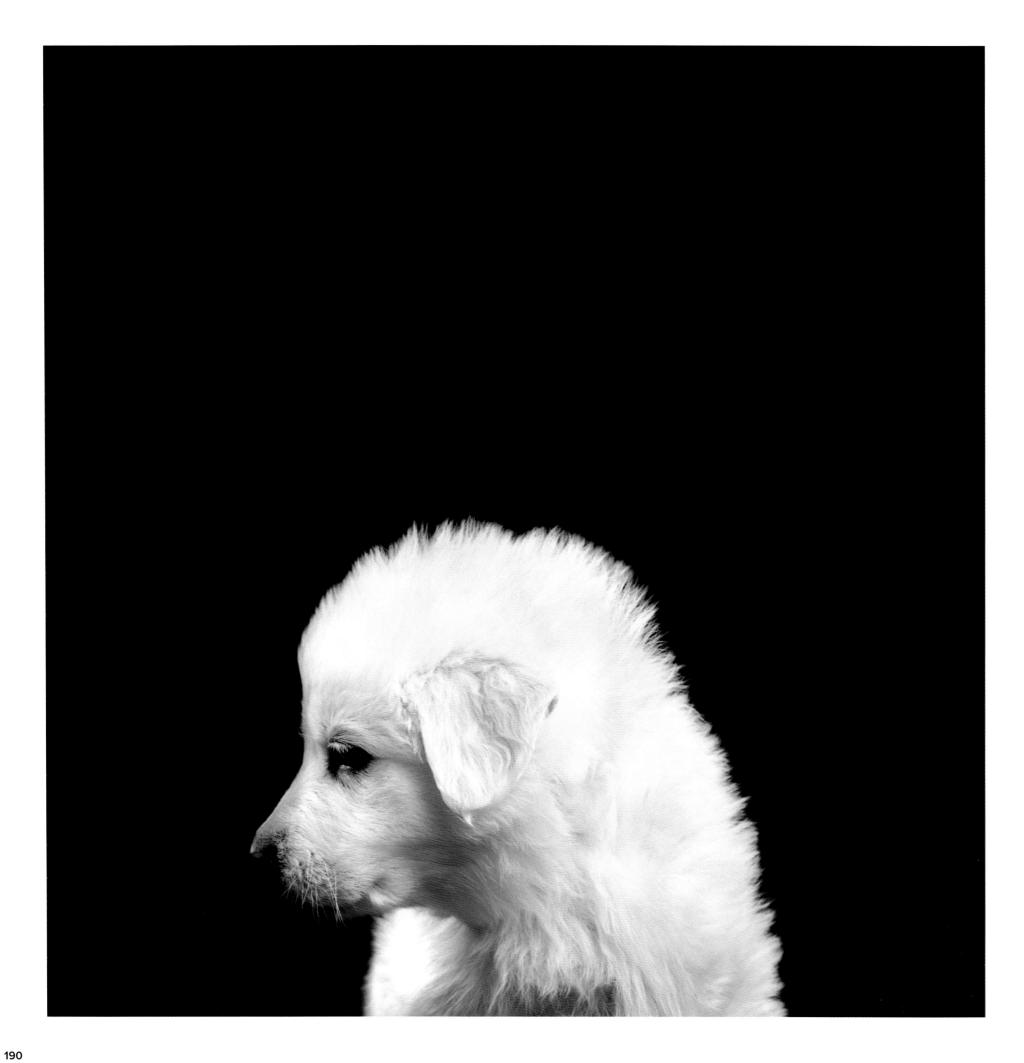

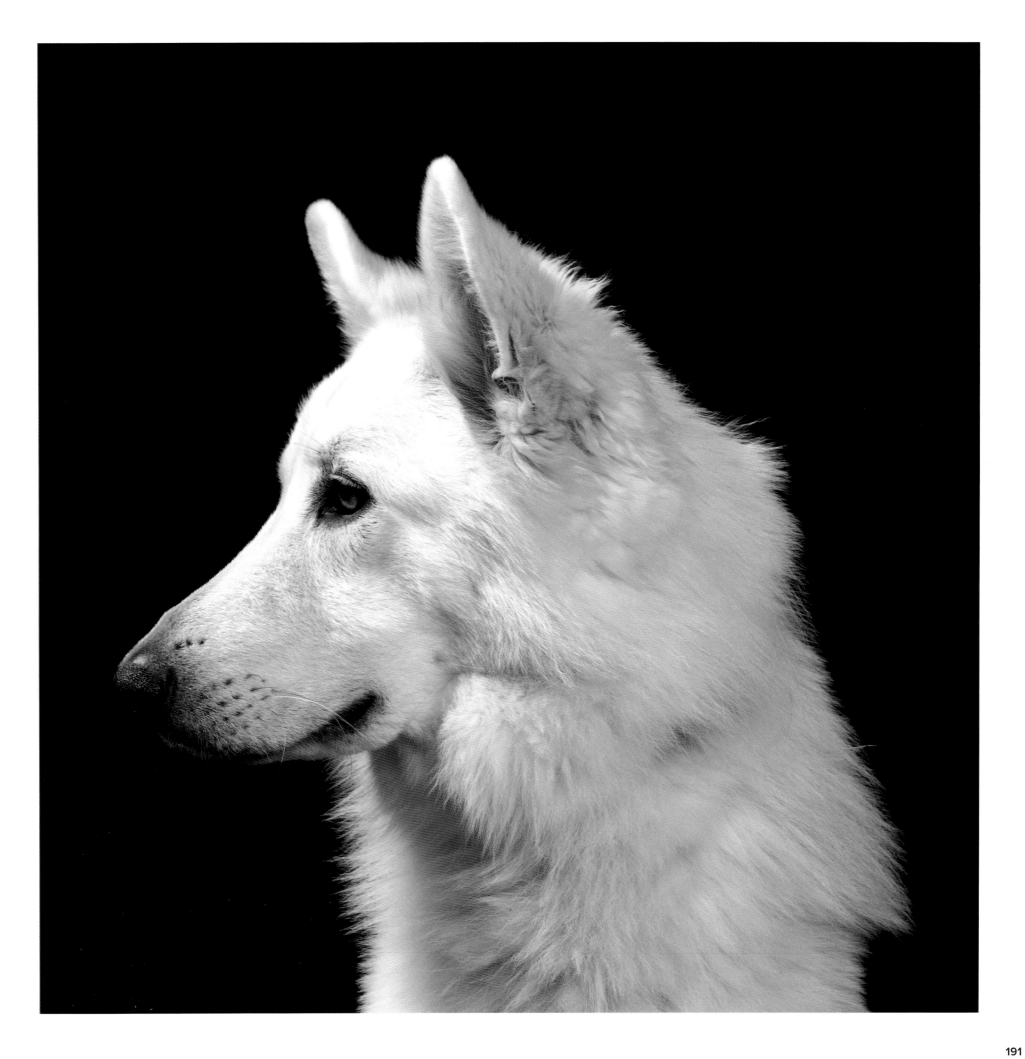

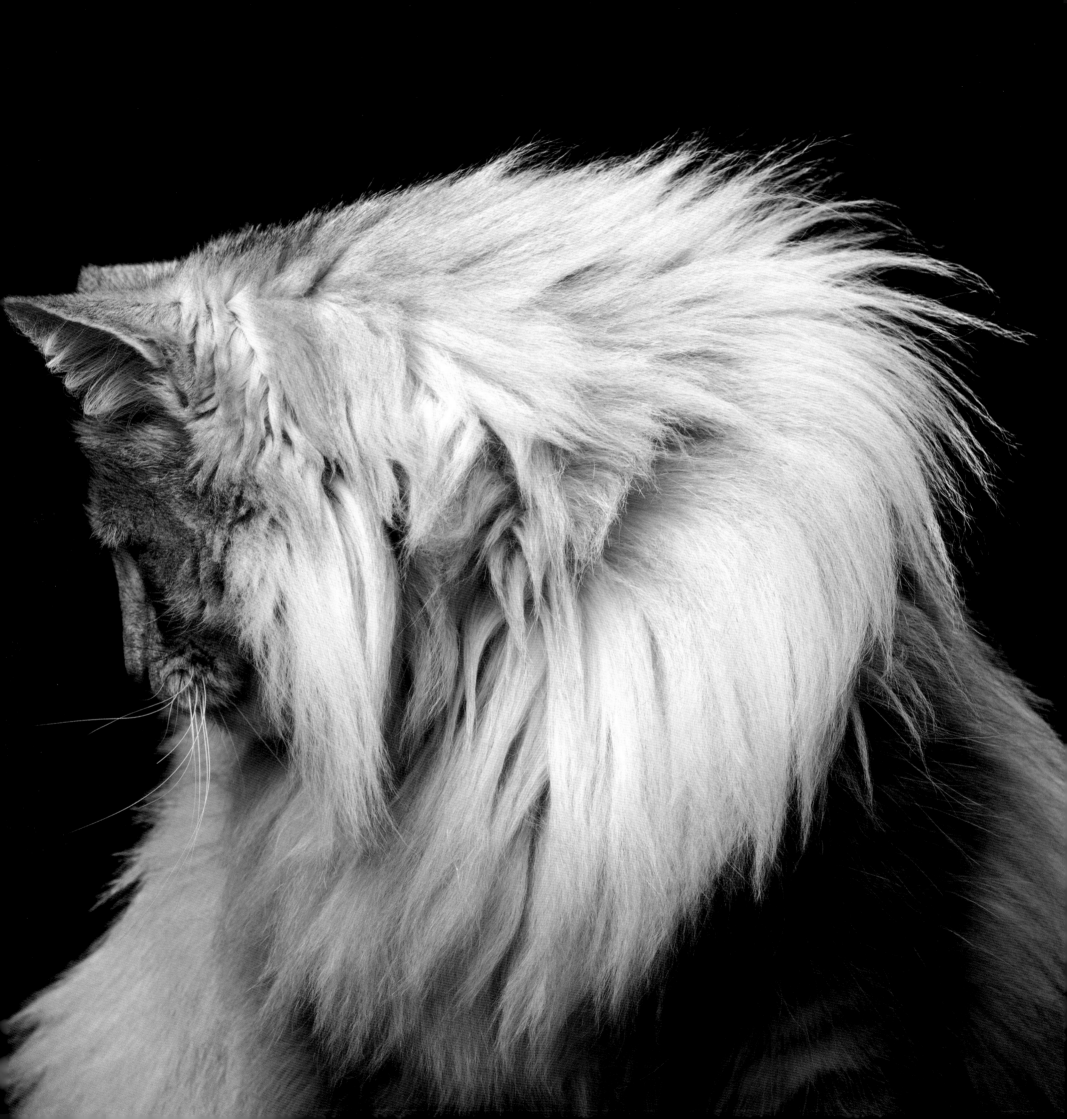

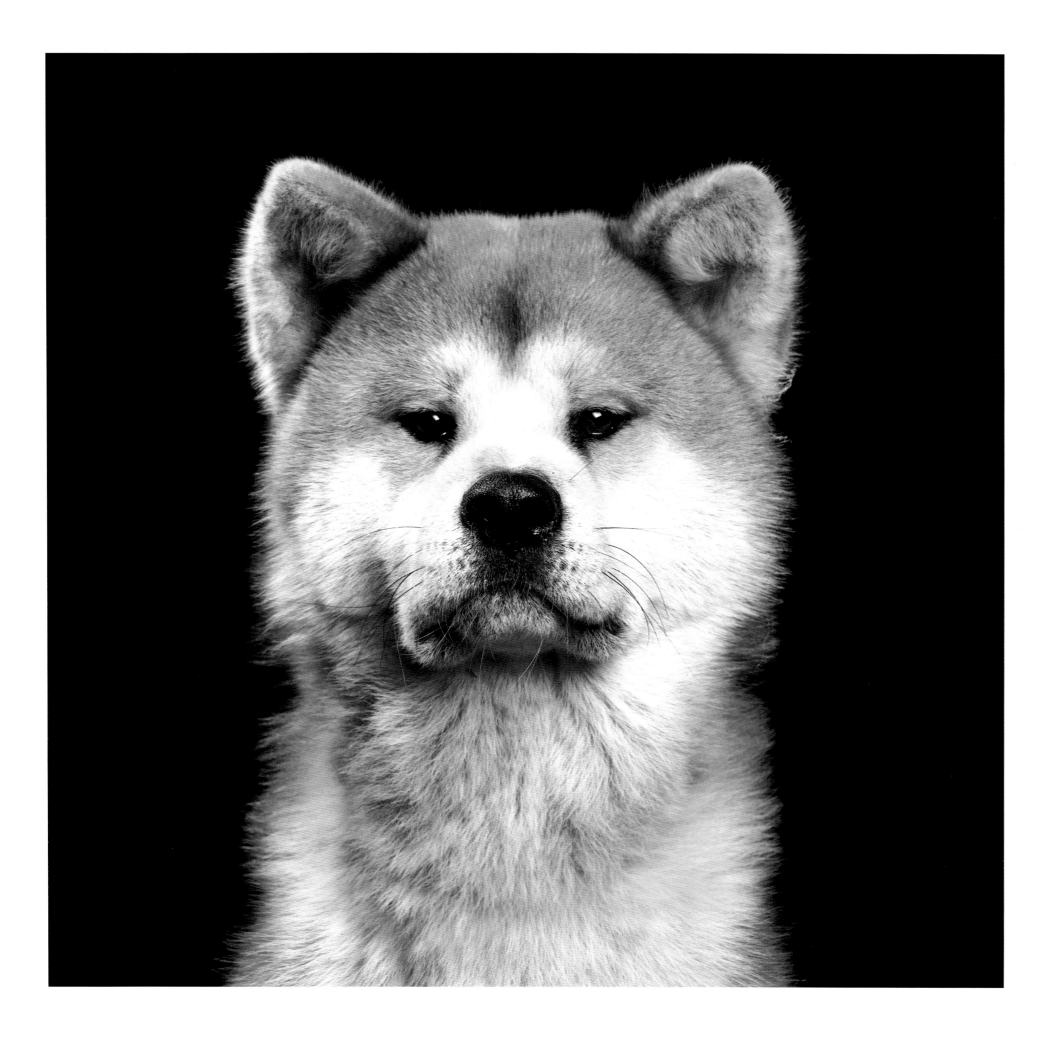

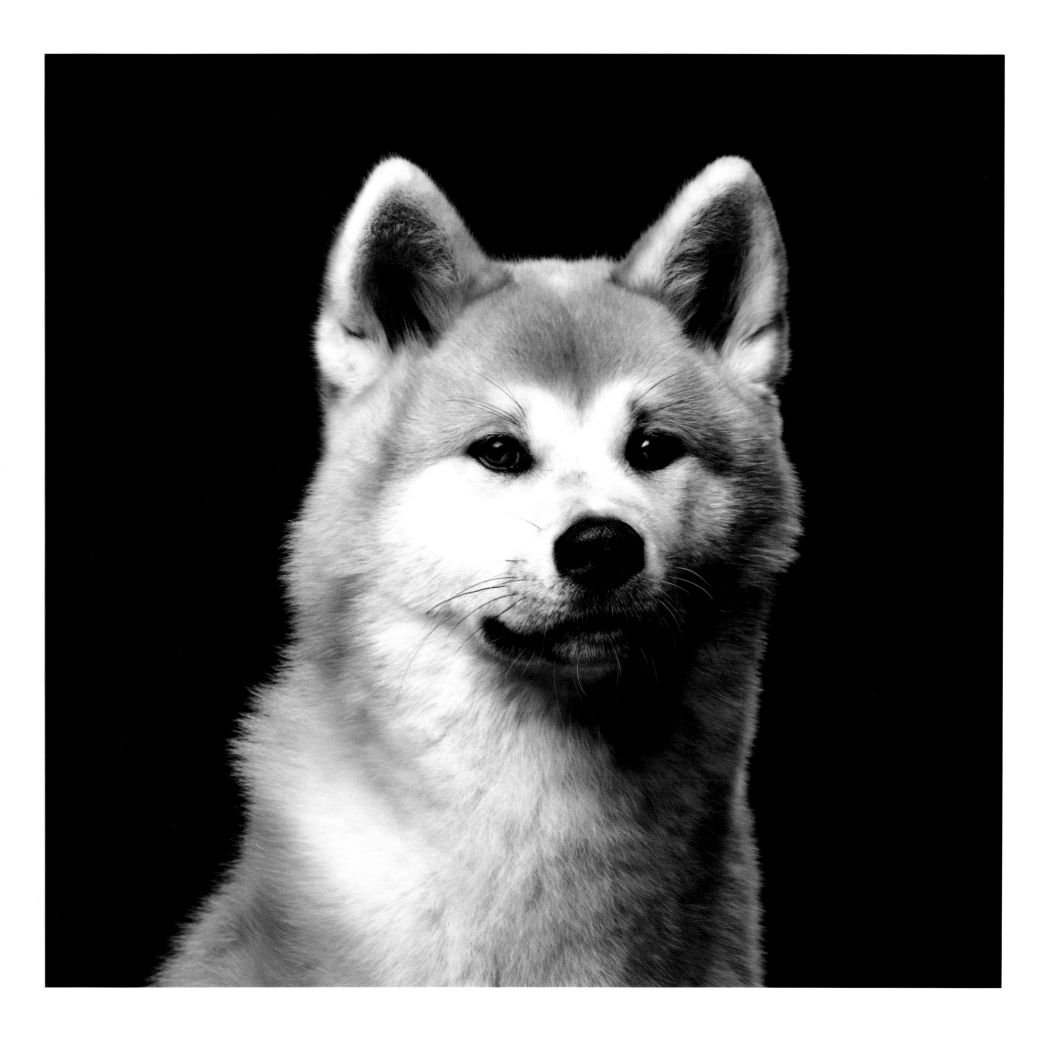

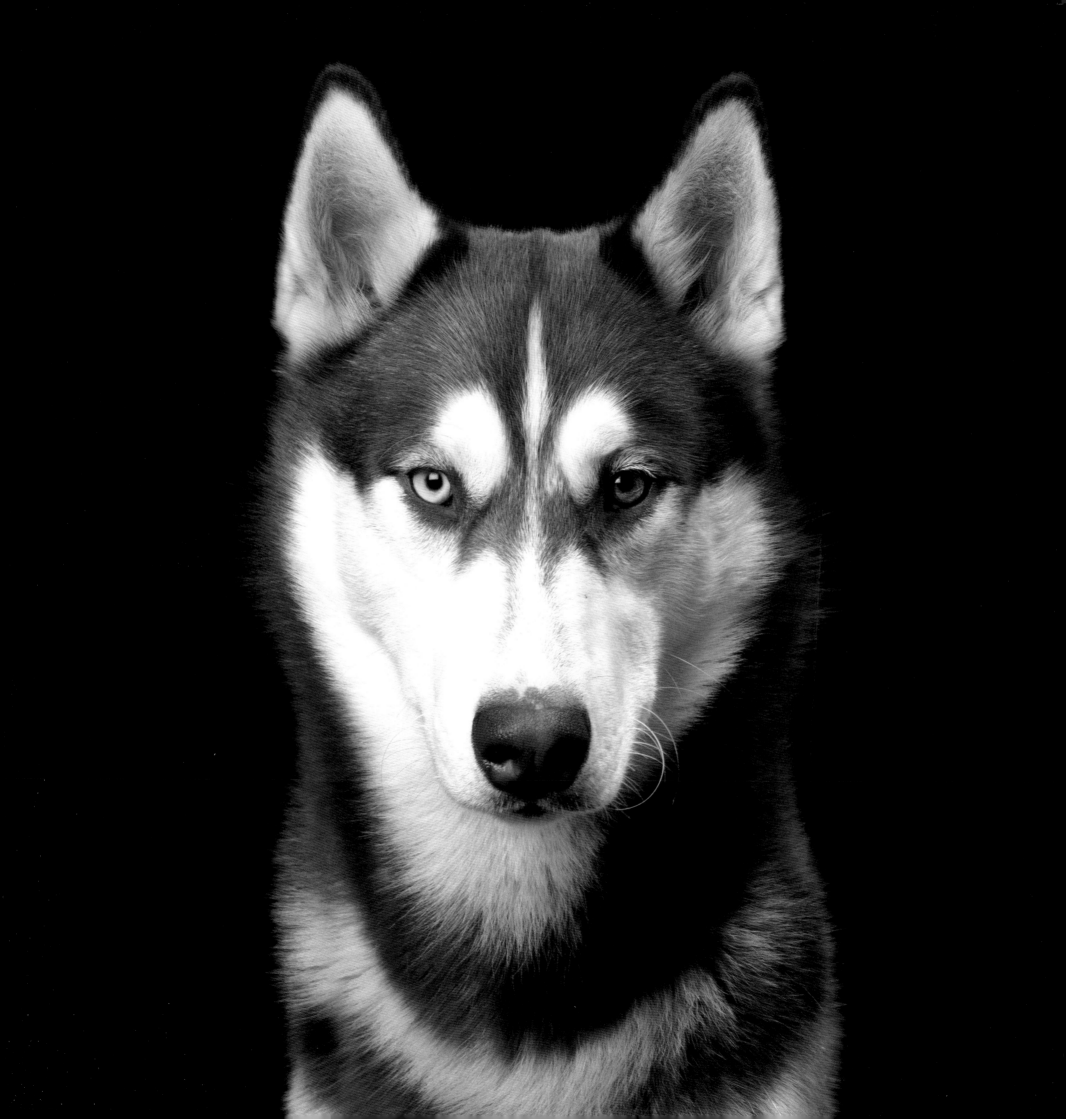

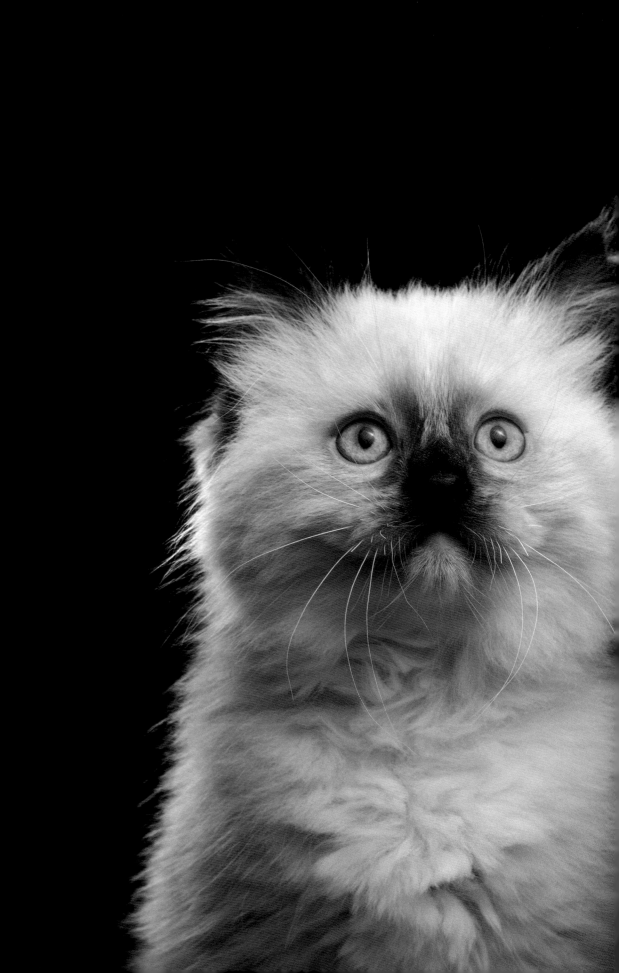

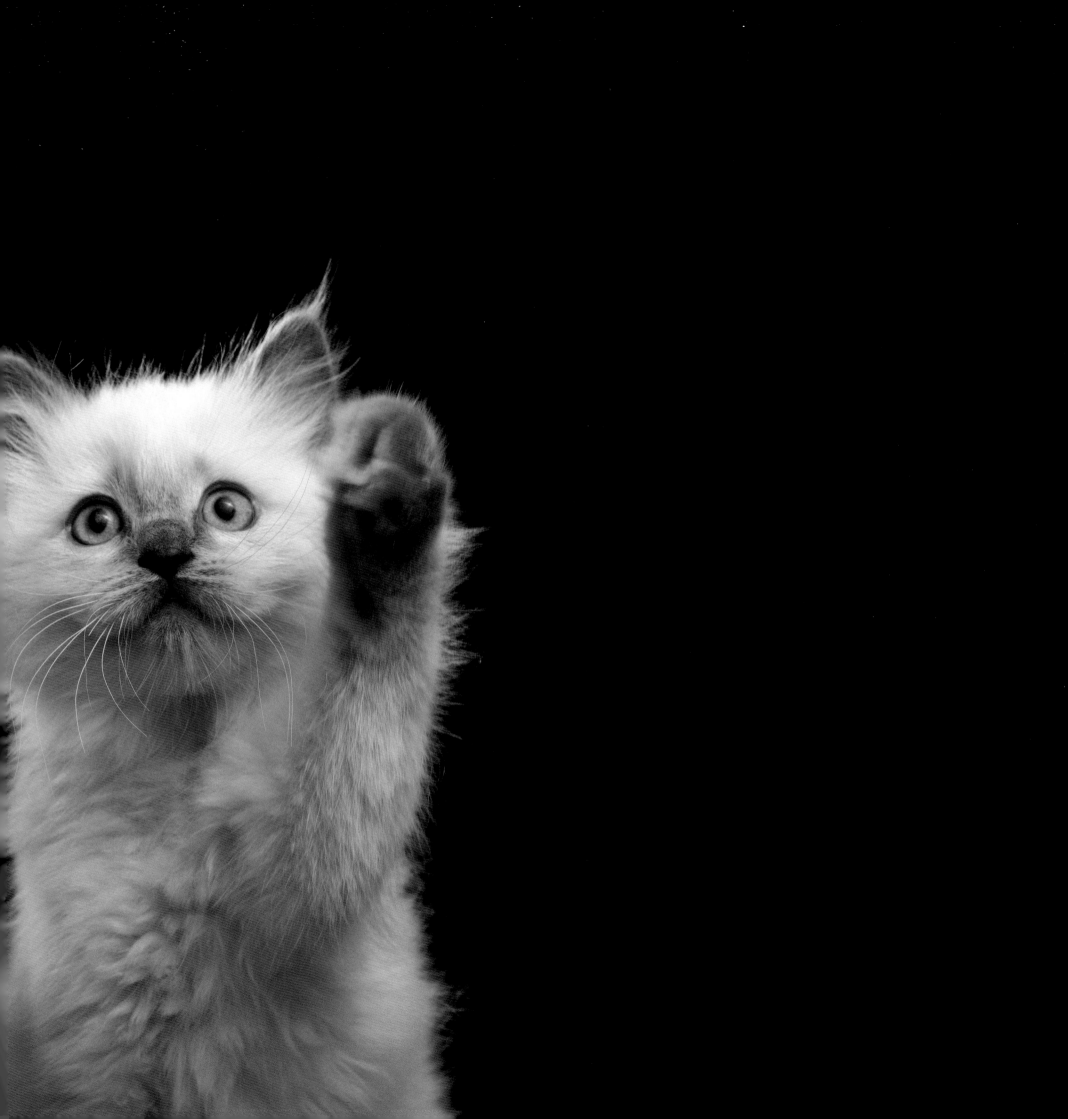

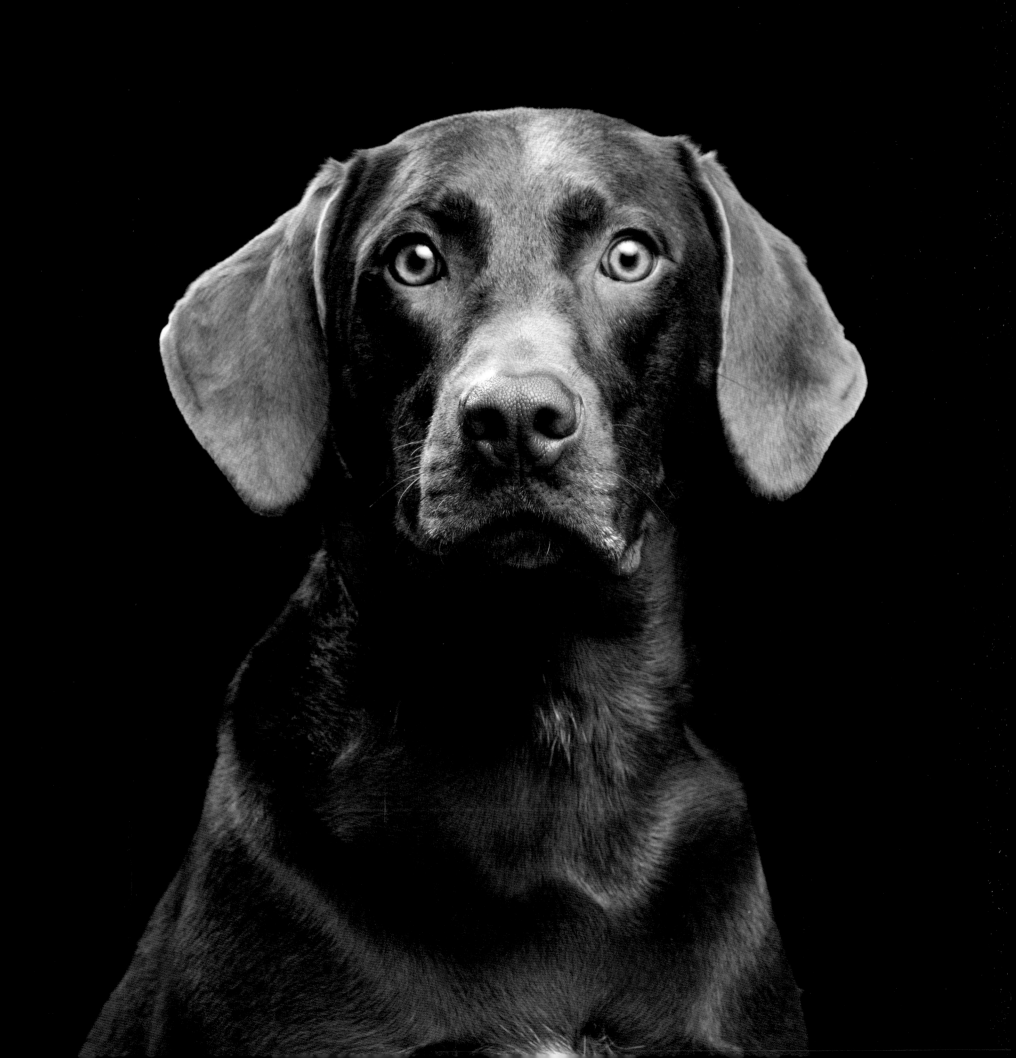

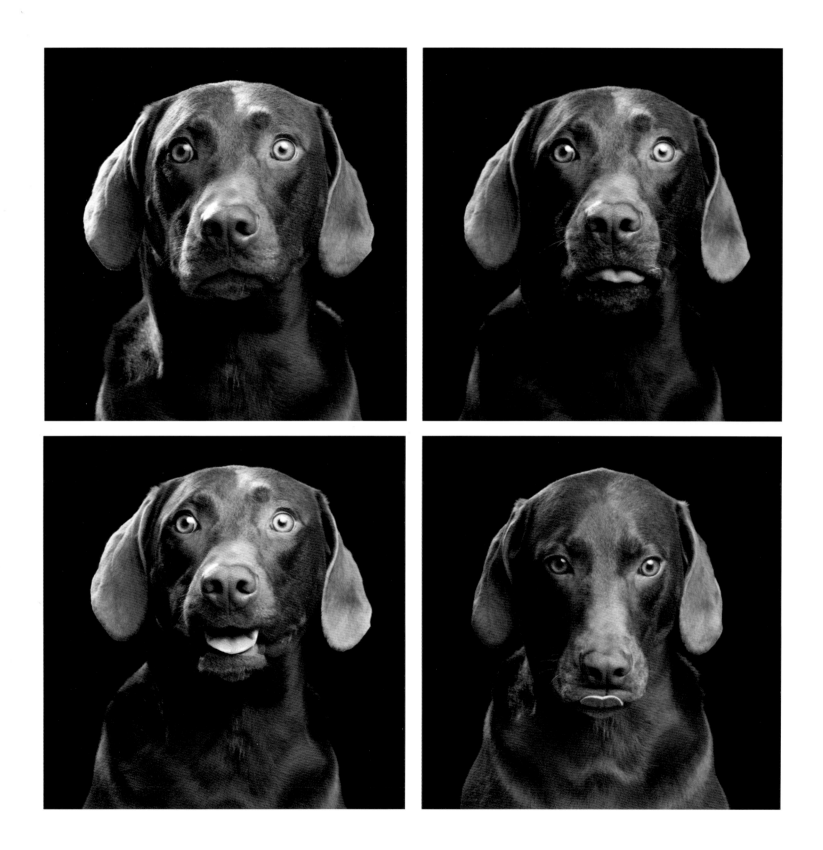

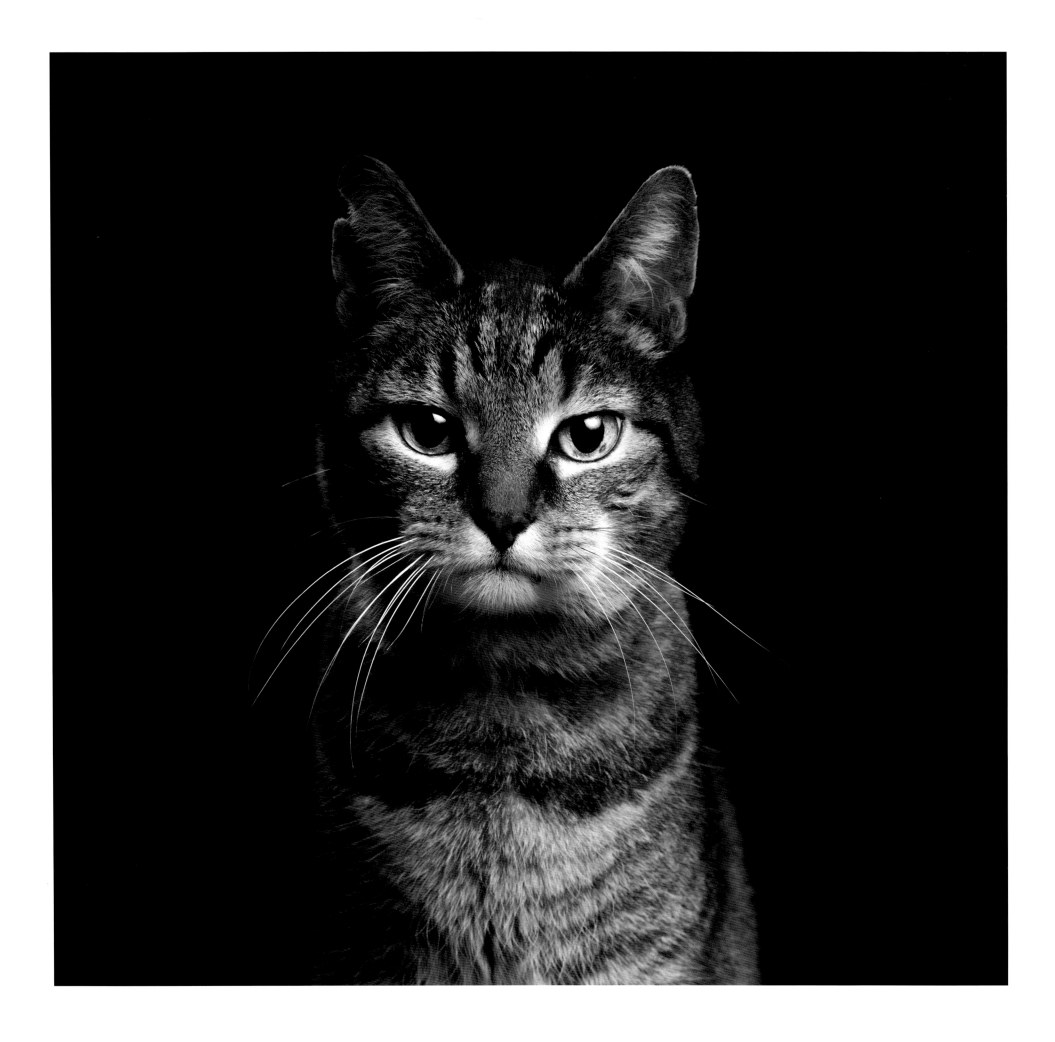

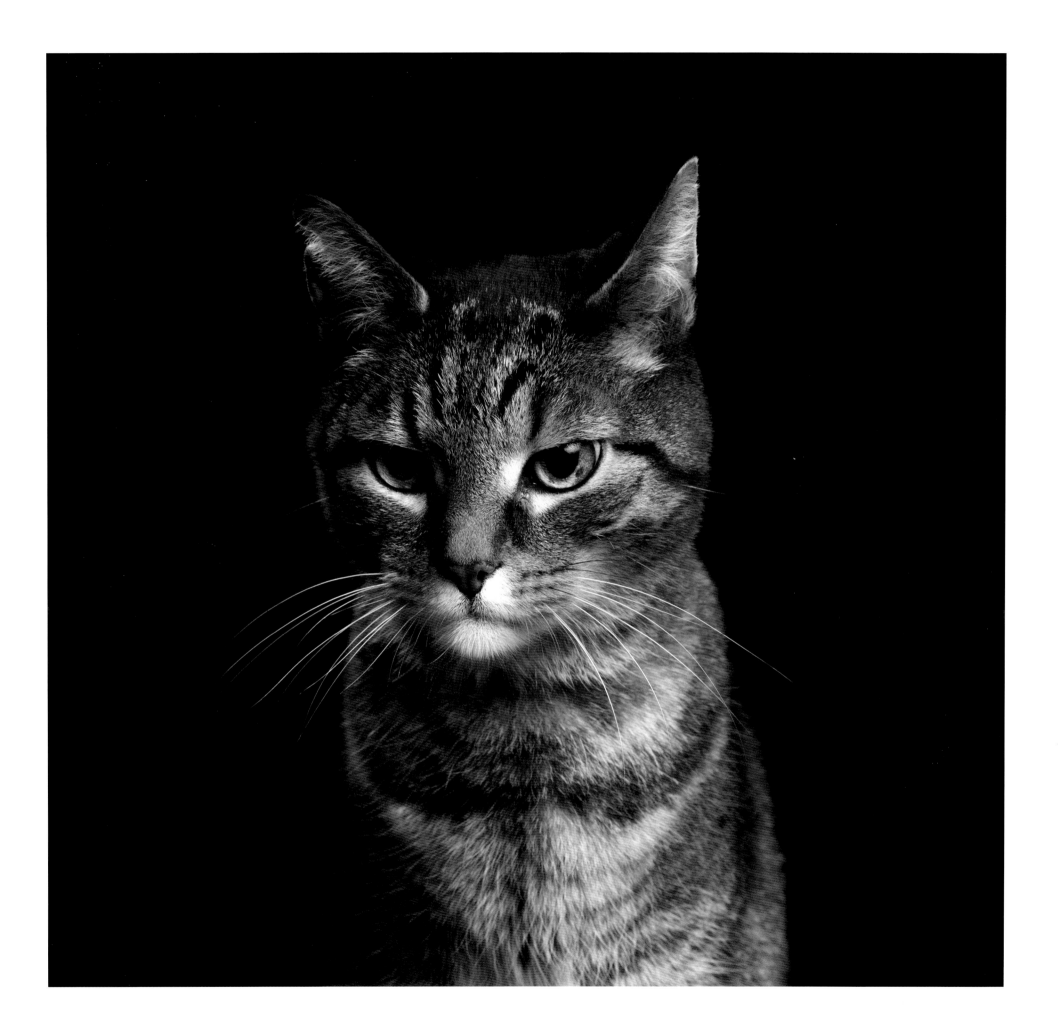

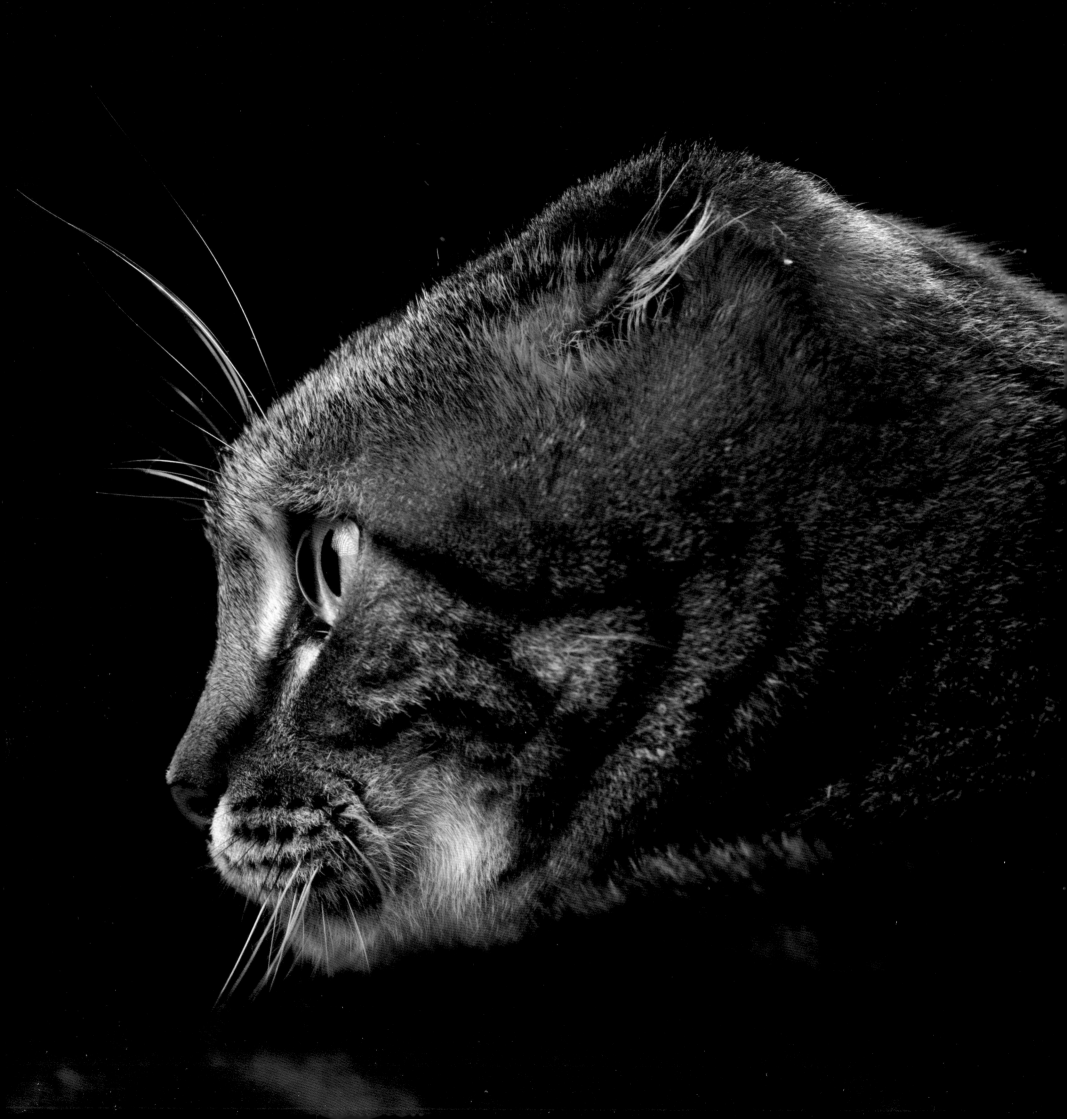

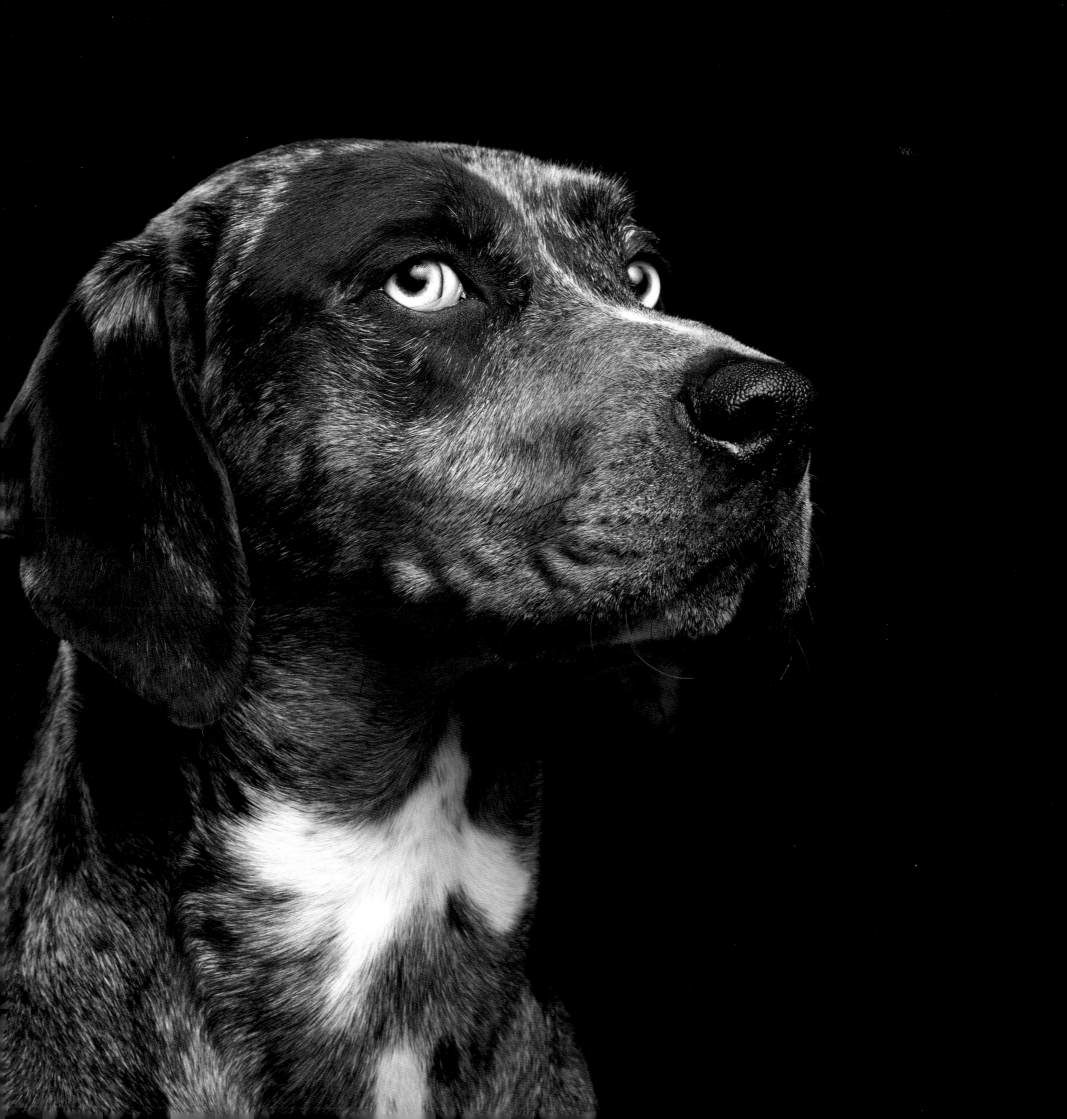

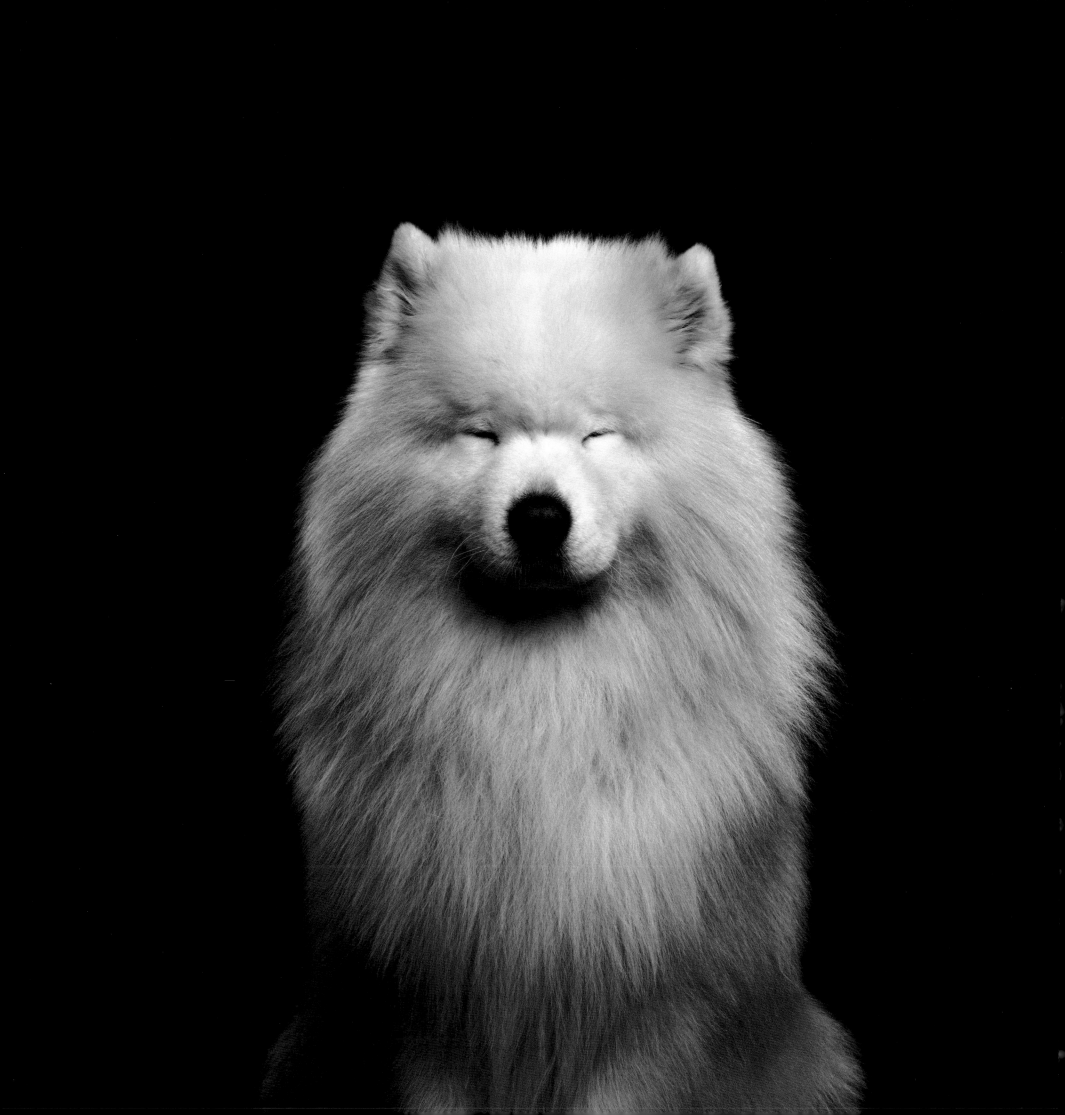

"Some people talk to animals. Not many listen though. That's the problem."

A.A. Milne

Technical Background

Almost every photograph was made with a Canon 5D Mark 3, with the exception of a few which were shot with a Hasselblad H5D-50. DSLRs are my tool of choice. They are fast, light and quite versatile. The MK3 has lightning-fast autofocus and excellent tracking. My subjects rarely sit still so a focus that follows them is quite important. Medium formats do not have this type of focusing, but if the animal can sit still I would obviously opt for the Hasselblad, there is hardly any comparison then. For my next project, I will likely opt for the 5DS. The resolution of a medium format camera with the speed of a DSLR. Absolutely ideal.

I exclusively use macro lenses for this series. My favourite, (and go-to) lens is the Canon 100m Macro f/2.8L IS. I do not know of many sharper lenses out there (with autofocus). Macros give me the option of coming in really close to the subject, which is more useful for cats than it is for dogs. In terms of settings, almost every photo was shot at a shutter speed of 1/200, with apertures ranging from f/8 to f/13 and an ISO at 100 all the time. The aperture varies on how bright the lights are firing.

At first, the idea of shooting a black cat against a black background seemed an unreasonable one. After a fair amount of trial and error I found a way to do it: edge lighting. This is really one of the most important facets of photographing against a dark background. By edge lighting, I am referring to a light source that outlines the subject so as to separate them from the background. Good edge lighting makes or breaks the image, especially with a darker animal. Add to this the fact that it offers the viewer a sense of depth. A one light set up with such a small subject can risk becoming flat if it is not supported with a fill or two.

I normally set up one, two or three lights, depending on the subject and the lighting style I am going for. I started with Bowens Gemini 500s, but now I use Profoto B1s. My main light is diffused by a large octabank with a honeycomb grid on it. The rear lighting alternates between medium-sized rectangular softboxes and small beauty dishes. The lighting setup is more or less the same on each shoot, with only the exposure values of the lights changing. There is no right or wrong in this, it boils down to what feels right. I take a number of test shots with a toy animal as my model to get it just right and to avoid wasting any time when the subject enters the frame. I could use a light meter but I have always found that I prefer a visual approach to a calculated one.

In terms of lighting setups, I have three styles that I like to shoot. My workhorse and go-to setup is a general, well lit two/three light setup, where the key light illuminates the subject from the front and there are one or two fill lights that highlight the edges to separate it from the background.

I call this clean portrait lighting (p.42, 103). The second is where I increase the exposure for the fill light and have that one serve as the key, to suggest the idea that there is a strong light source coming from above, I call this cellar lighting (p.6, 67, 137, 155). The third setup is one that pays homage to Michelangelo Merisi, better known as Caravaggio. I set one light up forty-five degrees above and behind the subject. Hard shadows are cast to produce a chiaroscuro (Italian; literally – light/shadow) leaving us with a dramatically lit composition (p.178). I did not include many of these in *Animal Soul* however.

I have been told that my portraits make photographing animals seem almost effortless. I can safely say that it is anything but that. Most of the time it is a long and relatively testing struggle. I first have to get to know the animal to have them warm up to me and trust me. I can sometimes skip the get-to-know-me phase in favour of their curiosity; if they are interested in me, they look at me. If the animal is scared of me or just scared in general, it is most likely a no-go. Getting a scared animal in place is possible, but getting them to look anything but terrified, especially considering how little these photos hide, is very difficult. You may be surprised about what you find if you deliberately set out to photograph an animal. With animals we often look for actions whereas, as you may have deduced by now, I avoid actions altogether in favour of stillness. It is that static moment that draws me in to the character, that moment of pause that often is only brief, but absolutely essential for the work I do.

Index

Page 4

Name: Alto
Breed: Abyssinian
Owner: Fam. Konink
Website: ravottersgaarde.nl

Page 6

Name: Baba
Breed: None / Arabian Domestic
Shorthair
Owner: Victoria M.

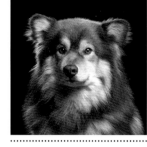

Page 9

Name: Ocho
Breed: Finnish Lapphund
Owner: Nanda T.
Website: peellappies.nl

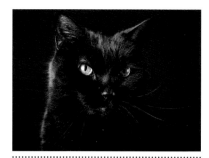

Page 10

Name: Tommy
Breed: None / European Domestic
Shorthair
Owner: Heleen R.

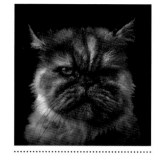

Page 13

Name: Gin
Breed: Persian Cat
Owner: Renée R.

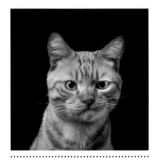

Page 14 (Also appears on p. 154, 174)

Name: Scuba
Breed: None / European
Domestic Shorthair
Owner: Elsa v. L.

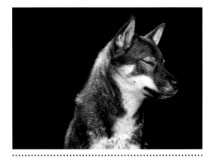

Page 16-17 (Also appears on p. 46)

Name: Chiyo
Breed: Shikoku Inu
Owner: Nico R.
Website: shikoku-ken.org

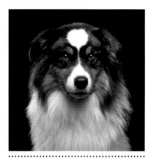

Page 18

Name: Rhythm
Breed: Australian Shepherd
Owner: Chiara & Co.
Website: lightitup4.webs.com

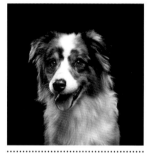

Page 19

Name: Medley
Breed: Australian Shepherd
Owner: Chiara & Co.
Website: lightitup4.webs.com

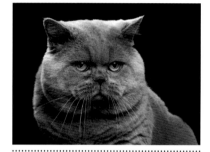

Page 20-21

Name: Whiseguy
Breed: British Shorthair
Owner: Brenda vd. L.

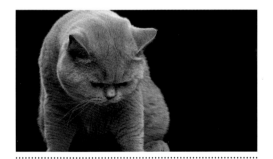

Page 22-23

Name: Guvnor
Breed: British Shorthair
Owner: Deborah T.
Website: britskorthaarengels.webs.com

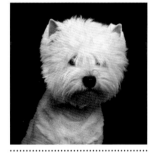

Page 24 (Also appears on p.25)

Name: Myra
Breed: West Highland
White Terrier
Owner: Ingrid V.

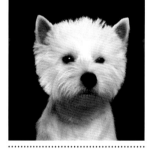

Page 25

Name: Happy
Breed: West Highland
White Terrier
Owner: Antoinette B.

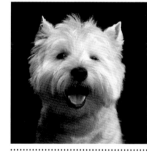

Page 25

Name: Iris
Breed: West Highland
White Terrier
Owner: Karin d. B.

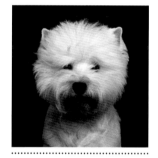

Page 25

Name: Abby
Breed: West Highland
White Terrier
Owner: Ingrid V.

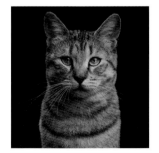

Page 27

Name: Eddie
Breed: Pixiebob
Owner: Karin v. E.
Website: dutchpixiebob.nl

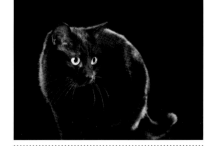

Page 28-29 (Also appears on p.83)

Name: Tartufo
Breed: None / European Domestic
Shorthair
Owner: Marit S.

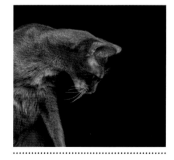

Page 30

Name: Queen
Breed: Abyssinian
Owner: Fam. Konink
Website: ravottersgaarde.nl

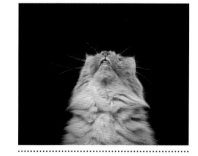

Page 31

Name: Sientje
Breed: Maine Coon
Owner: Marjan B.
Website: boonland.nl

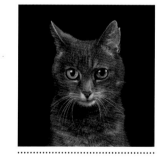

Page 33

Name: Nikky
Breed: None / European
Domestic Shorthair
Owner: Julia H.

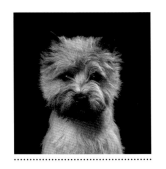

Page 34,35

Name: Poker
Breed: Cairn Terrier
Owner: Norah S.
Website: cloudofjoycairnterriers.nl

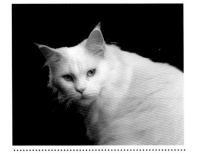

Page 36-37

Name: Peony
Breed: Maine Coon
Owner: Marjan B.
Website: boonland.nl

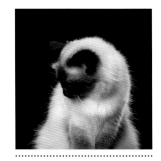

Page 38

Name: Farah Inés
Breed: Birman
Owner: Marja L.
Website: deluro.nl

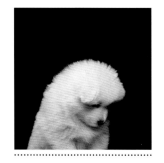

Page 39

Name: Finn
Breed: Samoyed
Owner: Stana
Website: sam-samoyed.nl

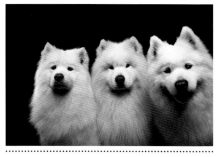

Page 40-41

Name: Yuki, Sam & Puk
Breed: Samoyed
Owner: Stana
Website: sam-samoyed.nl

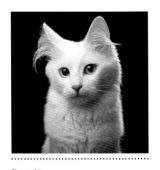

Page 42

Name: Smoke
Breed: Turkish Angora
Owner: Marianne
Website: havvanur.nl

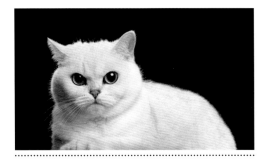

Page 44-45

Name: Tenenssee
Breed: British Shorthair
Owner: Brenda vd. L.

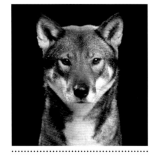

Page 46

Name: Sumi
Breed: Shikoku Inu
Owner: Nico R.
Website: shikoku-ken.org

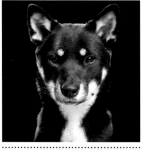

Page 46 (Also appears on p.77)

Name: Haru
Breed: Shikoku Inu
Owner: Nico R.
Website: shikoku-ken.org

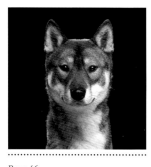

Page 46

Name: Tetsu
Breed: Shikoku Inu
Owner: Nico R.
Website: shikoku-ken.org

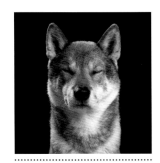

Page 47

Name: Shosei
Breed: Shikoku Inu
Owner: Nico R.
Website: shikoku-ken.org

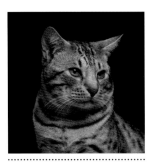

Page 48,49

Name: Vashka
Breed: Ocicat
Owner: Els v.d. B.
Website: ocicatsite.nl

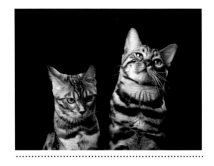

Page 50,51

Name: Uni, Kito
Breed: Bengal Cat
Owner: Willeke
Website: dutchpanthers.nl

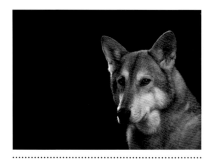

Page 52-53 (Also appears on p.128)

Name: Duet
Breed: Saarloos Wolfdog
Owner: Marijke Saarloos
Website: www.kilstroom.nl

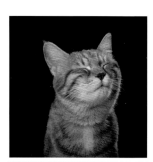

Page 54

Name: Mish Mish
Breed: None / Arabian
 Domestic Shorthair
Owner: Caecilia D.

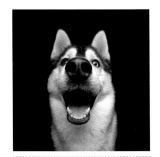

Page 55 (Also appears on p.91)

Name: Suzi
Breed: Siberian Husky
Owner: Pieter & Sari

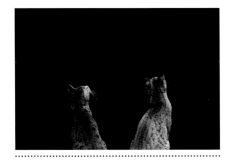

Page 56,57

Name: Balynda & Chloe
Breed: Savannah
Owner: Heika & Mark
Website: savannah-jungle.nl

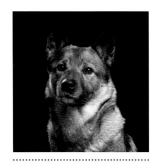

Page 58

Name: Nana
Breed: Norwegian Elkhound
Owner: Marijke Saarloos
Website: www.kilstroom.nl

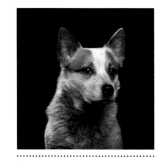

Page 59

Name: Kanda
Breed: Australian Cattle Dog
Owner: Zoza d. L.

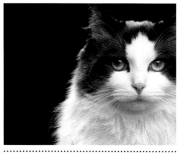

Page 60-61

Name: Magic Mike
Breed: Ragdoll
Owner: Ineke L.
Website: catterydeknorretjes.com

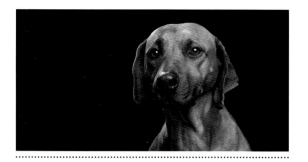

Page 64 Also appears on p. 100

Name: Tigra
Breed: Rhodesian Ridgeback
Owner: Dennis
Website: ofthepridelands.nl

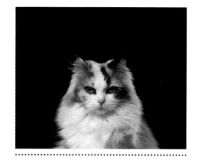

Page 64,65

Name: Tessa
Breed: Ragdoll
Owner: Ineke L.
Website: catterydeknorretjes.nl

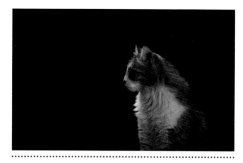

Page 66,67

Name: Zaatar
Breed: None / Arabian Domestic Longhair
Owner: Maia A.

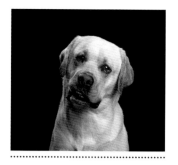

Page 68

Name: Cooper
Breed: Labrador
Owner: Rogier d. K.

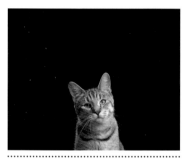

Page 69

Name: Stevie
Breed: Pixiebob
Owner: Karin v. E.
Website: dutchpixiebob.nl

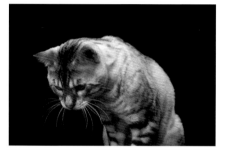

Page 70-71 (Also appears on p. 104-105)

Name: Merkur
Breed: Snow Bengal
Owner: Willeke
Website: dutchpanthers.nl

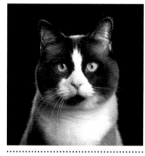

Page 72

Name: Bink
Breed: None / European DSH*
Owner: Wilhelmien K.
Website: specialspirit.nl

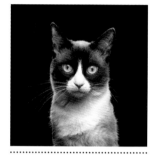

Page 73

Name: Gio
Breed: Snowshoe
Owner: Wilhelmien K.
Website: specialspirit.nl

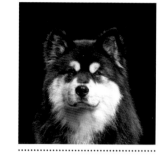

Page 74

Name: Arttu
Breed: Finish Lapphund
Owner: Nanda T.
Website: peellappies.nl

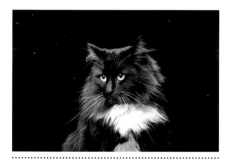

Page 75

Name: Asmara
Breed: Norwegian Forest Cat
Owner: Miranda M.
Website: hofvanfelis.nl

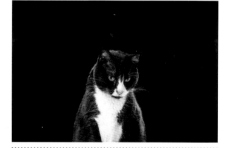

Page 76

Name: Jellicle
Breed: None / North American
 Domestic Shorthair
Owner: Meghan M.

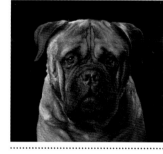

Page 78,79

Name: Freek
Breed: Bullmastiff
Owner: Greetje v. O.
Website: thepeatcutters.nl

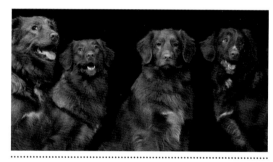

Page 80-81

Name: Tess, Yuna, Hera, Shivah
Breed: Nova Scotia Duck Tolling Retriever
Owner: Rob & Anneke W.
Website: tevreden-rakkers.nl

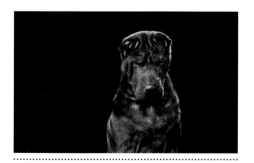

Page 85

Name: Igor
Breed: Shar Pei
Owner: Nataschja H.
Website: hntm-sharpei.nl

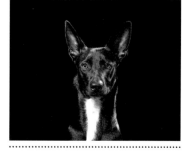

Page 86

Name: Maffin
Breed: None / Moroccan Mutt
Owner: Tomek G.

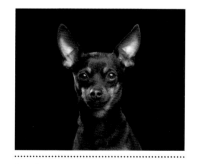

Page 87

Name: Wodan
Breed: Pražský Krysařik
Owner: Jannie

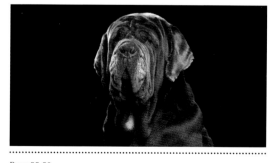

Page 88-89

Name: Esperia
Breed: Neapolitan Mastiff
Owner: Tien & Wilhelmien v. R.
Website: wiltimana.com

*European Domestic Shorthair

215

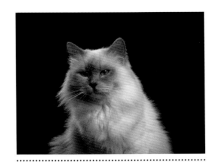

Page 90

Name: Romy
Breed: Birman
Owner: Marja d. L.
Website: deluro.nl

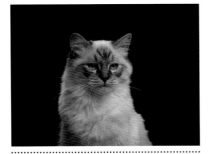

Page 91

Name: Tinker Bella
Breed: Ragdoll
Owner: Ineke L.
Website: catterydeknorretjes.com

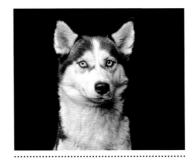

Page 92

Name: Svura
Breed: Siberian Husky
Owner: Vasia

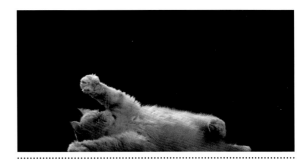

Page 94-95

Name: Gingersnaps
Breed: Persian Cat
Owner: Ibraheem H.

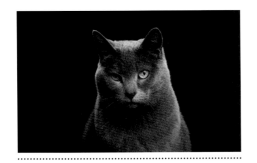

Page 97

Name: Iulinka
Breed: Russian Blue
Owner: Yasmine W.
Website: catterydunoe.nl

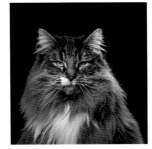

Page 98

Name: Diesel
Breed: Norwegian Forest Cat
Owner: Miranda M.
Website: hofvanfelis.nl

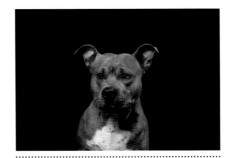

Page 99

Name: Django
Breed: Pitbull
Owner: Esther B.

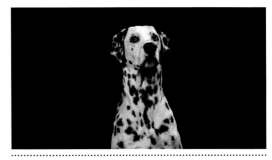

Page 101

Name: Hurko
Breed: Dalmatian
Owner: Enrique

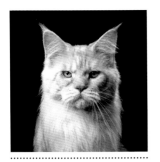

Page 103

Name: Happy
Breed: Maine Coon
Owner: Marjan B.
Website: boonland.nl

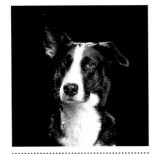

Page 106

Name: Bengal
Breed: Portuguese Mutt
Owner: Johanna H.

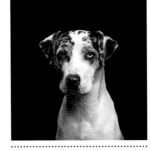

Page 107

Name: Nita
Breed: Louisiana Catahoula
Leopard Dog
Owner: Daniele

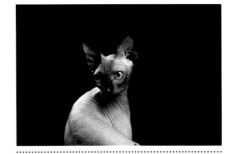

Page 108-109

Name: Lolah
Breed: Canadian Sphynx
Owner: Rixt
Website: noxalys.nl

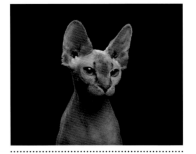

Page 110 (Also appears on p.113)

Name: Wina
Breed: Canadian Sphynx
Owner: Rixt
Website: noxalys.nl

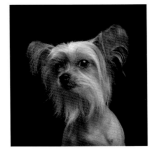

Page 111

Name: Mira
Breed: Chinese Crested Dog
Owner: Jannie

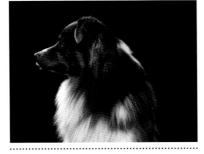

Page 114-115

Name: Relay
Breed: Australian Shepherd
Owner: Chiara & Co.
Website: lightitup4.webs.com

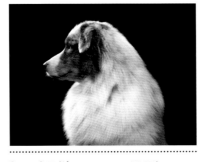

Page 116-117 (Also appears on p152,153)

Name: Fedde
Breed: Australian Shepherd
Owner: Chiara & Co.
Website: lightitup4.webs.com

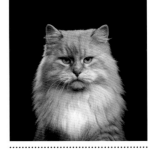

Page 118

Name: Fatian
Breed: Siberian
Owner: Ingrid B.
Website: jenmerin.nl

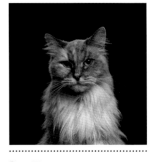

Page 119

Name: Inga
Breed: Siberian
Owner: Ingrid B.
Website: jenmerin.nl

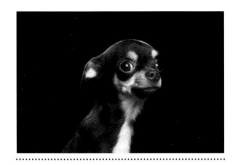
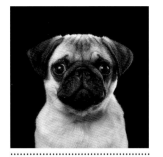
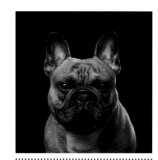
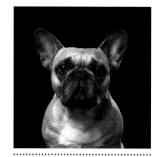
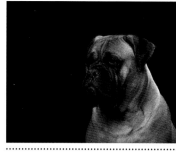

Page 120-121

Name:	Freddy
Breed:	Chihuahua
Owner:	Abraham L.

Page 122,123

Name:	Lissie
Breed:	Pug
Owner:	Samantha

Page 124

Name:	Lucca
Breed:	French Bulldog
Owner:	Mariska L.
Website:	frenchieflowers.nl

Page 125

Name:	Balou
Breed:	French Bulldog
Owner:	Mariska L.
Website:	frenchieflowers.nl

Page 127

Name:	Ruby
Breed:	Bullmastiff
Owner:	Greetje v. O.
Website:	thepeatcutters.nl

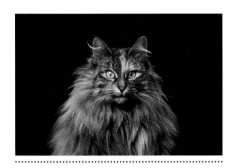
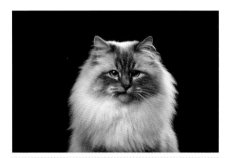
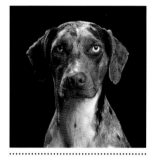
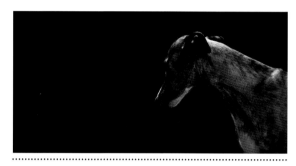

Page 131

Name:	Camila
Breed:	Norwegian Forest Cat
Owner:	Miranda M.
Website:	hofvanfelis.nl

Page 133

Name:	Davino
Breed:	Birman
Owner:	Marja d. L
Website:	deluro.nl

Page 134

Name:	Rogue
Breed:	Louisiana Catahoula
	Leopard Dog
Owner:	Jose F.

Page 137

Name:	Isa
Breed:	Whippet
Owner:	Kris & Jan Willem
Website	cremeanglaise.nl

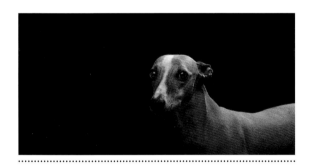
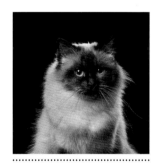
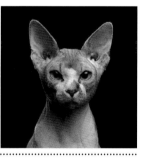
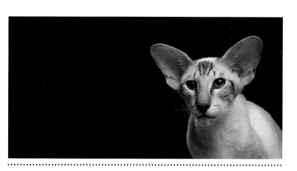

Page 139

Name:	Nicky
Breed:	Whippet
Owner:	Kris & Jan Willem
Website:	cremeanglaise.nl

Page 140

Name:	Farah Inés
Breed:	Birman
Owner:	Marja d. L
Website:	deluro.nl

Page 141

Name:	Luxor
Breed:	Canadian Sphynx
Owner:	Rixt
Website:	noxalys.nl

Page 143

Name:	Precious
Breed:	Modern Siamese Cat
Owner:	Annemarie
Website	sweetcats.nl

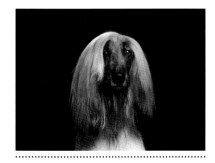
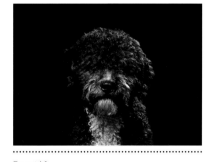
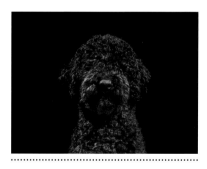
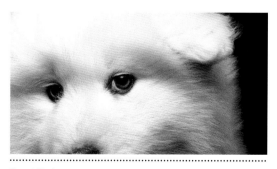

Page 144,145

Name:	Venya
Breed:	Afghan Hound
Owner:	Hetty L.
Website:	afghanen-el-kharaman.nl

Page 146

Name:	Jack
Breed:	Spanish Waterdog
Owner:	Petra v. D.
Website:	todosjuntos.nl

Page 147

Name:	Luc
Breed:	Labradoodle
Owner:	Jan G.

Page 148-149

Name:	Finn
Breed:	Samoyed
Owner:	Stana
Website:	sam-samoyed.nl

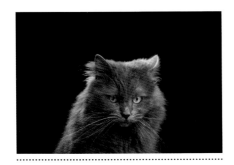

Page 150

Name: Tommy Hilfiger
Breed: Ragdoll
Owner: Ineke L.
Website: catterydeknorretjes.com

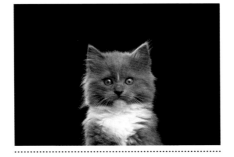

Page 151

Name: Tresor
Breed: Ragdoll
Owner: Ineke L.
Website: catterydeknorretjes.com

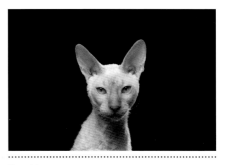

Page 156

Name: Curly
Breed: Devon Rex
Owner: Marjan B.
Website: boonland.nl

Page 157

Name: José
Breed: Cornish Rex
Owner: Mariska L.
Website: rexflowers.nl

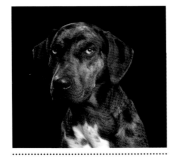

Page 158

Name: Cold
Breed: Louisiana Catahoula
Leopard Dog
Owner: Johanna H.

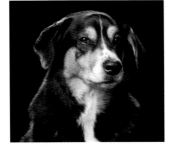

Page 159

Name: George
Breed: None / North American Mutt
Owner: Umy B.

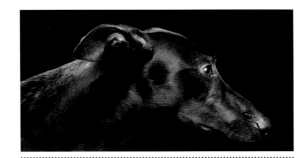

Page 160-161

Name: Hugo
Breed: Greyhound
Owner: Naomi K.

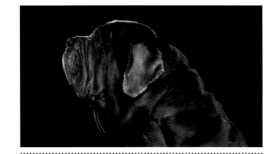

Page 162-163

Name: Balou
Breed: Neapolitan Mastiff / Mastino
Owner: Tien & Wilhelmien v. R.
Website: wiltimana.com

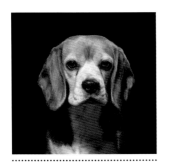

Page 164

Name: Bella
Breed: Beagle
Owner: Armineh M.

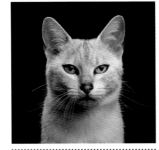

Page 165

Name: Aylinn
Breed: Egyptian Mau
Owner: Gertrude & Jaap
Website: asenka.nl

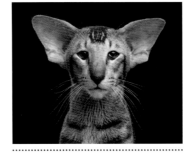

Page 166

Name: Wietje
Breed: Oriental Shorthair
Owner: Annemarie
Website: sweetcats.nl

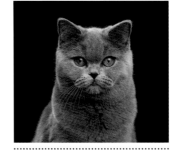

Page 168

Name: Wally
Breed: British Shorthair
Owner: Deborah
Website: attheraces.jouwweb.nl

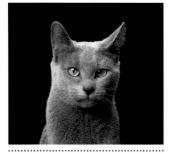

Page 169

Name: Nanoushka
Breed: Russian Blue
Owner: Yasmine W.
Website: catterydunoe.nl

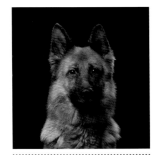

Page 172

Name: Kaos
Breed: German Shepherd
Owner: Michael S.
Website: saendenland.nl

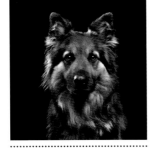

Page 173

Name: Max
Breed: Bohemian Shepherd
Owner: Jannie

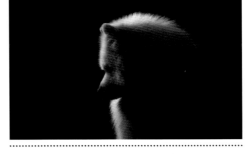

Page 178-179 (Also appears on p.41, 208 & front cover)

Name: Sam
Breed: Samoyed
Owner: Stana
Website: sam-samoyed.nl

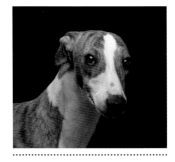

Page 180

Name: Pan
Breed: Whippet
Owner: Kris & Jan Willem
Website: cremeanglaise.nl

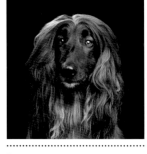

Page 181

Name: Fhiroz
Breed: Afghan Hound
Owner: Hetty
Website: afghanen-el-kharaman.nl

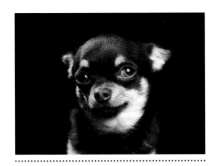

Page 184

Name: Brown Sugar
Breed: Chihuahua
Owner: Patricia B.
Website: chickatjieka.nl

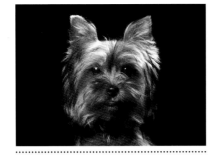

Page 185

Name: Santiago
Breed: Yorkshire Terrier
Owner: Juliana L.

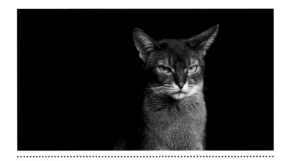

Page 187

Name: Quiomme
Breed: Abyssinian
Owner: Fam. Konink
Website: ravottersgaarde.nl

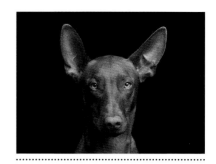

Page 188

Name: Rover
Breed: Pharaoh Hound
Owner: Rogier d. K.

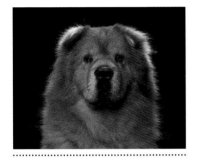

Page 189

Name: Koebikai
Breed: Chow Chow
Owner: Ronald

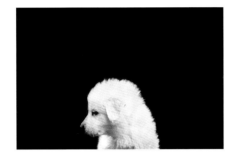

Page 190

Name: Gerhart Wolfgang
Breed: Swiss Shepherd
Owner: Üter Z.

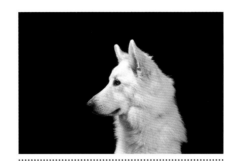

Page 191

Name: Avalon
Breed: Swiss Shepherd
Owner: Alma & Piet G.
Website: witte-herder.nl

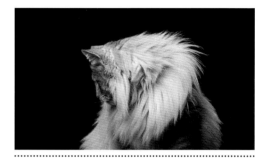

Page 192-193

Name: Sanna
Breed: Norwegian Forest Cat
Owner: Miranda M.
Website: hofvanfelis.nl

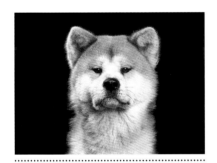

Page 194

Name: Katsuo
Breed: Japanese Akita
Owner: Christel V.
Website: akitas.nl

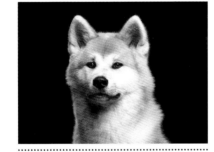

Page 195

Name: Kaiya
Breed: Japanese Akita
Owner: Miranda M.

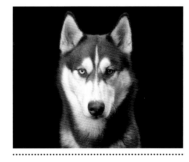

Page 197

Name: Owen
Breed: Siberian Husky
Owner: Anita C.

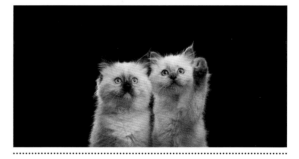

Page 198-199

Name: Lilly & Skittles
Breed: Ragdoll
Owner: Ineke L.
Website: catterydeknorretjes.com

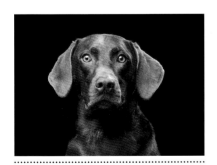

Page 200,201

Name: Fay
Breed: Louisiana Catahoula Leopard Dog
Owner: Fleur

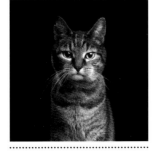

Page 202,203

Name: Tiger
Breed: None / European
Domestic Shorthair
Owner: Renée R.

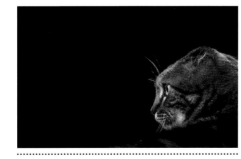

Page 205

Name: Sophie
Breed: Unknown
Owner: Maaike B.

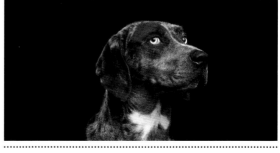

Page 206-207

Name: Cold
Breed: Louisiana Catahoula Leopard Dog
Owner: Jose F.

This book would not be half the book it is were it not for the tireless help and commitment I received every day from Alesi Enríquez. I do not want to imagine the chaos that would have ensued had I attempted to make this book without you. Thank you Lesi, *Animal Soul* is every bit as much yours as it is mine.

I would like to express my sincere gratitude to the three individuals who formed my de facto panel of judges for virtually every facet of this book. My brother Tarik Bahou has been an invaluable part of the process, offering his neutral and balanced opinion to every idea I presented. Joonas Toivainen, my friend of ten years, helped me tremendously with his astute business acumen and headstrong conviction in making the tough decisions. Aram Zegerius, in many respects my partner in crime in all things photo and video, offered me a fair and fresh perspective for almost everything I put on his plate, not afraid to tell me when something did not work, and helping me onwards to the solution.

Of course, my parents Frederique Boes and Kamal Bahou. A very special thank you for the unwavering support you have shown me from day one. Helping me through every page, every photo, sifting through the thousands of outtakes and for being a listening ear for virtually every problem I faced in the production of *Animal Soul.*

I would like to thank Javier Enríquez and Lisa Barricklow for being the professional and experienced eyes I needed for *Animal Soul.* I knew nothing about producing a book, but you helped me understand the real ins and outs of doing so and helped me through the entire process from the very beginning.

I would like to express my gratitude to Patrick Barb for initially approaching me with the idea of creating a book. Although we may not have produced *Animal Soul* together, I do not know if I would have produced it at all were it not for the jumpstart you offered me.

A very special thank you to Elsa van Latum for letting me photograph the wonderful Scuba. That one spring evening in the university dormitories has done more for me and my work than I could have ever expected.

Also, I would like to thank all the individuals who allowed me to come over and photograph their dogs and cats. I could not have made this book without your help.

In addition, an incredible thank you for the community of individuals who pledged generous amounts of money to help *Animal Soul* come to life through Kickstarter.

And finally, to all the dogs and cats that grace these pages. You are the bread and butter of *Animal Soul.* Although you may rarely think back to the day we met, I will do so for the both of us.

Robert Bahou, Amsterdam, April 2016

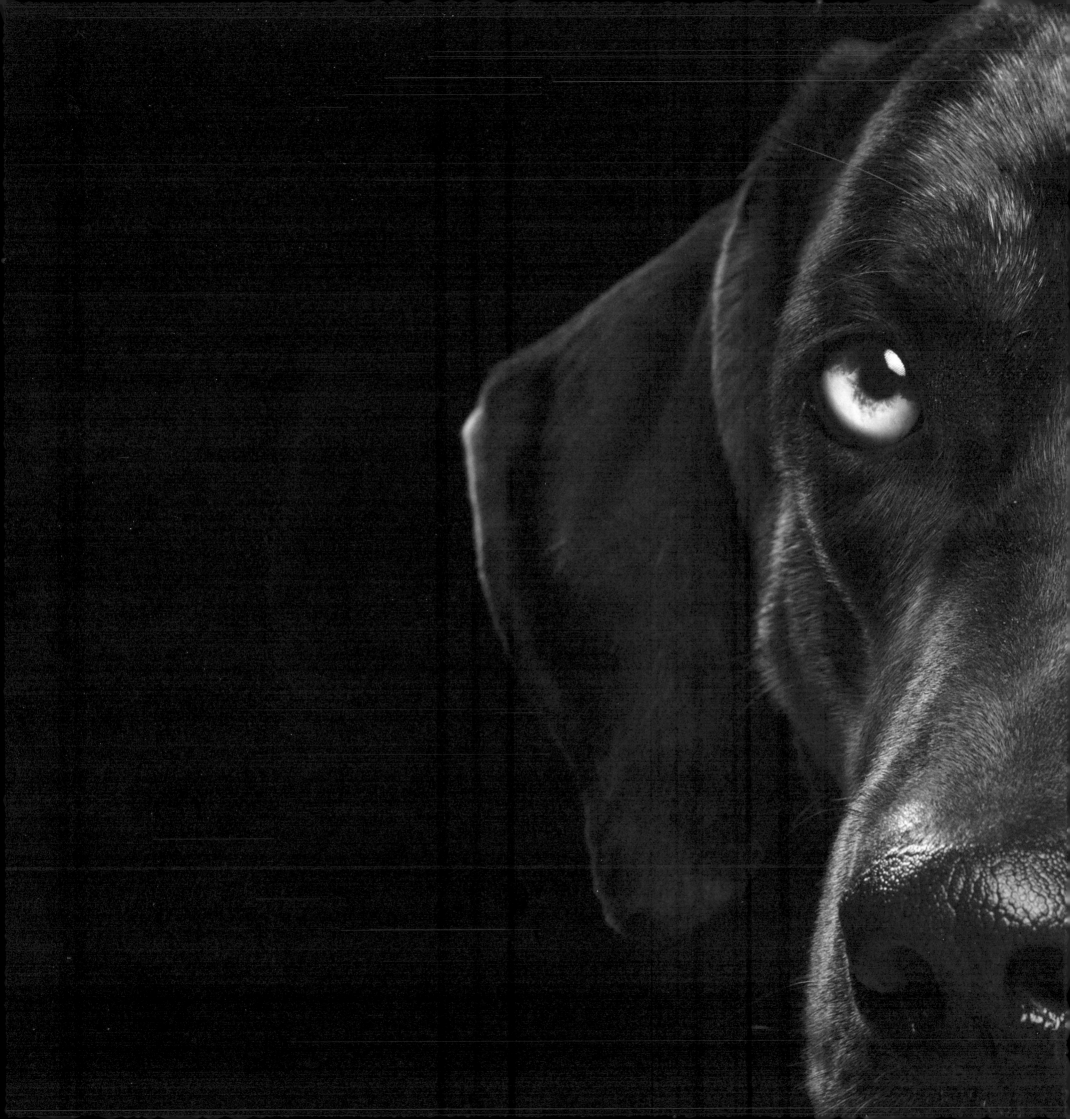